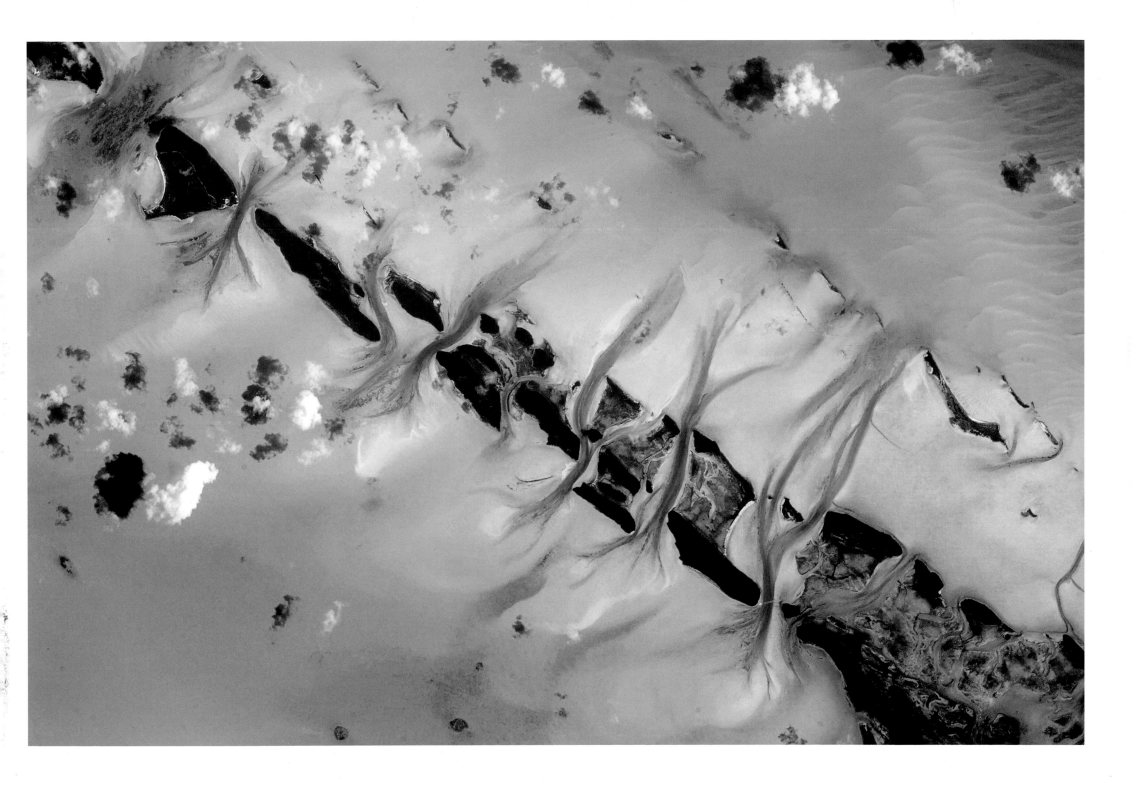

ALSO BY SCOTT KELLY

Endurance: A Year in Space, a Lifetime of Discovery

My Journey to the Stars

Endurance, Young Readers Edition: A Year in Space and How I Got There

Previous page: The Exuma islands in the Bahamas look like the spine of a dinosaur lying in the shallows.

Overleaf: After a particularly hard day's work, I had only enough energy to tweet this photo of an almost full moon at moonset before I went to sleep.

INFINITE WONDER

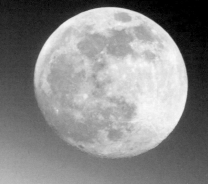

INFINITE WONDER

An Astronaut's Photographs from a Year in Space

SCOTT KELLY

ALFRED A. KNOPF · NEW YORK · 2018

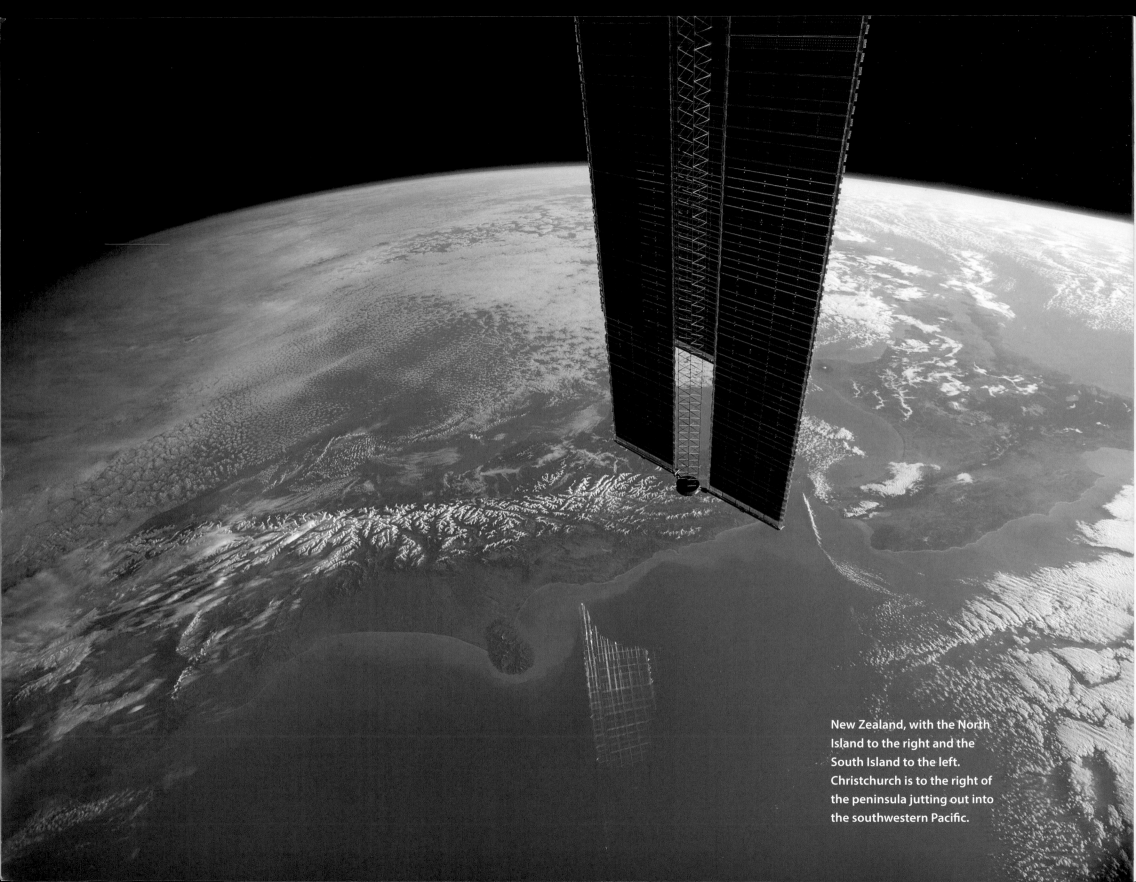

New Zealand, with the North Island to the right and the South Island to the left. Christchurch is to the right of the peninsula jutting out into the southwestern Pacific.

CONTENTS

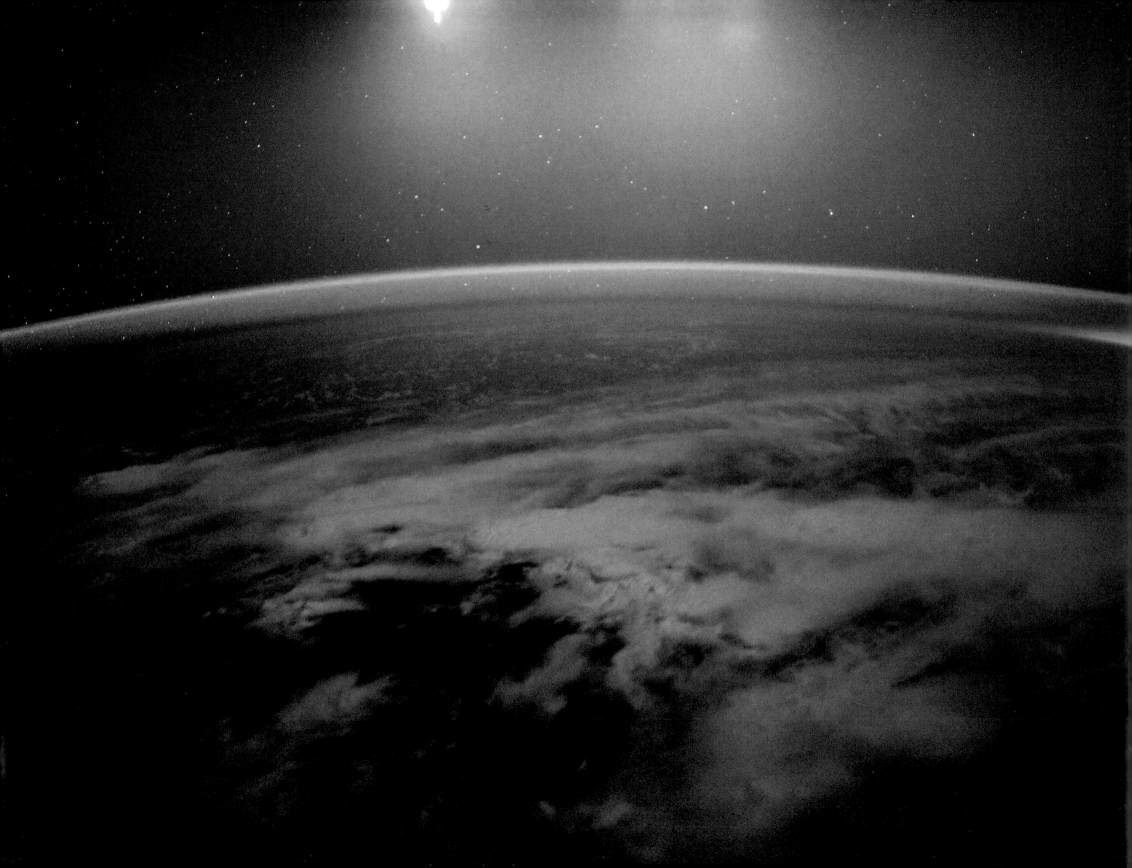

PREFACE

My first flight into space was aboard the space shuttle *Discovery* in December 1999 on a mission to repair the Hubble Space Telescope. There are many things about a first space flight that are surprising: the adrenaline rush of the launch countdown, the roar of the main engines, and the sheer power of the solid rocket motors as they explode with millions of pounds of instantaneous thrust. These all pale, however, in comparison to the beautiful views of the Earth. After our eight-and-a-half-minute ride into orbit I glanced outside and saw something on the horizon that seemed completely surreal. I turned to the commander of the mission, Curt Brown, and asked excitedly, "What the hell is that?" Curt, on his sixth flight into space, replied nonchalantly, "Oh, that's the sunrise." I was awestruck. Later, I would admire the luminescent waters of the ocean, as if someone had taken the most brilliant blue paint and brushed it across a mirror right in front of my eyes. The bright reds, oranges, and yellows of the deserts were often juxtaposed against the blues of the adjacent waters. The majestic moun-

For an instant before sunrise when it is still a little dark outside, the International Space Station glows as if it is on fire.

that of my Russian colleague Misha Kornienko, was to understand the negative effects on the human body and mind of ultra-long-duration space flight, so when we venture farther out from our planet we will be prepared.

Living in space for a year, I had the time to learn our planet—its geography, its nuances, and all the surprises it has to offer—like few others have ever had. To quote Doug Wheelock, one of my former astronaut colleagues, "The Earth never disappoints."

Most of my days on the space station were filled with conducting scientific experiments, repairing hardware that had failed, or doing general maintenance. Photographing the Earth and space was more of a hobby than a critical part of my job, although we were scheduled daily to take pictures of specific spots on Earth for scientific observation, documenting the effects of our changing environment from human causes like urban growth and water depletion, as well as natural dynamic events such as hurricanes, floods, wildfires, and volcanic eruptions. The photos we took of such natural disasters were used to support disaster response and humanitarian aid efforts by mapping and identifying the extent of the resulting damage.

Most of the pictures I took, though, were for fun. I would often take photos in the morning just after waking up or in the evening when the workday was complete. The most famous set of windows in the space station is the cupola, a set of seven windows connected together, which reminded me of half a soccer ball or maybe even the gun pod of the *Millennium Falcon* in *Star Wars*. On most mornings soon after I woke up, I would float to Node 3 and open the window shades in the attached cupola. Depending on what time it was, I would often be greeted by morning views of Europe or Africa or late evening views over North or South America. If there were good targets of opportunity, I would grab my Nikon D4 and snap a few pictures before getting ready for the day's work.

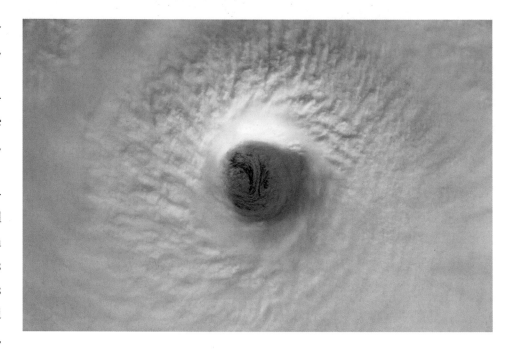

Looking into the eye of a hurricane

In the cupola, over the Bahamas. With the growing trend of feet photos on Instagram, I decided to turn myself so my feet were pointing toward Earth as I snapped this photo to share my unique point of view from our "glass bottom boat" in space.

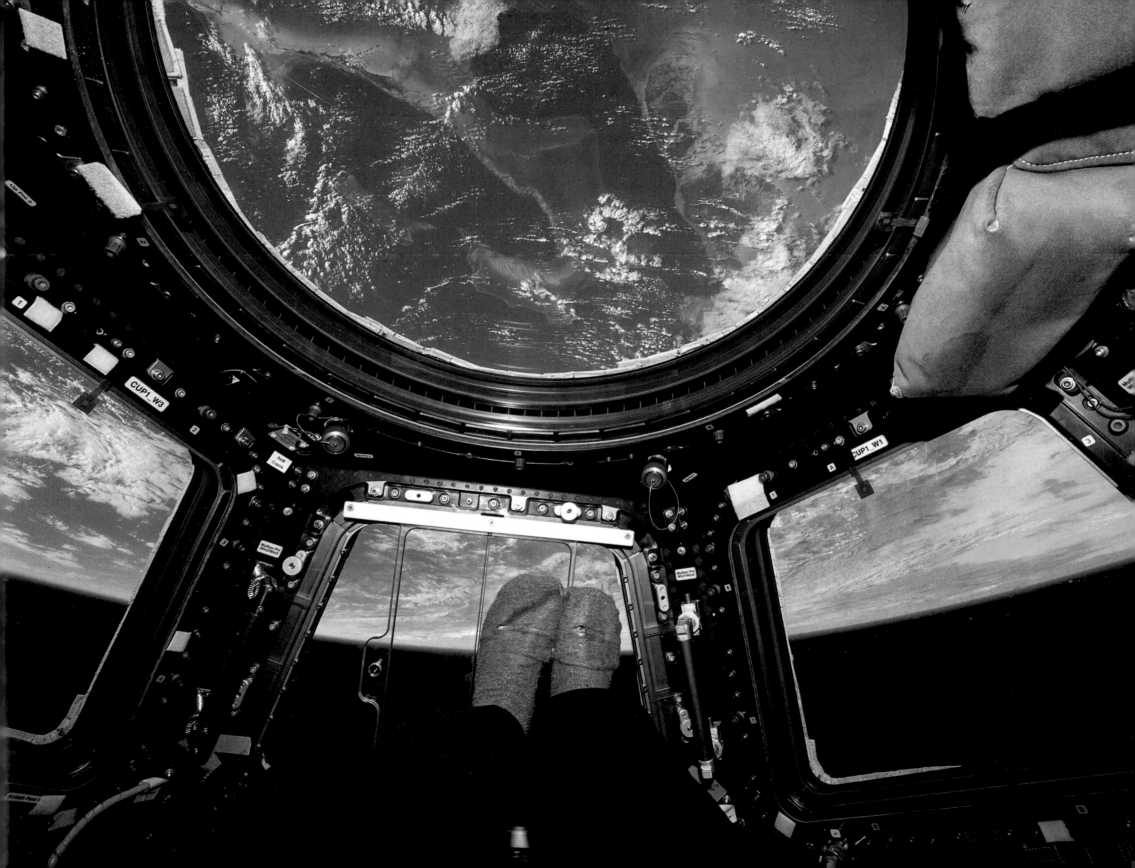

My favorite place to take pictures, though, was a less known lab window, the porthole in the floor of the U.S. laboratory module, a near optically perfect window designed for scientific observation of the Earth. I could use the long lens to get closeup photos of the planet. Sometimes I had a plan as to what I was attempting to capture. During the National Football League season I tried to get a picture of every stadium in which games were played—during the games. I wasn't successful, but I did get a photo of the San Francisco 49ers' stadium during Super Bowl 50. I also tried to get a picture of Everest Base Camp after a 7.8 earthquake struck Nepal and the surrounding areas and killed twenty-two people on the mountain on April 25, 2015, a month after my arrival to the space station. I didn't succeed.

I was able, however, to capture locations on Earth that connected me to home or to people I missed. I photographed Houston, Clear Lake, and Galveston, Texas, where some of my family, including my oldest daughter, Samantha, and many of my colleagues and friends lived. I took a photo of Virginia Beach, where my daughter Charlotte lives with her mother. I successfully photographed my hometown of West Orange, New Jersey, though it took nearly my entire 340 days in space to capture it.

I took a photo of my house and NASA's Johnson Space Center. I tried to take a photo of my now fiancée, Amiko. As far as I know, it would have been the first documented photo of a human being from space taken by another person (we probably have spy sat photos of people). When I knew I would be flying over the home we shared in Clear Lake, Texas, we coordinated photo shoots where she would spread out white sheets in our backyard, don all black clothing, and lay stretched out on the sheets. I would call her, and we'd talk as I flew over, trying to capture a glimpse of a minuscule dark dot that would be her contrasted on a larger white spot. I didn't achieve that photo either, but I enjoyed the challenge.

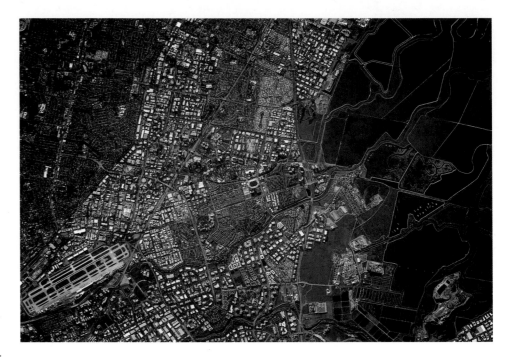

I got to see the fiftieth Super Bowl with my own eyes through a very long lens—in the center of this photo is Levi's Stadium in San Francisco during the game. Traveling at 17,500 miles per hour, I didn't get to see it for long.

In the winter months, we would often see incredible auroras in the Northern Hemisphere (often referred to as northern lights). Auroras are formed when charged particles carried by solar winds from the sun hit the Earth's magnetic field. When I saw auroras over North America, I was reminded of the line from the Canadian national anthem, "O Canada! Beneath thy shining skies."

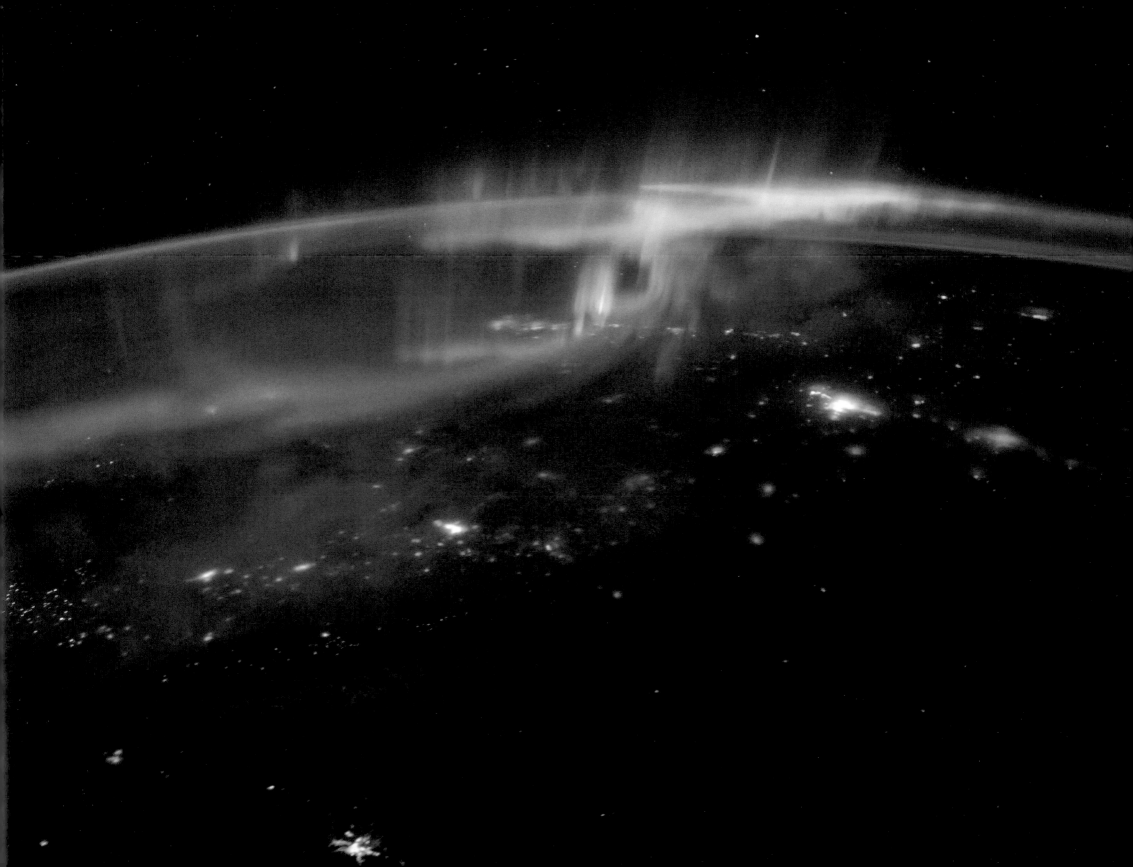

I was usually content to photograph whatever scene I happened to be looking at 250 miles below. On rare occasions I would open the window shades and be pleasantly surprised by an aurora—sometimes referred to as the northern or southern lights—that appeared as green or even rarer red translucent clouds that covered the planet below and at times seemed to dance around the space station.

The ISS is also a great place to take pictures of the cosmos—the soft white glow of intergalactic gas and dust dotted with billions of stars of the Milky Way against a deep purplish backdrop of space or the alignment of cosmic bodies like the moon, Jupiter, and Mars. On my yearlong mission, I captured several rare celestial events, including a supermoon (when the moon is closest to Earth), the Perseids meteor shower, and, in July 2015, a blue moon (the second occurrence of a full moon within one month). Some of these photos are included here.

At times during my voyage, I couldn't help but be conscious of our own threatened environment, so some of the pictures here reflect that. But for the most part the images collected here celebrate the beauty of space, and mostly our own planet. I call those Earth Art, and they represent an attempt to sharpen the beauty of what is sometimes obscured when seen from so far away in space. I remain in infinite wonder of what I saw, and I hope you enjoy my effort to share it with you.

The Milky Way—old, dusty, gassy, and warped, but beautiful

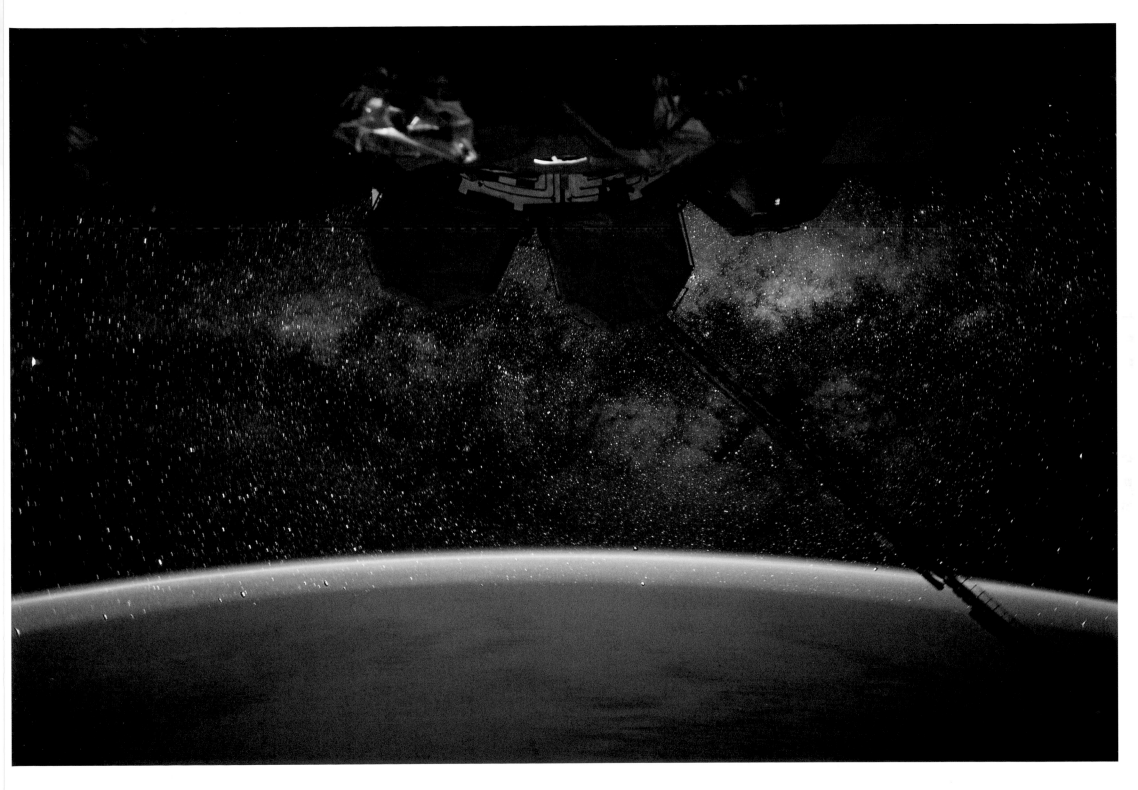

Previous spread: A space-walk selfie

Our Soyuz TMA-16M, as it's dragged out to the launchpad by a train only two days prior to flight. The Russians put ruble coins on the tracks, and having one crushed by your Soyuz is a sign of good luck. The garbage strewn about in the nearby fields makes for an interesting contrast with the rocket.

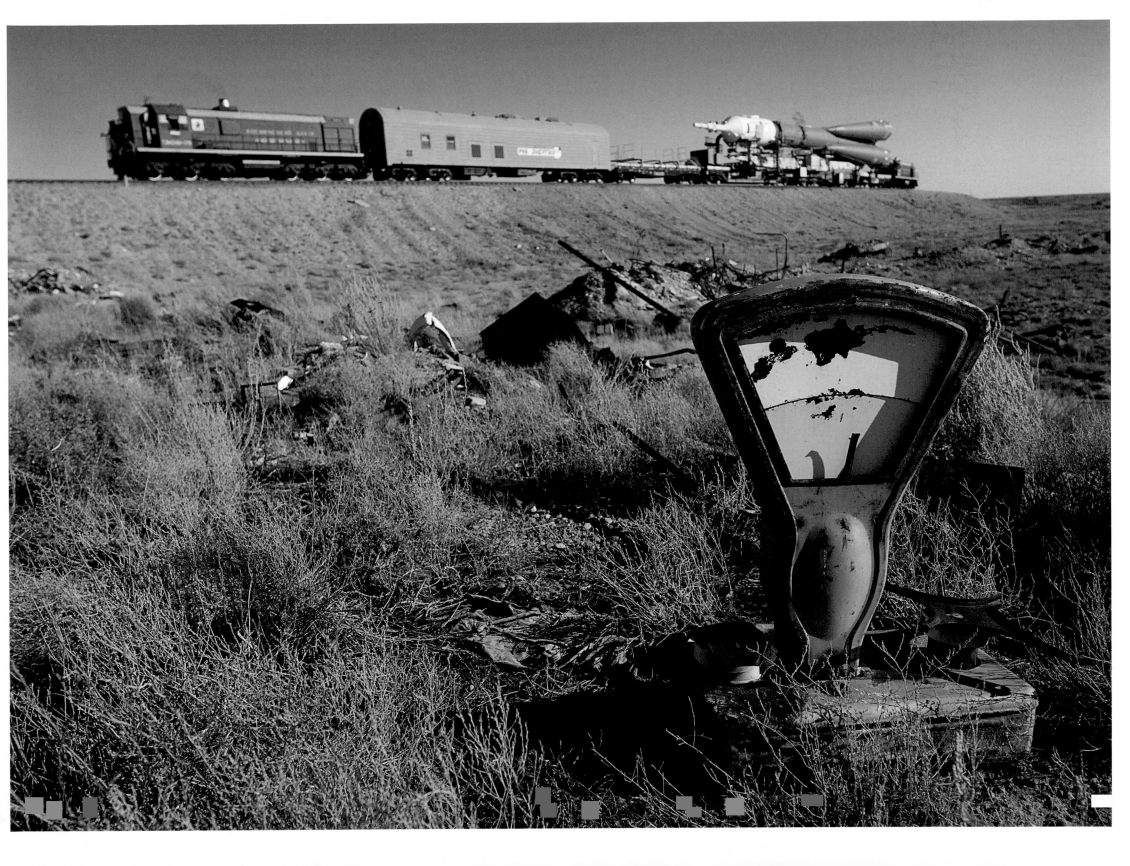

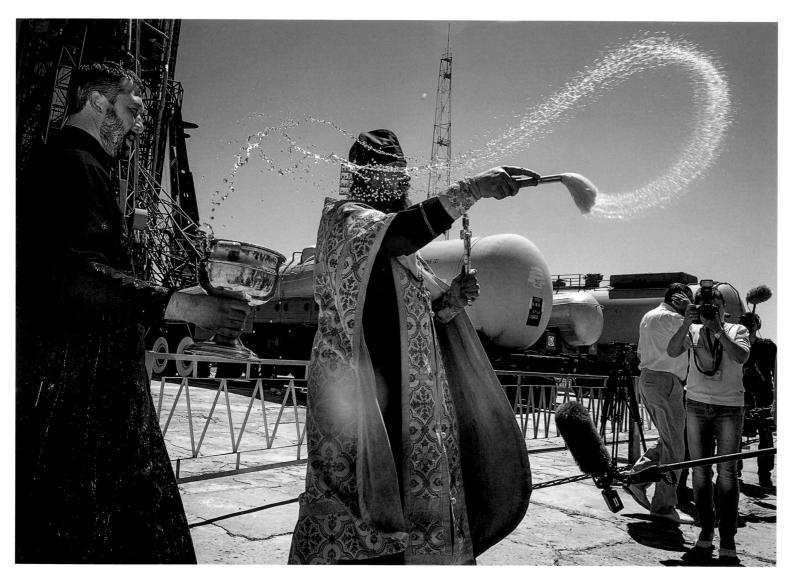

Father Job (pronounced Jobe), a Russian Orthodox priest, blesses the rocket after it arrives at the pad. Despite religion's being effectively banned during Soviet times, the Russian people are in general very nonsecular.

Opposite: Gennady Padalka is on my left, and Misha Kornienko is on his left, as we share our last traditional Russian breakfast with our backup crew before the flight. American astronaut Jeff Williams is in the foreground on the right.

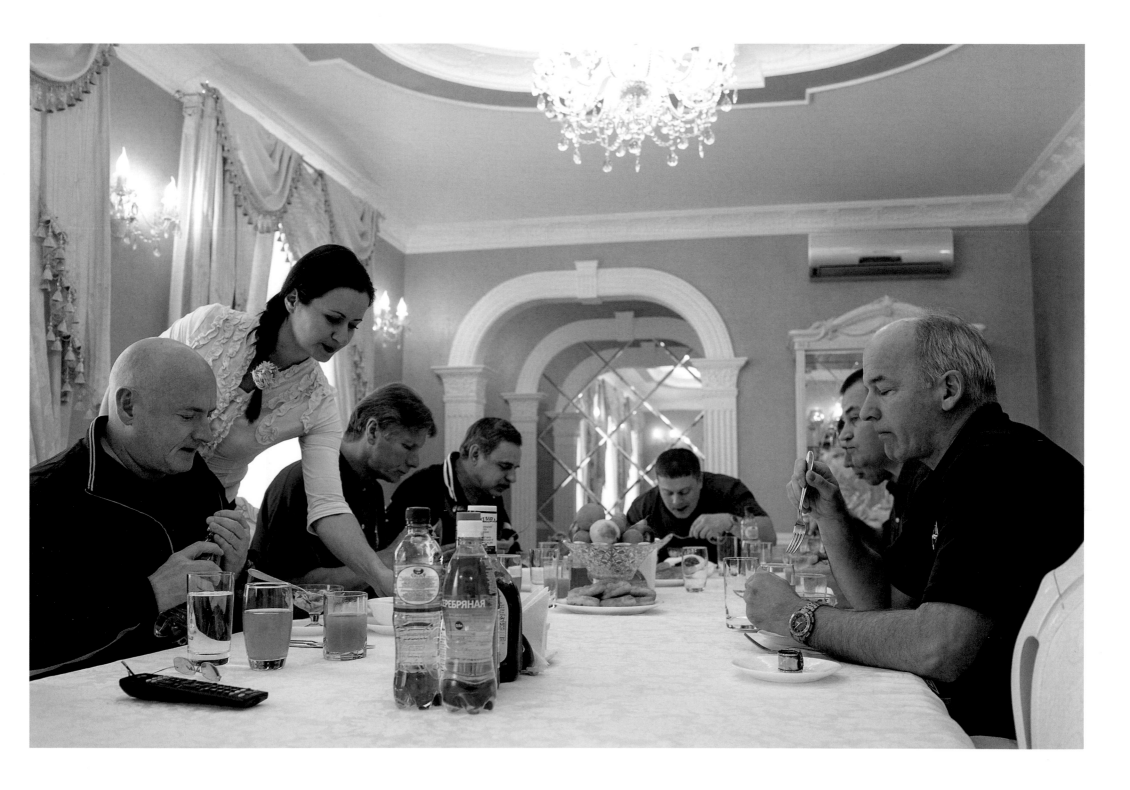

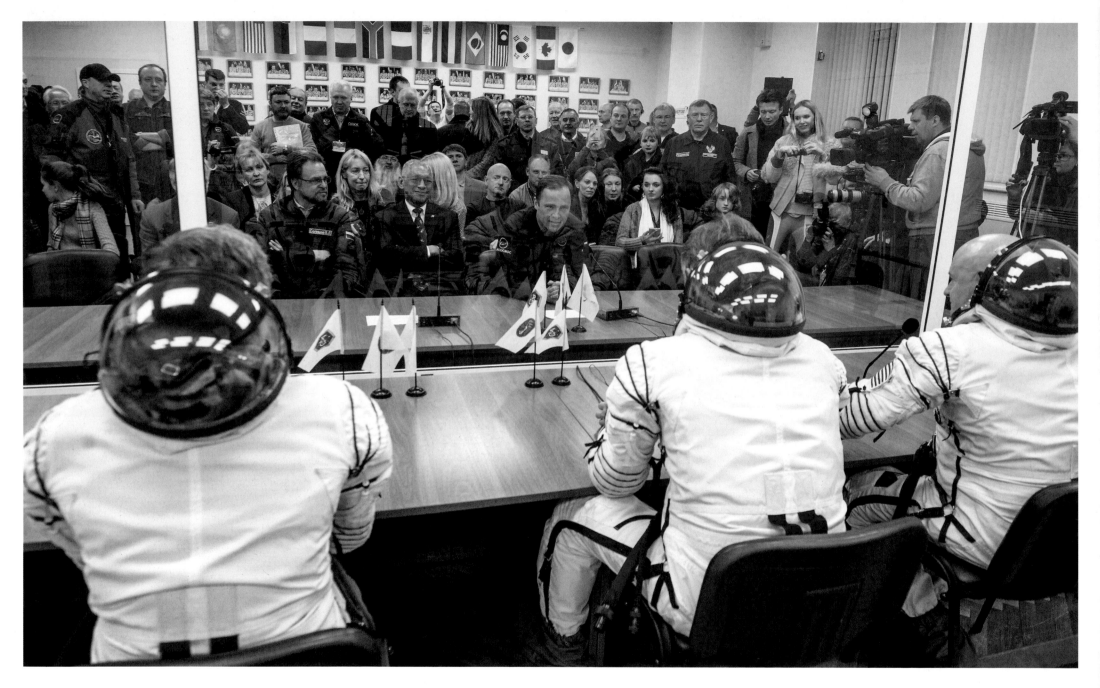

Above: Misha, Gennady, and me as we get ready to head to the launchpad. We are allowed to talk to management and some family members through this large glass window to protect us from potential infection. At the end of the second row of the audience, you can see from left to right my brother, Mark; my fiancée, Amiko Kauderer; and my two daughters, Samantha and Charlotte.

Opposite: On our way to board a bus that will take us to the launchpad

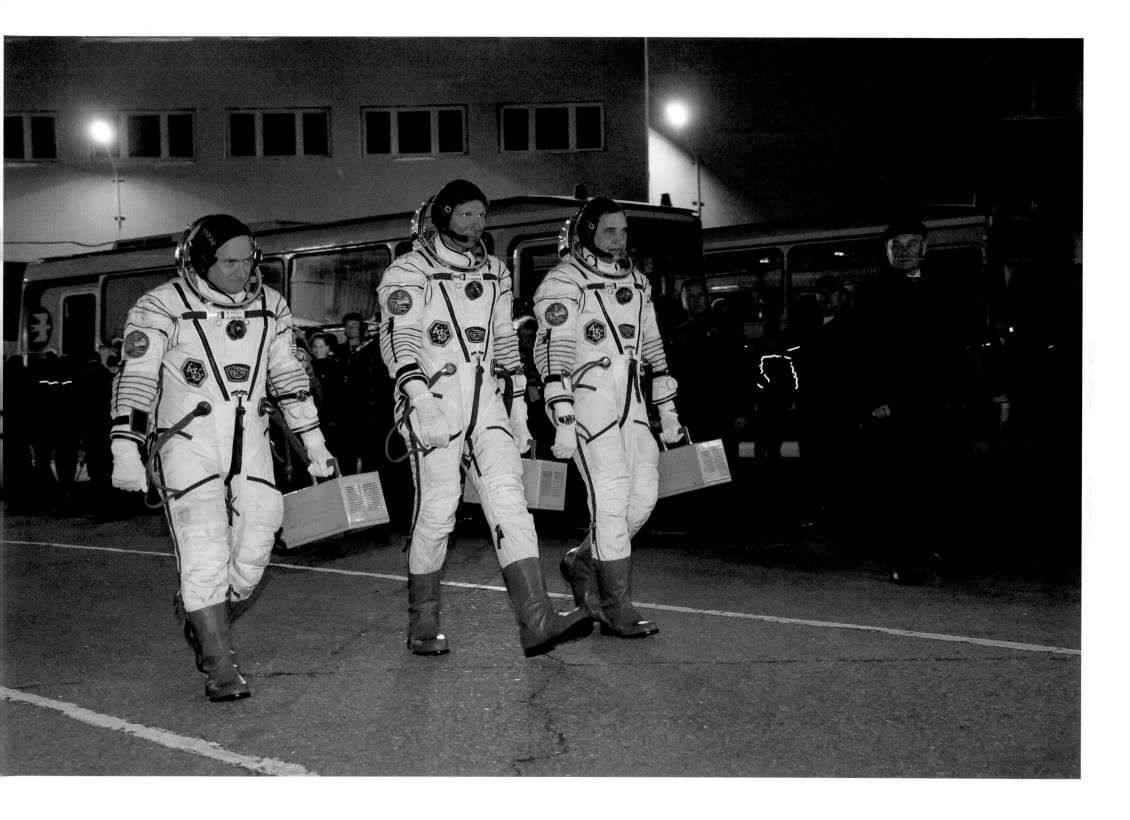

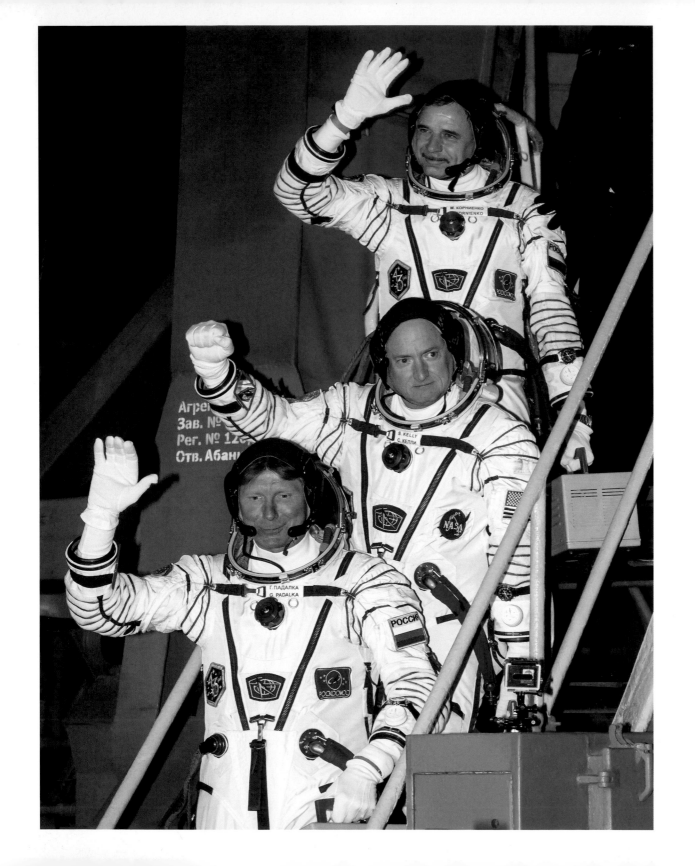

We wave good-bye to friends and planet Earth as we board our Soyuz spacecraft before launch.

Opposite: Blastoff, or as astronauts say, liftoff. Headed to space on our Soyuz to spend the next year on board the International Space Station

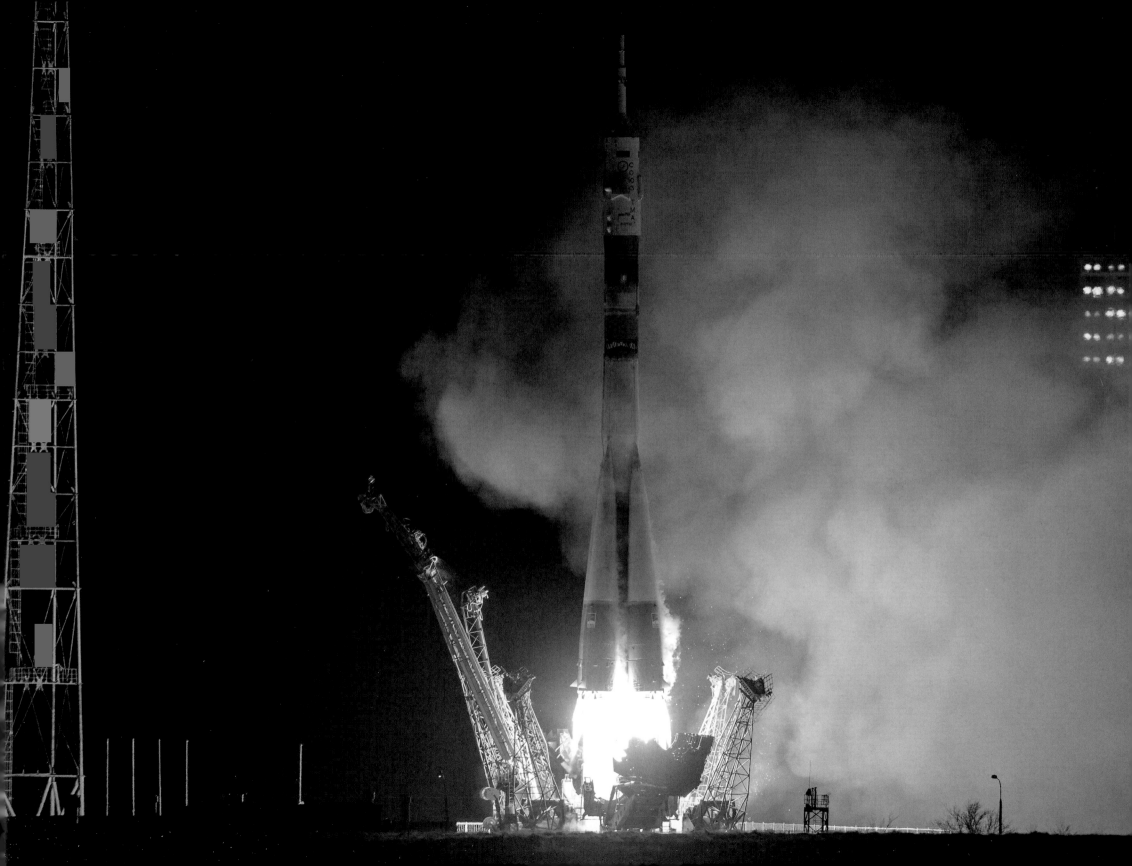

Misha and I float through the hatch together on day one of a year in space. Before we entered, I turned to him and said, "We are in this together, let's enter together as a team."

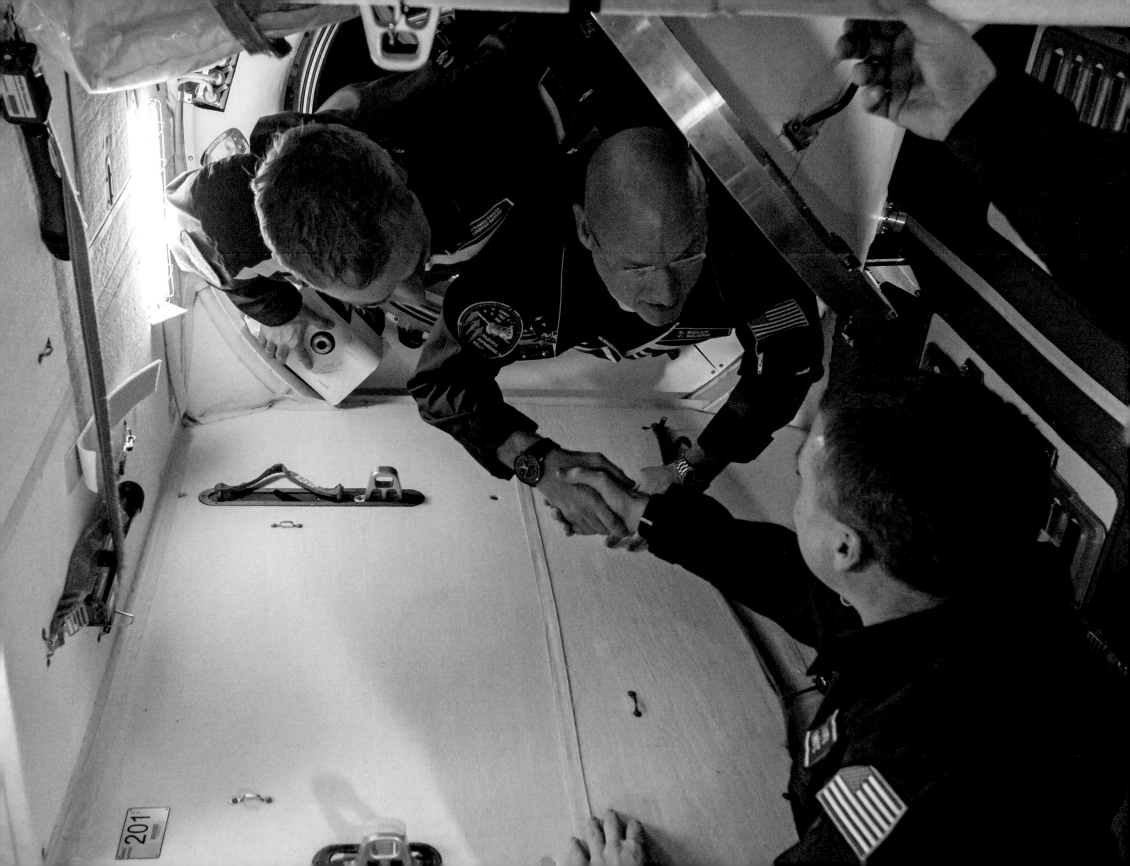

Shortly after arriving on board the space station, I'm still getting settled into my crew quarters, or CQ, a small phone-booth-sized room where we sleep, do office work, e-mail, and talk on the phone. The green bag behind me is my sleeping bag, which is secured to the wall.

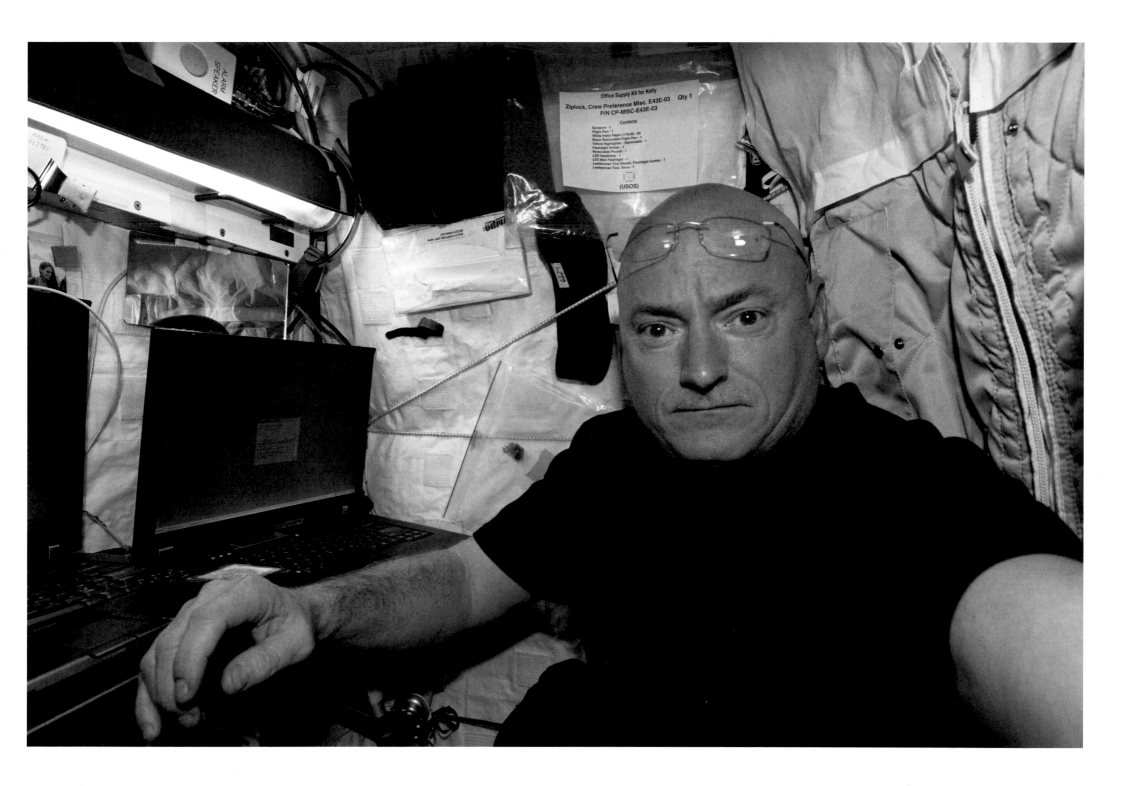

Office Supply Kit for Kelly Qty 1
Ziplock, Crew Preference Misc. E43E-03
P/N CP-MISC-E43E-03

Contents:

Scissors - 1
Flight Pen - 1
White Index Paper (110LB) - 60
Black Retractable Flight Pen - 1
Yellow Highlighter - Retractable - 1
Flashlight Holster - 1
Removable Pocket - 1
LED Headlamp - 1
LED Mini Flashlight - 1
Leatherman Tool Sheath, Flashlight Combo - 1
Leatherman Tool, Wave - 1

(USOS)

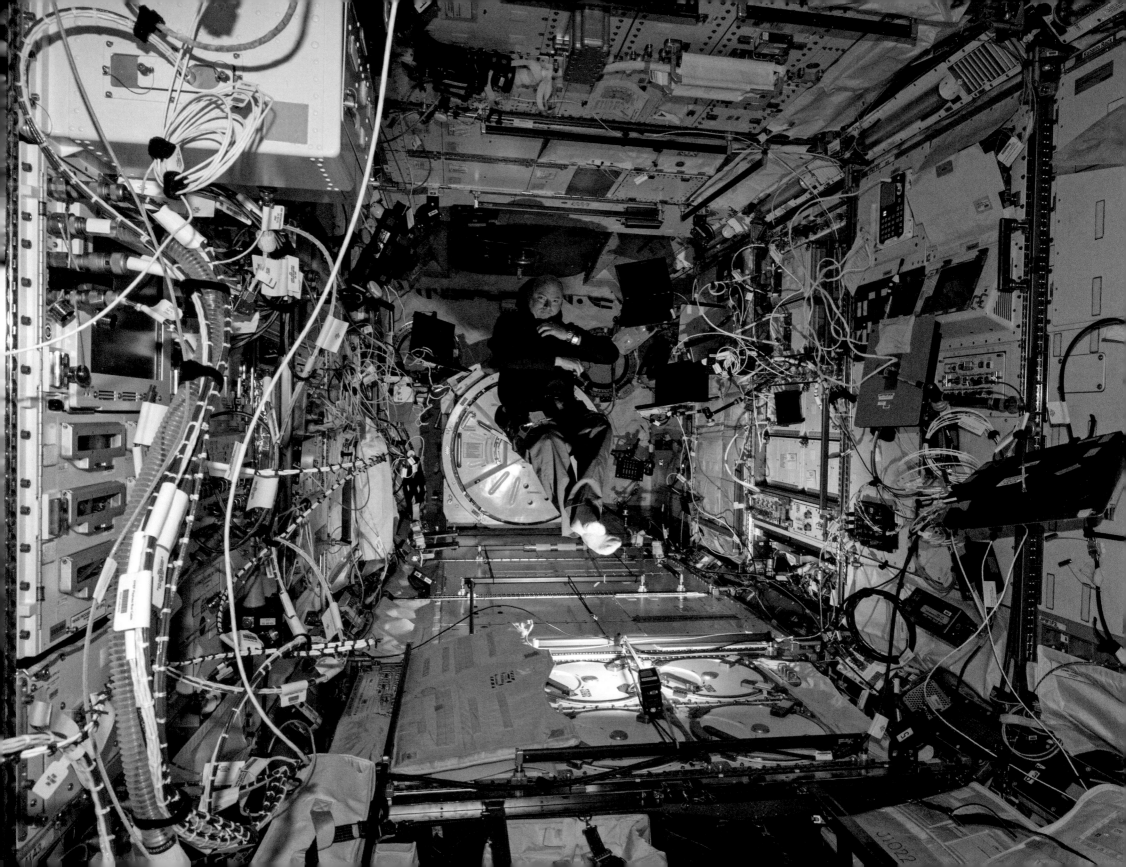

Opposite: Floating quietly in the Japanese experimentation module, the largest module on the ISS. Strewn about the walls, floors, and ceiling are a myriad of equipment, computers, and science experiments that would make life for the obsessively compulsive problematic.

Right: Our dining room table on the U.S. side of the space station; it hangs off the wall at a forty-five-degree angle to save space. Here, you can see a variety of food, the irradiated kind that come in the pale green packages, from rehydratable cereal to a fancy applesauce from the European Space Agency. The silver bags are beverages; the yellow bags with our names contain our utensils.

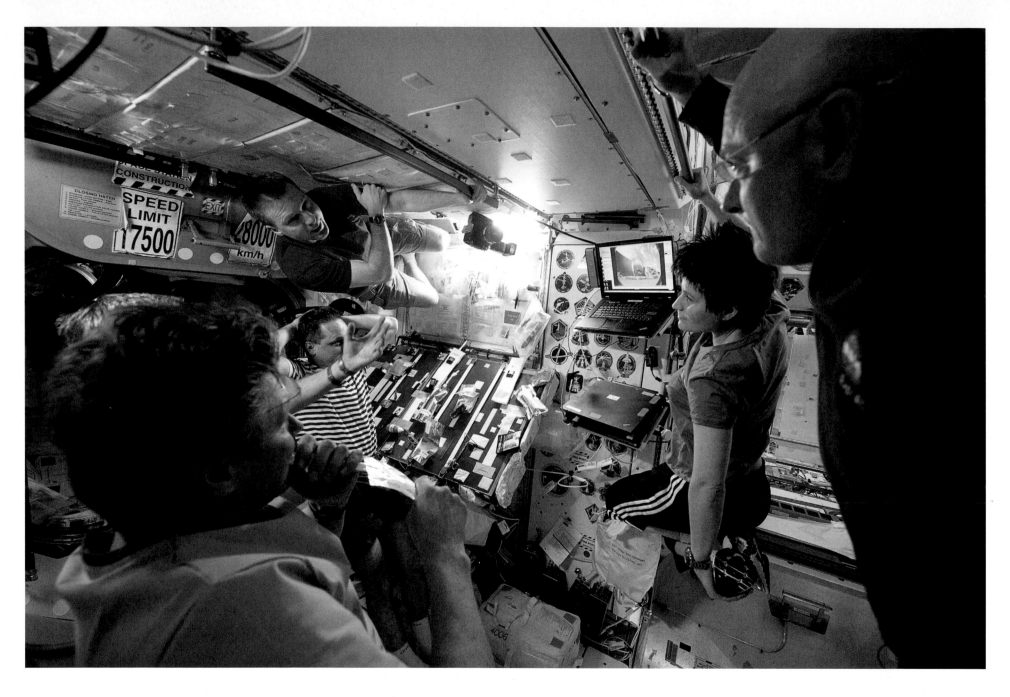

Above: Getting together in Node 1 to watch the launch of the SpaceX resupply rocket on a laptop streaming live from the ground. Samantha Cristoforetti will grab the capsule a few days later from the U.S. cupola module.

Opposite: Me working in the back part of the U.S. laboratory module, which is more cluttered than the Japanese module and is the main workspace for U.S. crew members. If you flew several hundred feet into the photo, you would end up in the Russian segment.

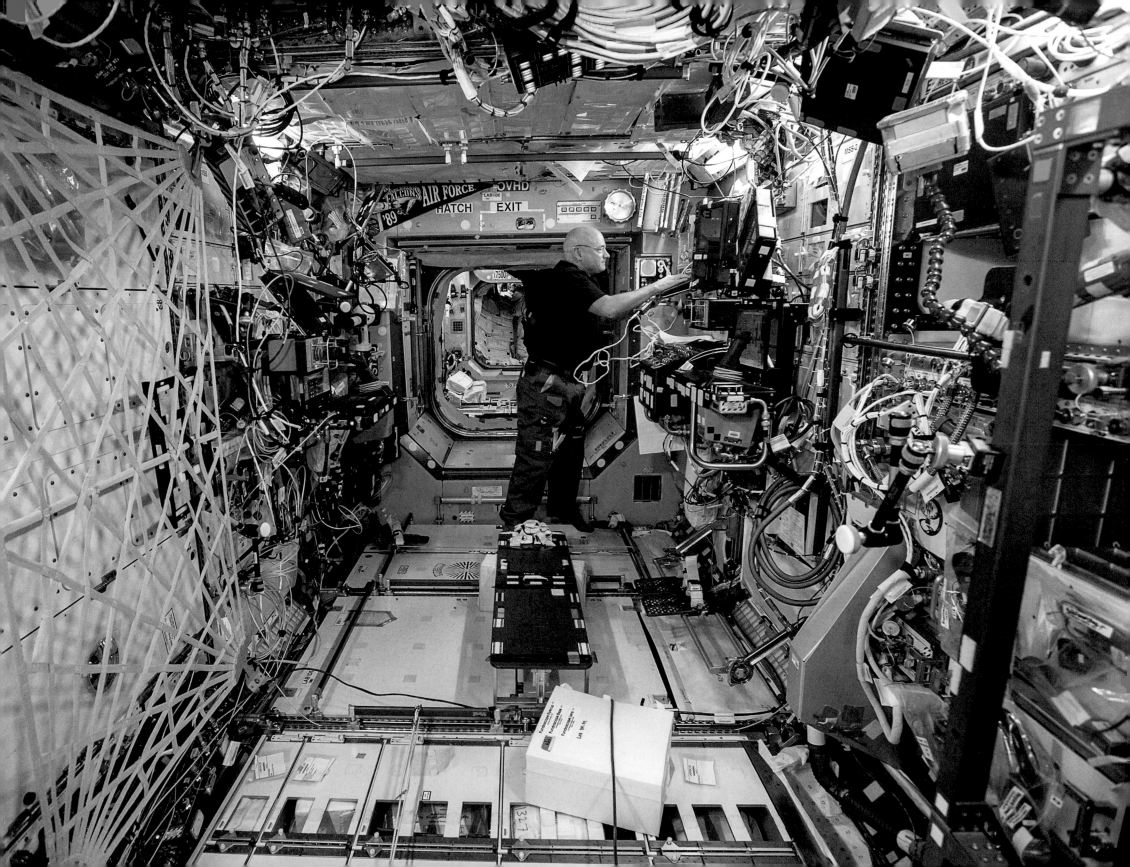

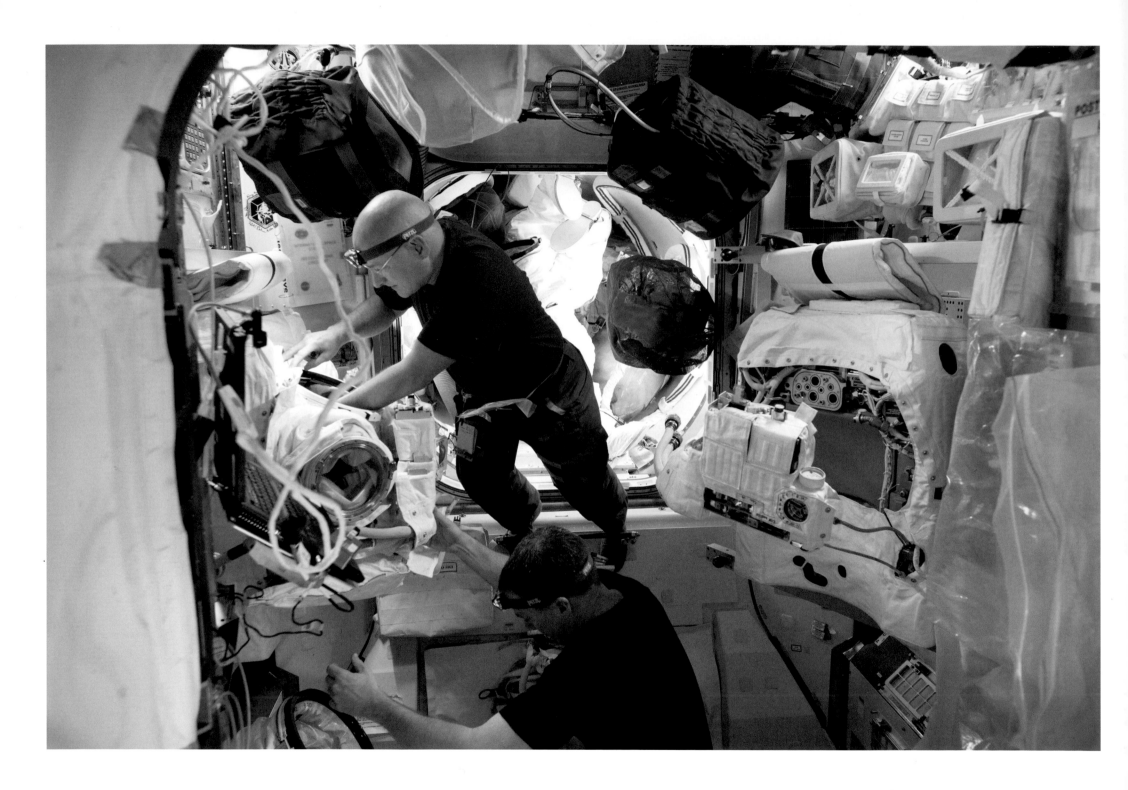

Opposite: Terry Virts and me working in the U.S. air lock to get the space suits prepared for EVA (extravehicular activity), a space walk that will take Kjell Lindgren and me outside the space station for the first time.

Right: Virts and me in our protective gear just prior to opening the hatch of the SpaceX that arrived the previous day. The goggles and masks are to protect us from any floating debris that might be in the module before the ventilation system is able to filter the air.

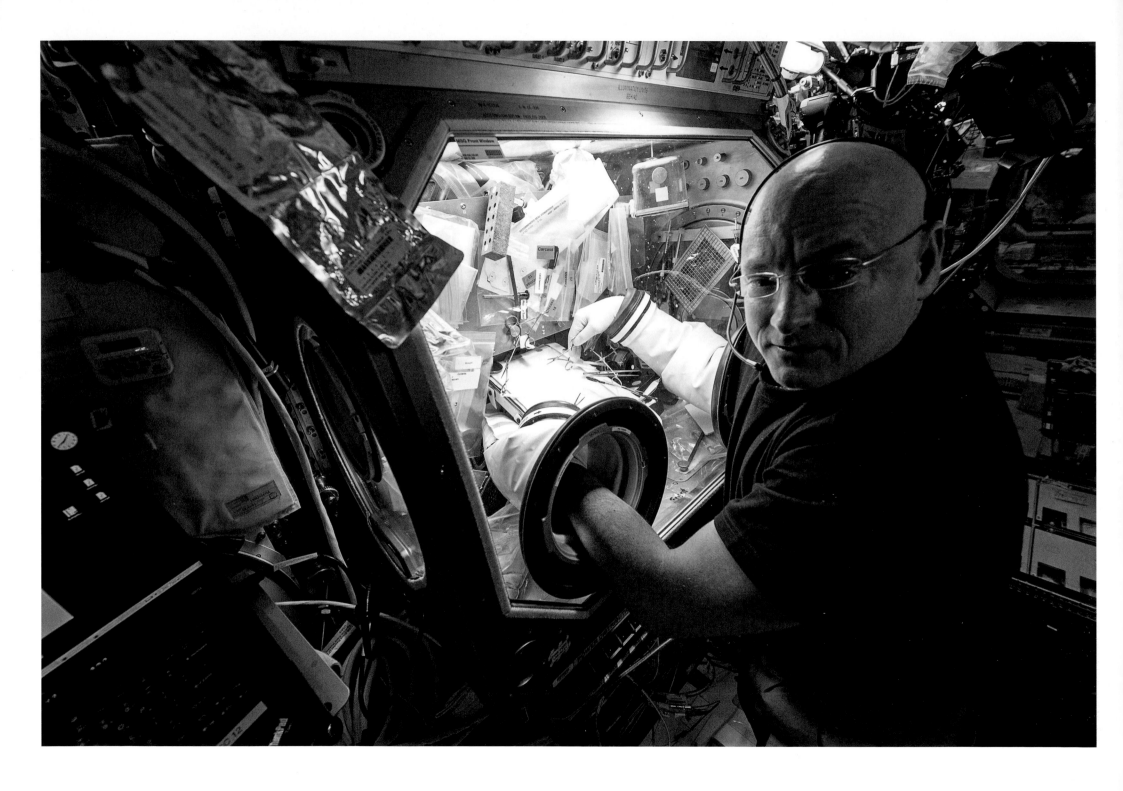

Opposite: Getting ready to work with the mice in the microgravity science glove box, a contained facility that allows us to do detailed work without liberating debris. Since everything floats in space, from mice to sharp objects, we need this type of containment.

Right: Me unpacking a million tomato seeds that will eventually be returned to the Earth to take part in student experiments around the world. If this bag were to break, it would be a serious problem.

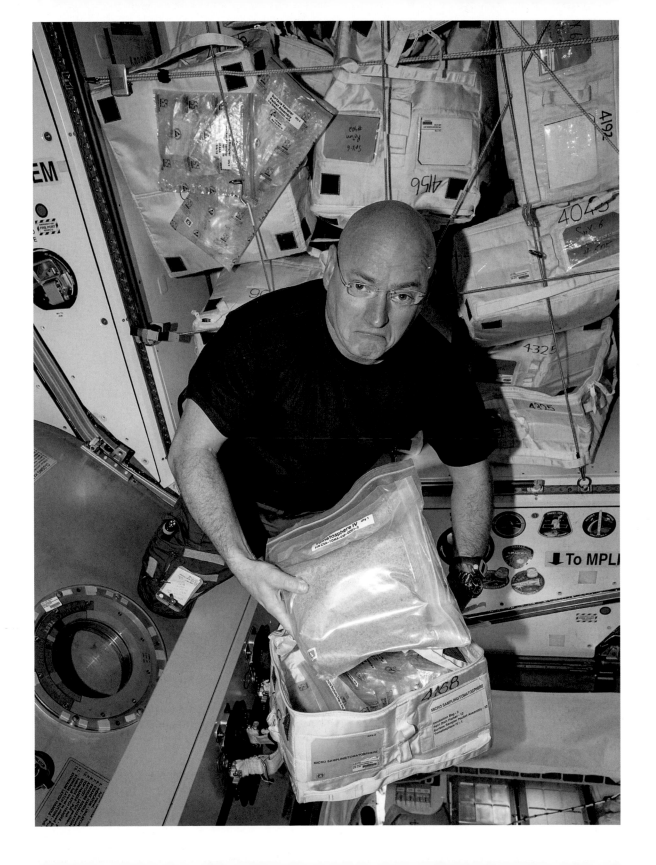

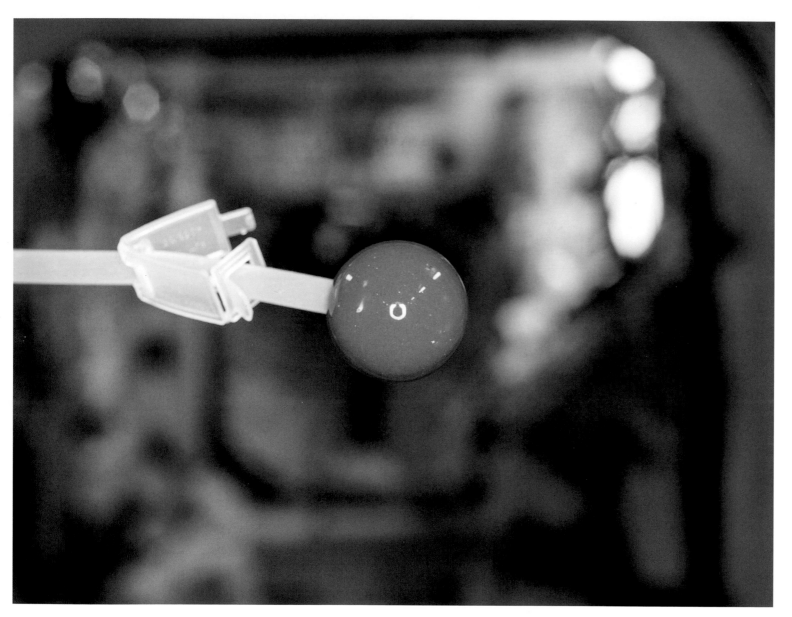

Opposite: Anton Shkaplerov and me enjoying ice cream in the U.S. laboratory module. The space ice cream you find in amusement parks isn't what we have in space. These were Klondike bars, and after a couple of months without having anything really cold, we thought these tasted amazing.

Left: This coffee ball forms a perfect sphere in microgravity.

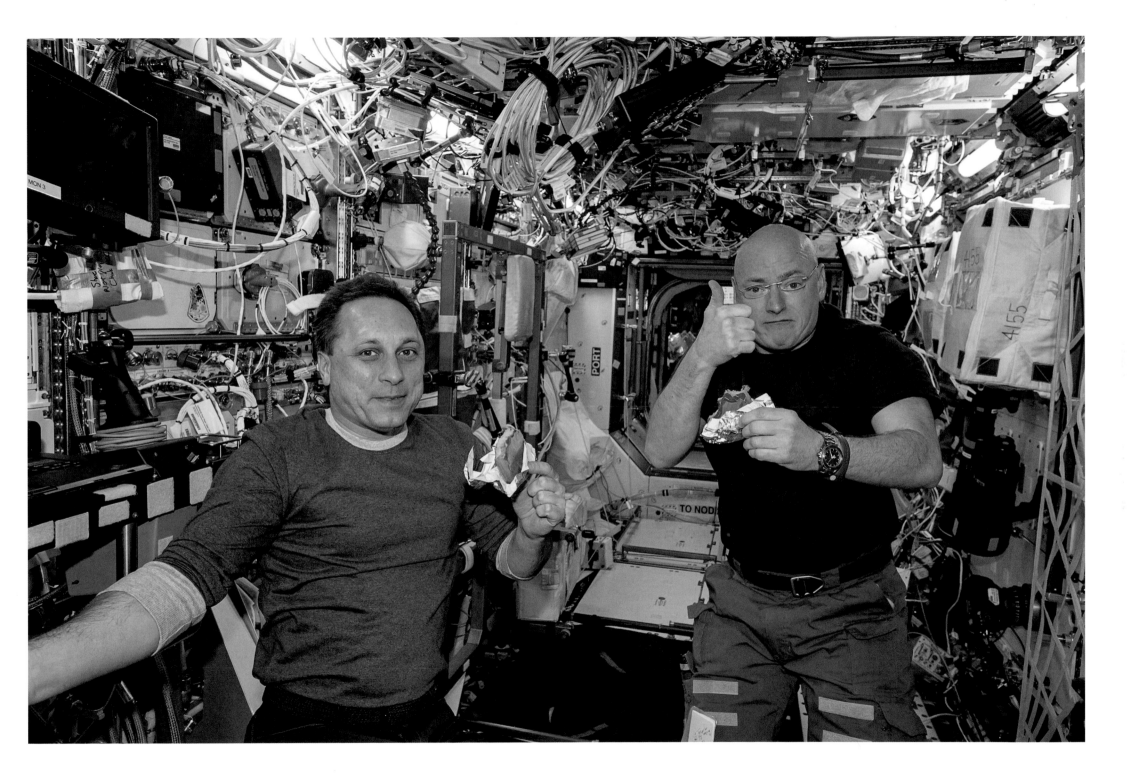

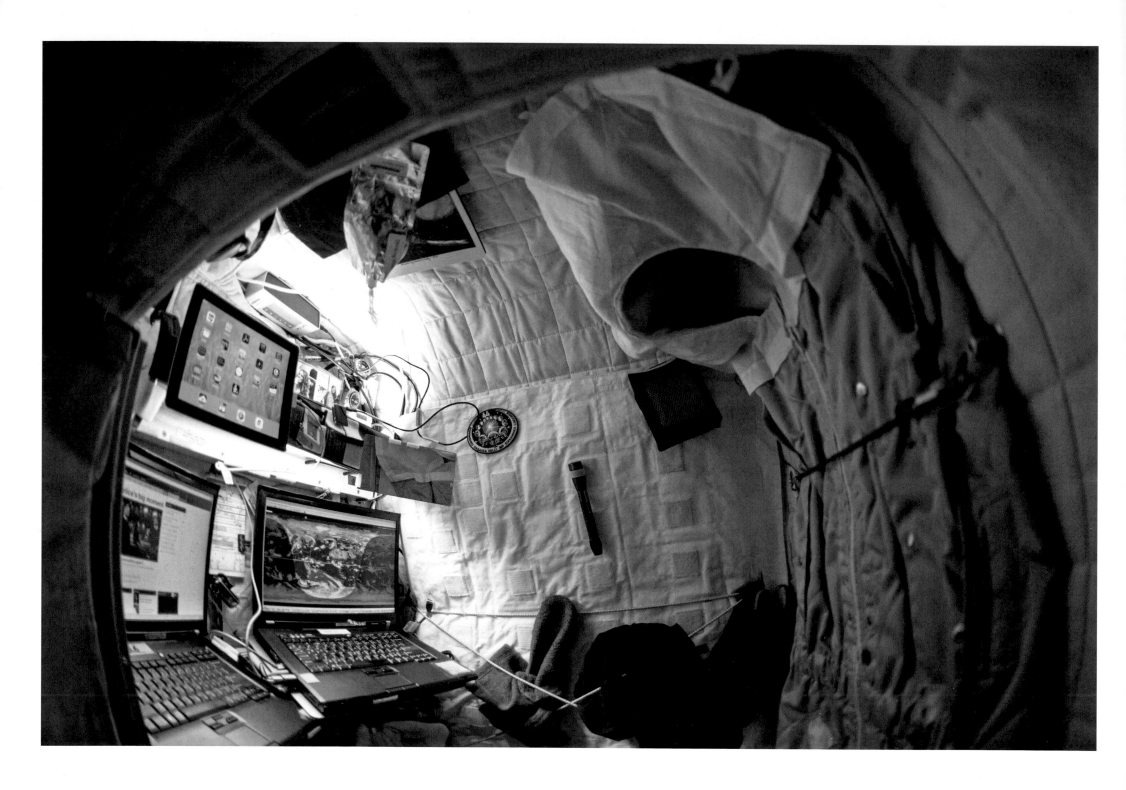

Opposite: A fish-eye lens view of my crew quarters. You can see my sleeping bag on the right, some clothes in the center, and two laptops and my iPad on the left. Also in the picture are a couple of family photographs.

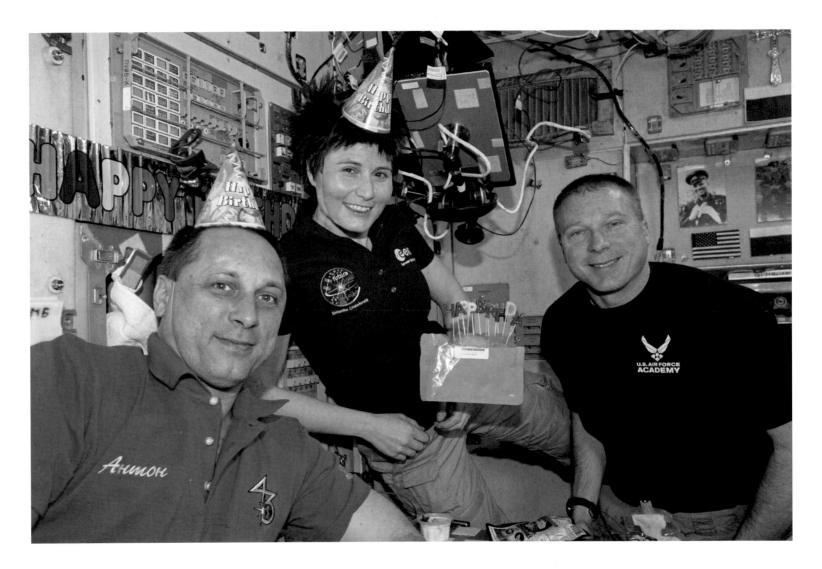

Right: On the ISS with my crewmates Anton Shkaplerov, left, Samantha Cristoforetti, center, and Terry Virts, celebrating Samantha's birthday

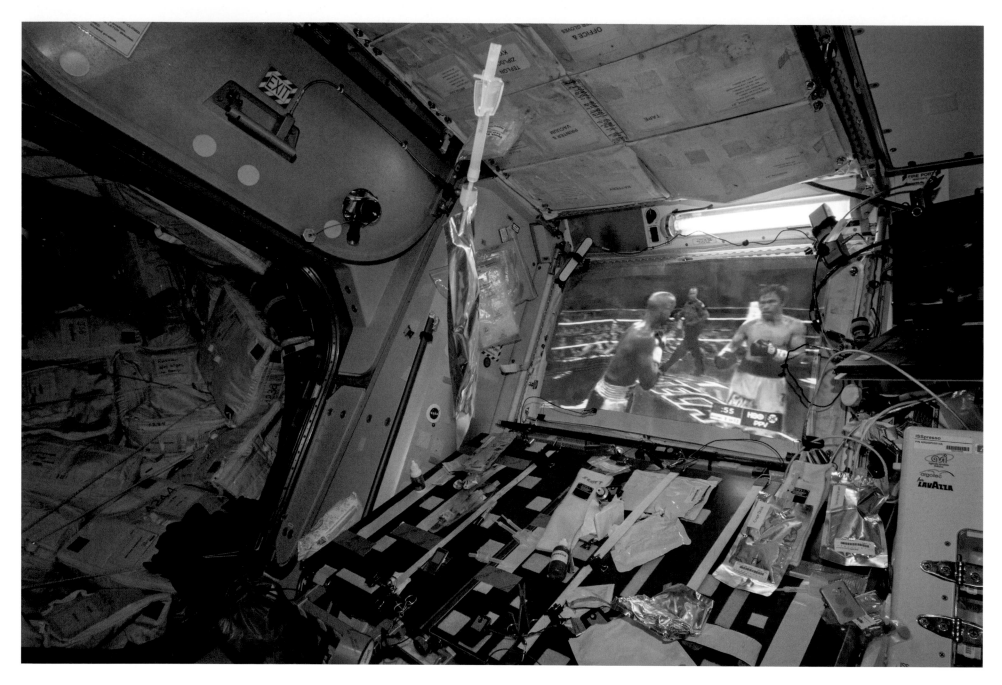

Watching the Mayweather vs. Pacquiao
fight in Node 1 of the ISS

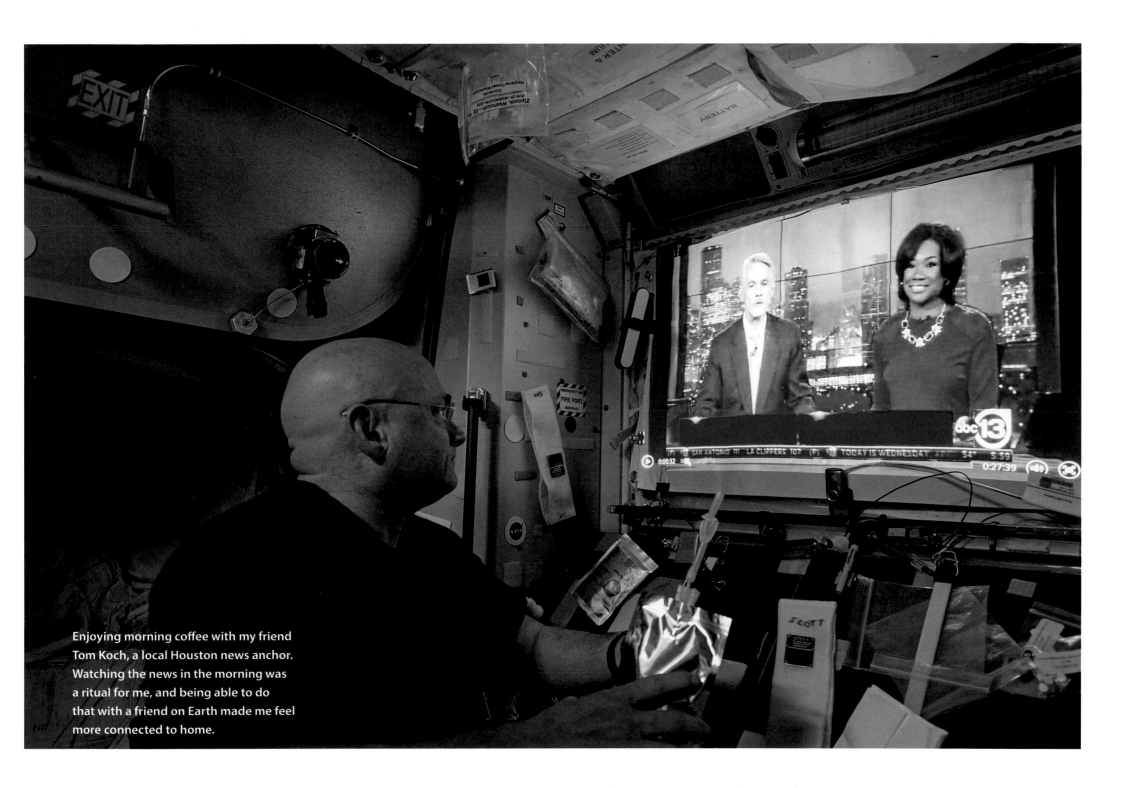

Enjoying morning coffee with my friend
Tom Koch, a local Houston news anchor.
Watching the news in the morning was
a ritual for me, and being able to do
that with a friend on Earth made me feel
more connected to home.

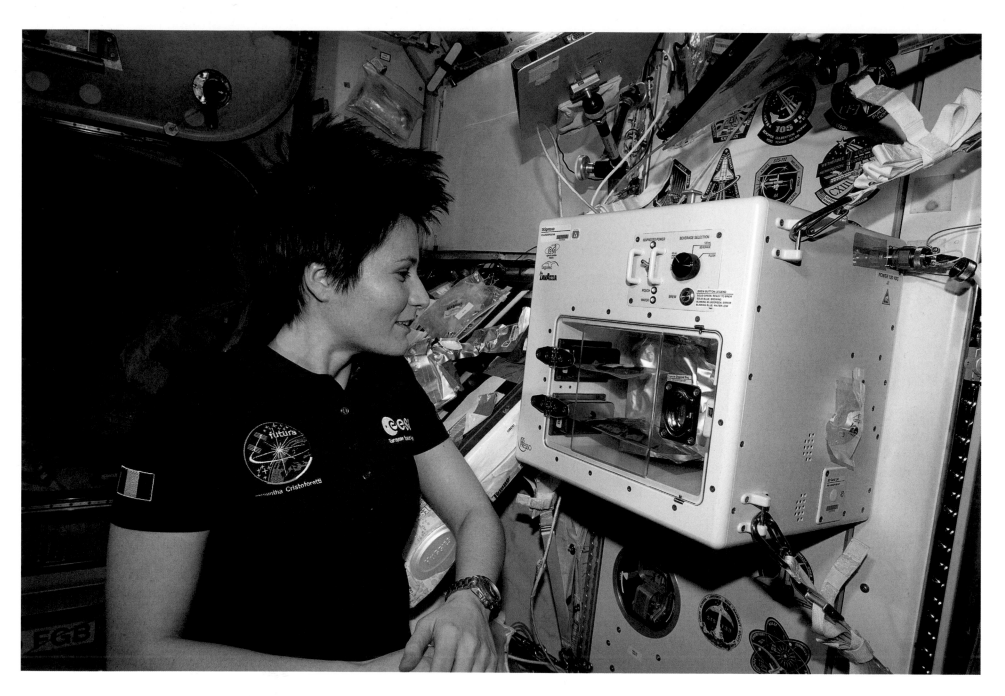

Samantha Cristoforetti brewing the very first space espresso. A special machine was sent to ISS to make good espresso and, of course, since Samantha is Italian, she enjoyed good espresso.

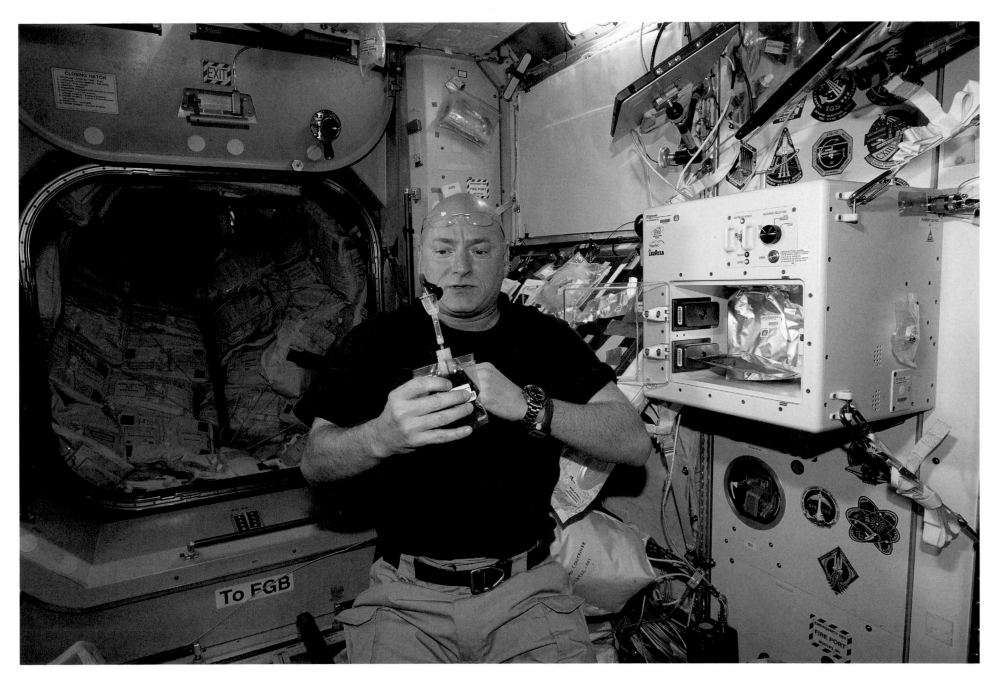

Me trying my first espresso in Node 1
of ISS

Terry Virts and me working on the CDRA, the carbon dioxide removal assembly, in the Japanese module of the ISS

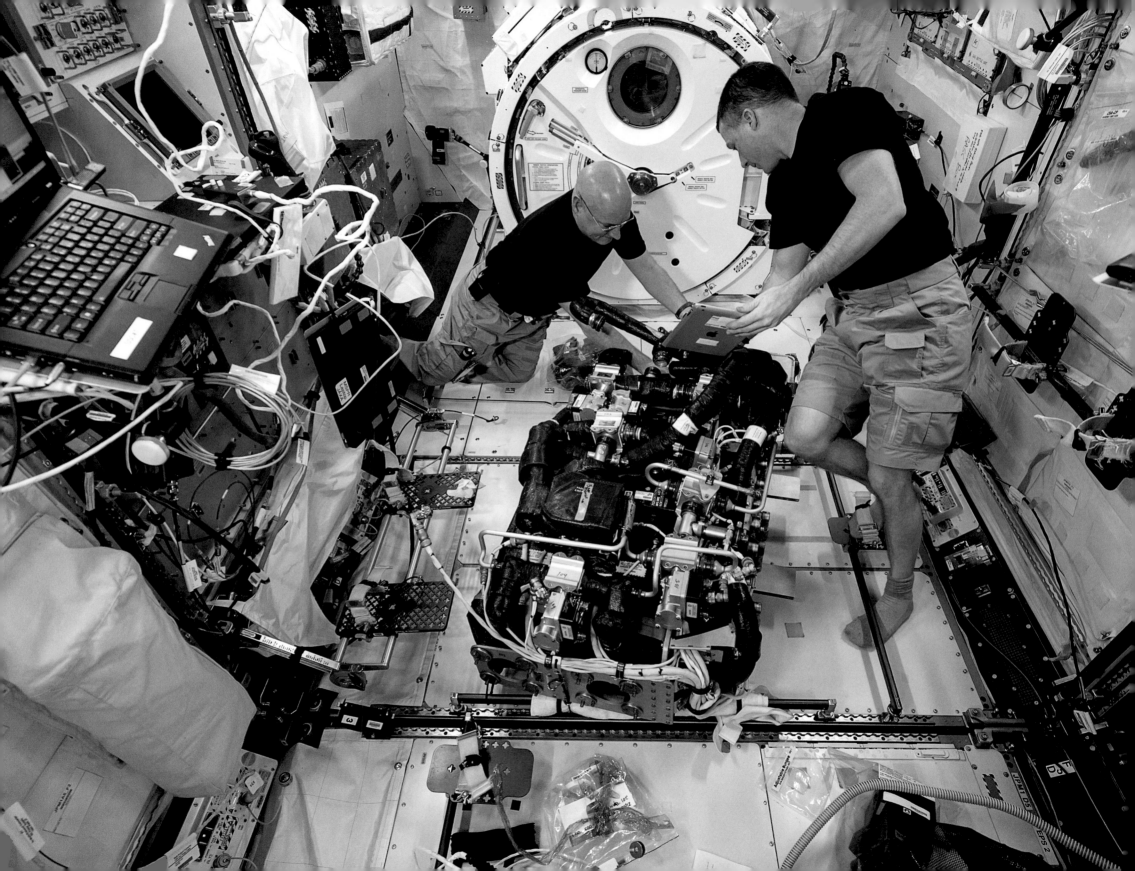

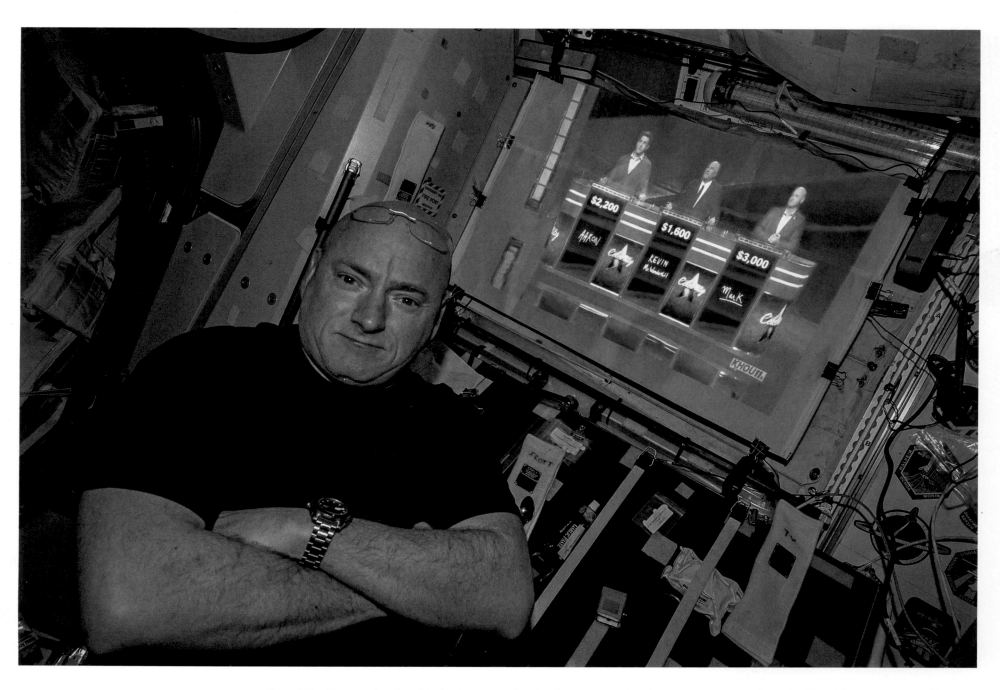

Above: Watching my brother, Mark, play *Celebrity Jeopardy!* against Aaron Rodgers and Kevin O'Leary from *Shark Tank;* despite the score, my brother gets beat. He did pretty well, though.

Opposite: Terry Virts and me watching our hometown basketball team, the Houston Rockets, play a game

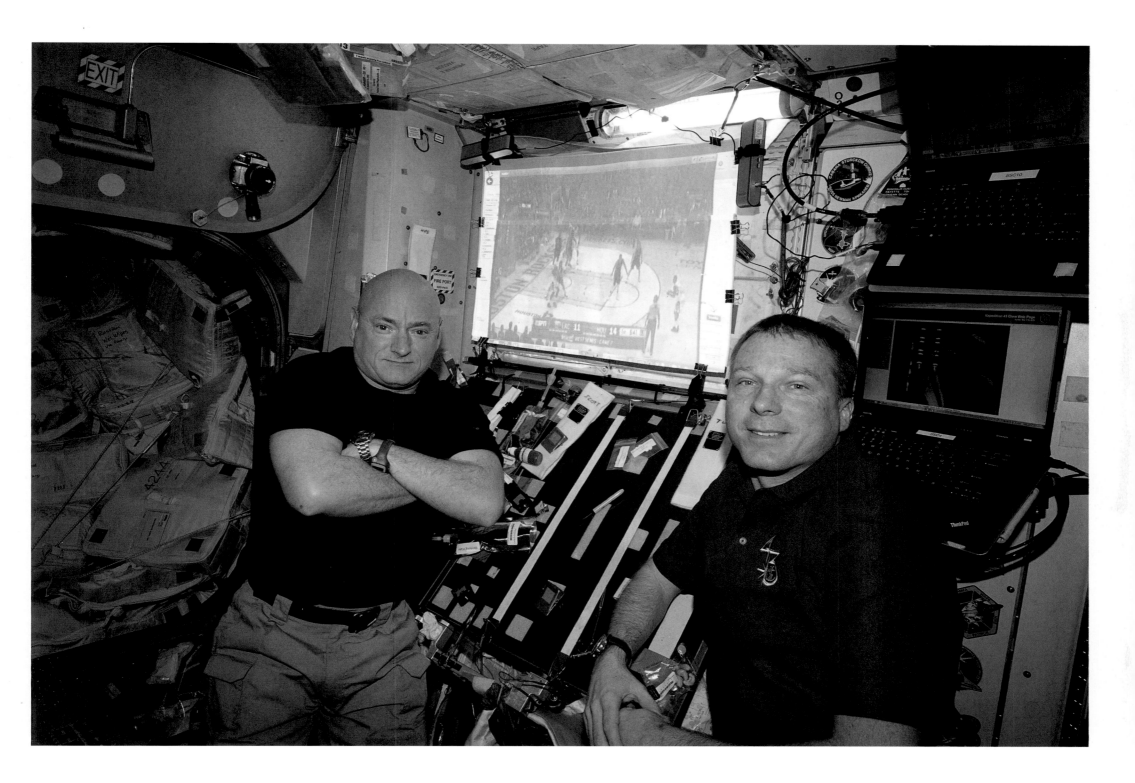

33

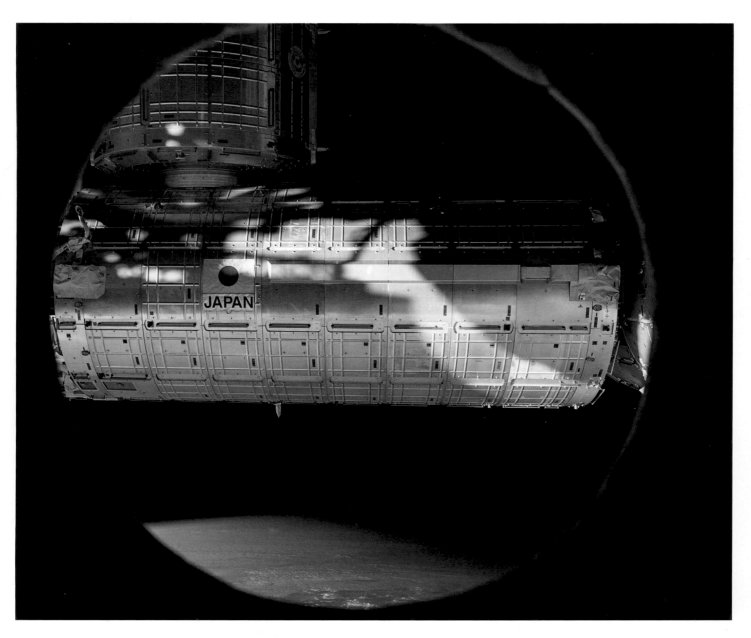

Left: I took this photo from the forward window of Node 3 right before we attached a module to this docking port that we were moving from another location. This is the last view of the outside from this window, so I thought it was appropriate to take this picture.

Opposite: The view looking down from the cupola over the western part of the United States (I think)

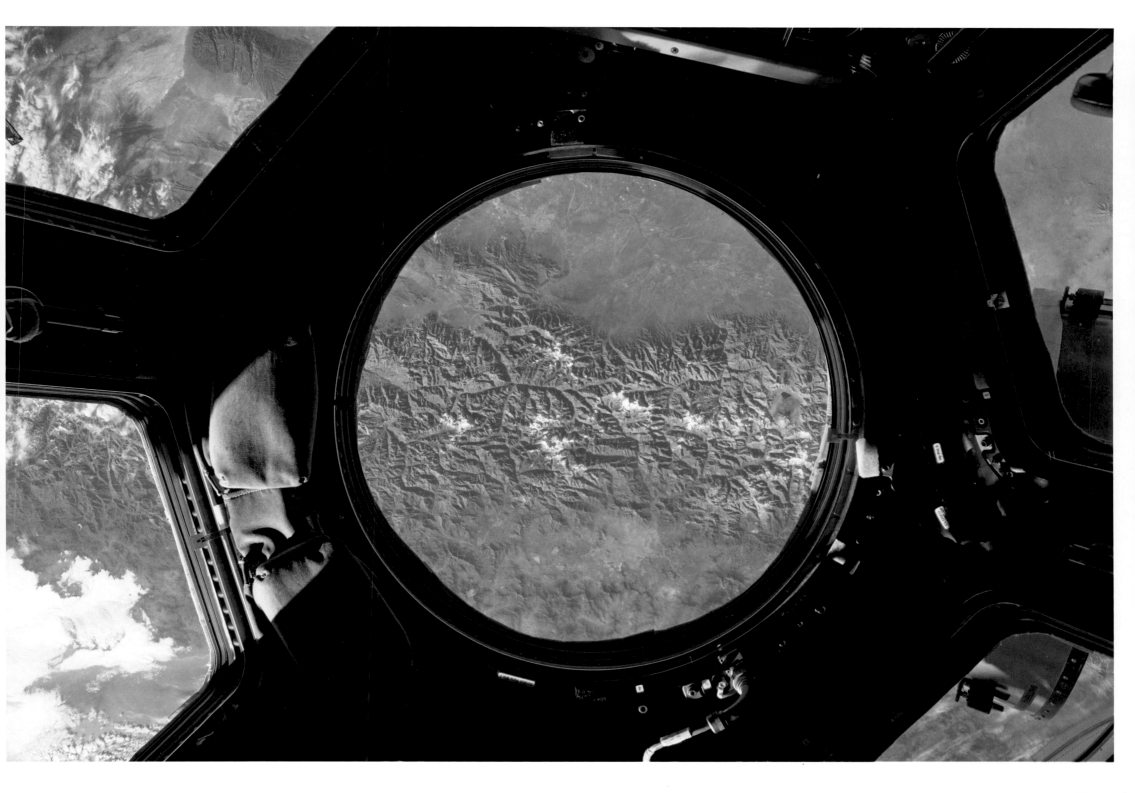

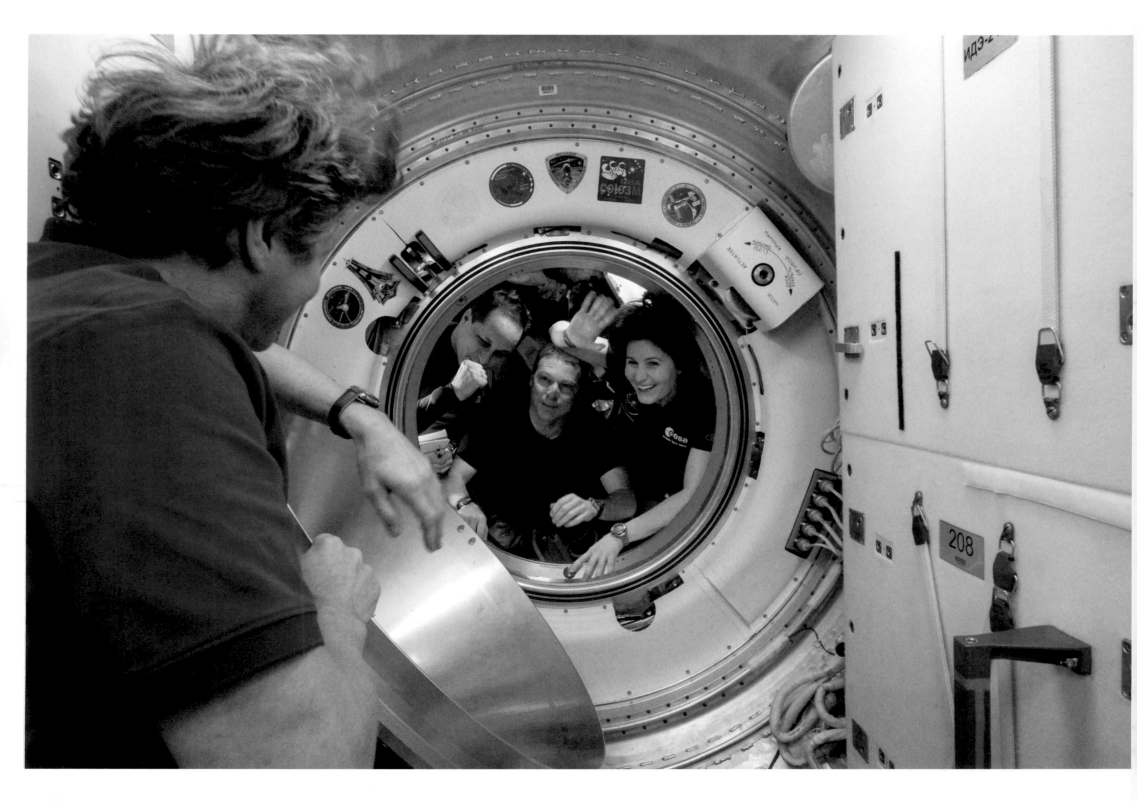

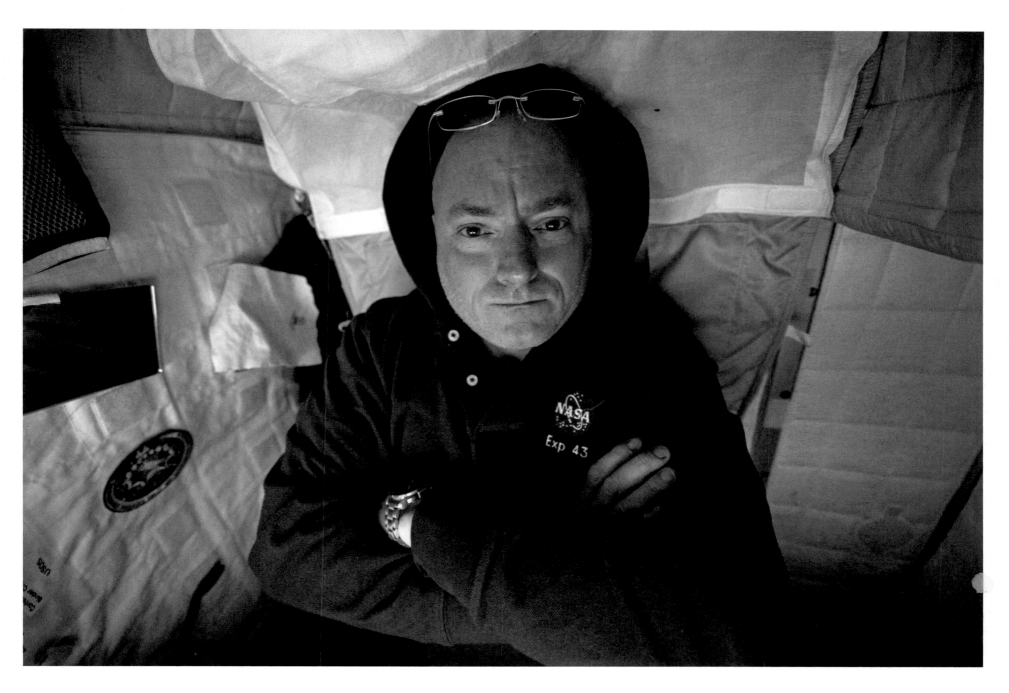

Opposite: Gennady Padalka closing the hatch to the Soyuz as my colleagues Anton Shkaplerov, Samantha Cristoforetti, and Terry Virts depart for Earth

Above: Feeling pretty solemn in my crew quarters with nearly ten months in front of me before I would return to Earth

I took these photos of myself over a window facing Earth to show the variation of colors emanating from the planet. The first was taken over the yellow, red, and orange sands

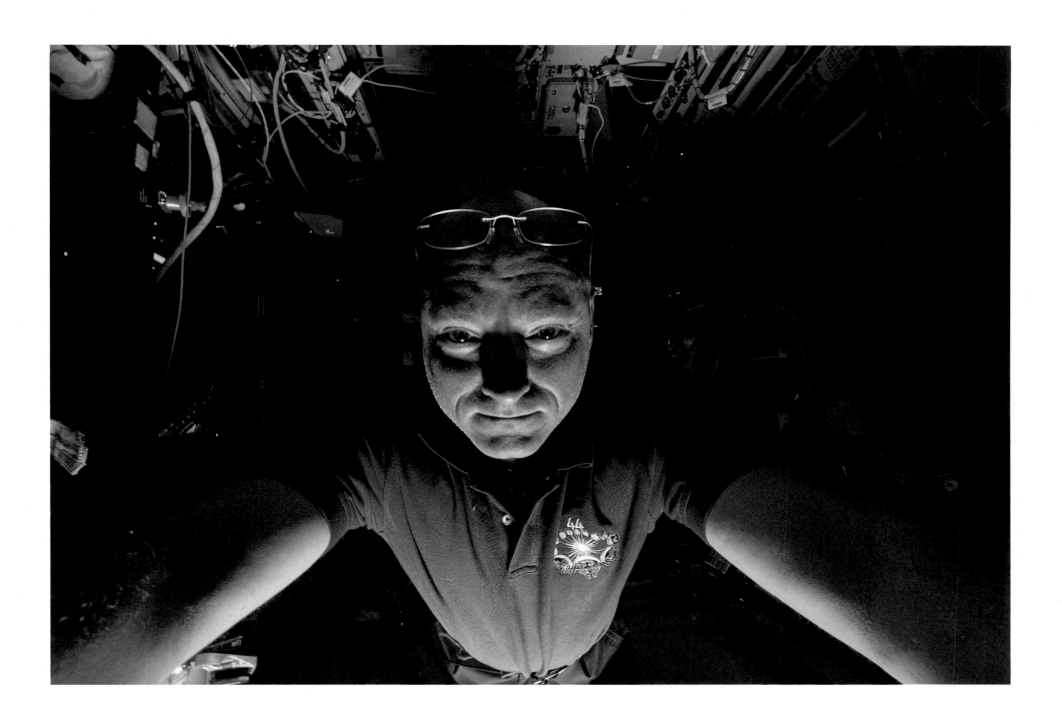

of Africa, and the second as we passed over the cool blue seas of the Mediterranean just
seconds later.

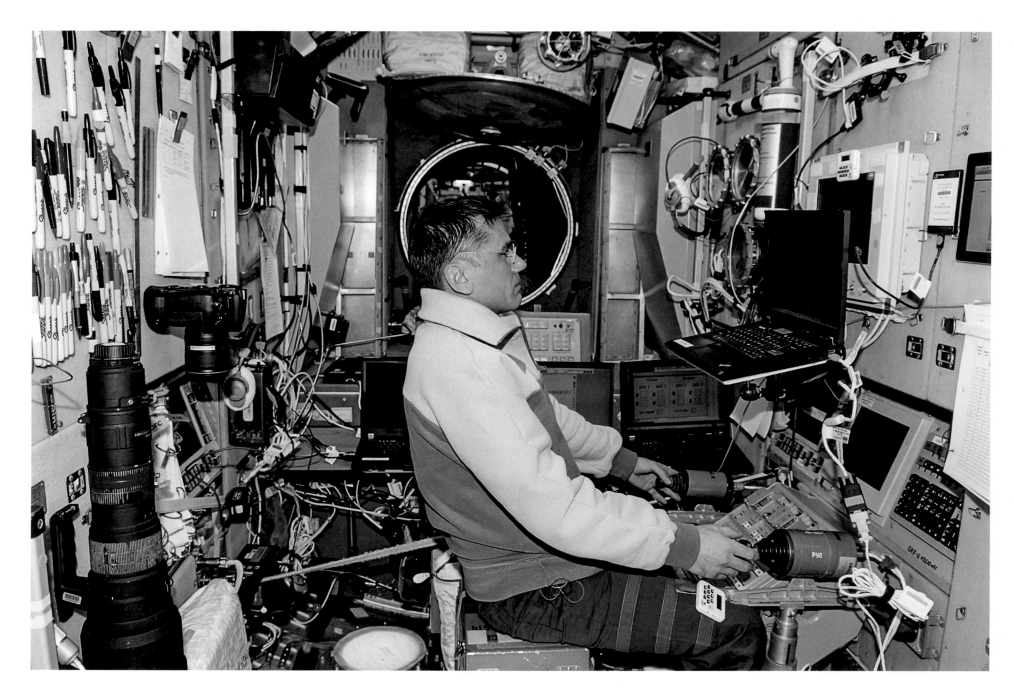

Above: Yuri Malenchenko remotely flies the Progress resupply ship from the Russian service module.

Opposite: Fresh fruit is always a welcome treat after a visit from one of our resupply ships.

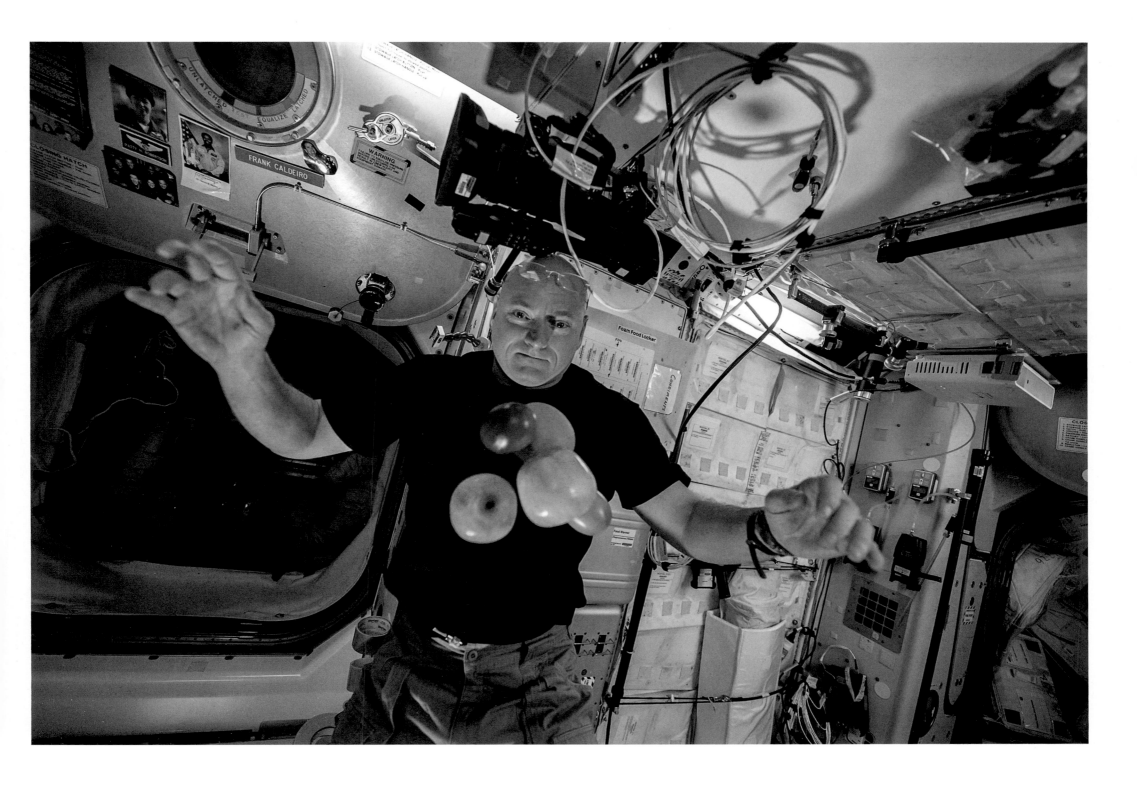

There was a week when we had nine crew members on board ISS. In the Russian service module from left to right, Oleg Kononenko, Gennady Padalka, Andreas Mogensen, Aidyn Aimbetov, me, Sergey Volkov, Kjell Lindgren, Mikhail Kornienko, and Kimiya Yui

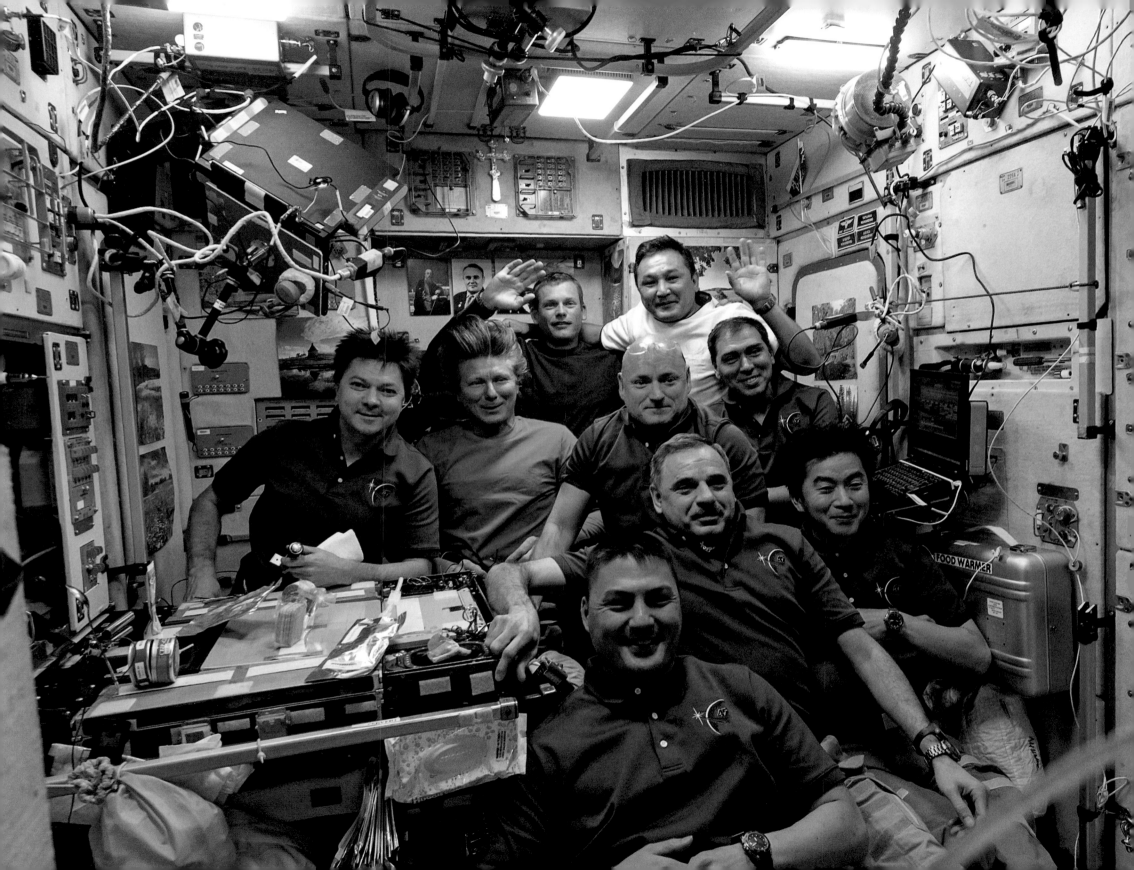

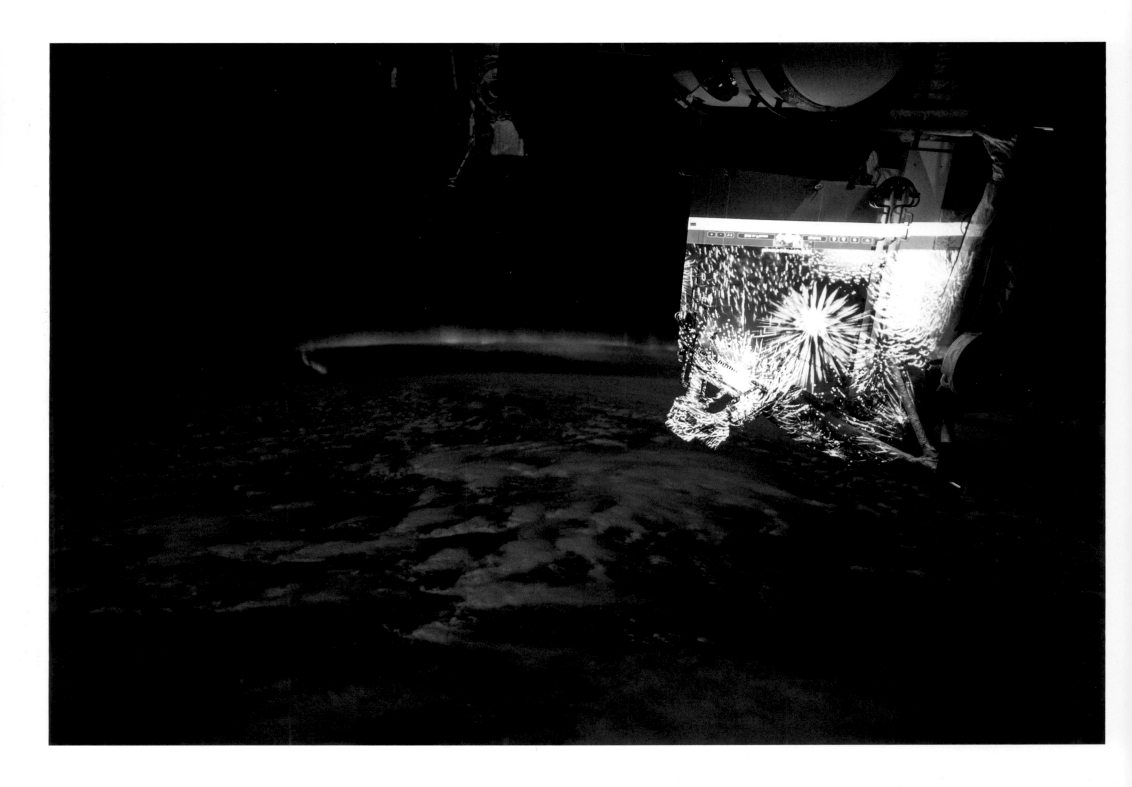

Opposite: For the Fourth of July, I set up our video projector to point out the window of the cupola and projected this image of fireworks on a white wall of the Russian segment. In the background you can see the aurora over the Earth.

Right: My Super Bowl 50 party in 2016. No one showed up.

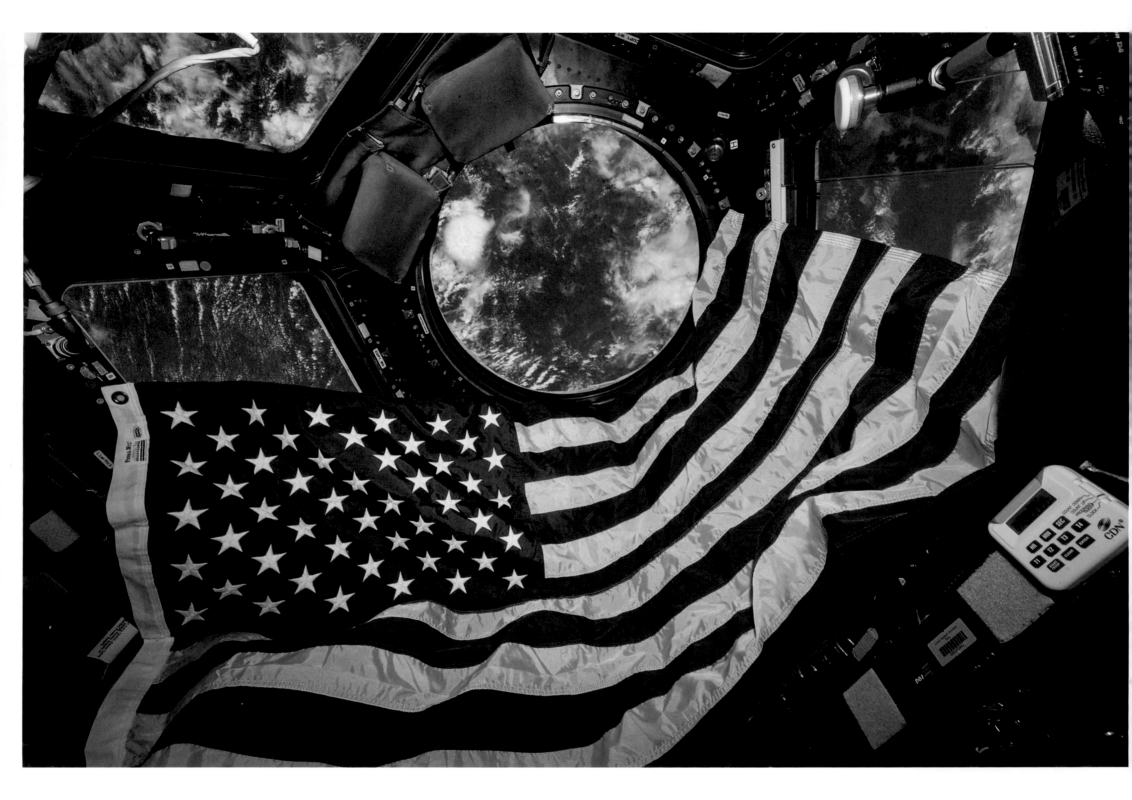

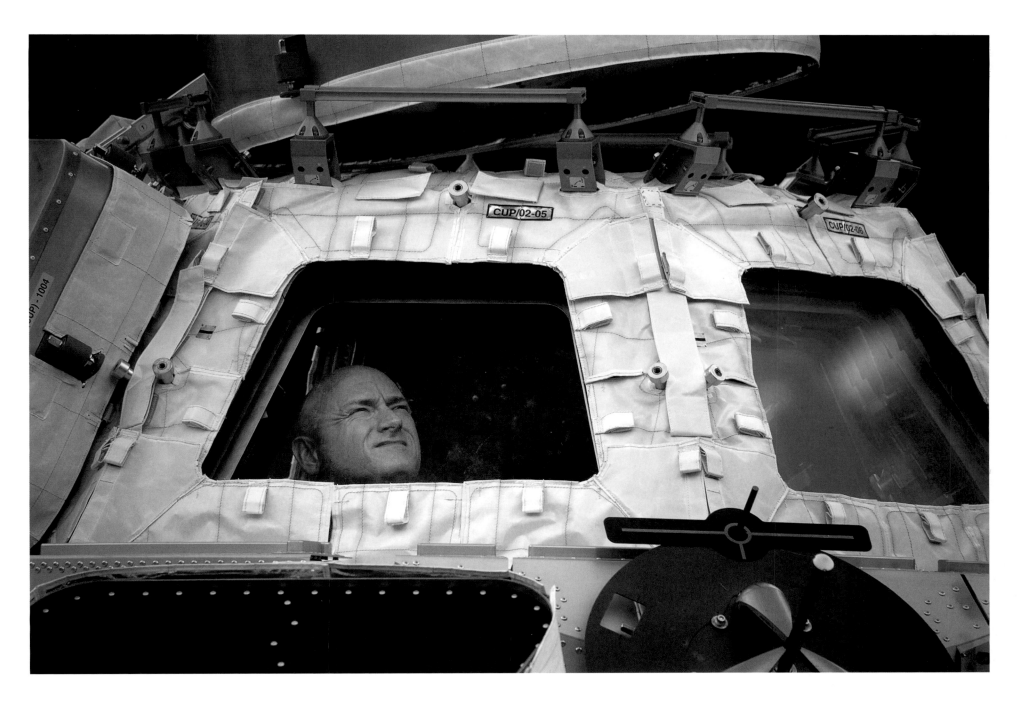

Opposite: The U.S. flag in the cupola with the Earth below

Above: Here I am in the cupola of the International Space Station, looking down on the Earth.

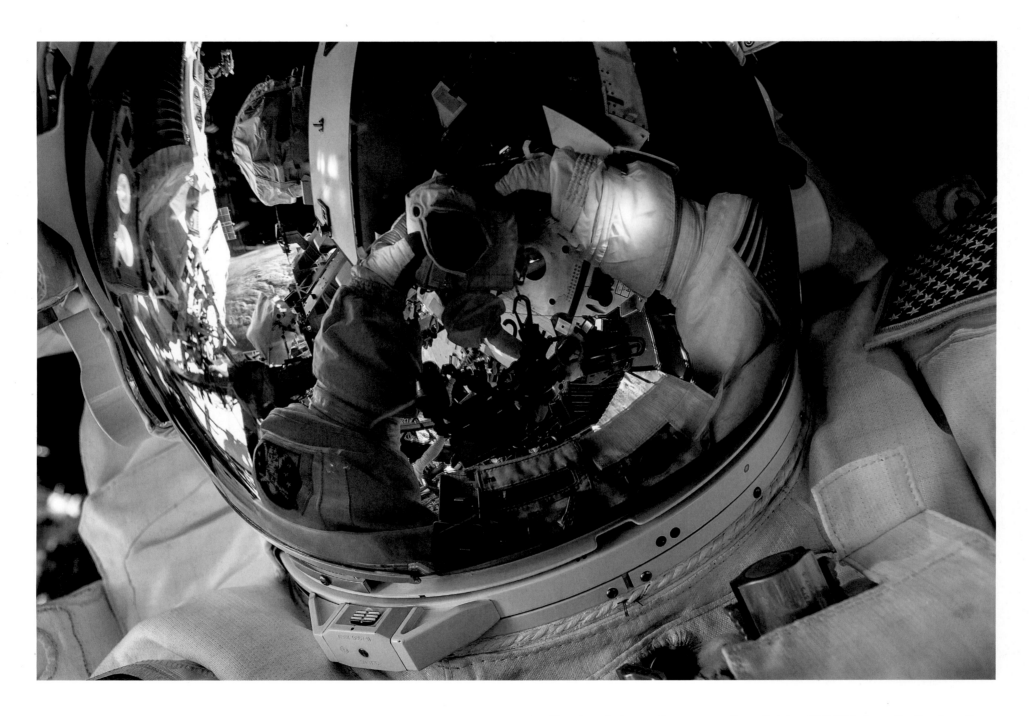

A selfie taken during my first space walk on October 28, 2015. In the reflection from the gold visor you can see the camera and the Earth off in the distance.

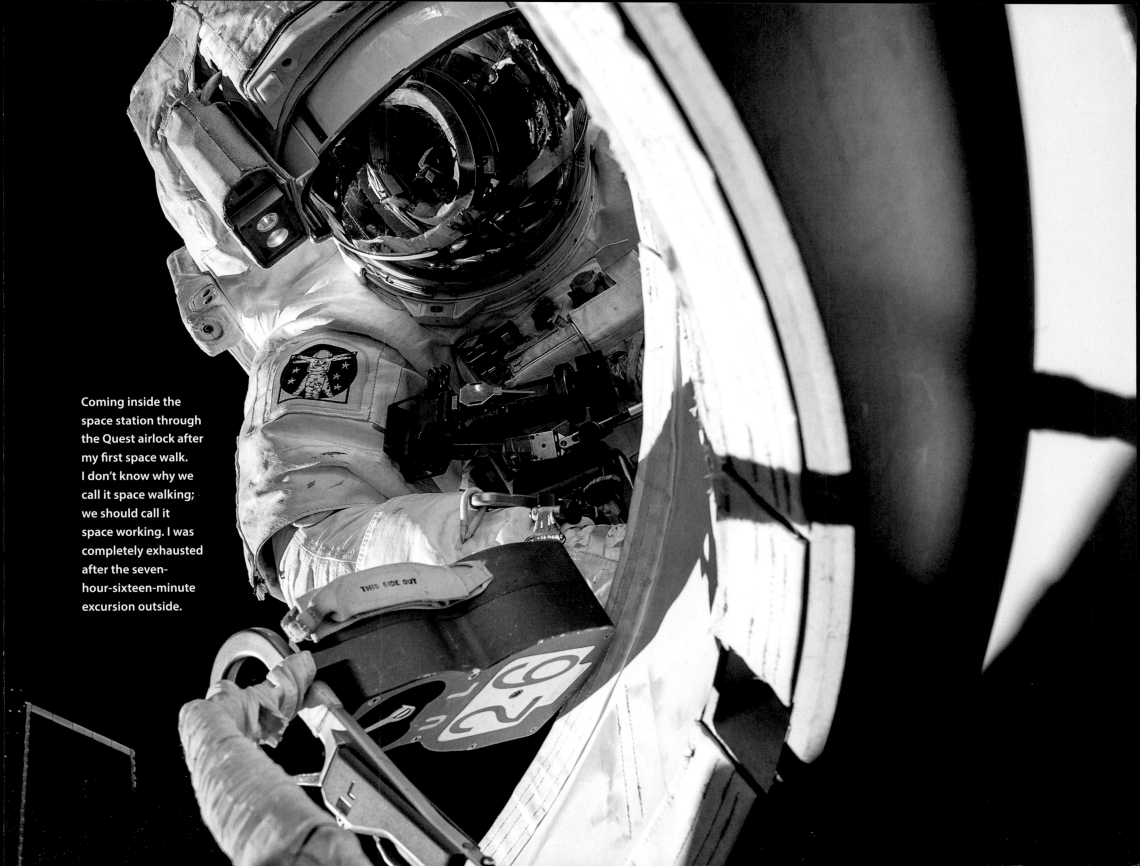

Coming inside the space station through the Quest airlock after my first space walk. I don't know why we call it space walking; we should call it space working. I was completely exhausted after the seven-hour-sixteen-minute excursion outside.

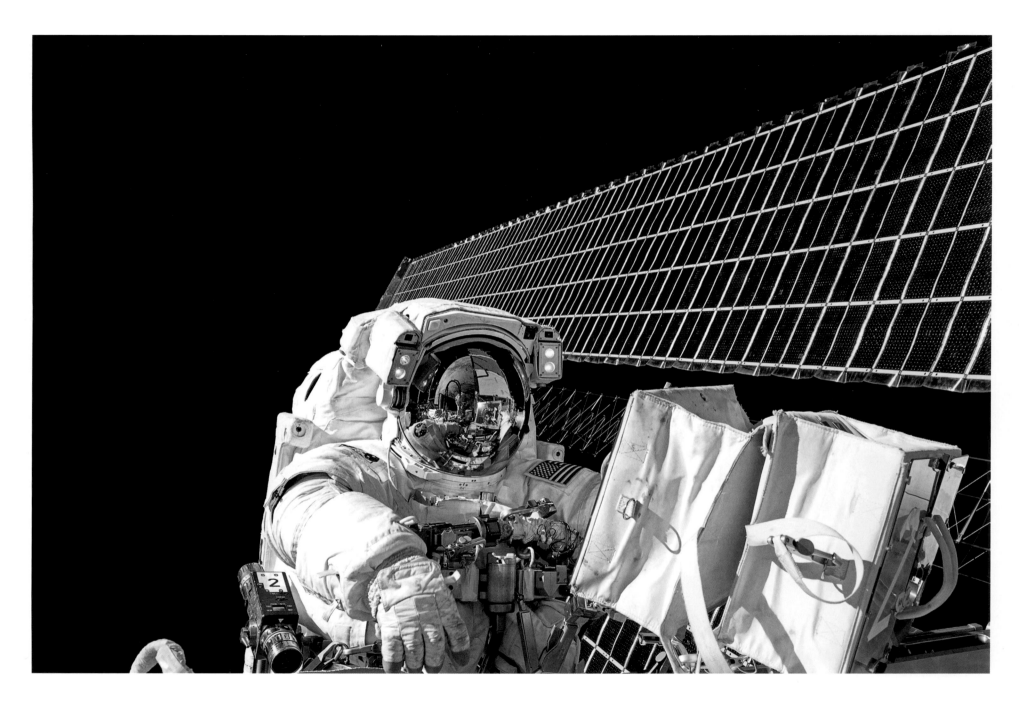

Kjell snapped this photo of me with the solar arrays in the background during our first space walk. When I posted this image to social media, the Internet collectively decided the solar arrays appeared to be a giant guitar behind me.

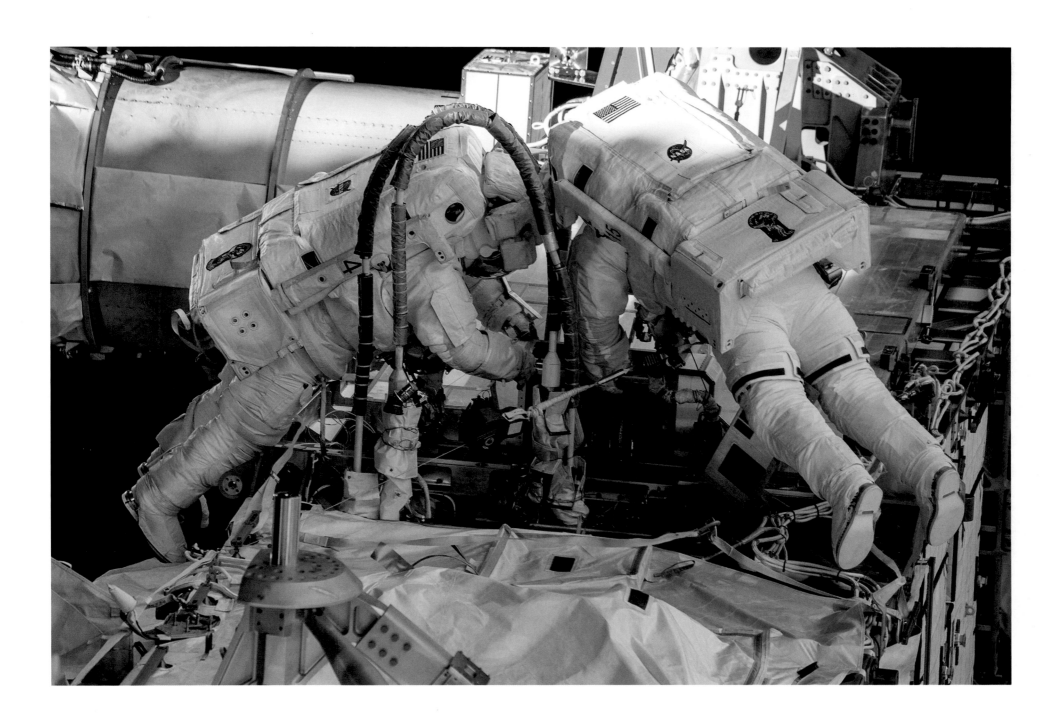

Teamwork. Here, Kjell Lindgren and I work
together during our second space walk.

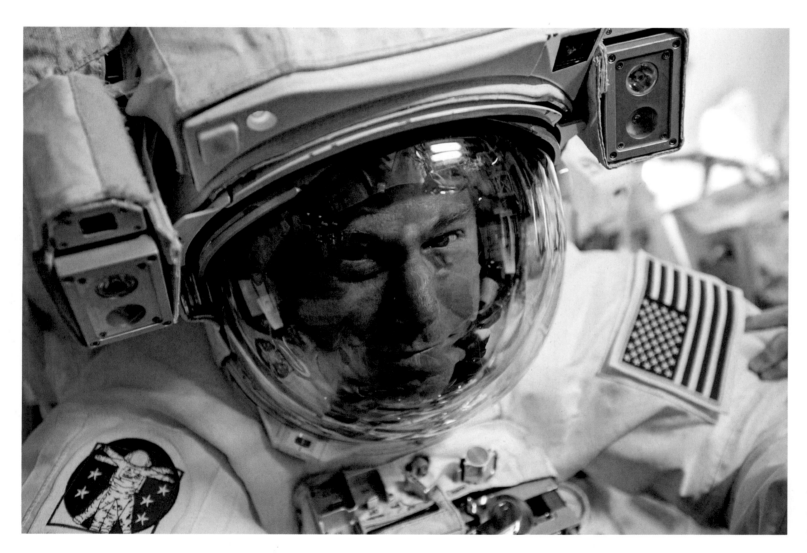

Left: My EVA, or space walk, partner Tim Kopra preparing to go outside on the space walk we did together later in the mission

Opposite: Waving for the camera on my third and final space walk. I enjoyed the challenge, but I was happy to have them done.

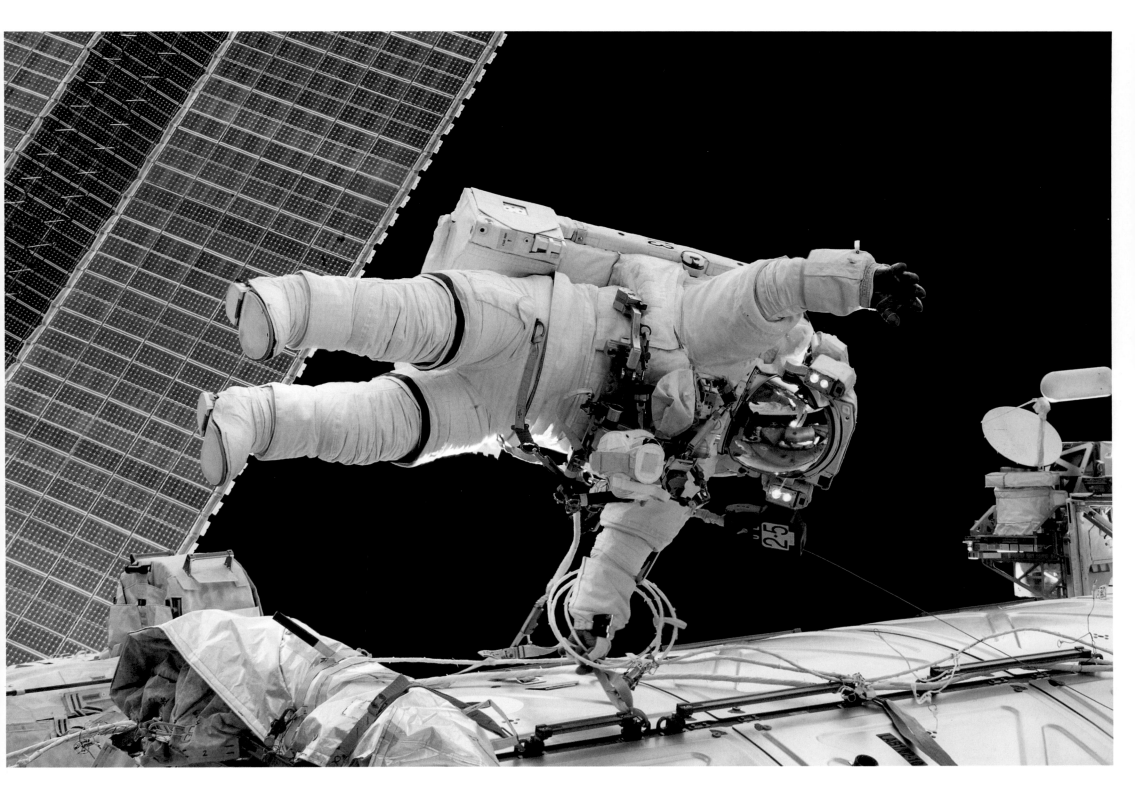

I took this photo of the U.S. laboratory with the lights out. You can see the pink glow of the lights from the plant growth

54

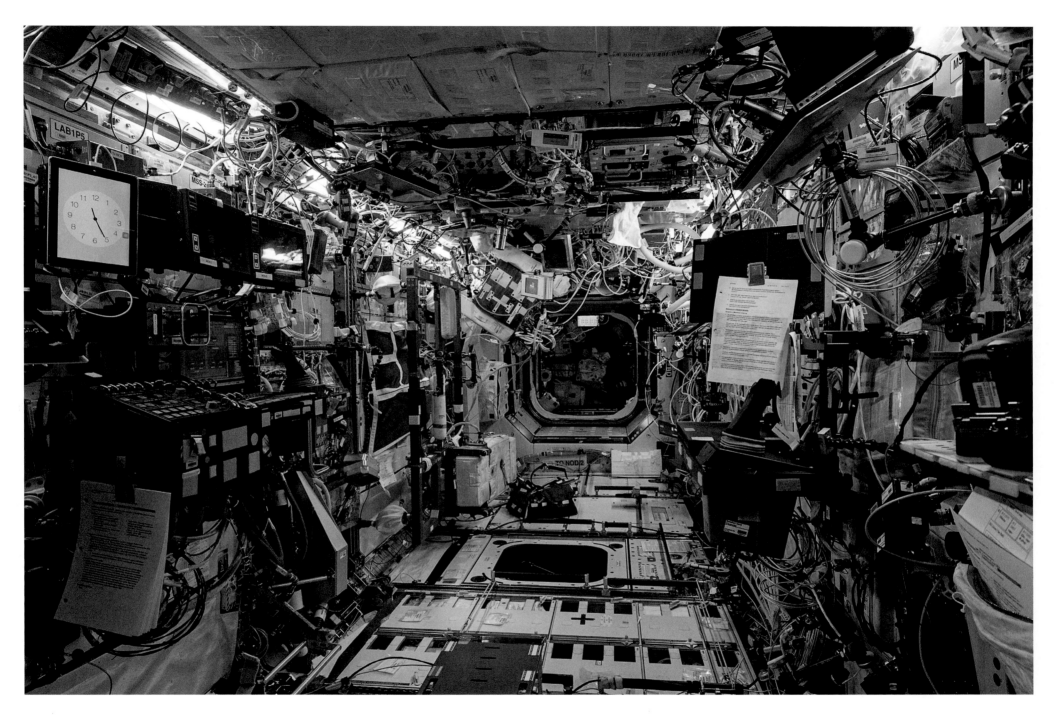

experiment in the center of the picture.
Contrast that with this photo with the
lights on.

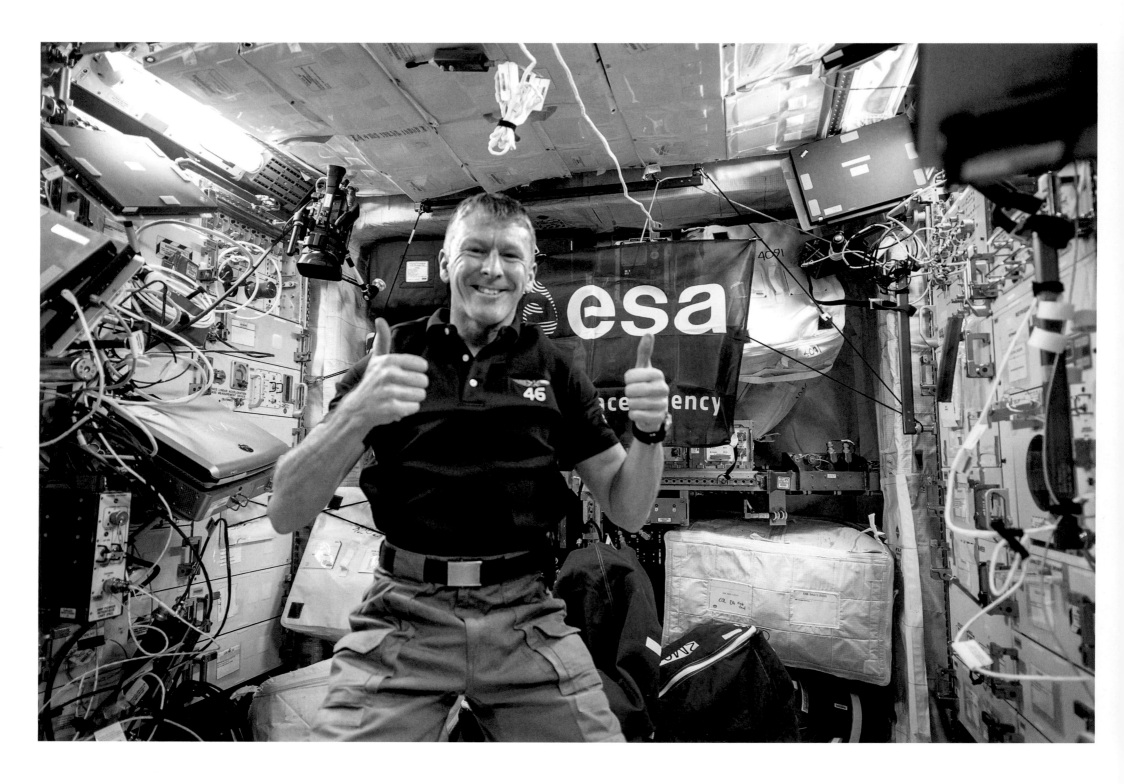

Opposite: British astronaut Tim Peake in the European Columbus module

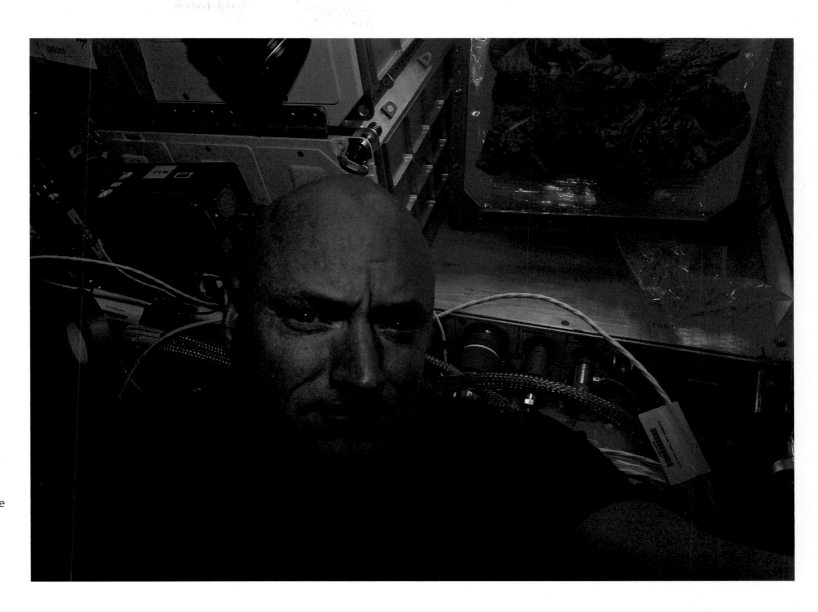

Right: A picture of me in the Columbus module, provided by the European Space Agency. In the background you can see the pink grow lights from our veggie experiment, where we were growing lettuce and flowers in space.

The Milky Way galaxy with the Earth
below and just a hint of aurora

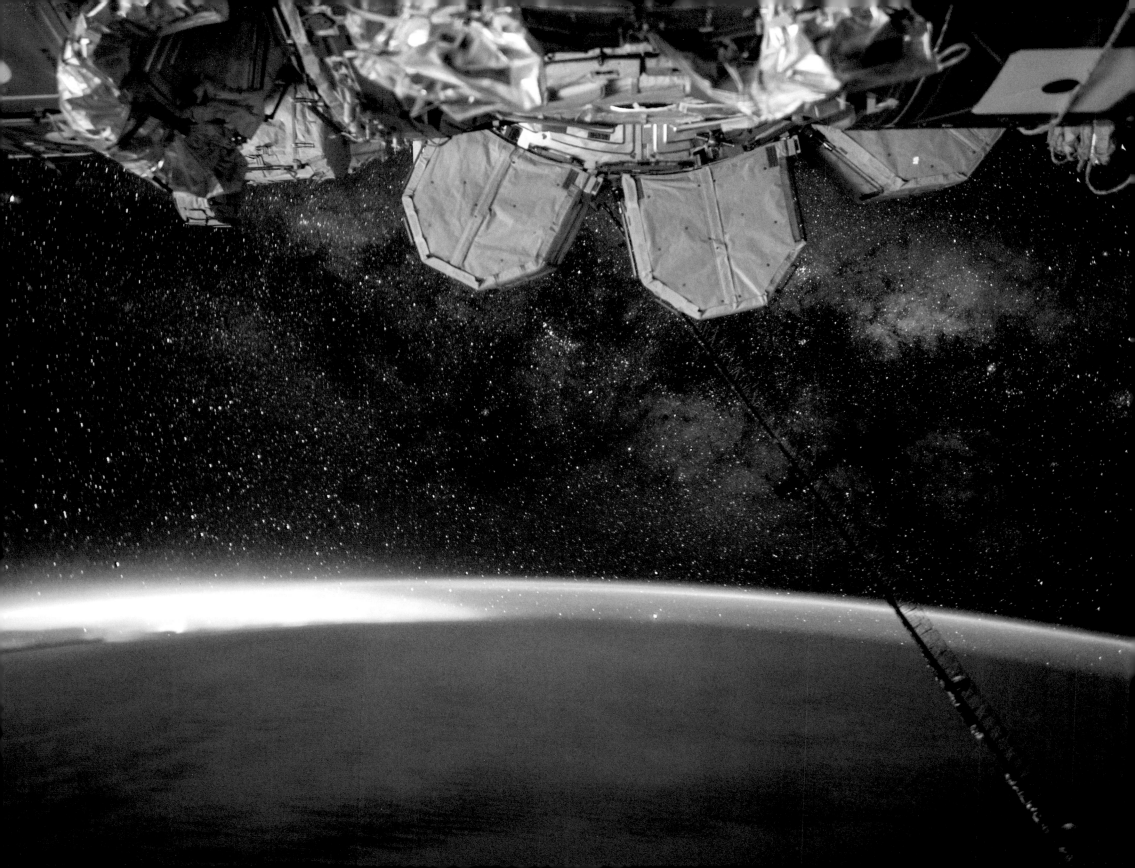

Our Soyuz descending back to Earth

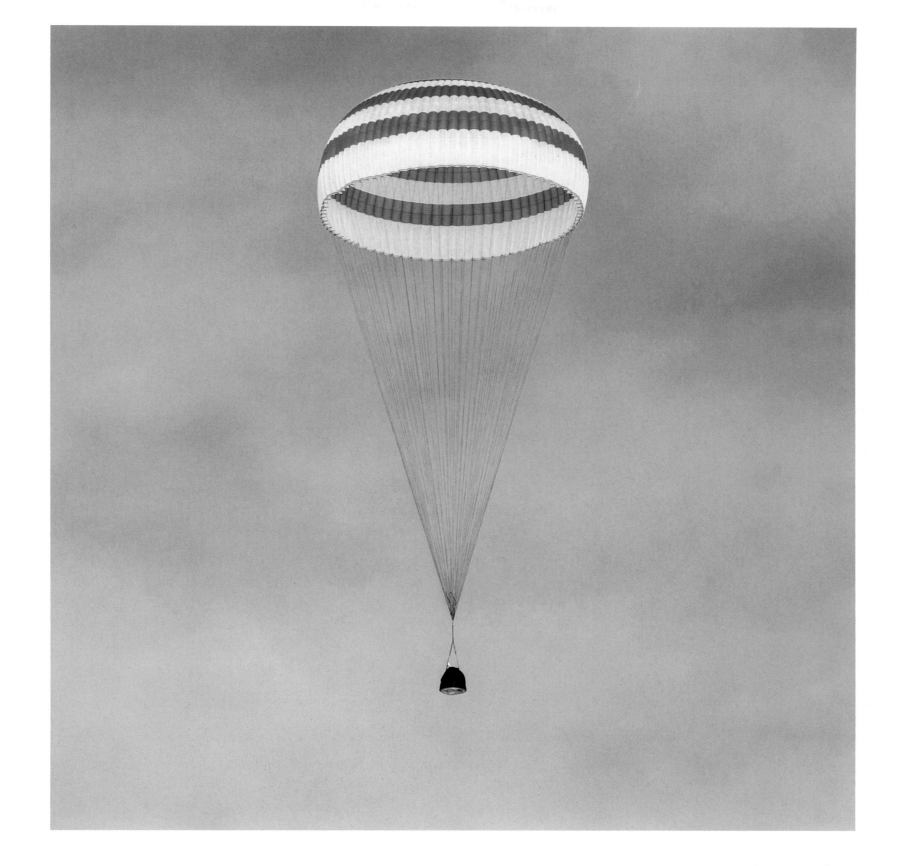

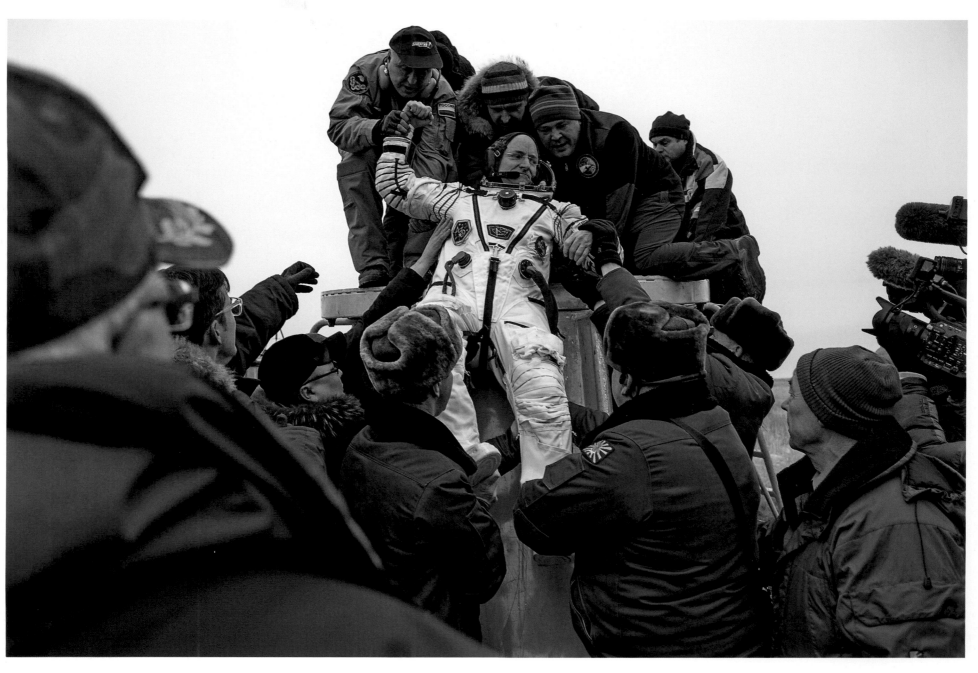

Above: Being pulled out of the Soyuz by the Russian rescue forces after a year in space

Opposite: An unidentified Russian, NASA manager Joe Montalbano, and U.S. astronaut Chris Cassidy carry me in a chair from the landing site.

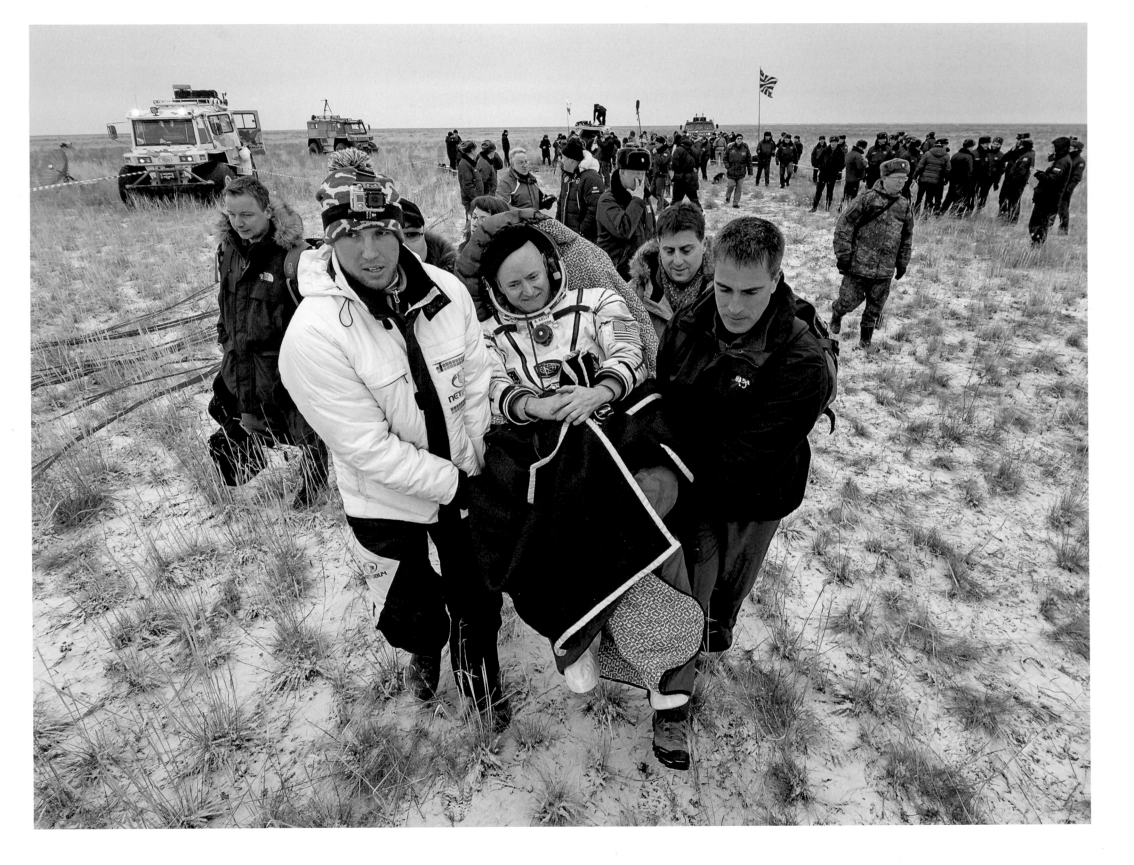

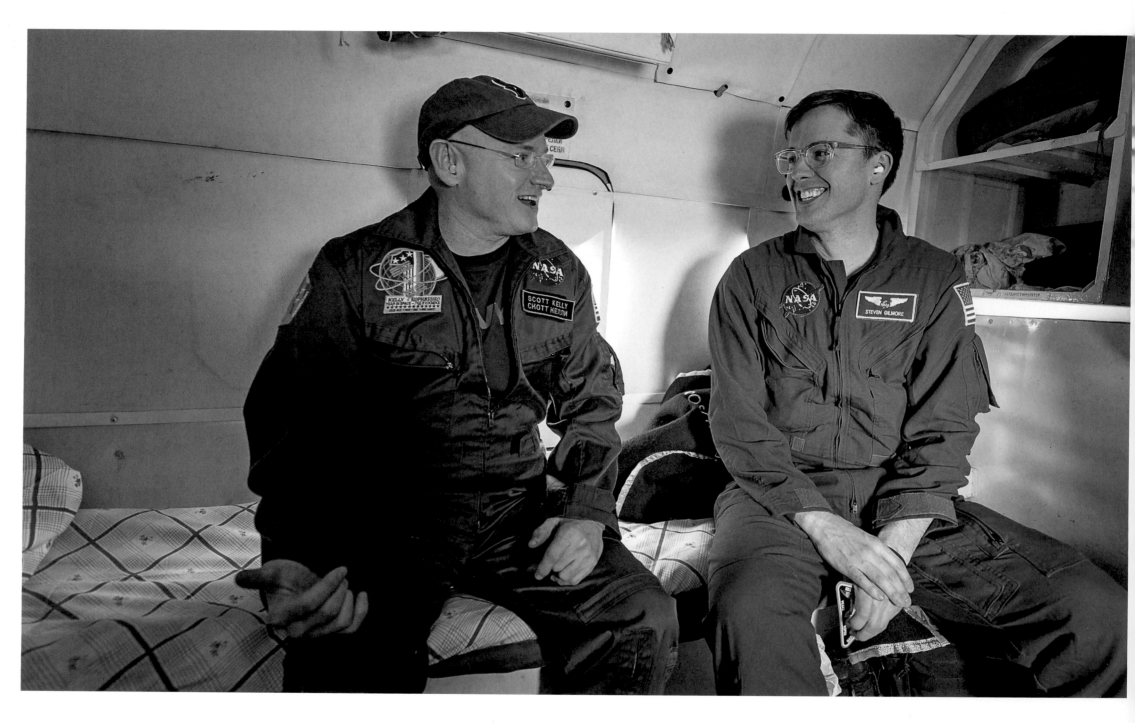

Flight surgeon and friend Dr. Steve Gilmore and me in the Russian military helicopter after landing the Soyuz in the desert steppes of Kazakhstan

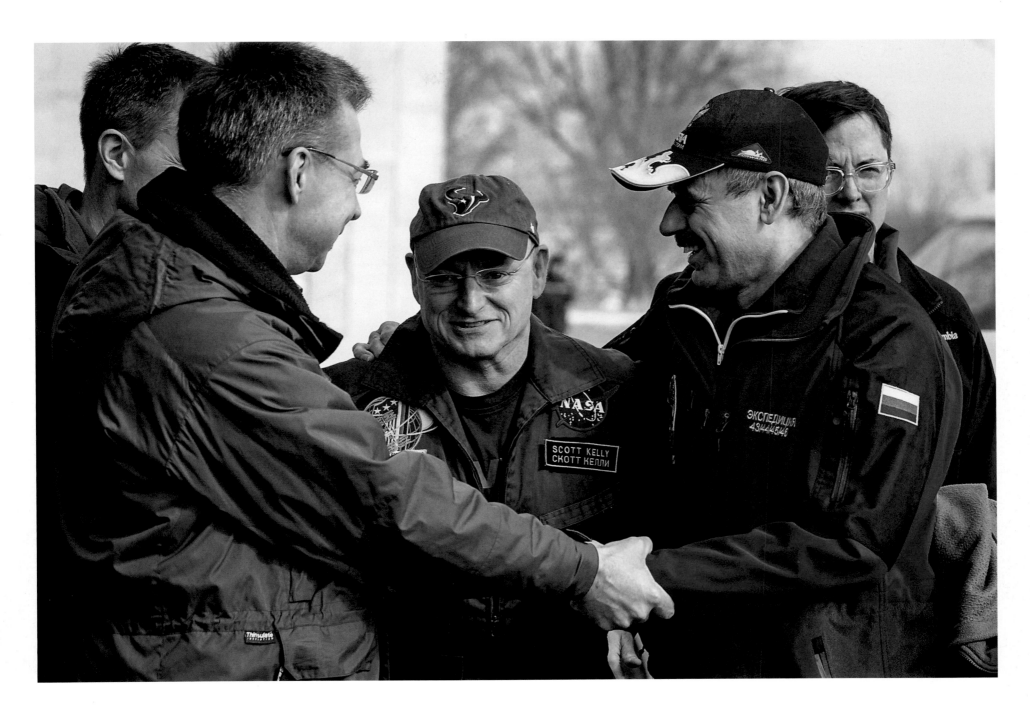

My friend Misha and me parting ways
after a year in space

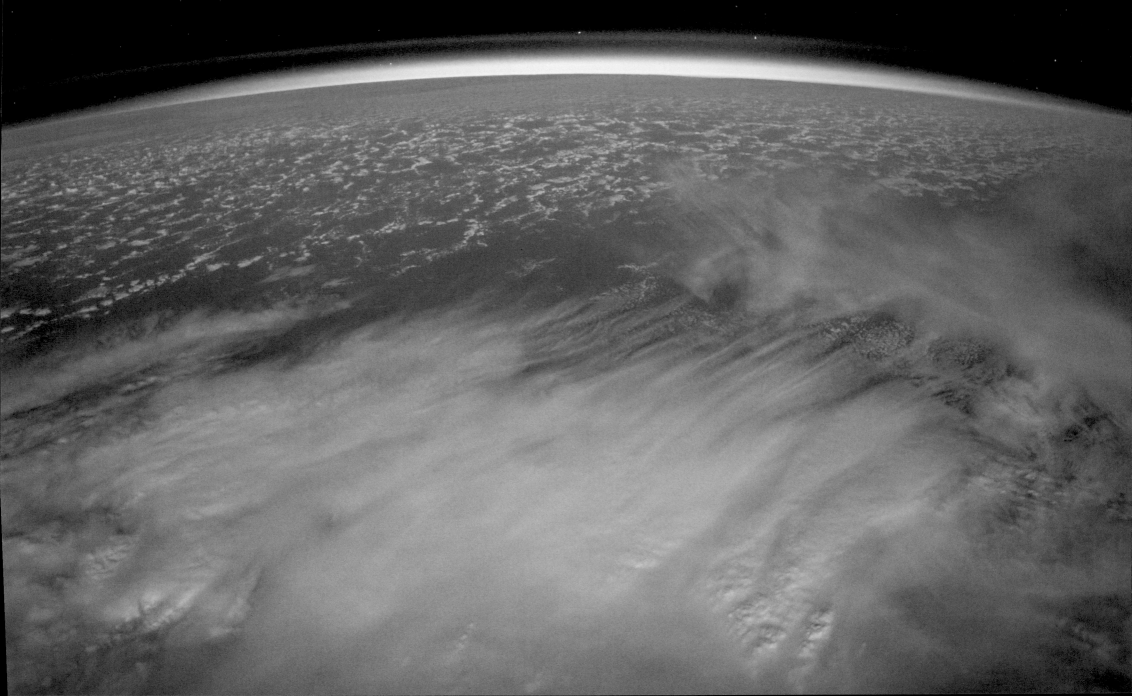

THE NATURAL WORLD

Previous spread: This is one of the first photos I took of Earth in 2016. The solemnness of the planet can delude you into thinking all is quiet and peaceful down below. Of course it never is.

In an experiment designed to see if we could grow simple flowers in space, with the idea of eventually growing tomatoes there to supplement our nutrition, these zinnias struggled. At one point, I took a keen interest in bringing them back from the brink of death and transported them to the cupola to get them some real sunlight for the first time. I like to think that helped.

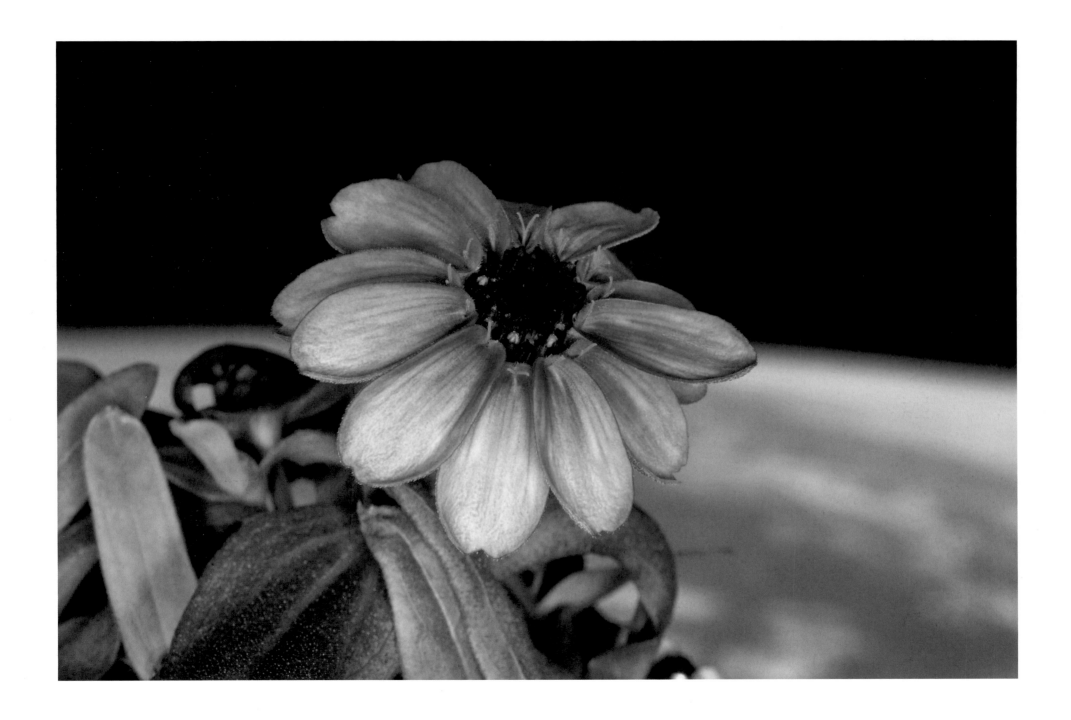

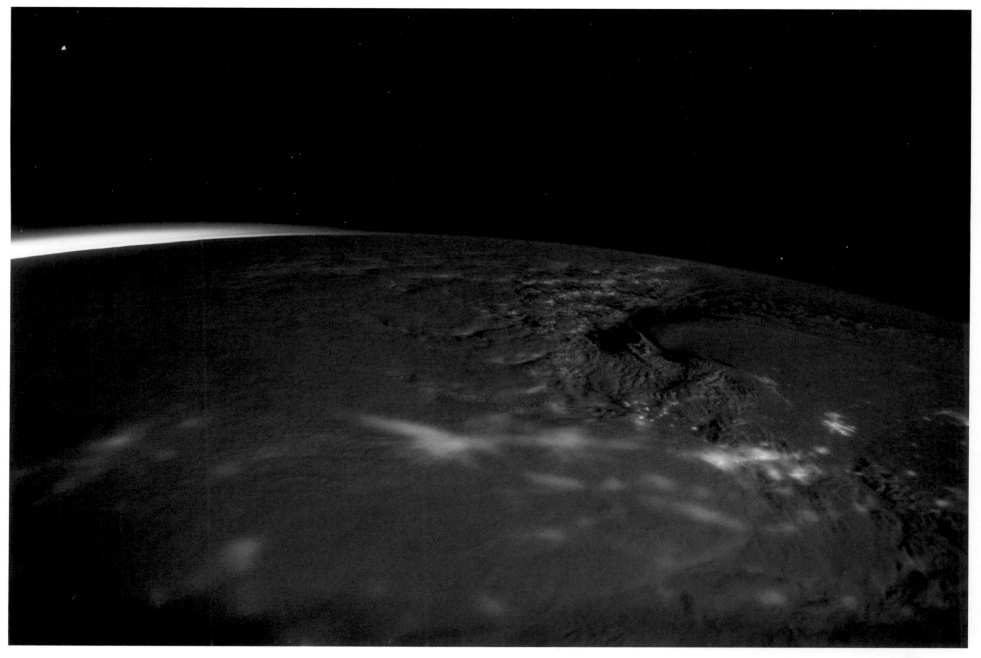

Above: Winter Storm Jonas, also known as Snowzilla, blankets the northeastern United States. The lights from New York City to Washington, D.C., are visible through the clouds.

Opposite: One night, just before going to sleep, I took this photo of the Mediterranean Sea, with the Balearic Islands in the foreground and Italy on the horizon. The reflected light from the moon is visible on the sea's surface.

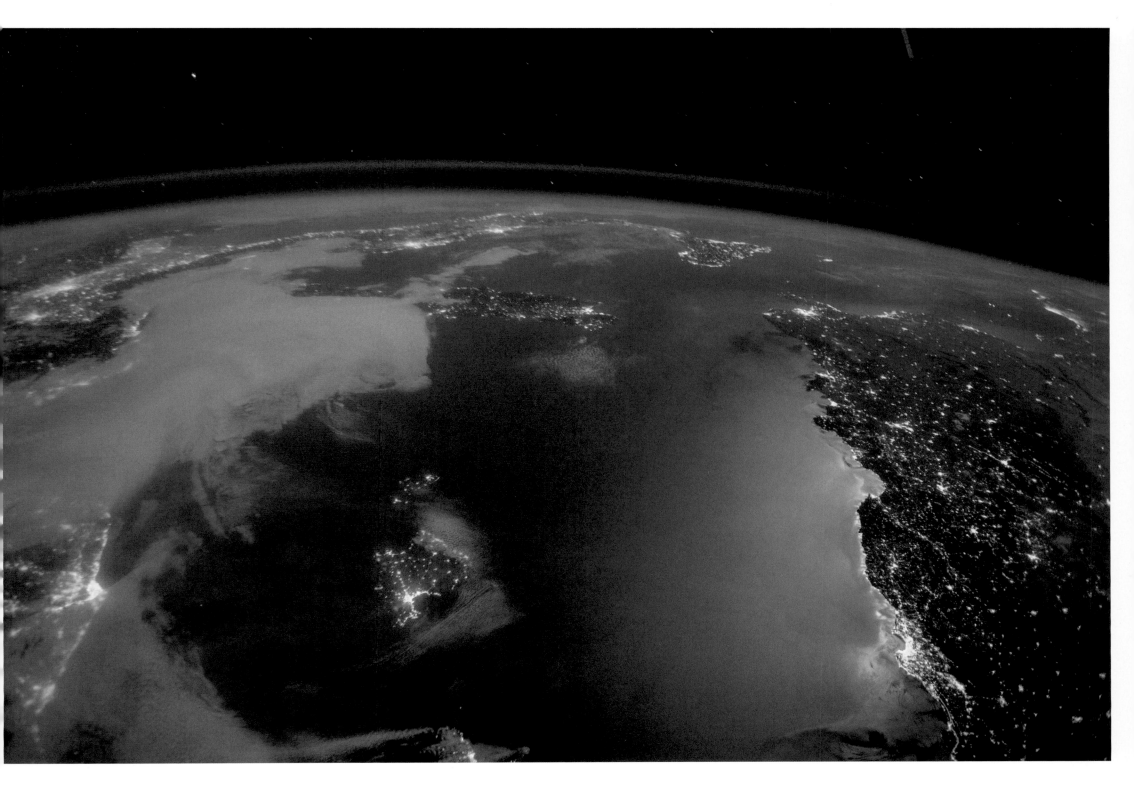

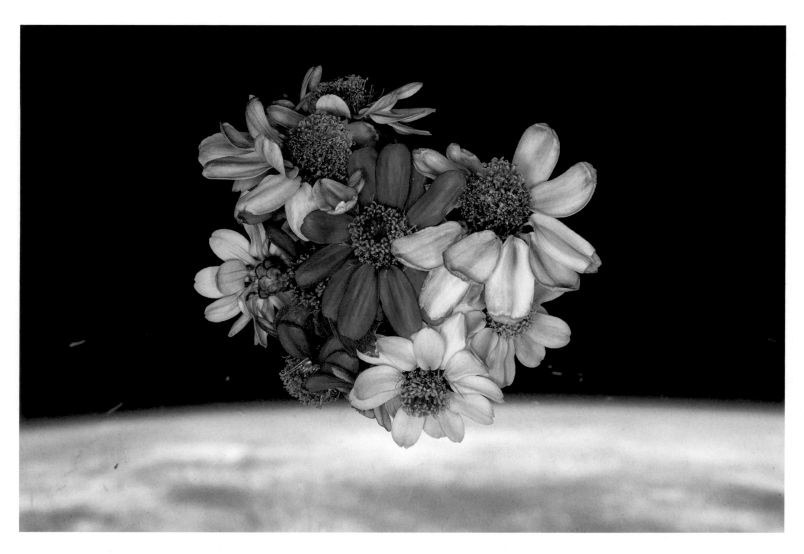

Left: My space flowers after the harvest. I posted this on Valentine's Day. Earth is in the background. I was genuinely touched by how, with a little help, the flowers thrived.

Opposite: It is a challenge to take great photos of the sun, since it rises and sets so rapidly. Furthermore, the brightness of the sun without the filtration of the atmosphere makes it risky to look anywhere near it, so you have to be very careful. This is one of my favorite sunset pictures, taken south of the island of Bermuda.

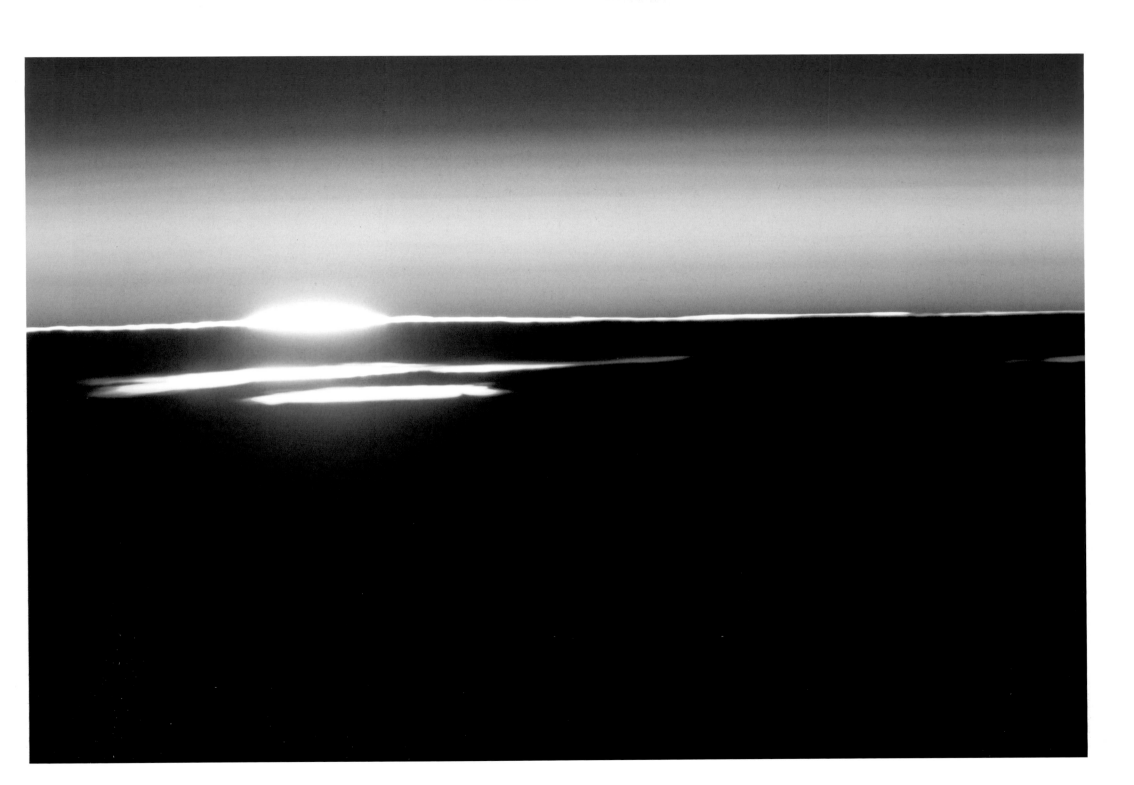

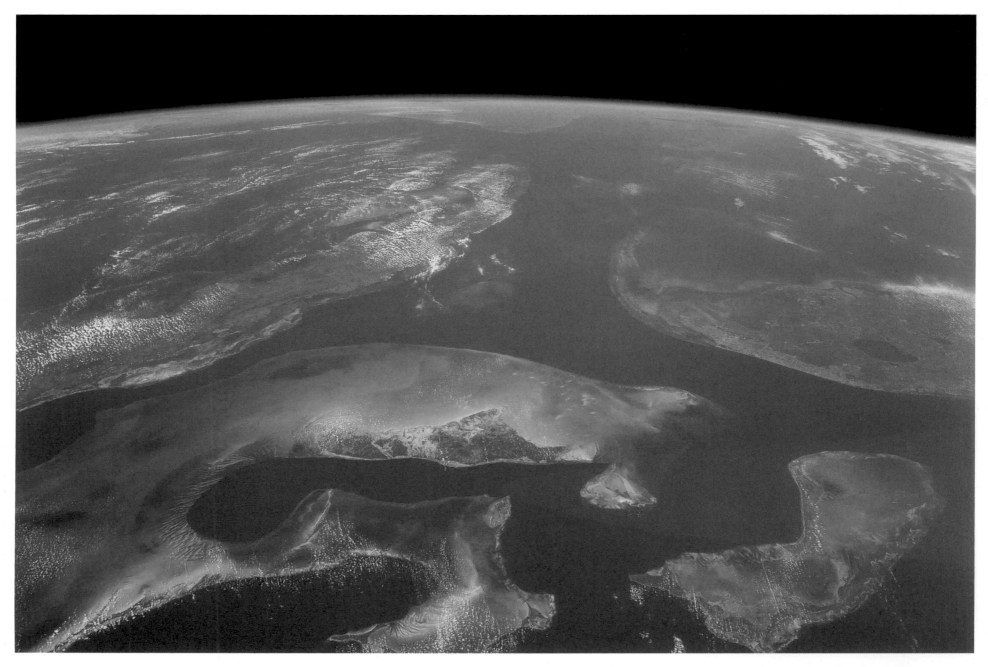

Above: On the day I had my first video conference with my daughter Charlotte, I took this picture of the Bahamas for her. The expansiveness of the blues and greens makes the Bahamas the most easily recognizable place to see from space, as well as one of the most beautiful.

Opposite: One of my favorite places on Earth, New York City. You can see the shadows pointed west, away from the rising sun.

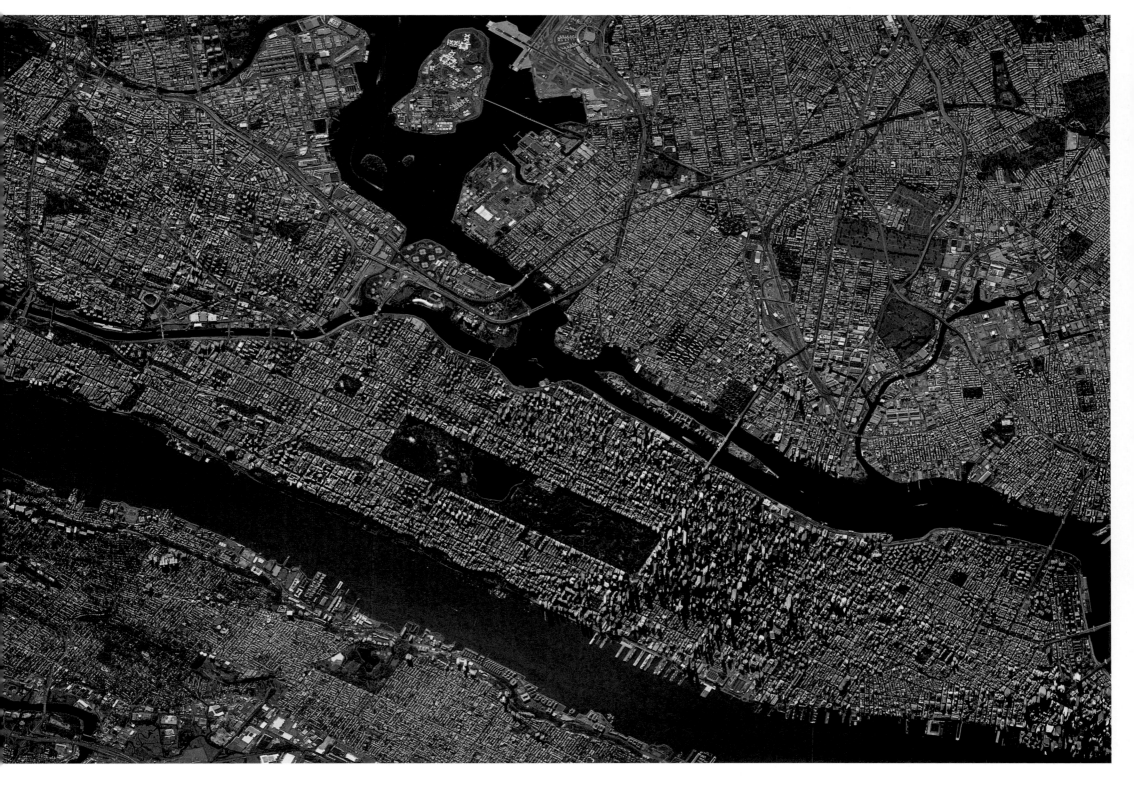

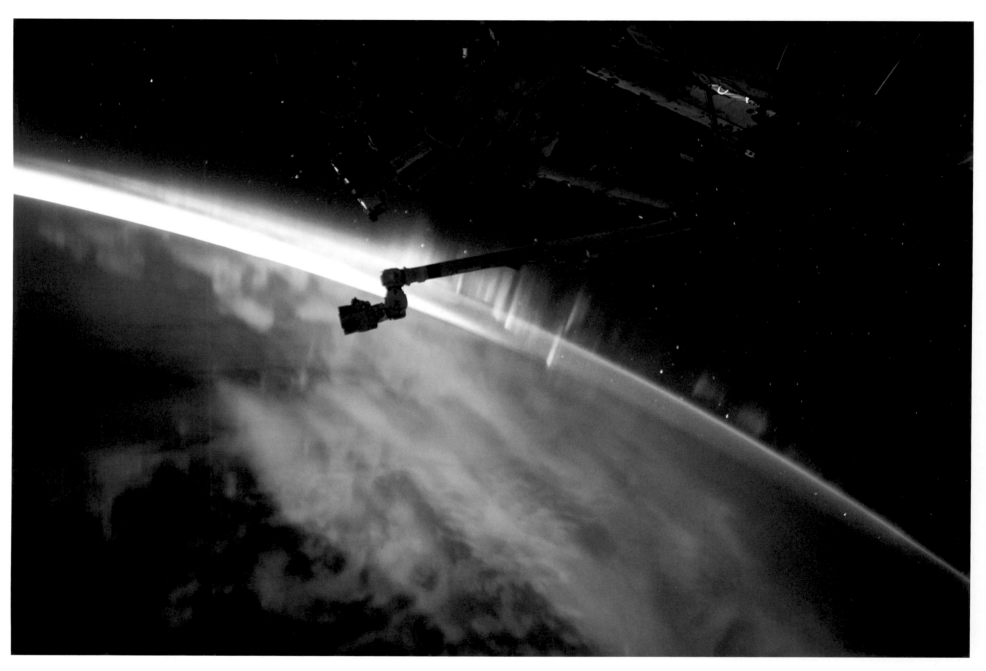

Most of the time the aurora is green. I
called my cosmonaut colleagues to come
and see this one because they, like me,
had never seen a purple-red aurora.

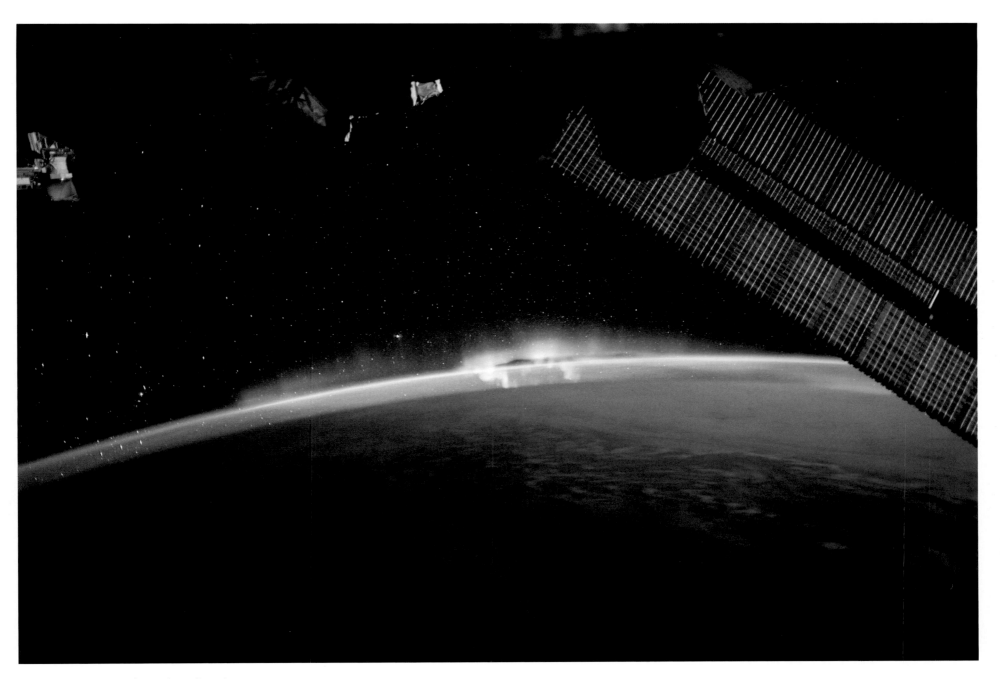

The aurora comes and goes based on the
activity of the sun. In the winter months
in the southern hemisphere the aurora is
more visible.

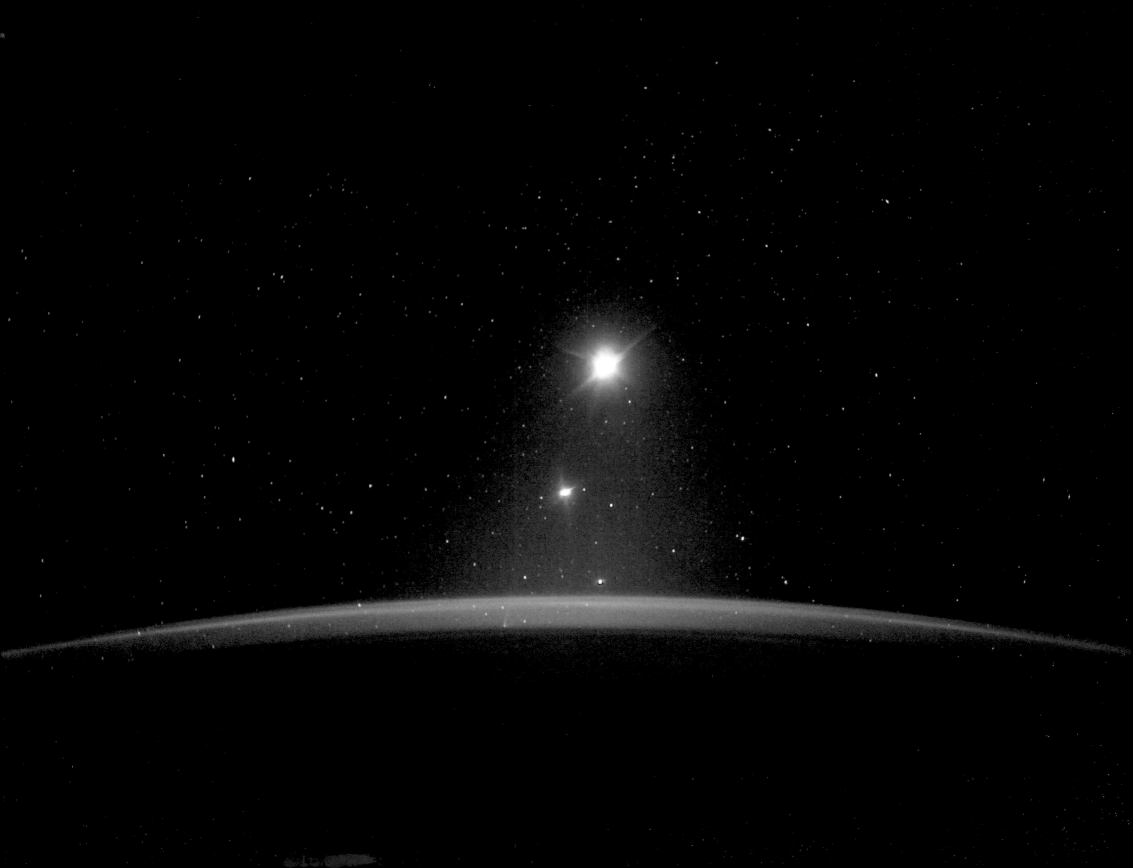

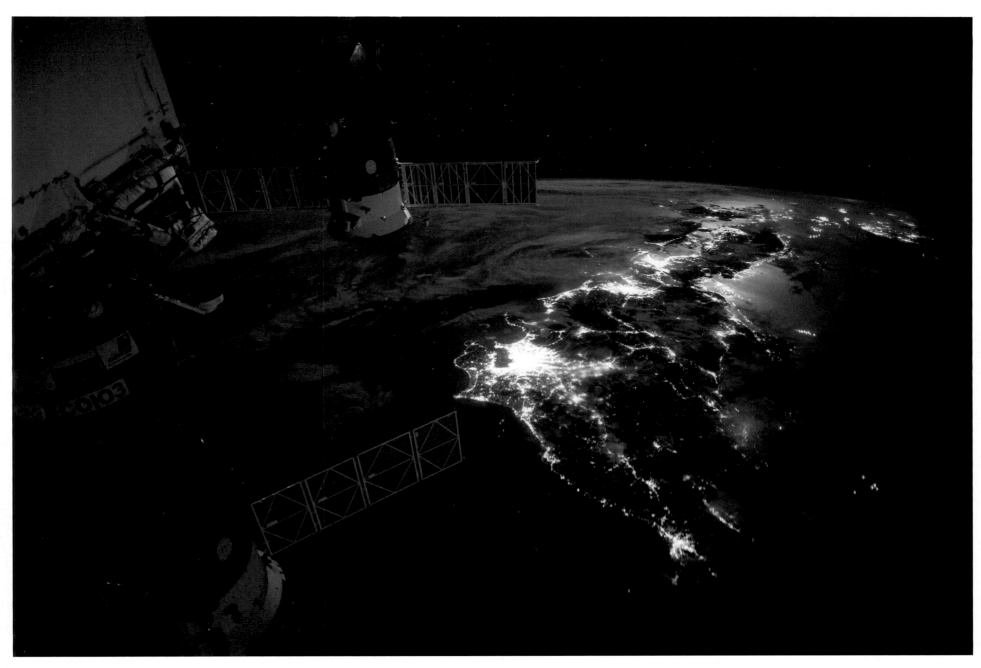

Opposite: Moon, Venus, Jupiter, and Earth lined up, a demonstration that all of us are in a similar orbital plane

Above: I captured a striking image of Japan while showing my crewmate Kimiya Yui how to take night photos of city lights.

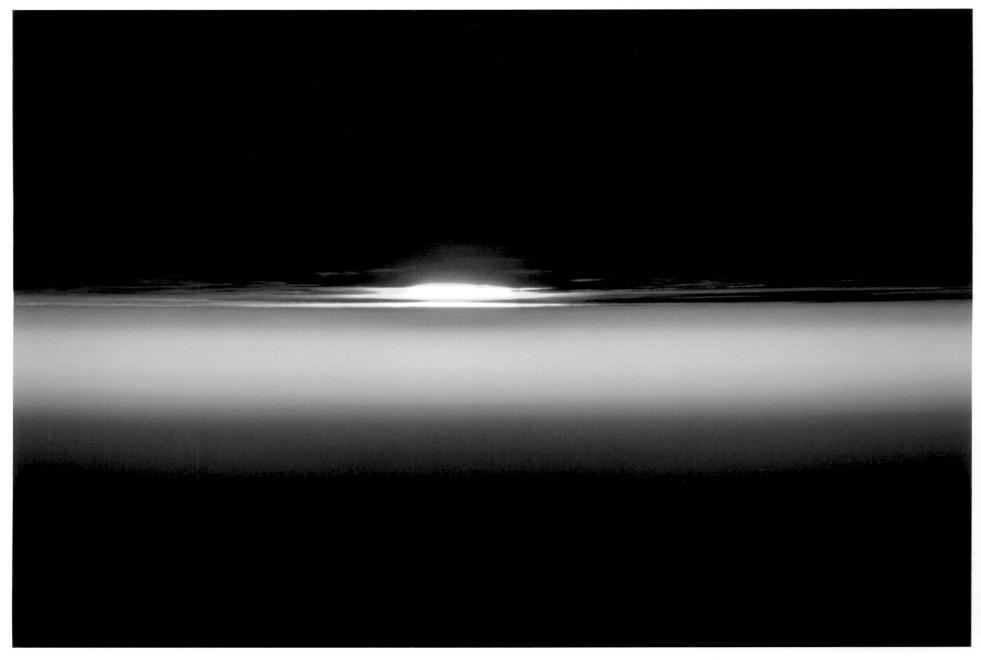

Above: After we had lived a week at "High Beta," when the sun shines on one side of the space station and doesn't set, the sunset finally returned, which is when I took this photo.

Opposite: The moon rises as we approach the west coast of South America.

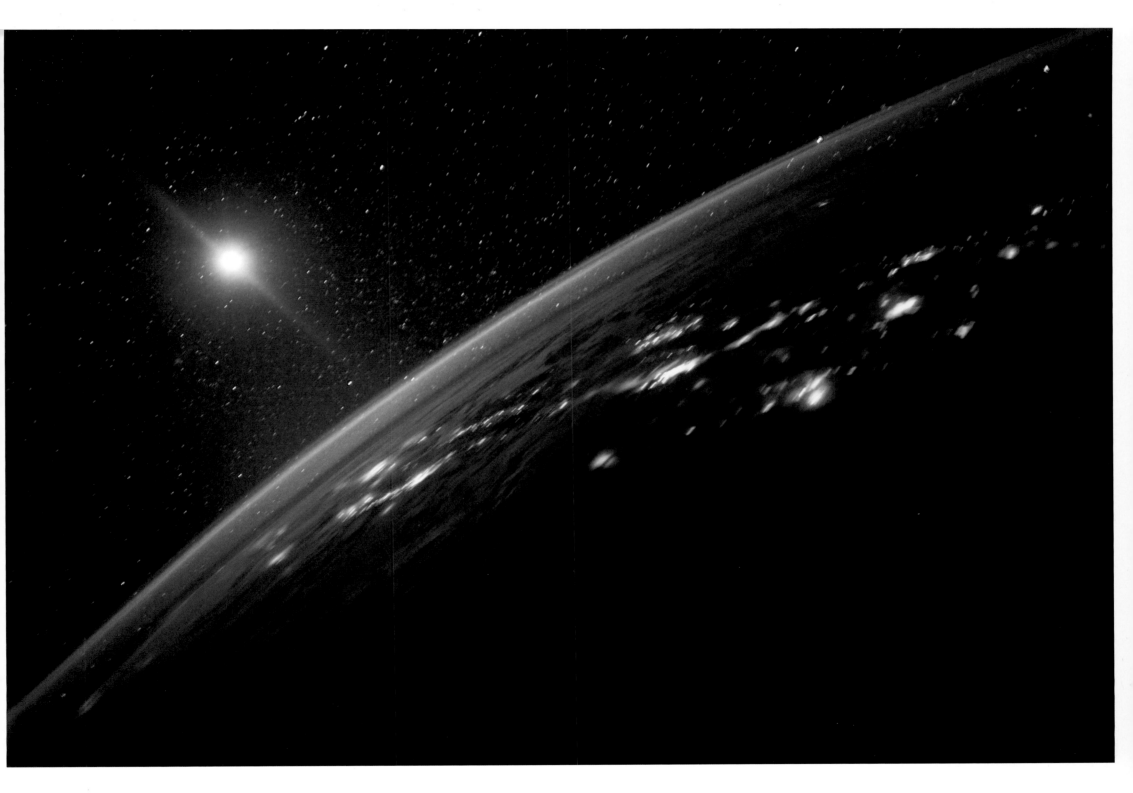

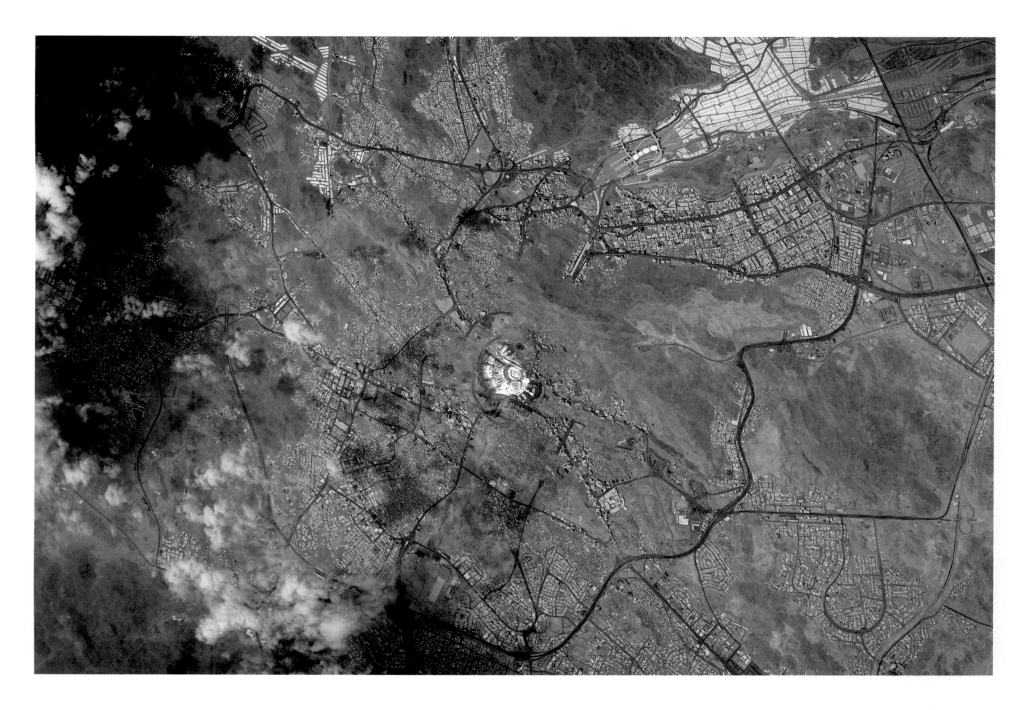

The holy city of Mecca in Saudi Arabia, the birthplace of Muhammad. You can almost make out the Kaaba, a shrine at the center of Islam's most sacred mosque.

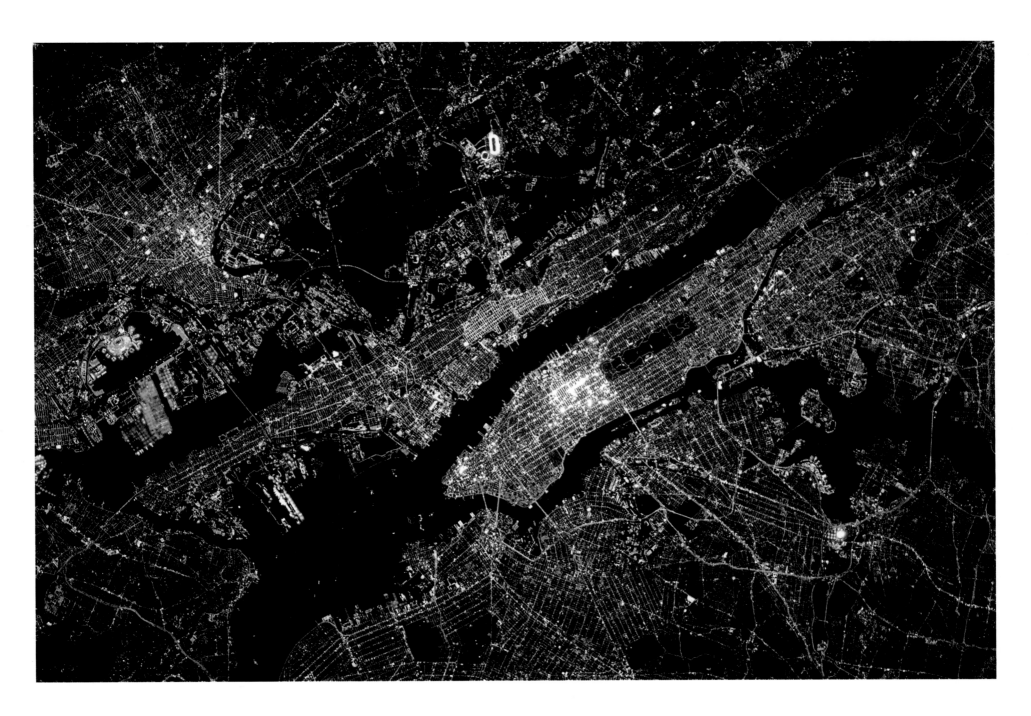

My cosmonaut colleague Oleg Kononenko took this incredible photo of New York City
at night.

Sometimes, the atmosphere, she glows.

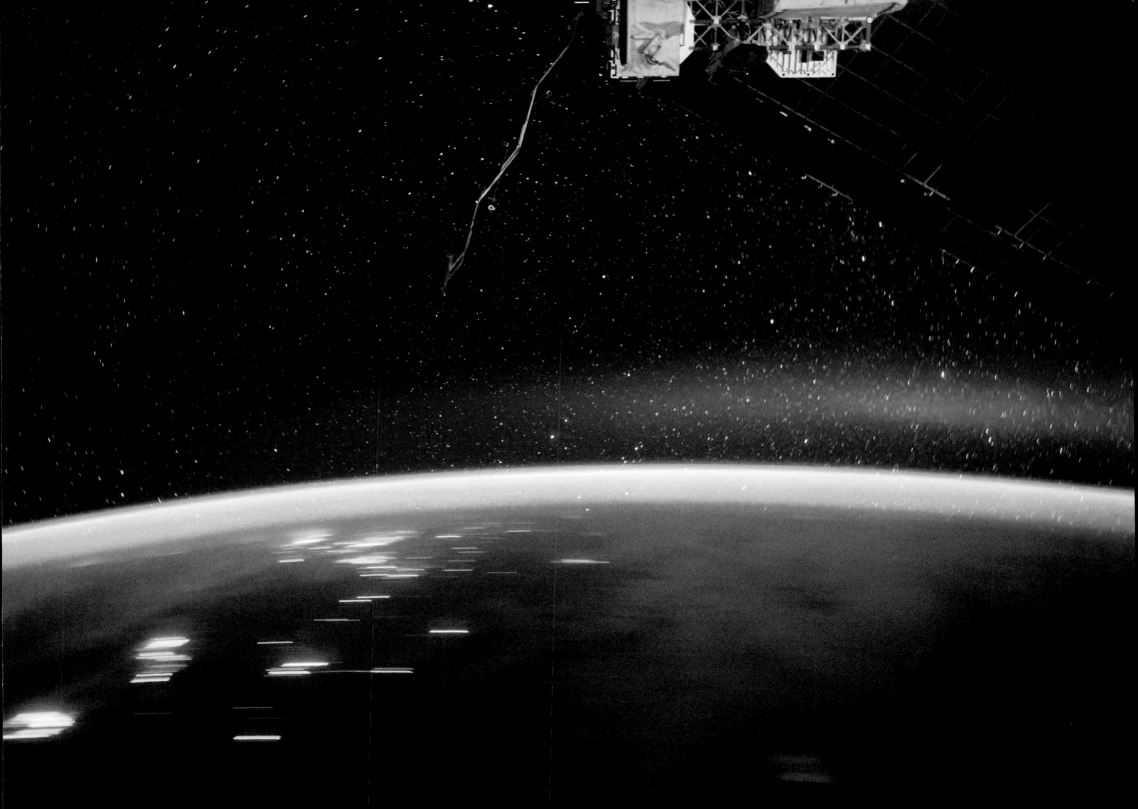

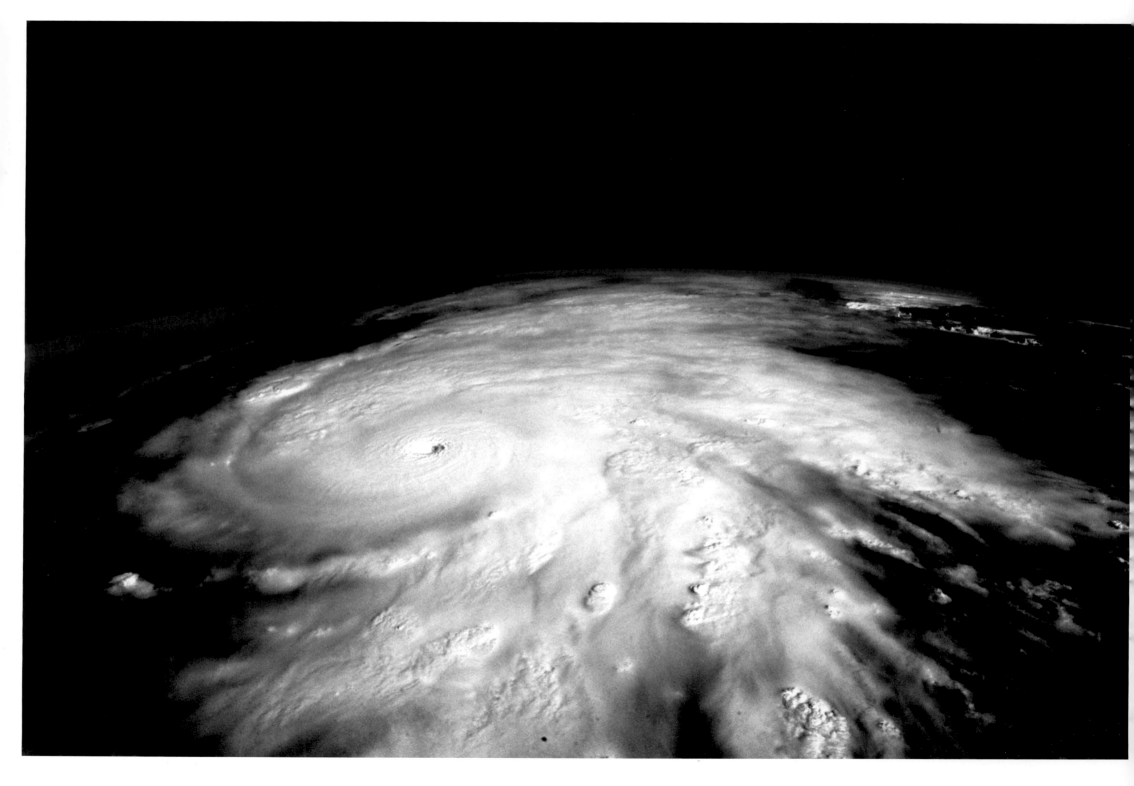

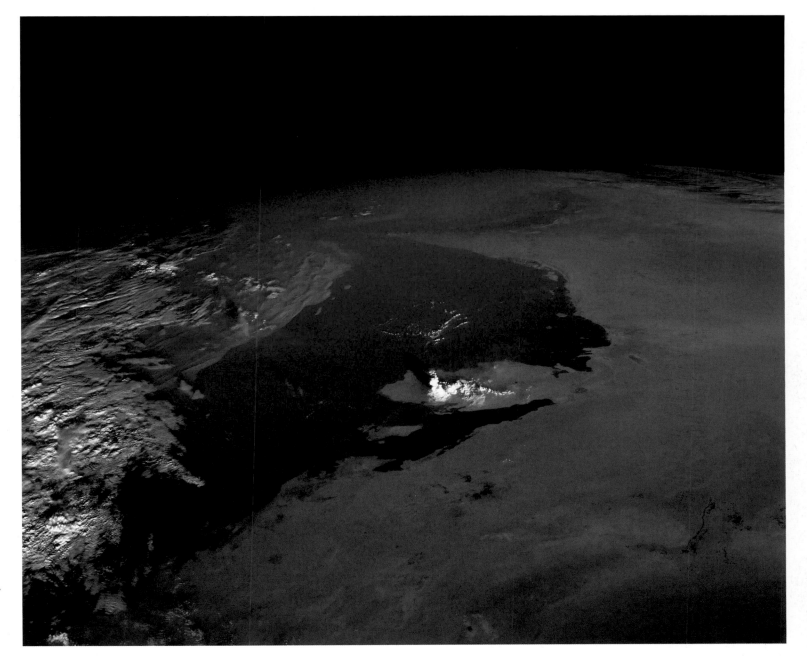

Opposite: I shot this photo of Hurricane Patricia, the strongest hurricane ever recorded at the time, edging closer to landfall on the Pacific coast of Mexico, a few days before my first ever space walk. The storm reminded me of my late mother, Patricia. She was a strong force in my life.

Right: When I saw this cumulus cloud over Qatar, it immediately reminded me of a pillow. Perhaps that was because in space, without gravity, pillows aren't needed, as our heads just float along with everything else, but we still miss them.

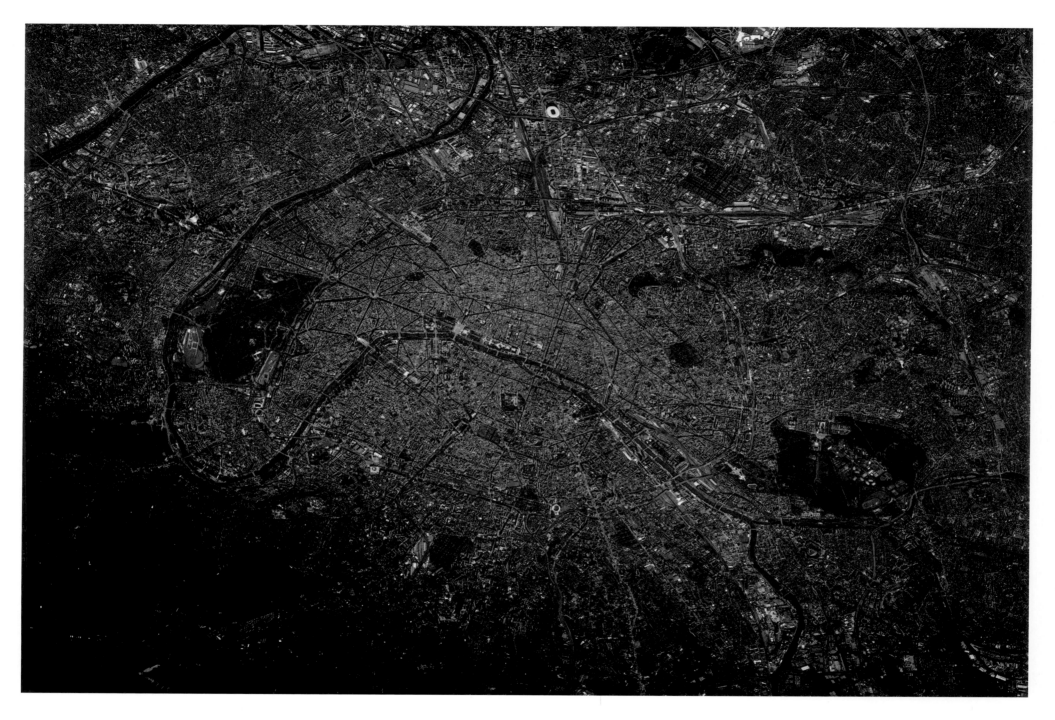

I captured this image of Paris after the shocking terrorist attack in November 2015. Lots of bad news from Earth is a constant reminder that despite the planet's beauty, we have serious issues.

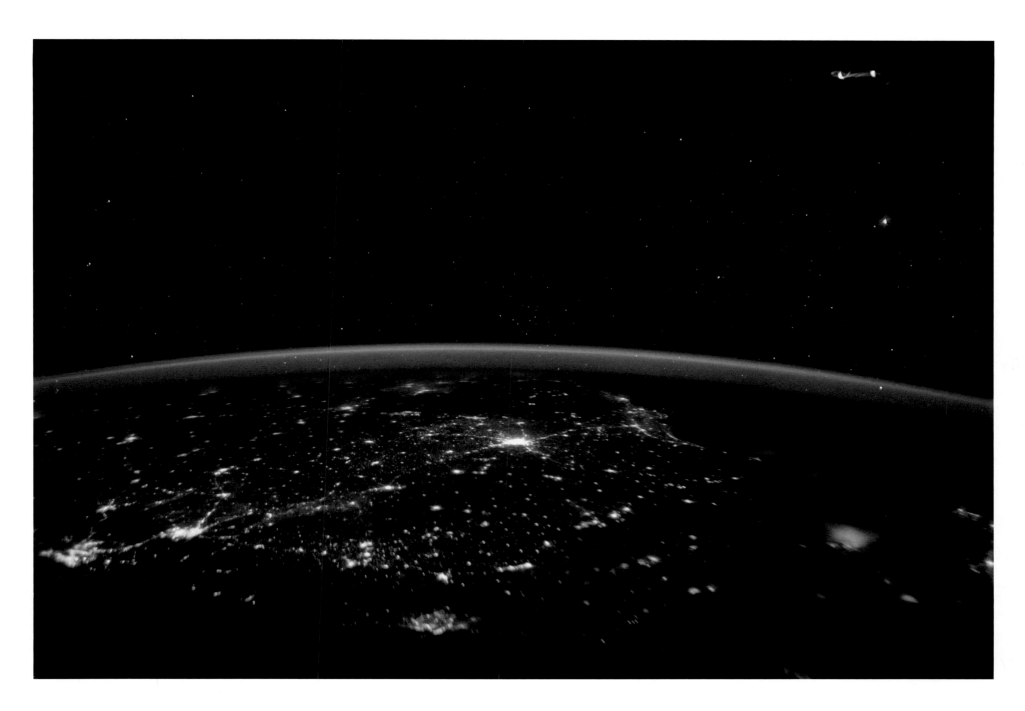

Over the Gulf of Mannar, in southern India, at night. The single spot in the sky is likely
Venus. The two dots in the upper right are actually the UHF (ultrahigh-frequency)
antenna on the ISS. Alien enthusiasts often comment that this is a UFO.

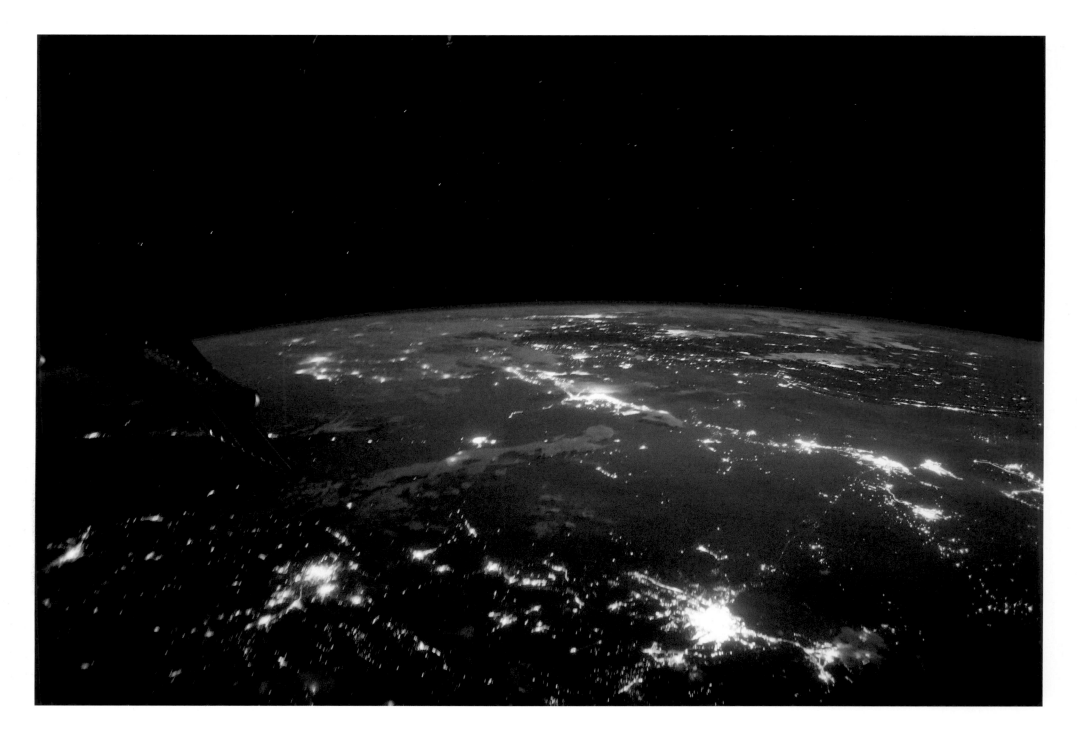

Night pulls its veil over the surface of the Earth.

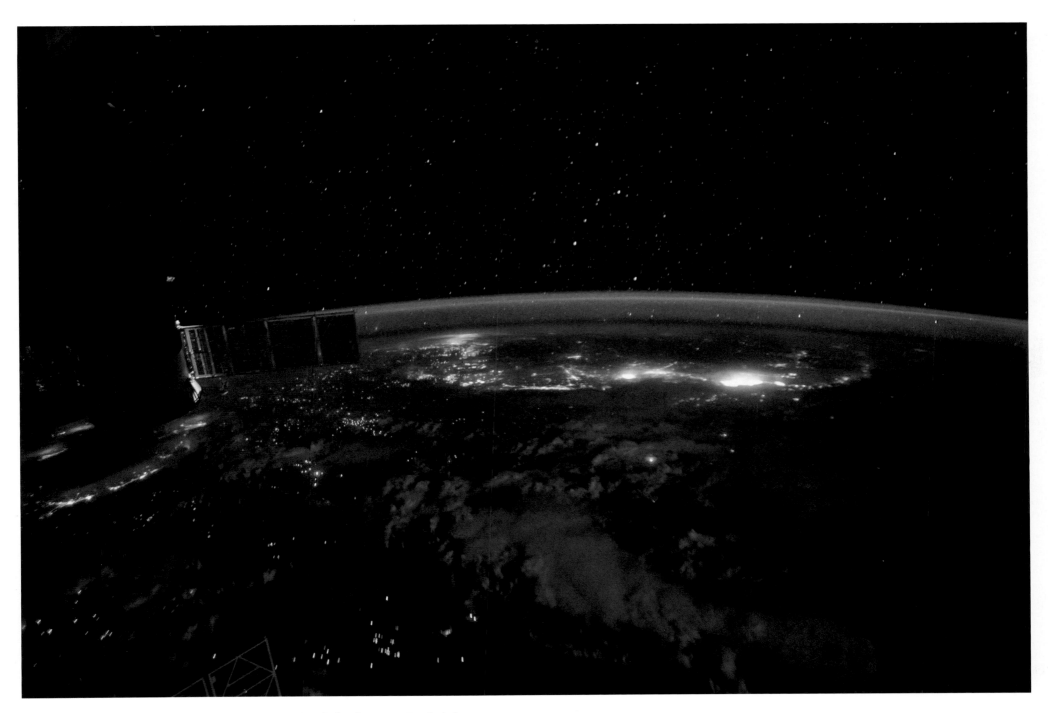

The green lights in Kuala Lumpur, Malaysia, are the glow lights from passion fruit farms, which are visible throughout Southeast Asia during the night. It took me five hundred days in space before I figured out what these were.

As we passed over Dubai one afternoon, I was struck by the vast development of this once-desolate city since my port visit aboard the USS *Dwight D. Eisenhower* as a Navy lieutenant twenty-five years earlier. The palm-tree-like structure of the man-made artificial island Palm Jumeirah is clearly visible and identifiable from the International Space Station.

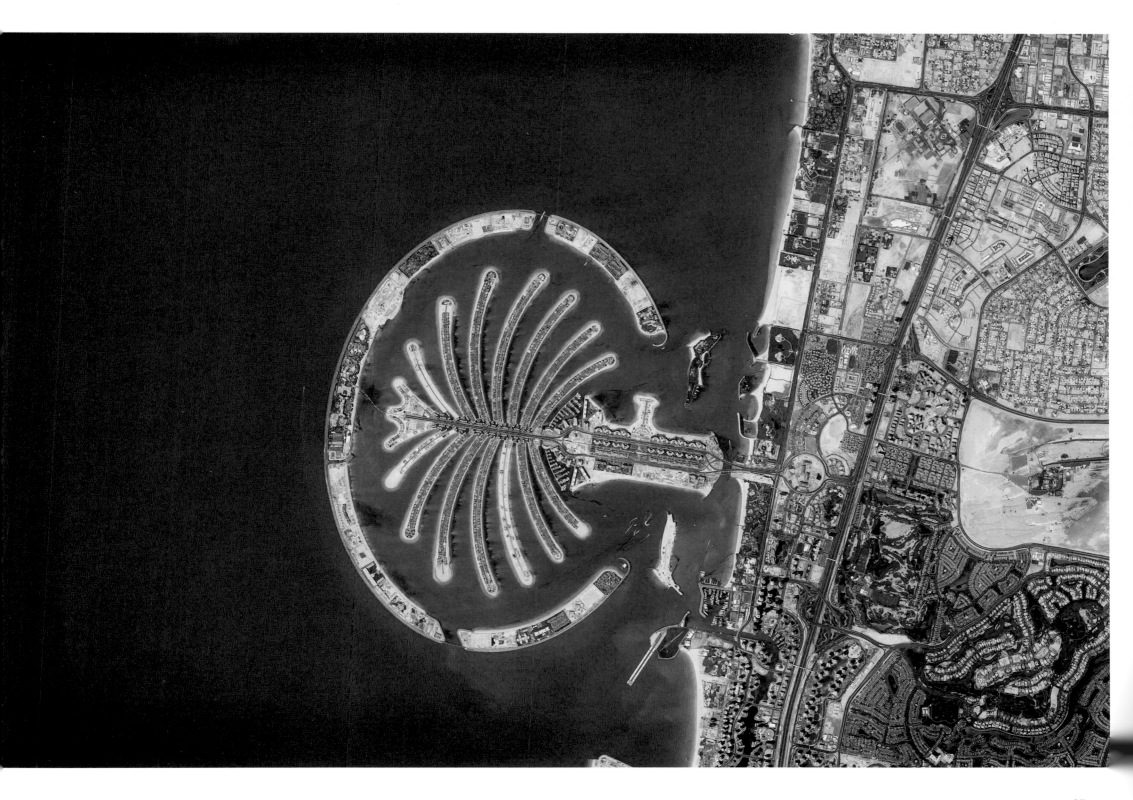

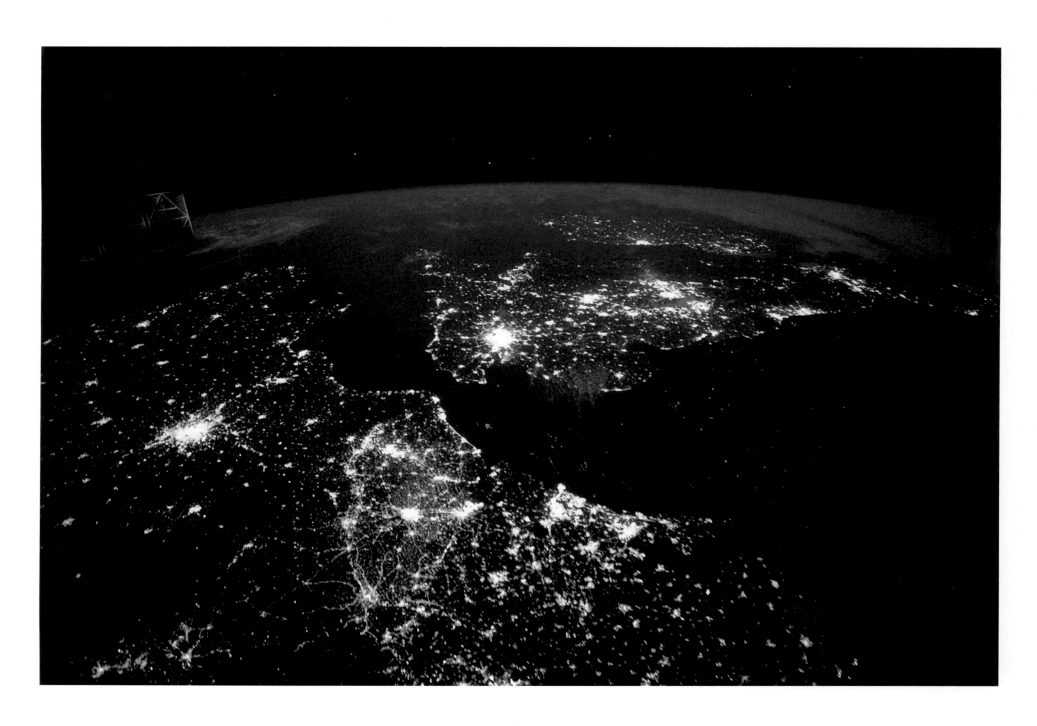

Paris on the left, London and the United Kingdom in the center, separated by the Strait of Dover, also known as the Dover Narrows

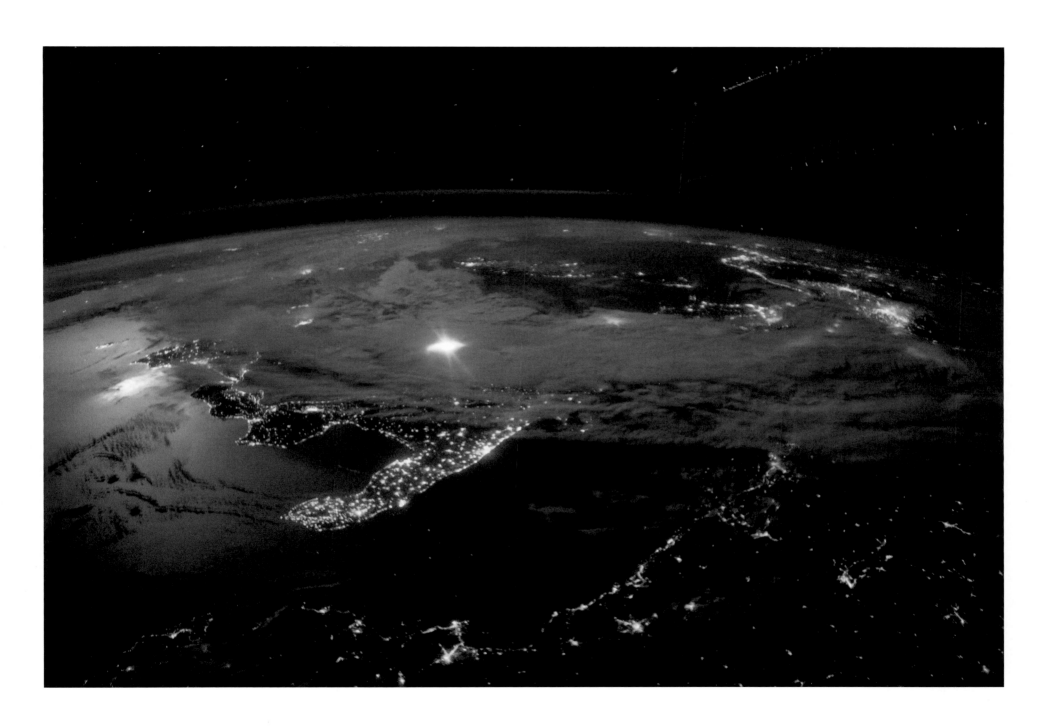

One night as we passed over Italy, it seemed to sparkle under the moonlight. Lightning is visible in the center of the image. I used this photo to wish everyone on Earth a good night, in Italian, *buona notte,* as my former Italian crewmate Samantha would have said.

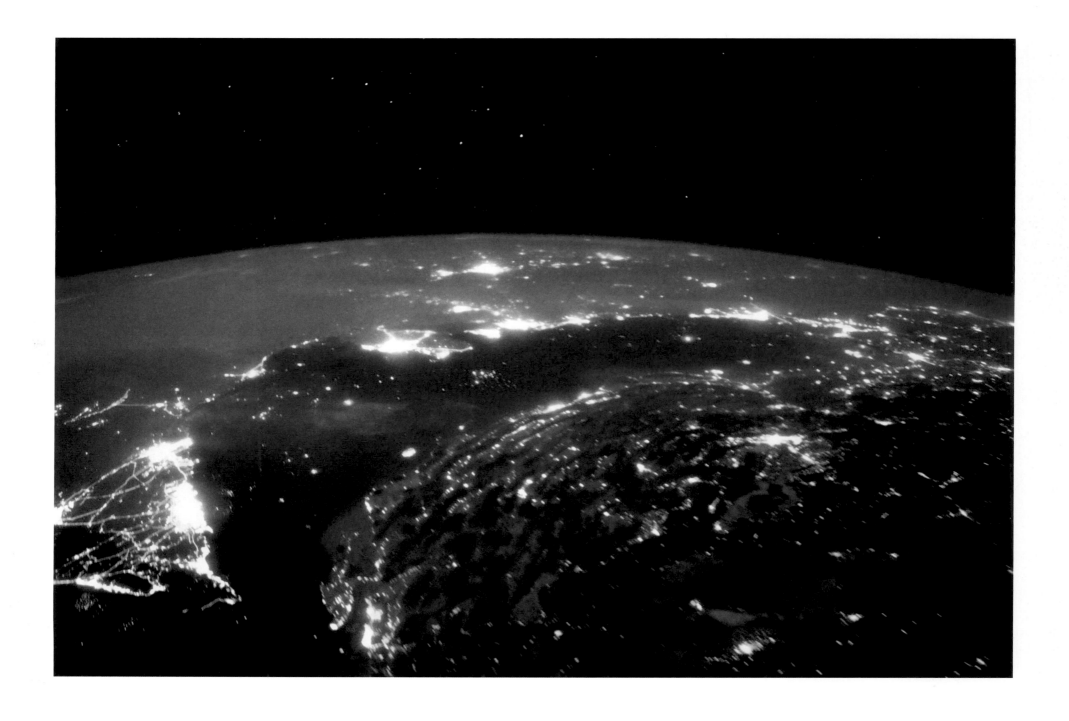

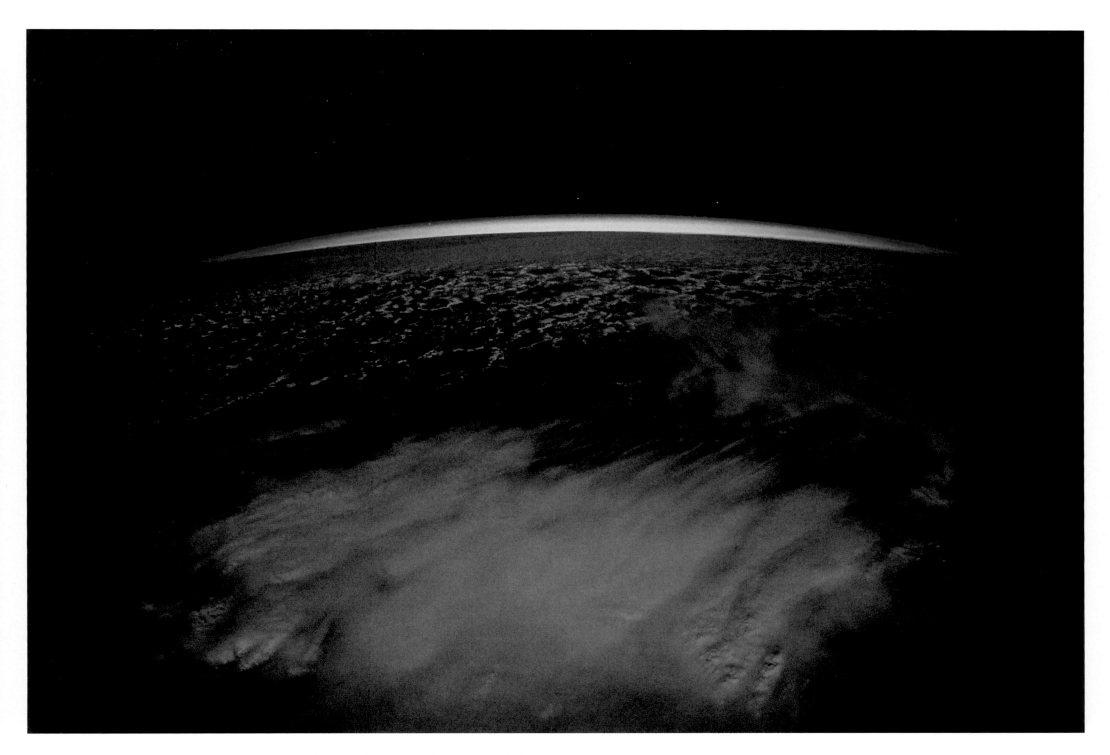

To me it seemed like a warm blanket had settled over the surface of the Earth at dusk.

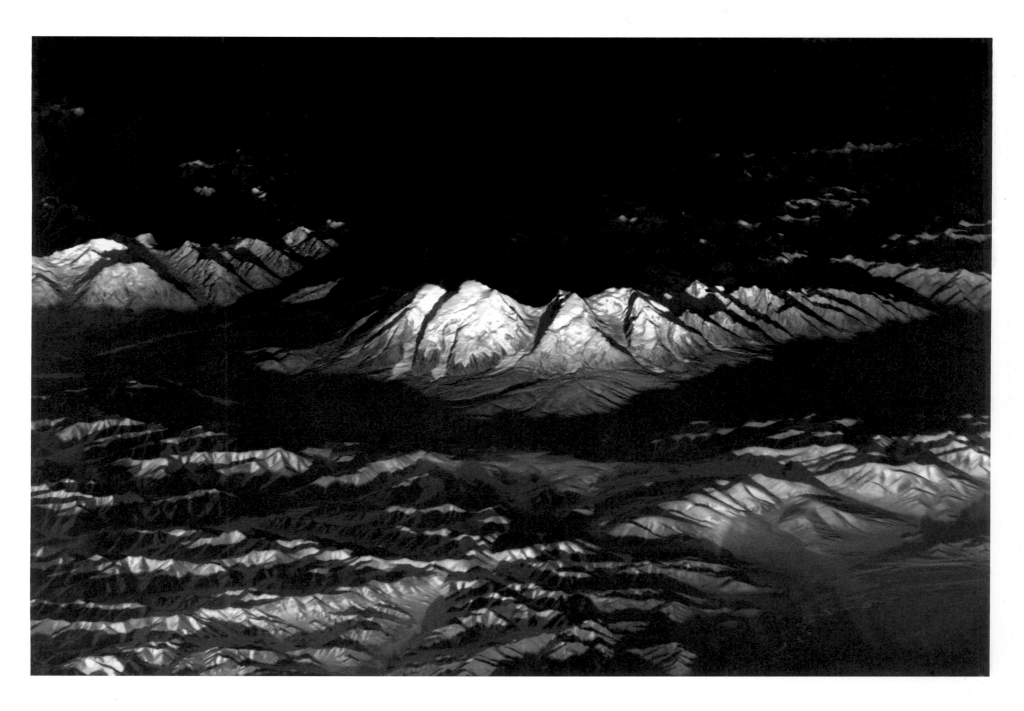

This mountain range represents one of my many failed attempts at getting a picture of nearby Mount Everest. I took the photo with a telephoto lens in an oblique view.

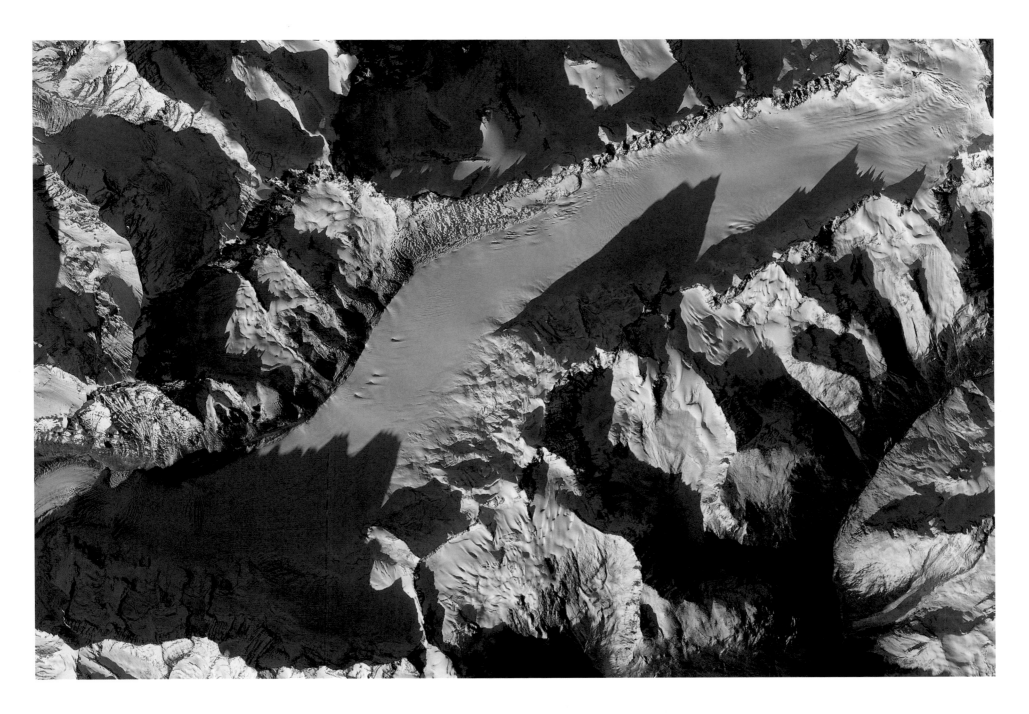

The shadows of the mountain peaks in the Himalayas as the sun begins to set
in the west

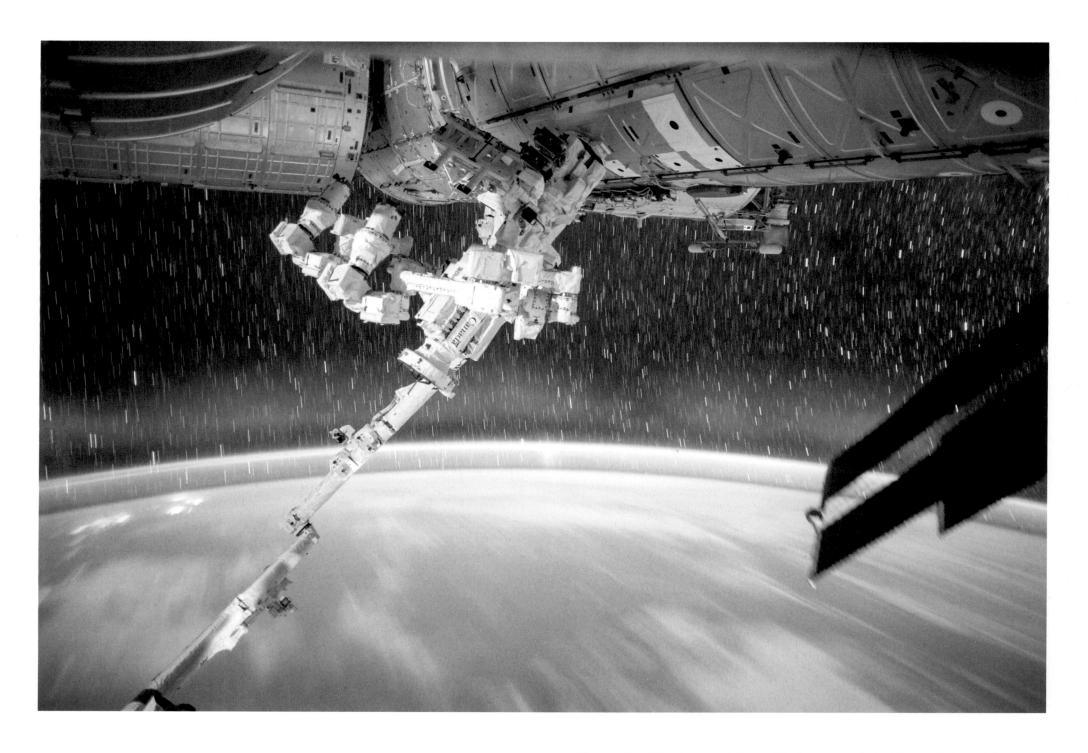

The streaks of the stars are visible in this time-lapse photo taken at night, and the Earth is bright due to the camera settings I used.

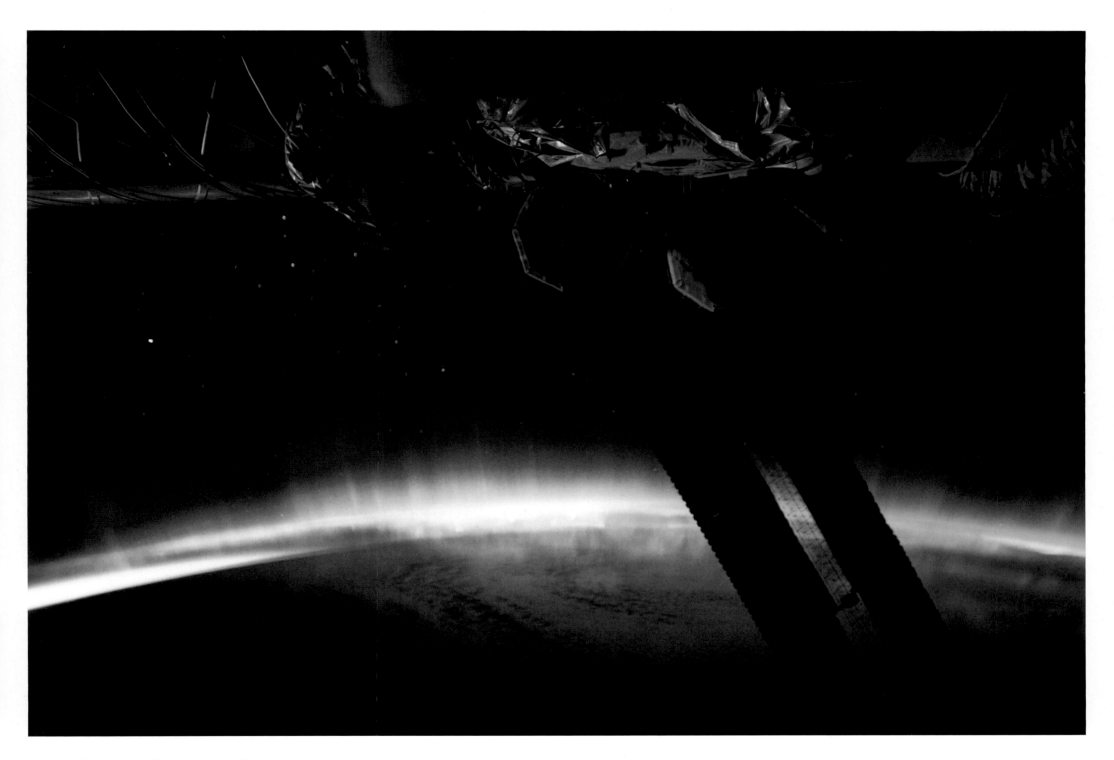

The reds, purples, and greens of the
aurora

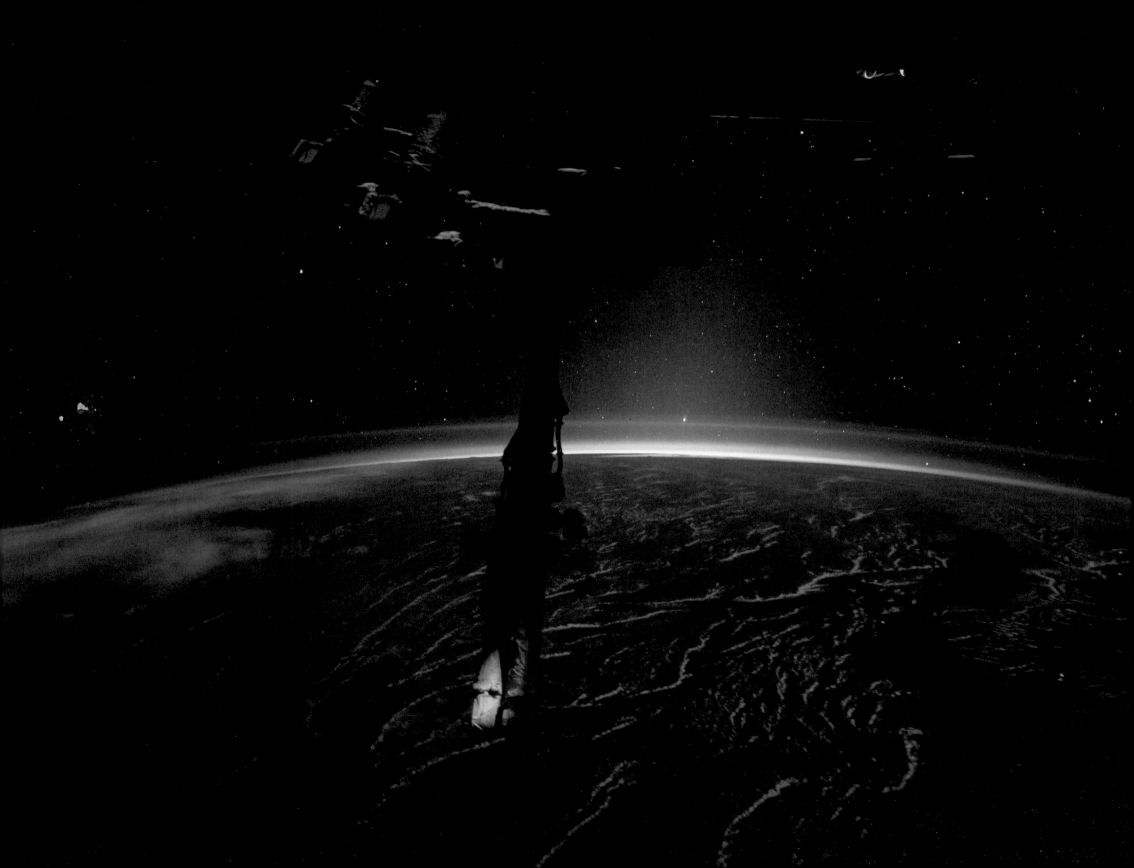

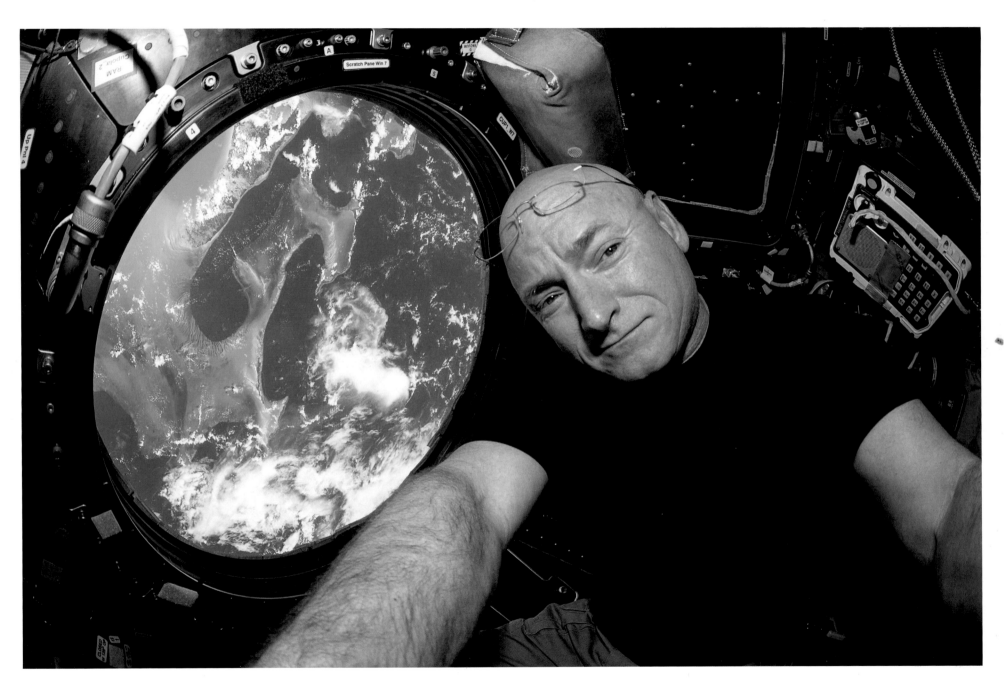

Opposite: The thin and sometimes colorful film of the atmosphere is visible along with the clouds over the ocean below.

Above: A selfie taken in the cupola with the blue waters of the Bahamas below

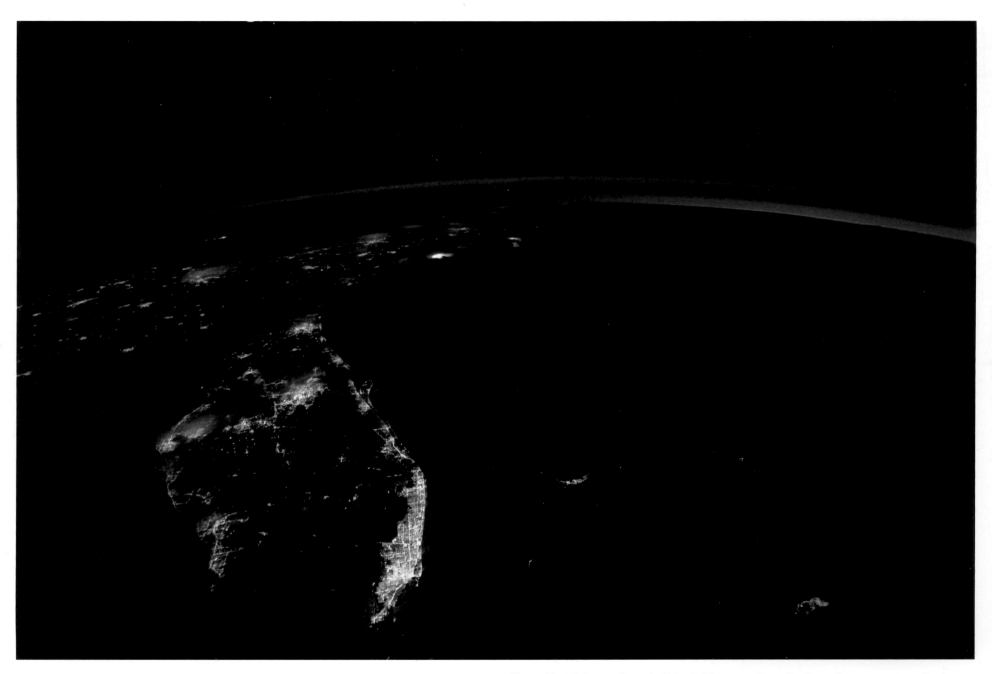

Above: Florida looms large in this night shot. A few thunderstorms can be seen along the eastern coast of the United States.

Opposite: Sometimes you see optical illusions in space. This one makes it appear that space is warped as in a science-fiction film.

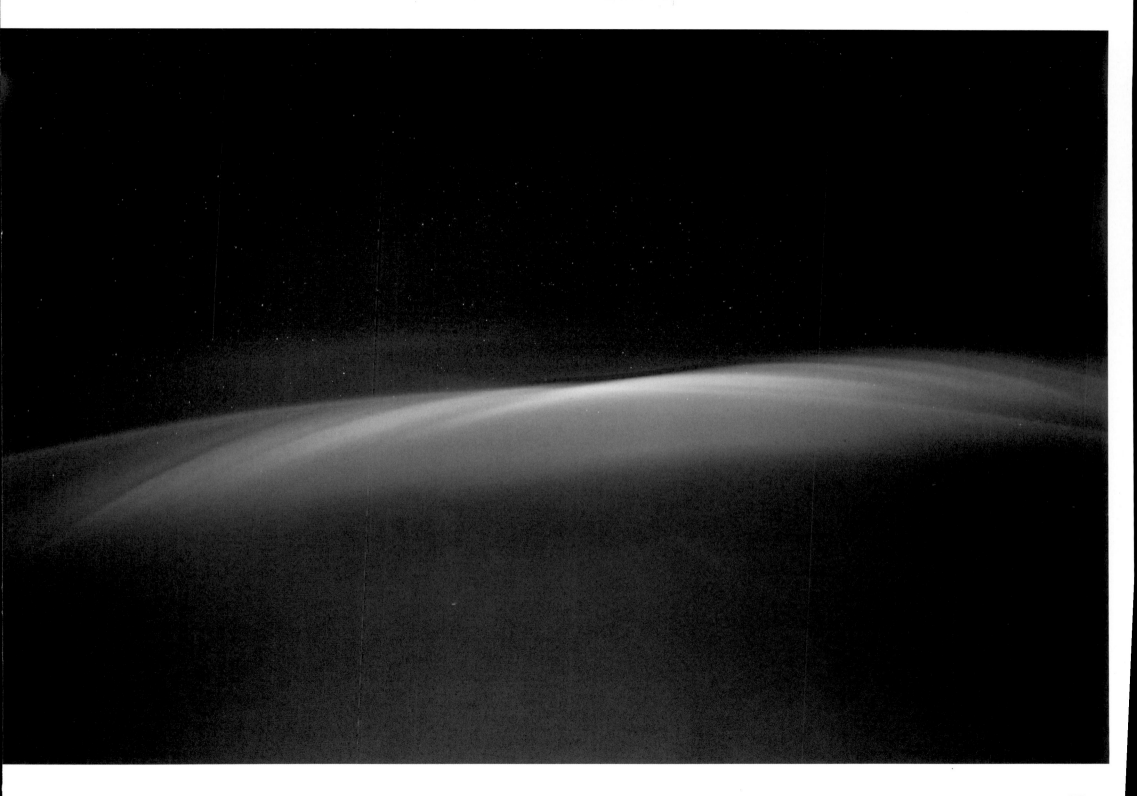

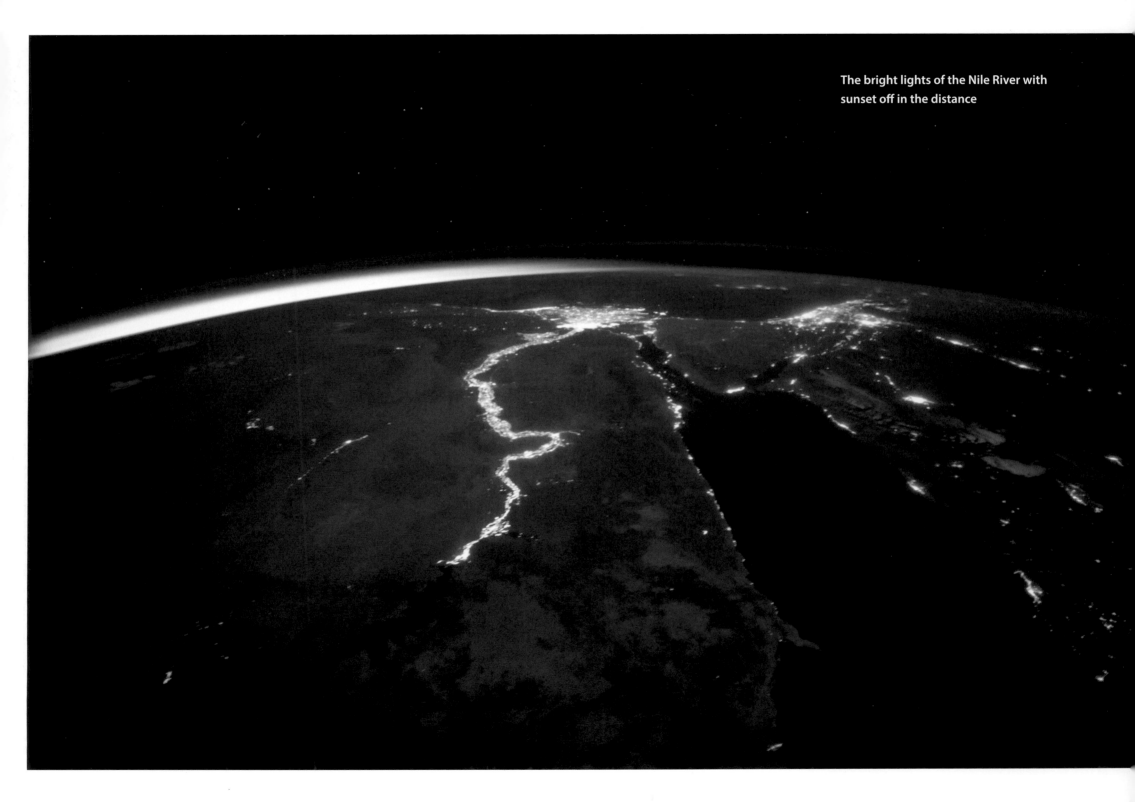

The bright lights of the Nile River with sunset off in the distance

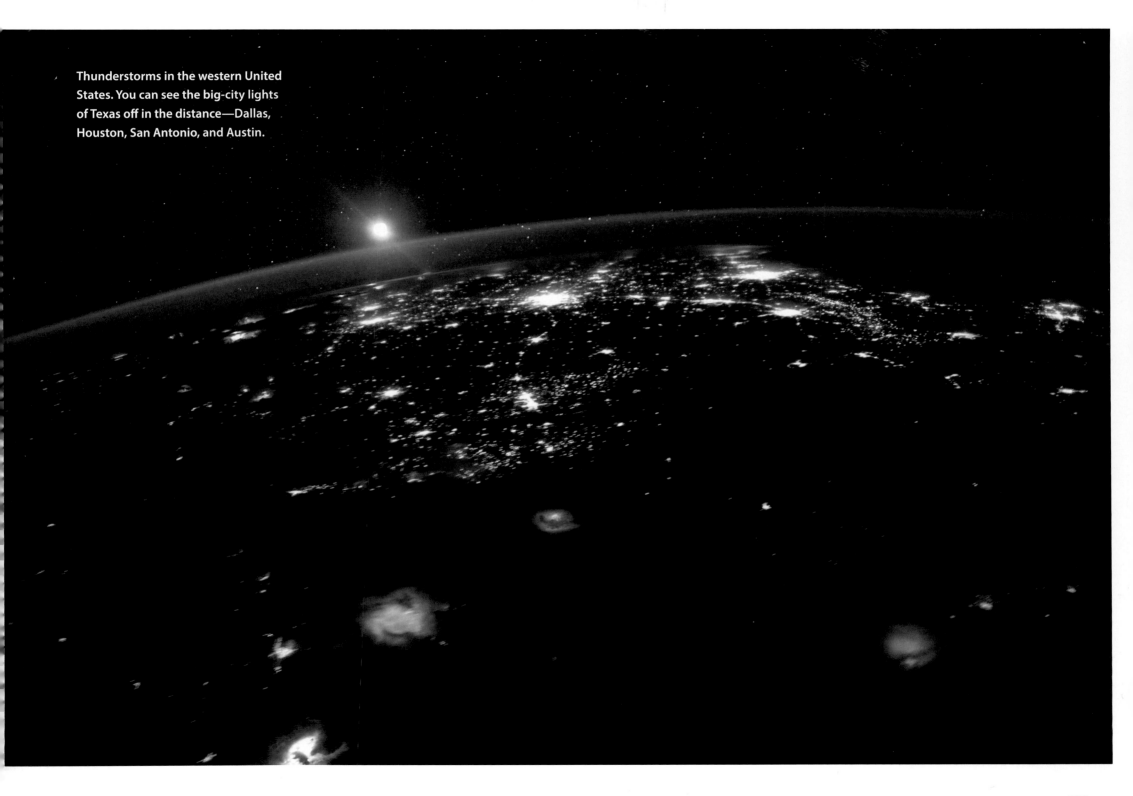

Thunderstorms in the western United States. You can see the big-city lights of Texas off in the distance—Dallas, Houston, San Antonio, and Austin.

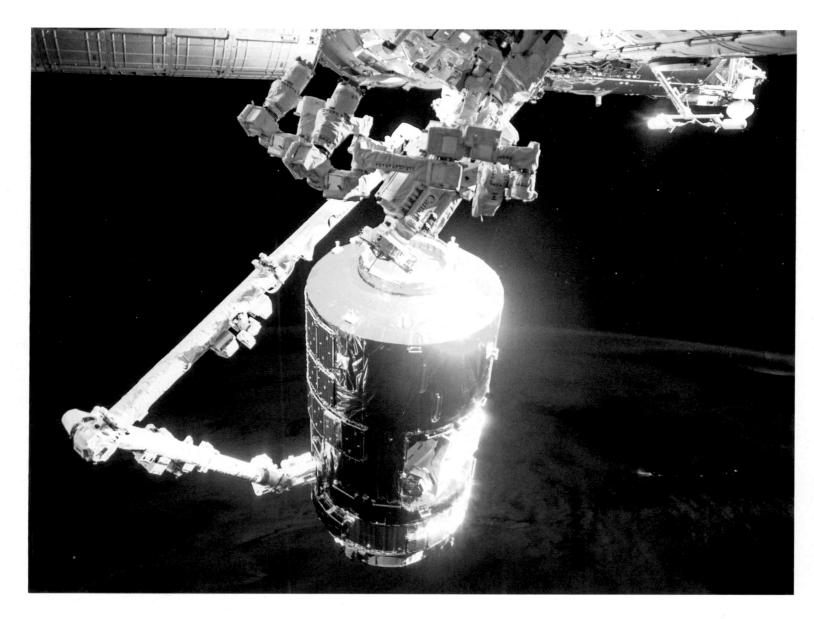

Left: The Japanese HTV (H-II Transfer Vehicle), a cargo ship, glows gold in the rising sun.

Opposite: The Canadian Robotic Arm, Canadarm2, moves the HTV as we fly over the Arabian or Persian Gulf.

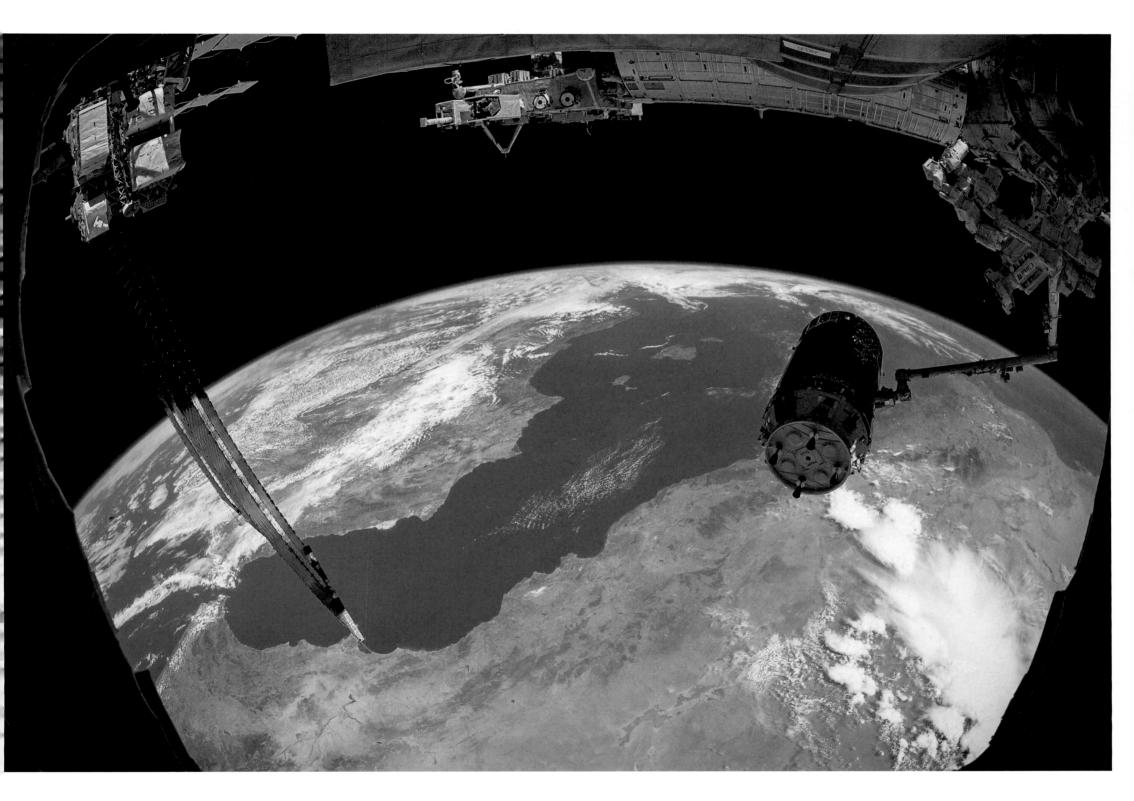

Above: A very green aurora partially blocked by the space-station structure

Opposite: The sun shines through a crack between the Russian modules of the ISS. The Russian Soyuz capsule is in the foreground and the Progress cargo ship is in the background.

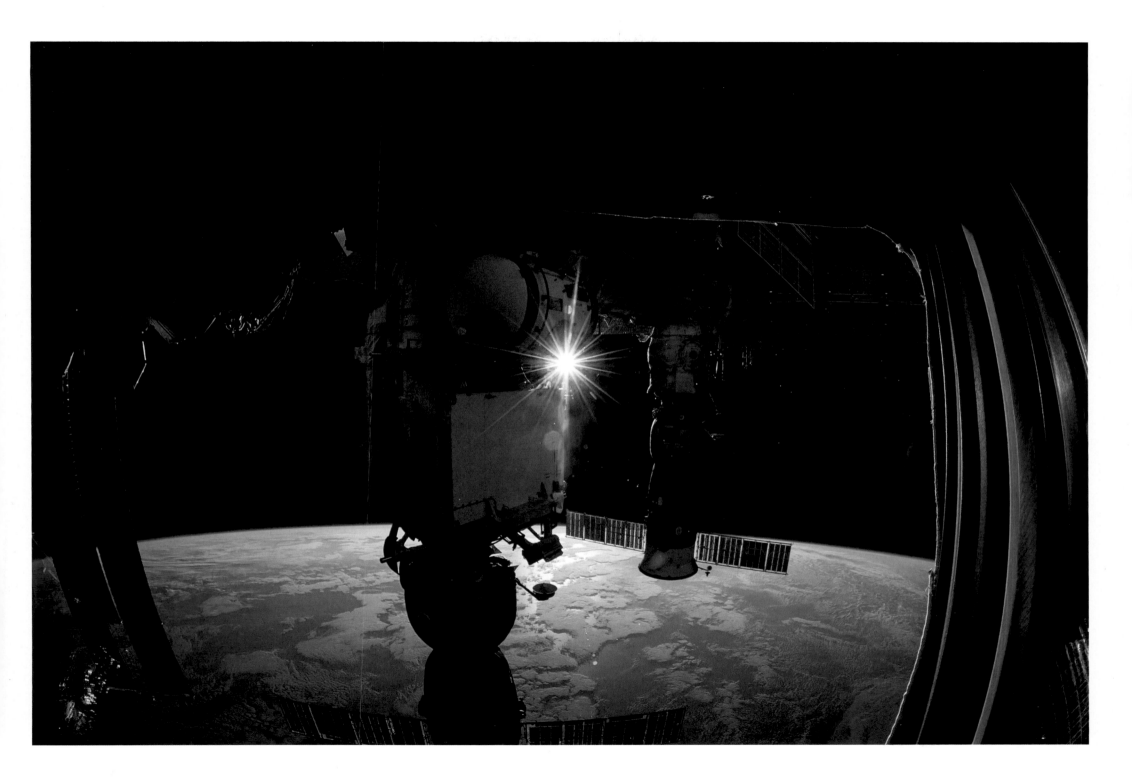

The mass of lights at the bottom of this photo is Seoul, South Korea. The demilitarized zone between the Koreas is also visible. Above the zone the dark landmass is North Korea, with the one bright area of light being Pyongyang, the capital. The lights farther toward the horizon are in China.

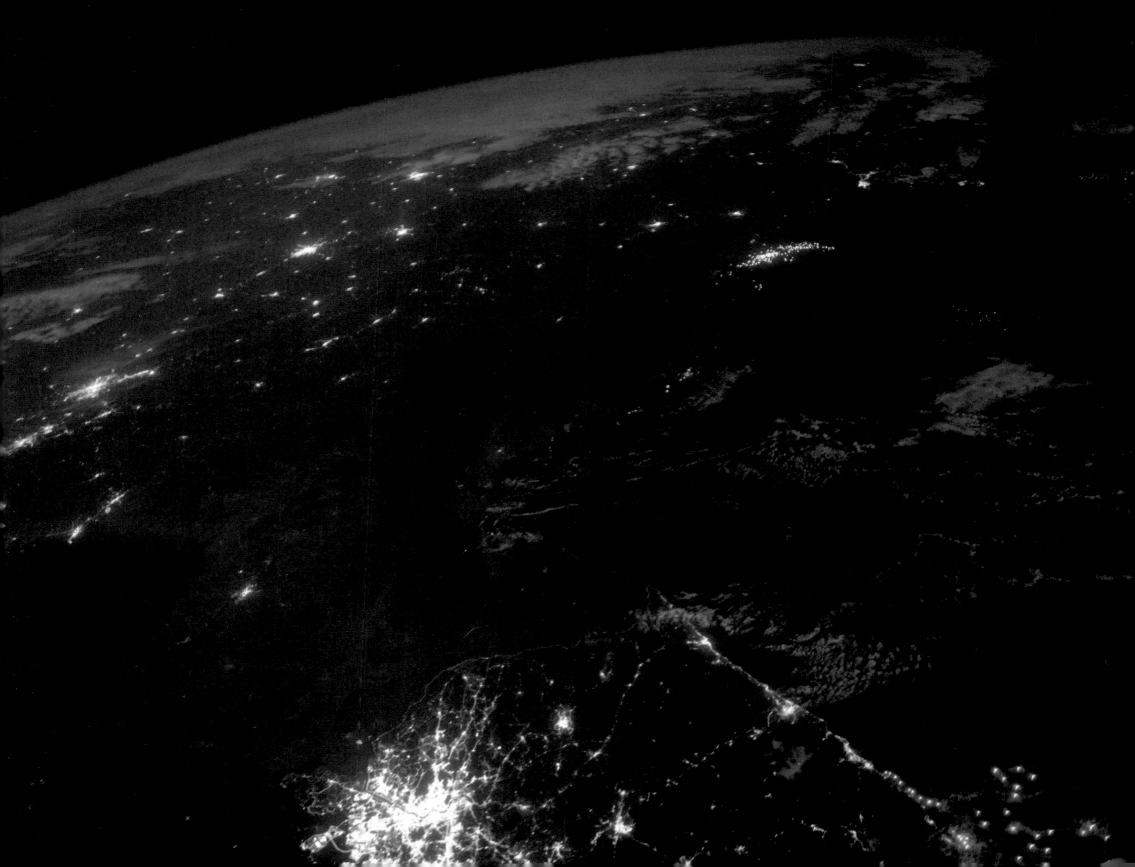

The contrails from the reentry of Soyuz TMA-17M on December 11, 2015, as my friends Kjell Lindgren, Kimiya Yui, and Oleg Kononenko returned to Earth.

Soyuz TMA-19M blasts through the atmosphere on December 15, 2015, carrying to the ISS a new crew consisting of American Tim Kopra, Brit Tim Peake, and Russian Yuri Malenchenko.

The setting sun peeks through the solar arrays of the Russian Soyuz spacecraft.

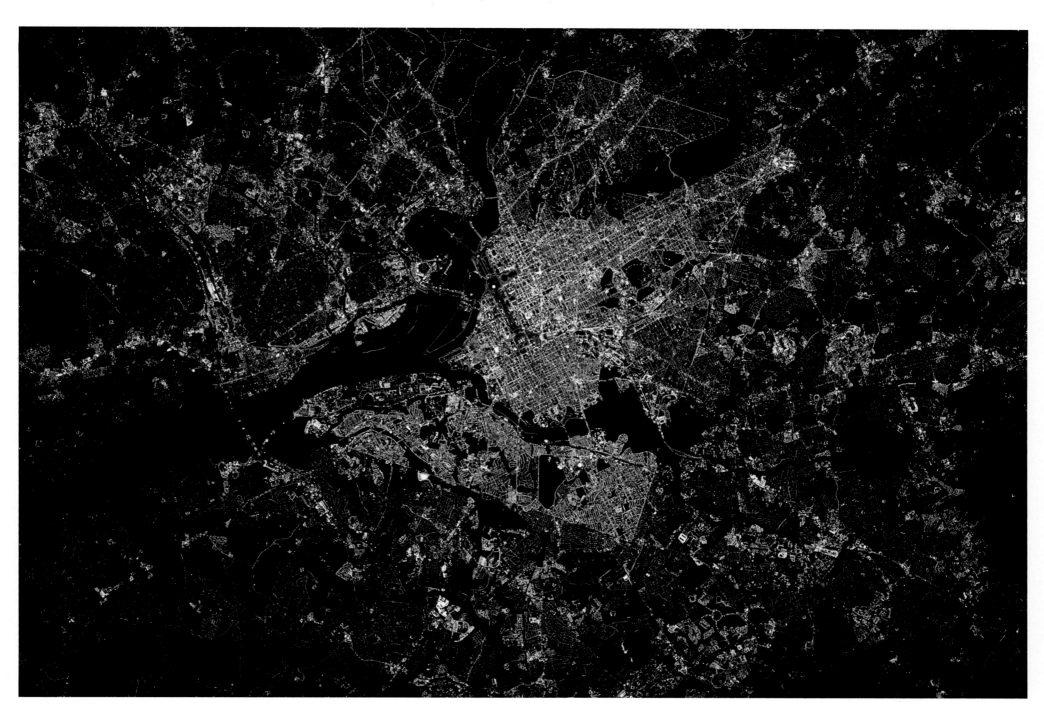

Washington, D.C., at night. You can see the difference in the streetlight bulbs used in the District as compared to those in the surrounding suburbs.

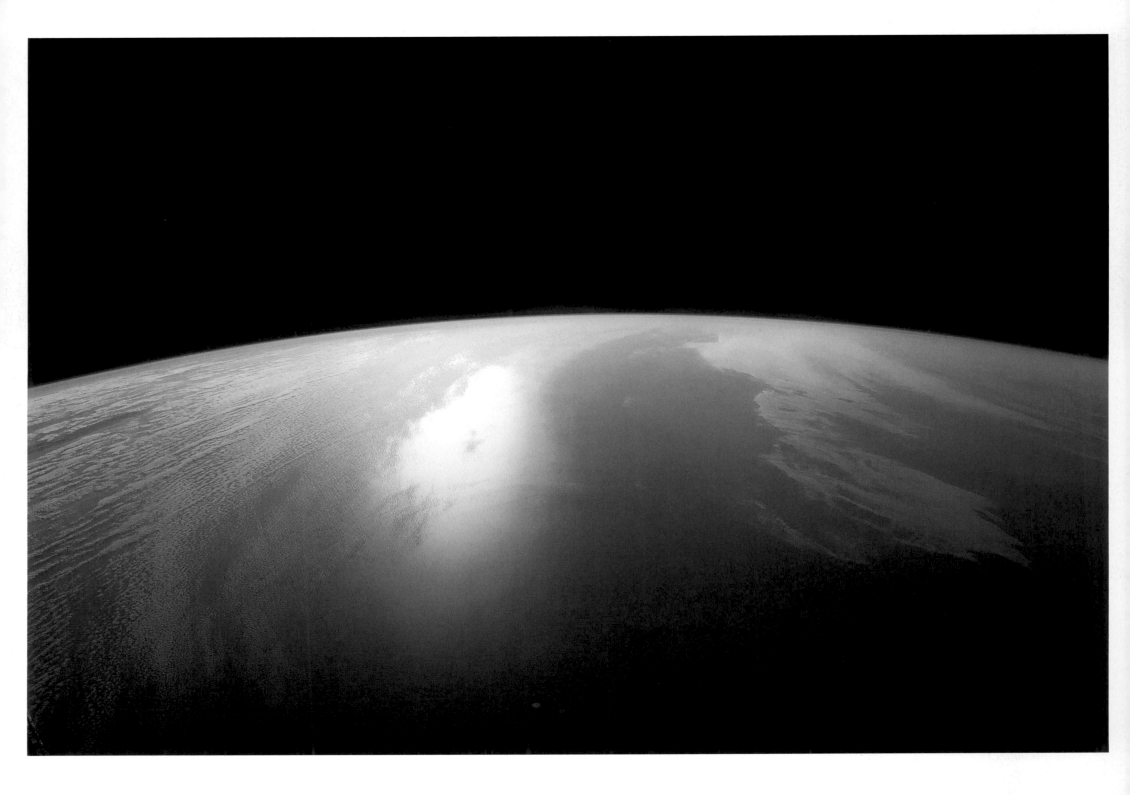

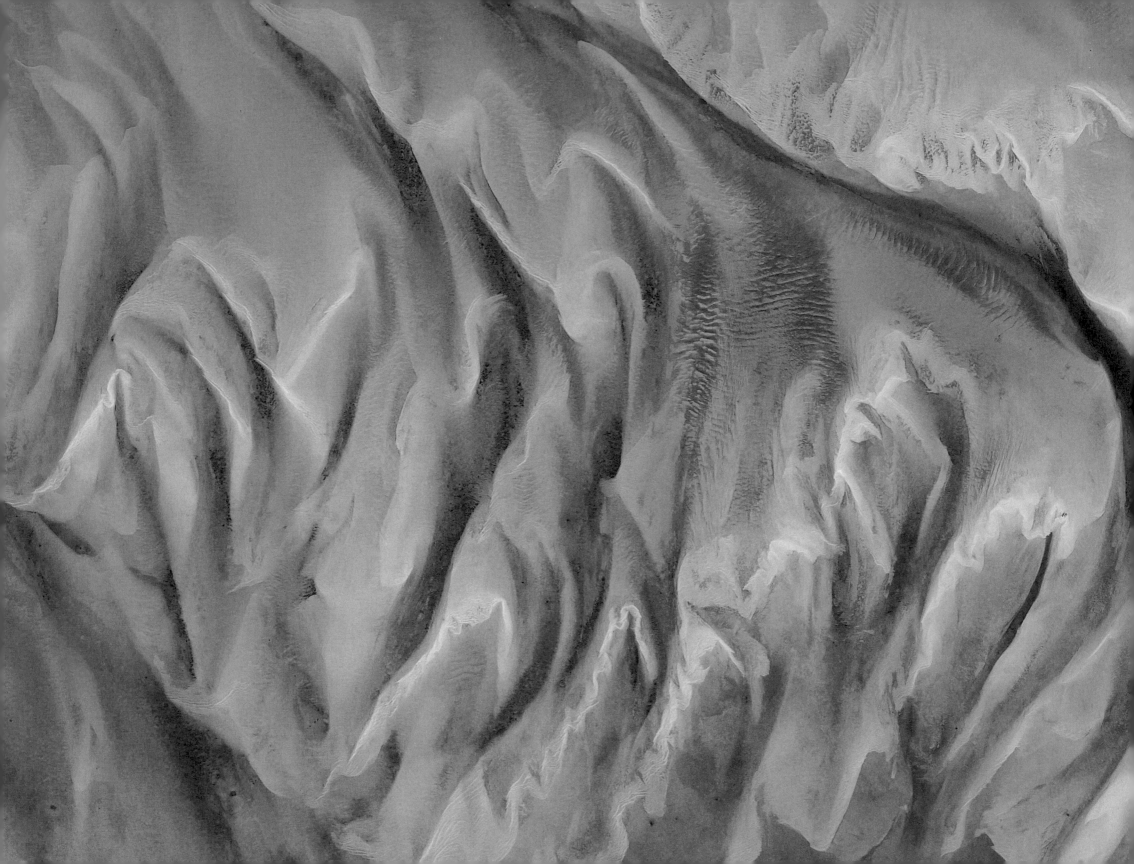

EARTH ART

Previous spread: A splash of brilliant blue
water northwest of South Eleuthera

Inyo County, California, on the eastern
side of the Sierra Nevadas and home to
Death Valley

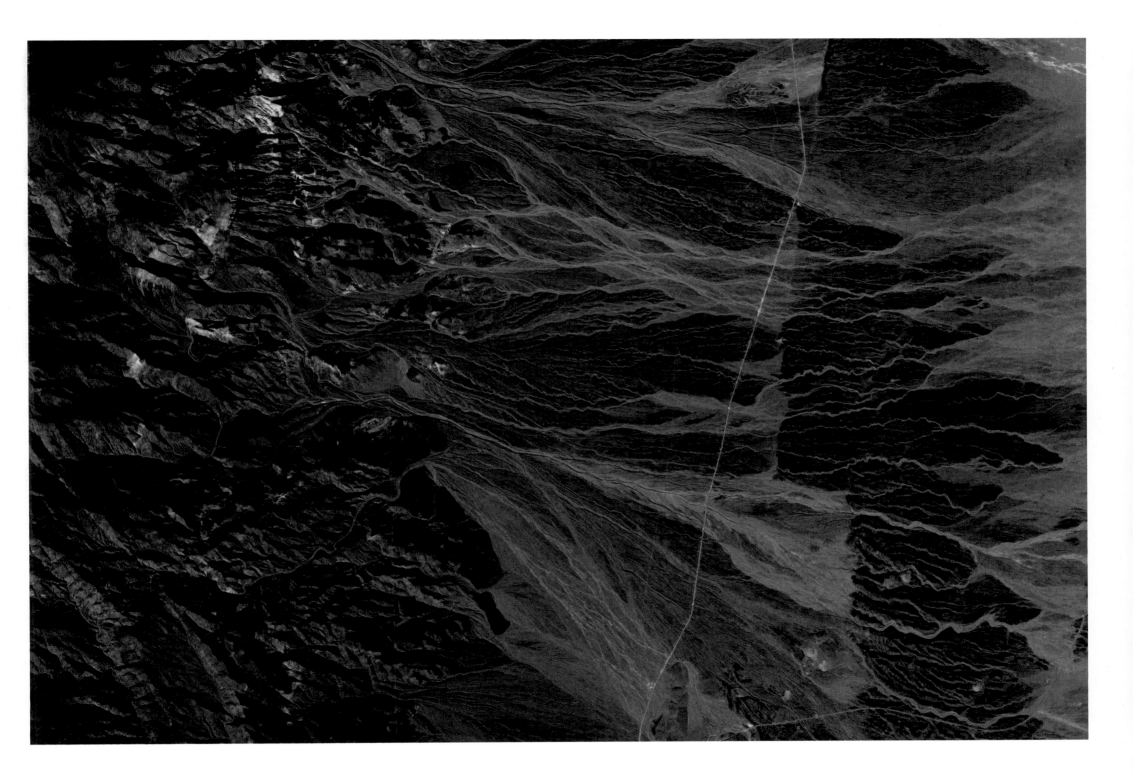

Alpine gold

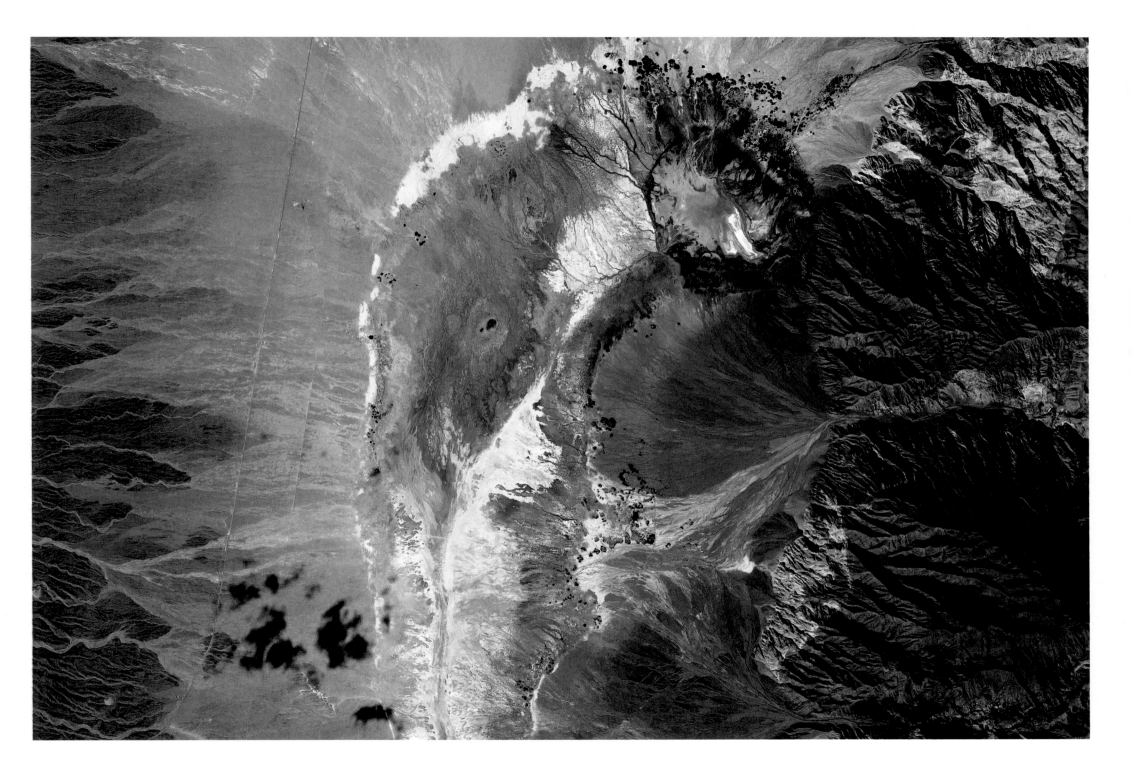

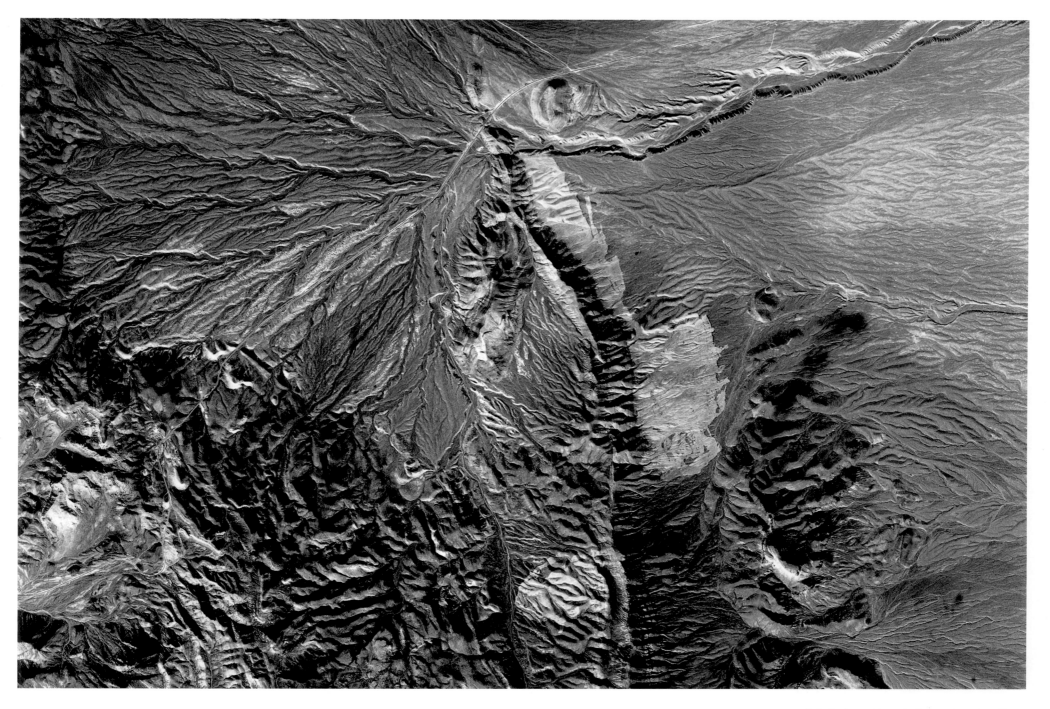

Ash Springs, Nevada, home to naturally
occurring hot springs

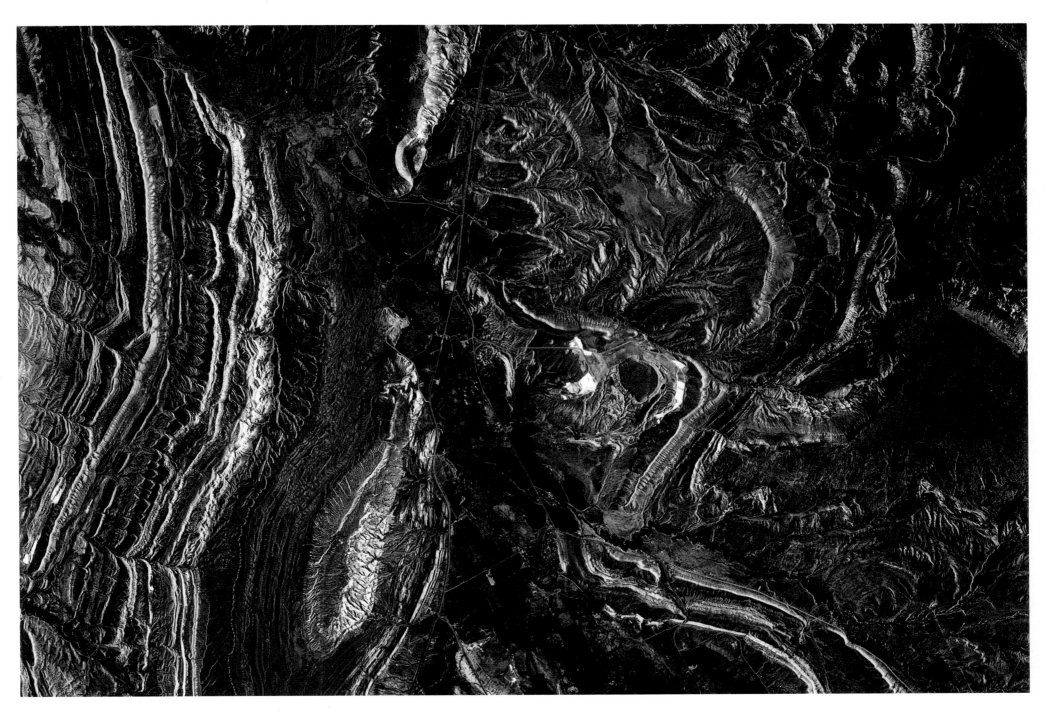

Wyoming. Natural rivers, canyons, mountains, and basins always make interesting, textural, and colorful art of the Earth.

Mono Lake, California. This shallow saline lake formed 760,000 years ago and has no outlet to the ocean, causing salts to accumulate.

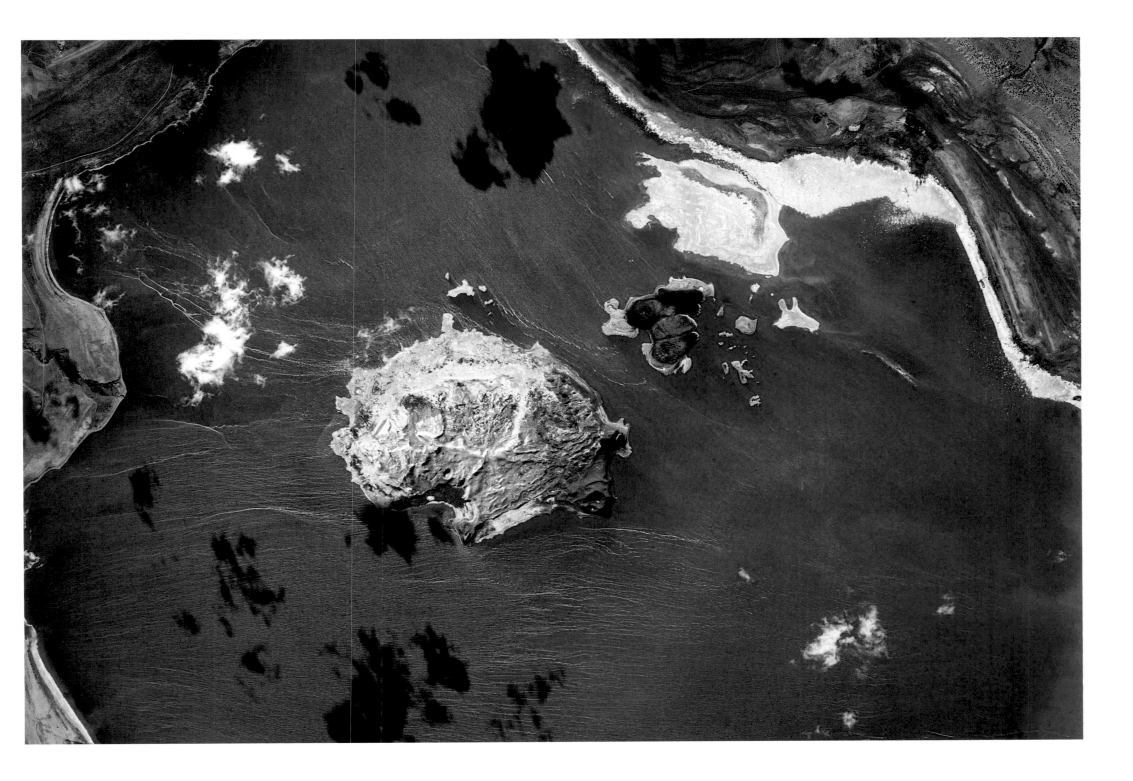

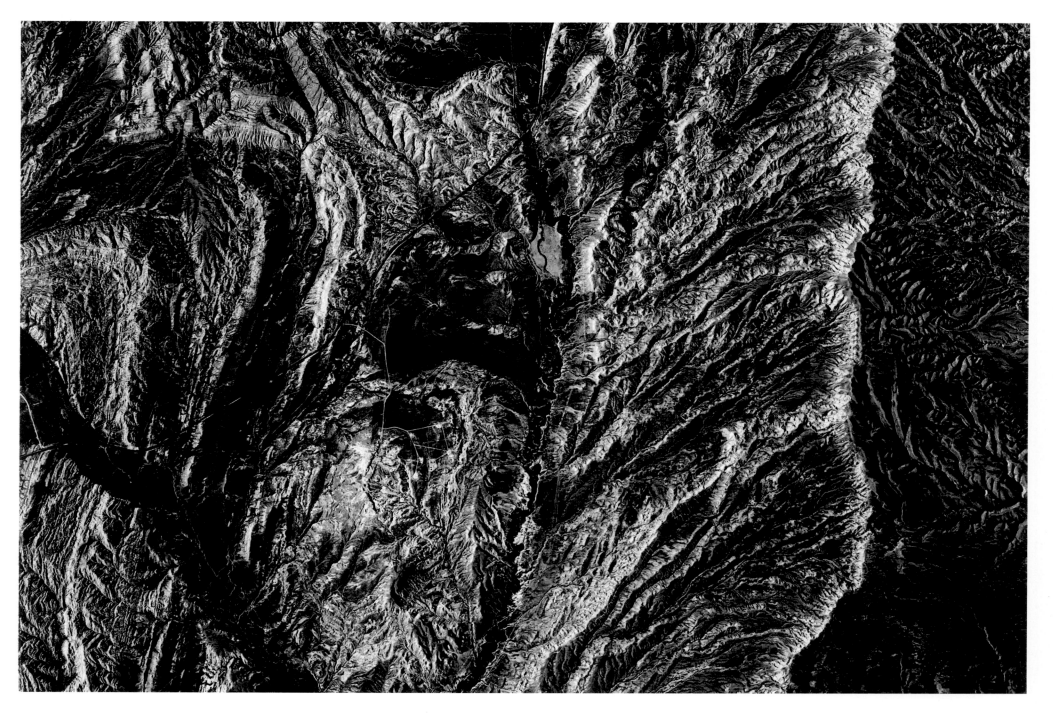

Again, the rugged terrain of Wyoming. Whenever I looked at this site, it somehow reminded me of the hard work we were doing, and its worthiness.

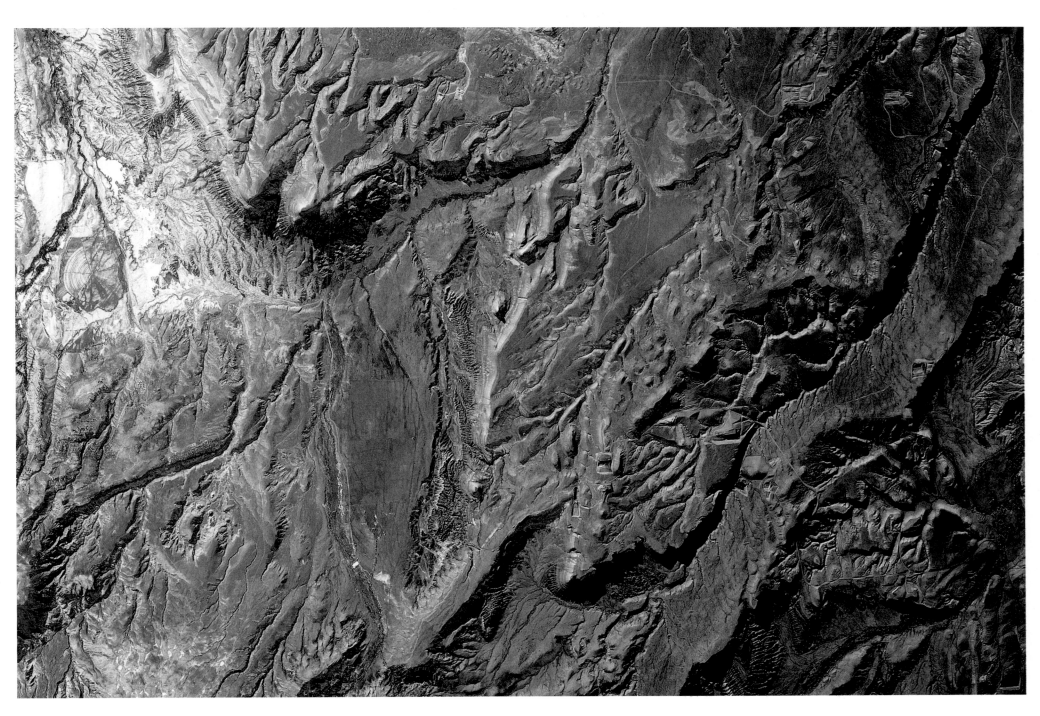

Shell, Wyoming. The rough textures of
Earth make for beautiful art.

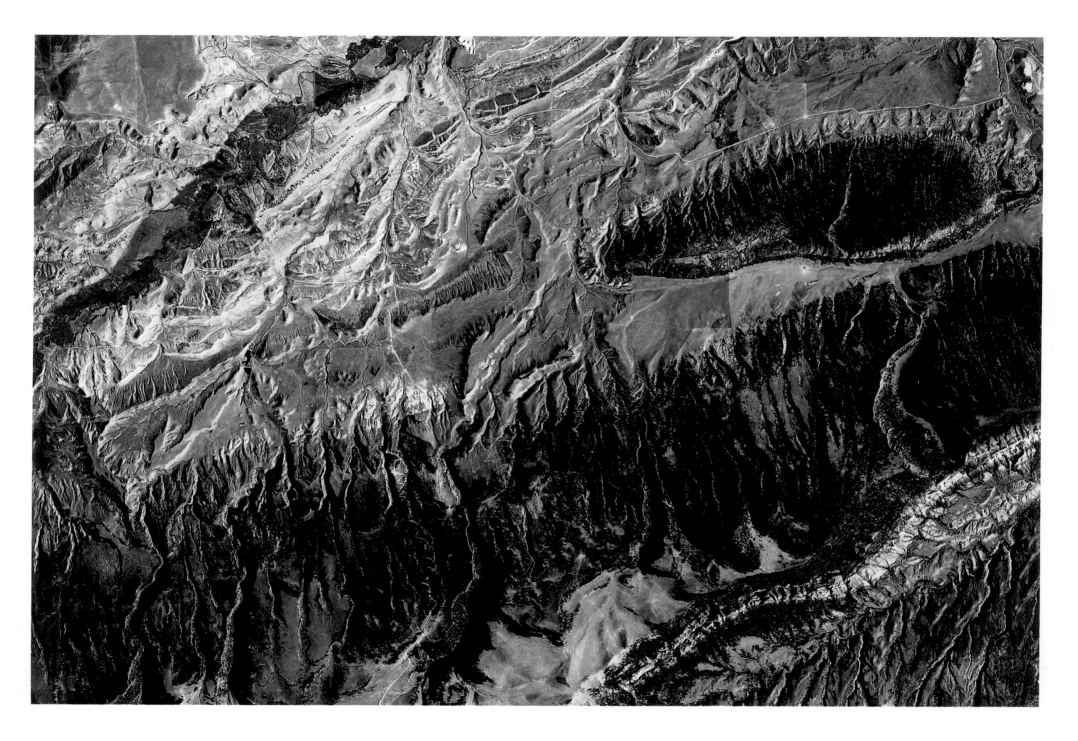

Johnson County in north central Wyoming

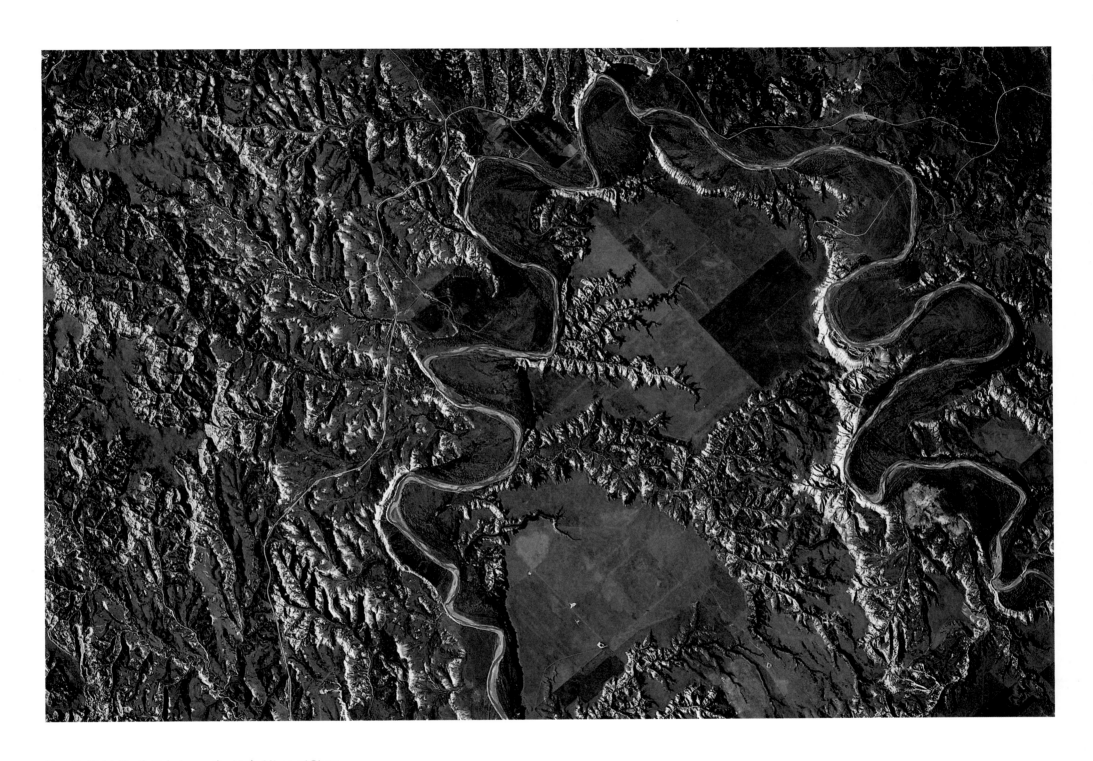

Near Belfield, North Dakota, on the Little Missouri River

The varied shades of brilliant blues
that reveal the depths of Compass Cay,
the Bahamas, always invited me to the
windows of the ISS.

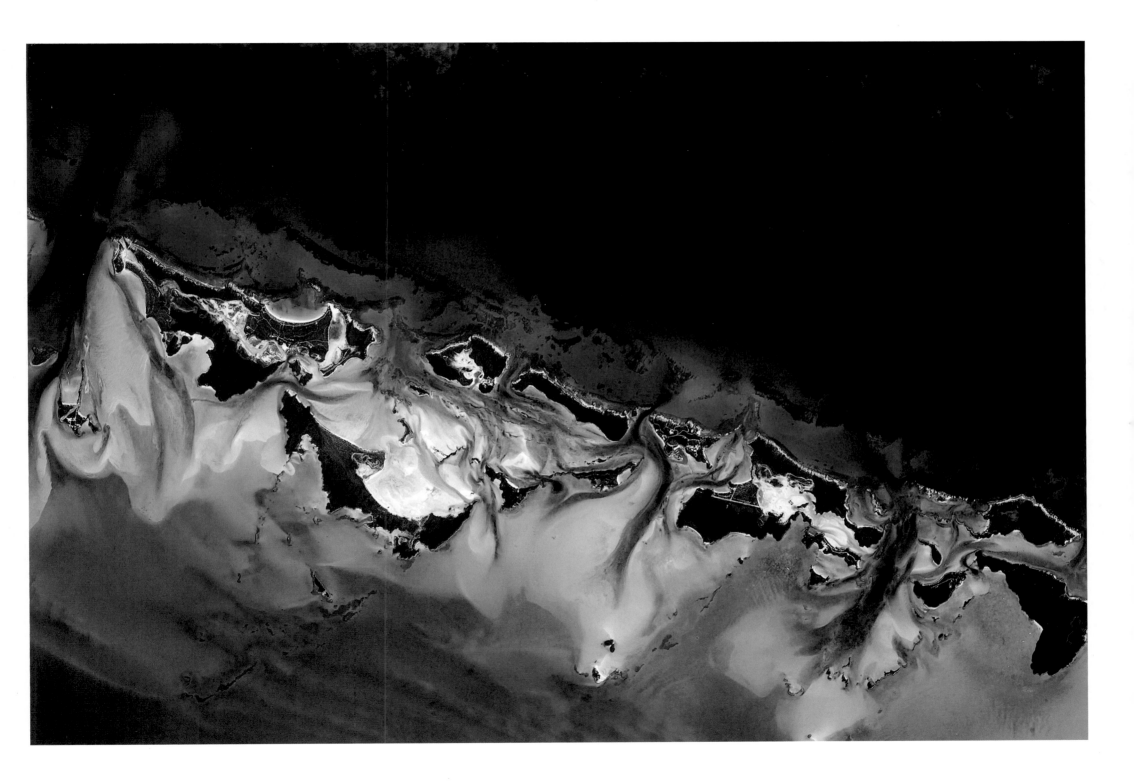

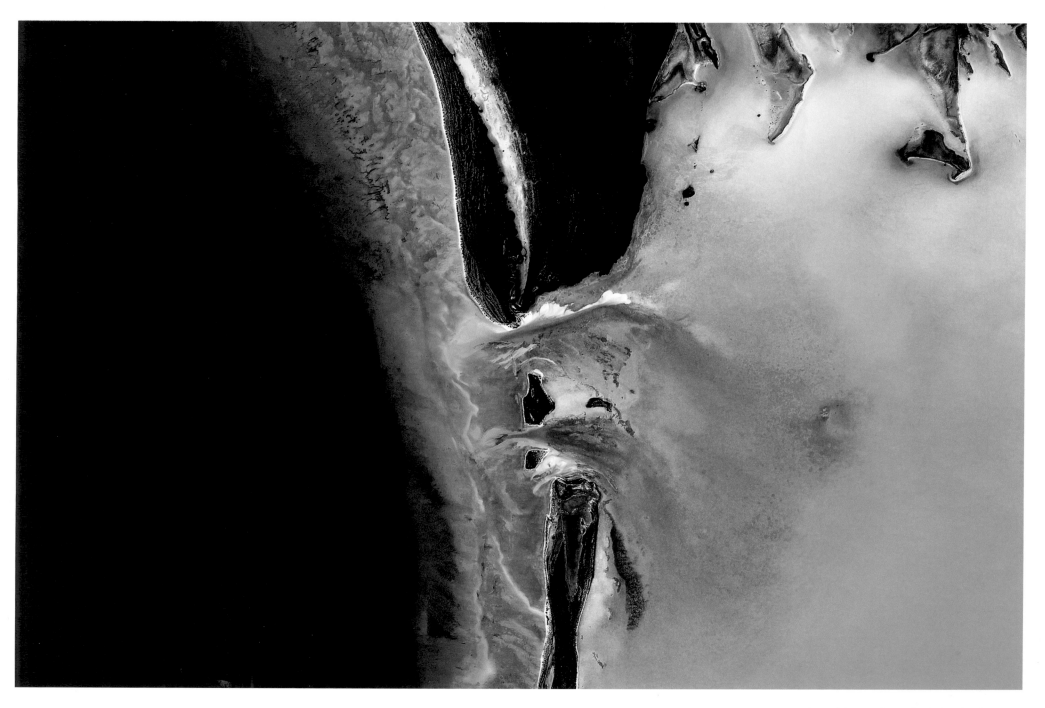

The Acklins and Crooked Islands, the most
solitary islands of the Bahamas

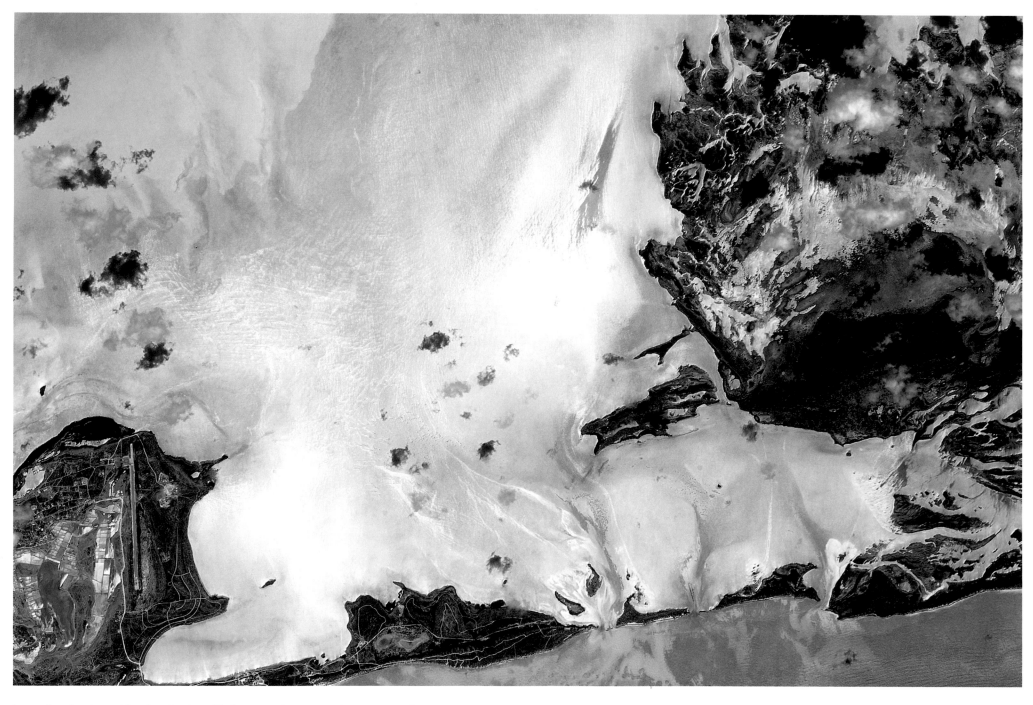

I am often fascinated by the physics of light. Here the sun on the water performs its magic
near South Caicos, Turks and Caicos Islands.

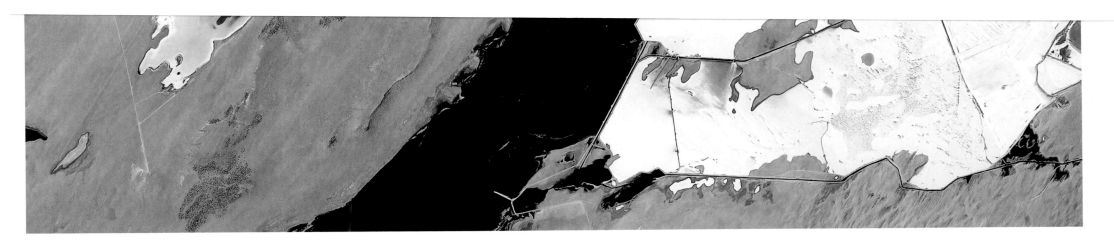

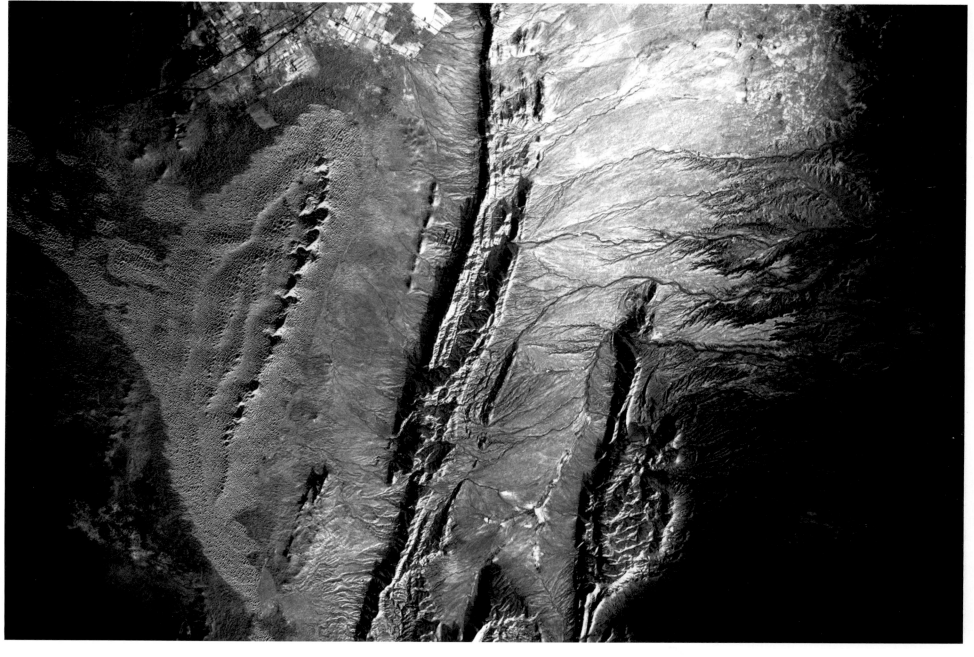

Wind creates new patterns as it moves the sands of the Samalayuca dunes in Mexico. I enjoyed looking down on Earth from my incredible vantage point, but I also missed things in nature like wind.

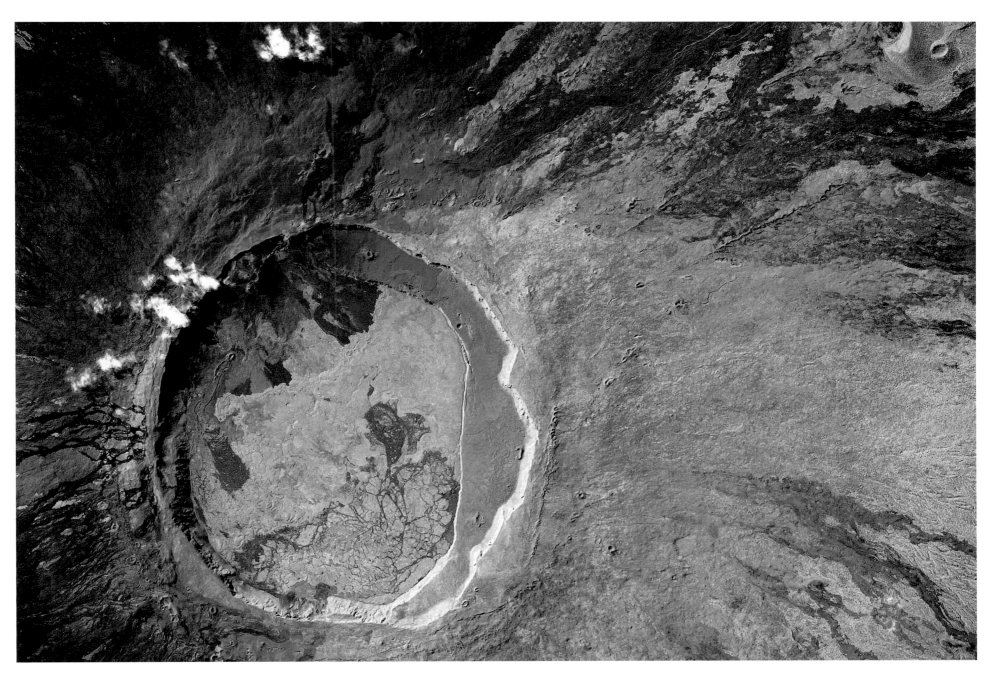

Peering into the isolated terrain of the volcanic Galápagos Islands gave me pause
because of its historical connotations. Often I was privileged to have such unique views
of storied locations.

Just off the Pacific coast of Colombia, one of the least visited parts of the country—unless you count the number of times I crossed over the beautiful, rugged terrain during my year in space

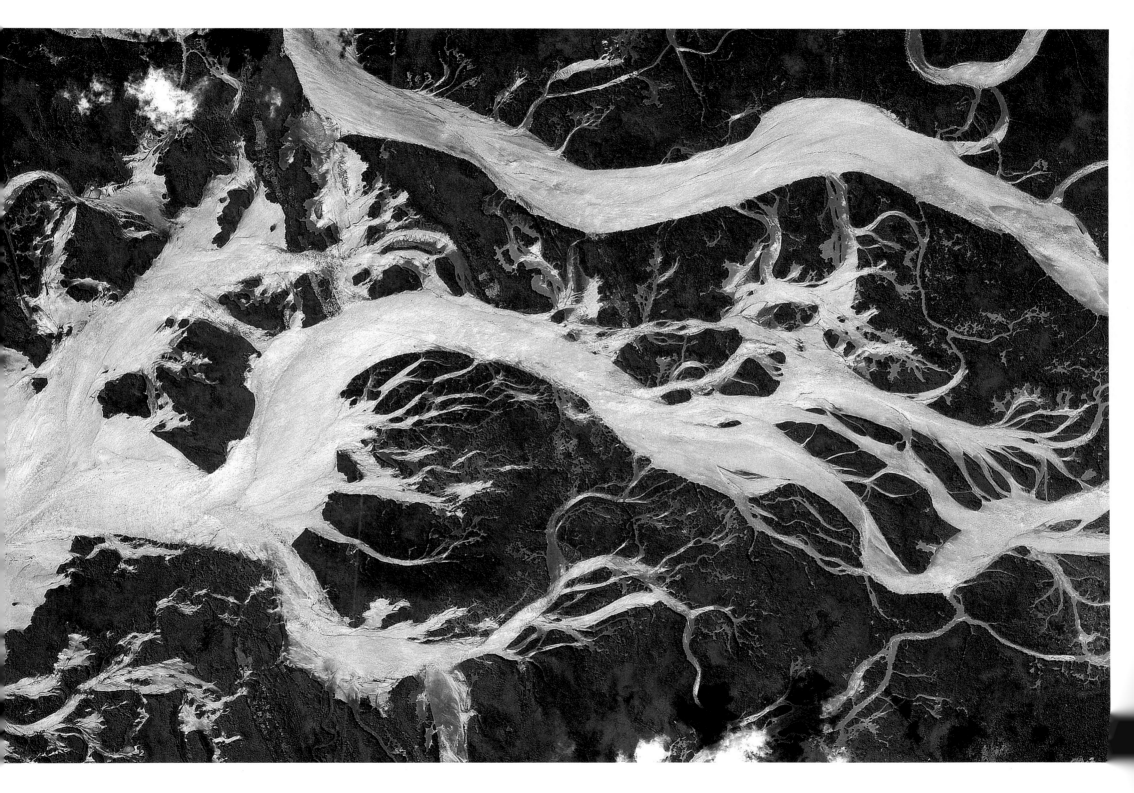

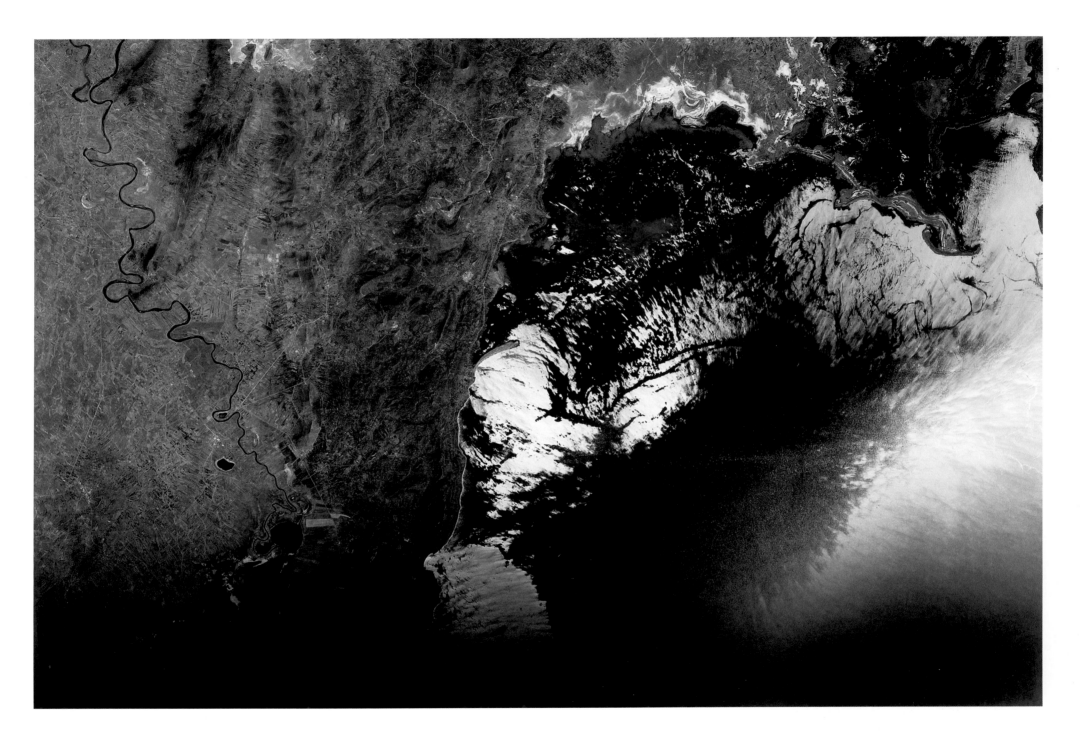

The brightly reflective waters of Lake Titicaca, straddling the coasts of Peru and Bolivia

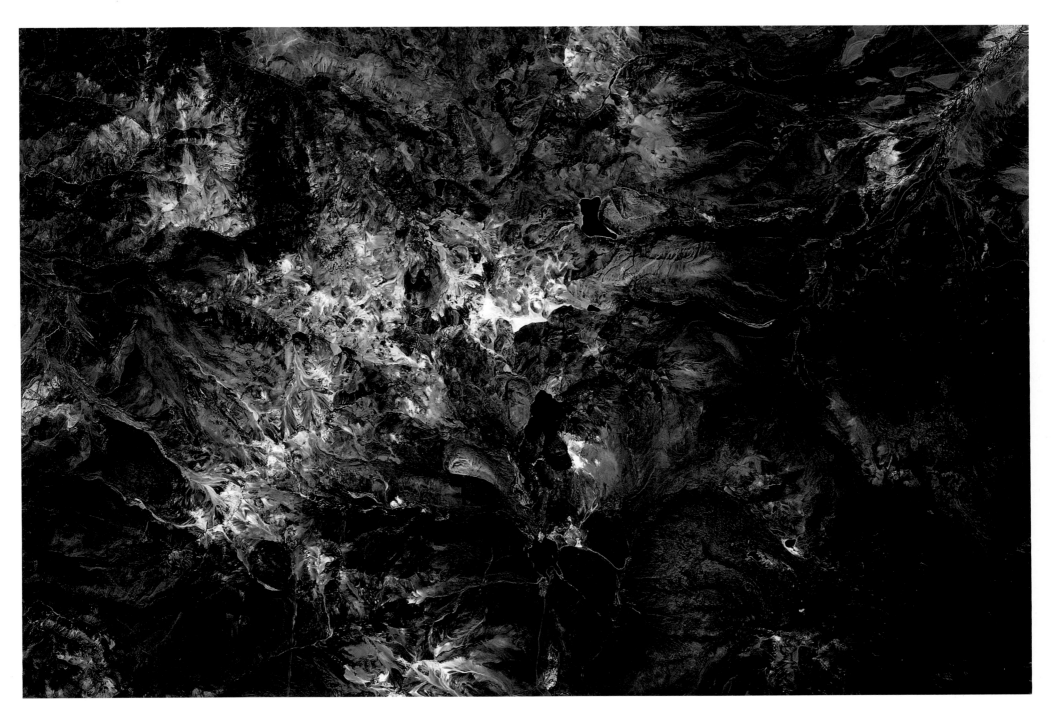

Peruvian volcanoes awakened my curiosity. I have never been to South America, but I vowed to myself to go there after I recorded these photos.

The varied water colors of Lake Poopó in Bolivia. My fiancée, Amiko, sent me a set of watercolors and paintbrushes aboard a visiting SpaceX Dragon cargo craft, which unfortunately exploded during its launch. I regretted the loss of my watercolors because I was often inspired to paint what I saw on Earth, rather than just photograph areas like this lake.

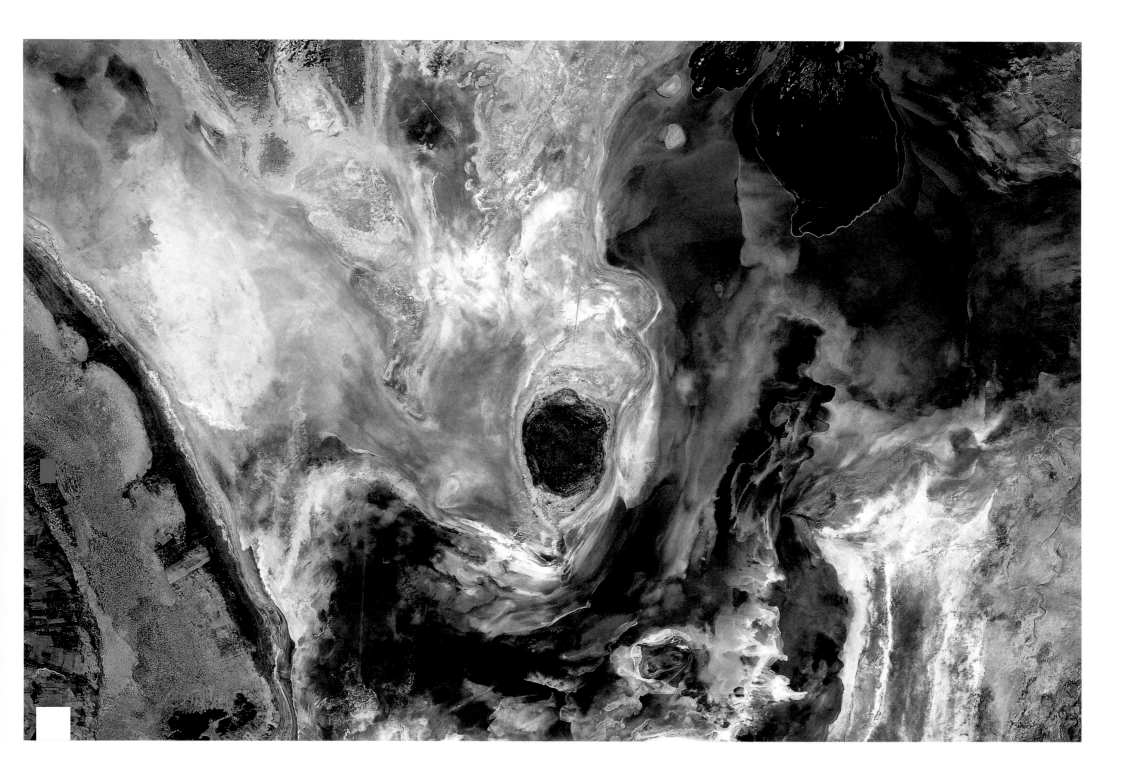

The stunning canyons of Charcas, Bolivia

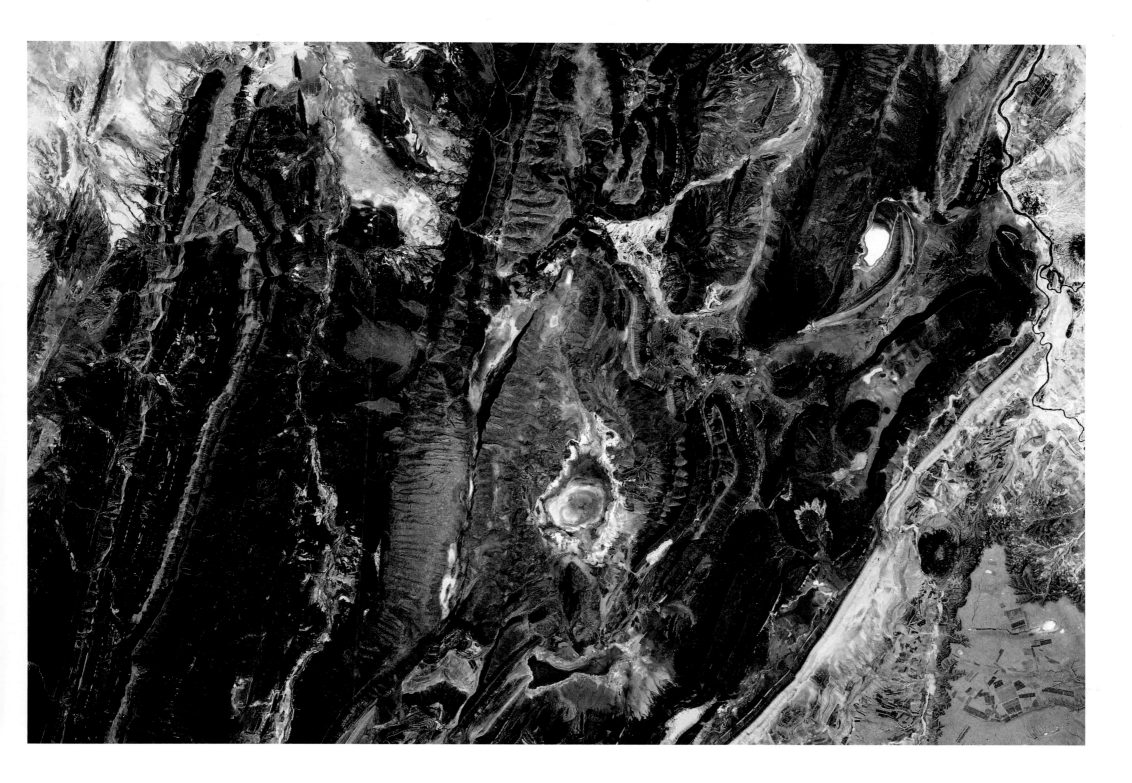

These wetlands near Corumbá, Brazil, appear surreal from space, as if I were looking through a microscope.

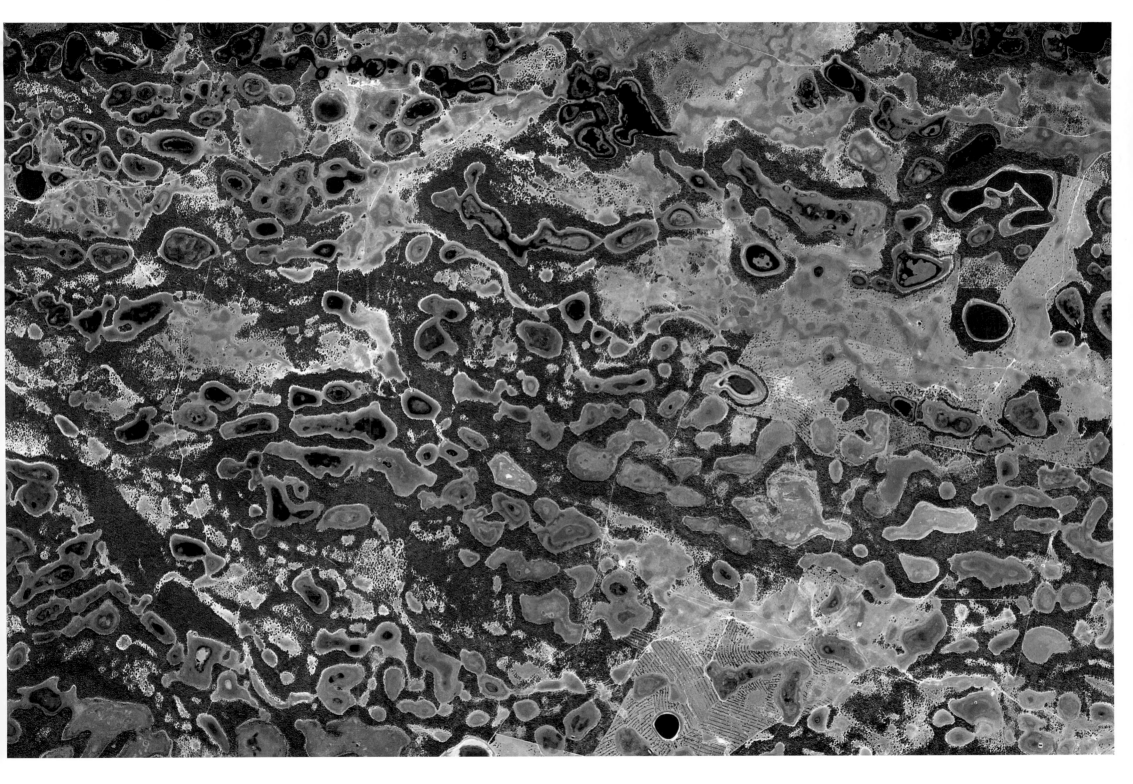

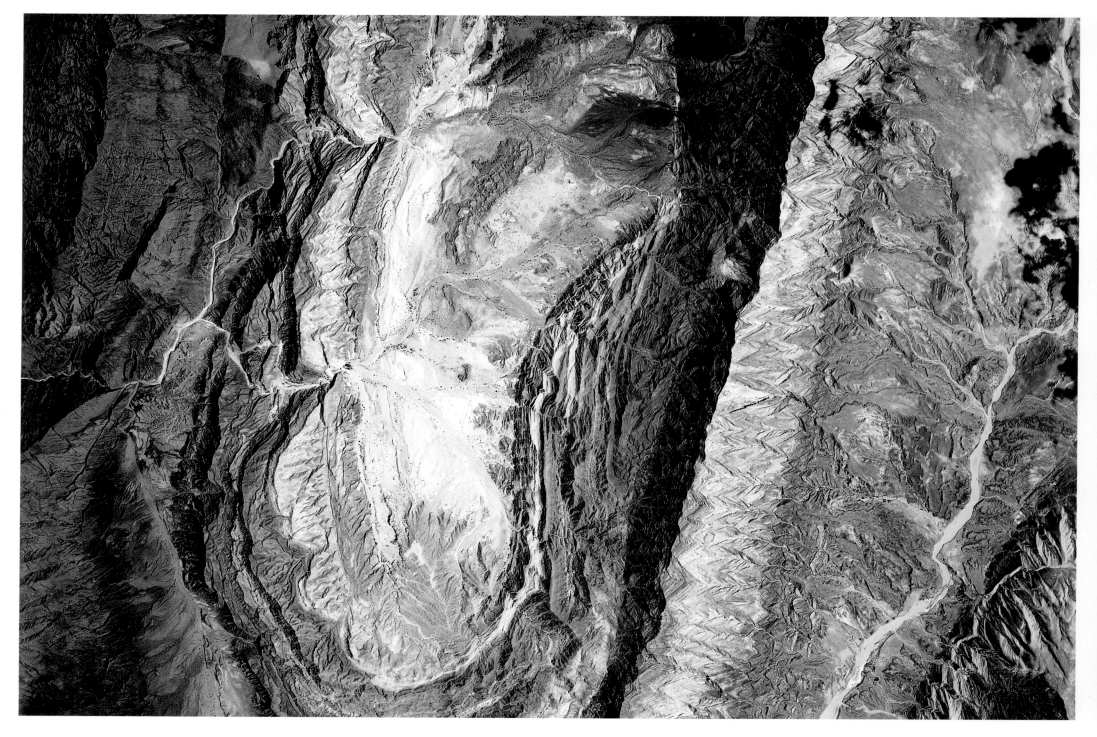

A river near Salta, Argentina

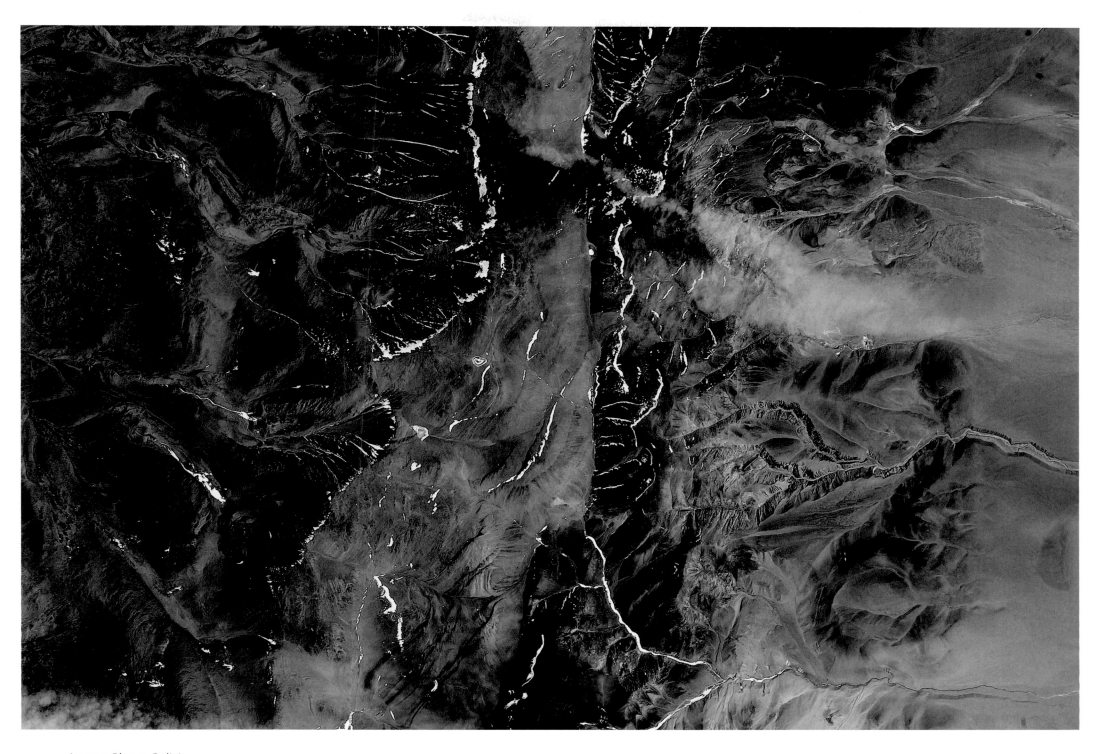

Laguna Blanca, Bolivia

Texture and lighting strike an impressive pose along the border that divides La Rioja and San Juan in the southern Andes.

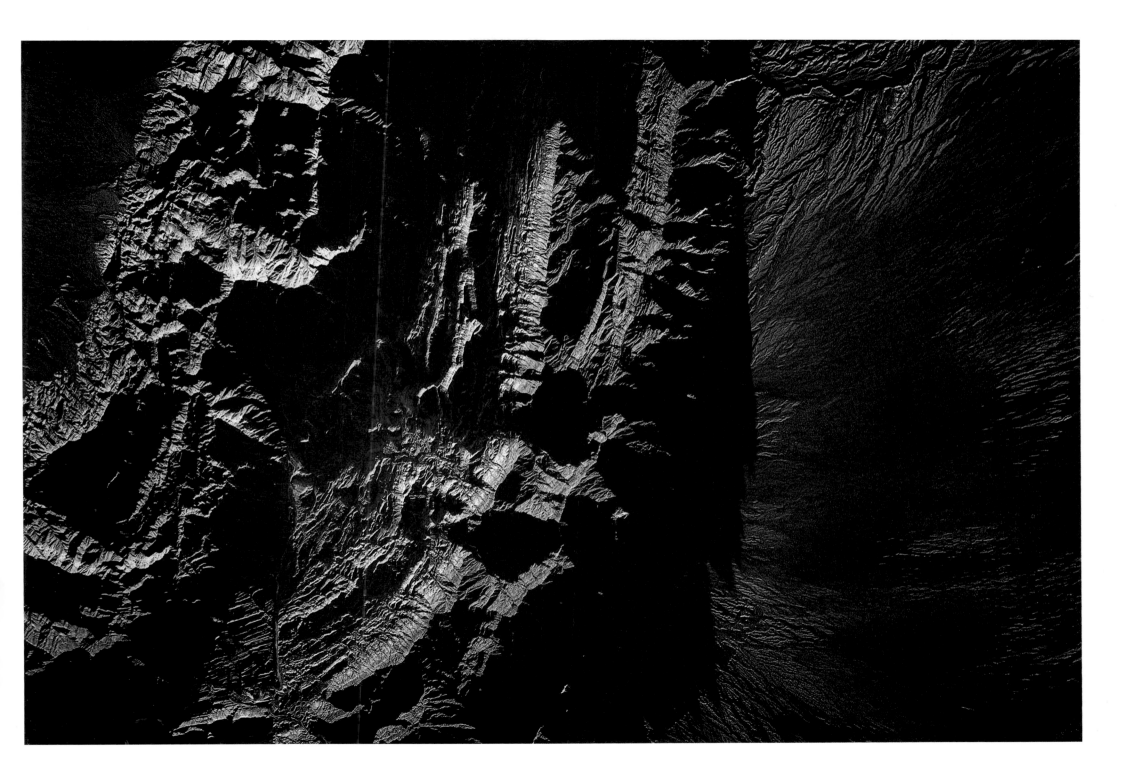

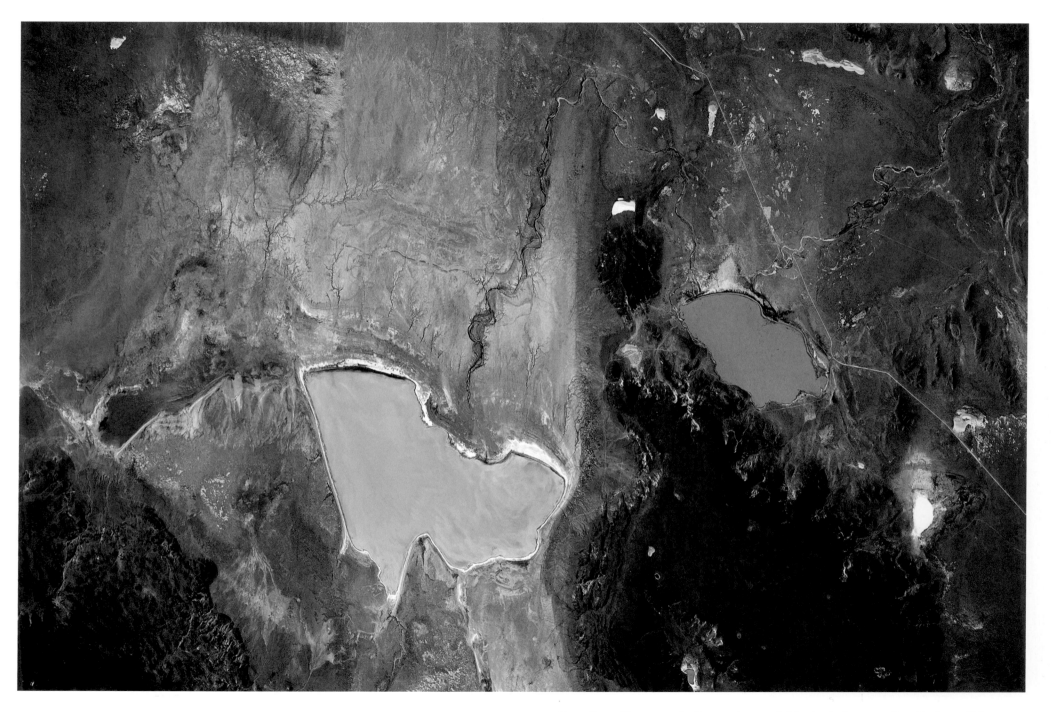

Sometimes the scenes I witnessed were strikingly stark, suggesting the incredible richness of the Earth. Here is Río Negro, Argentina.

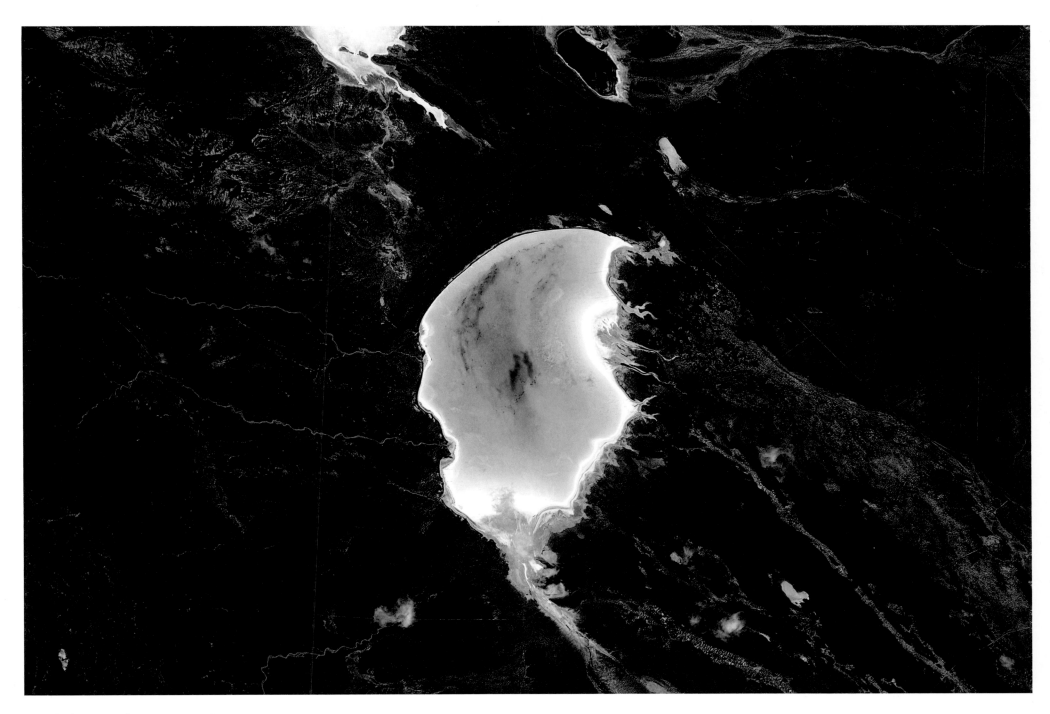

A swirl of green in the Laguna Tres Picos
in Argentina

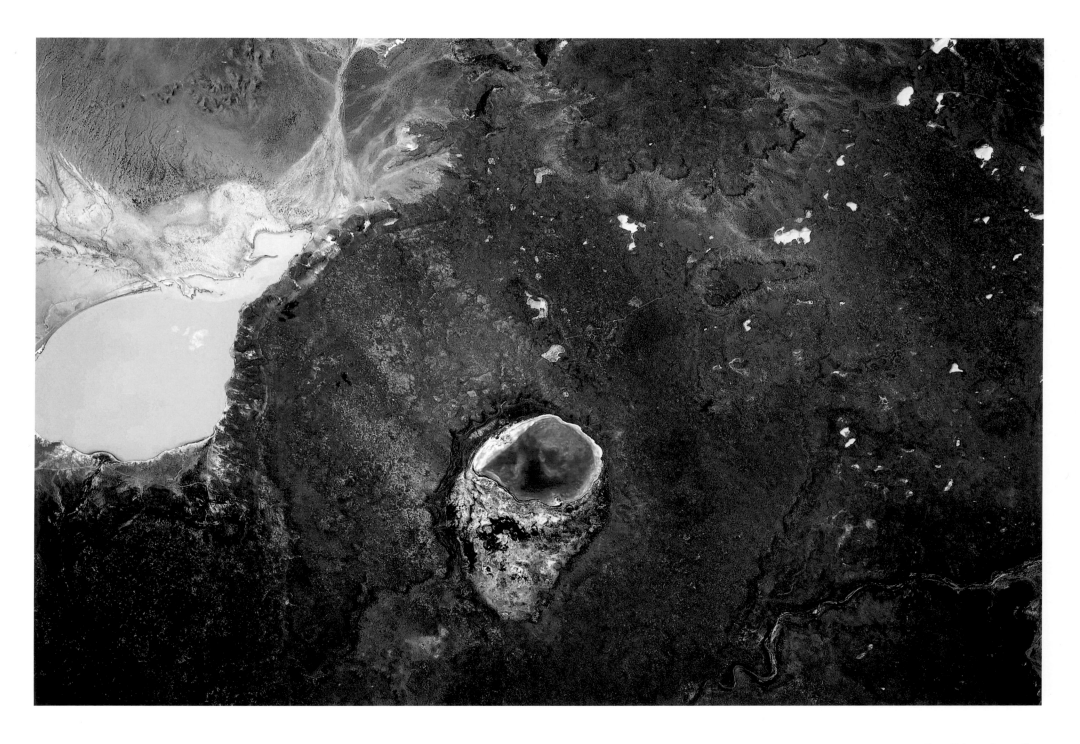

Near Telsen, Argentina

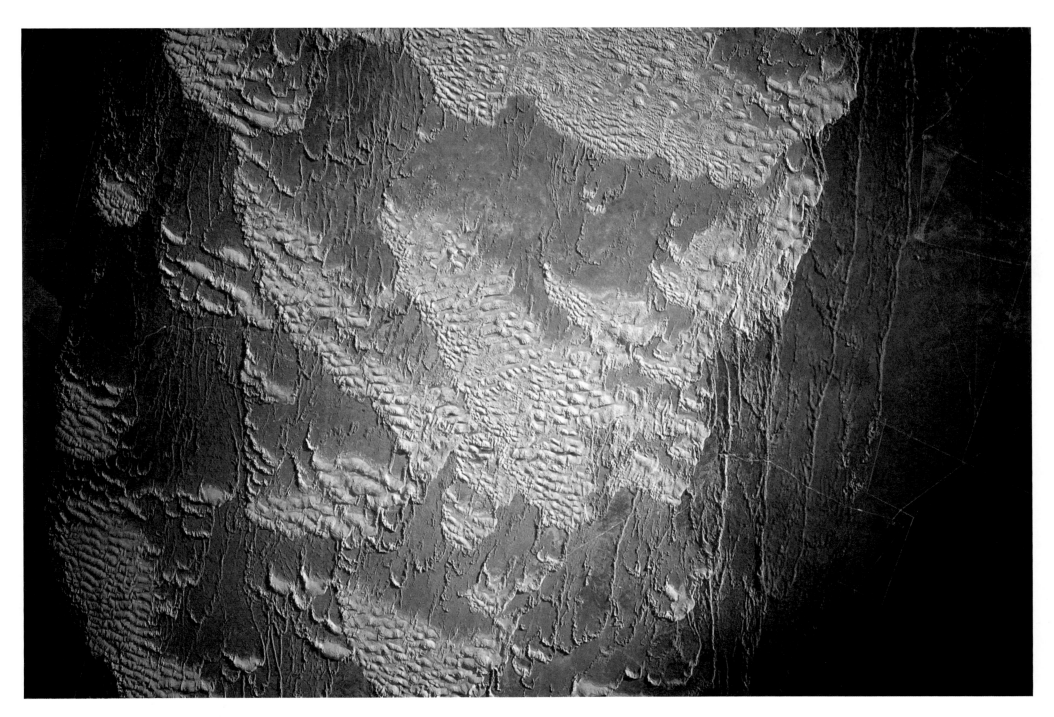

Deserts offer some of the most beautiful art from space, such as this desert, in the Río Negro Province on the Gulf of San Matías in South America.

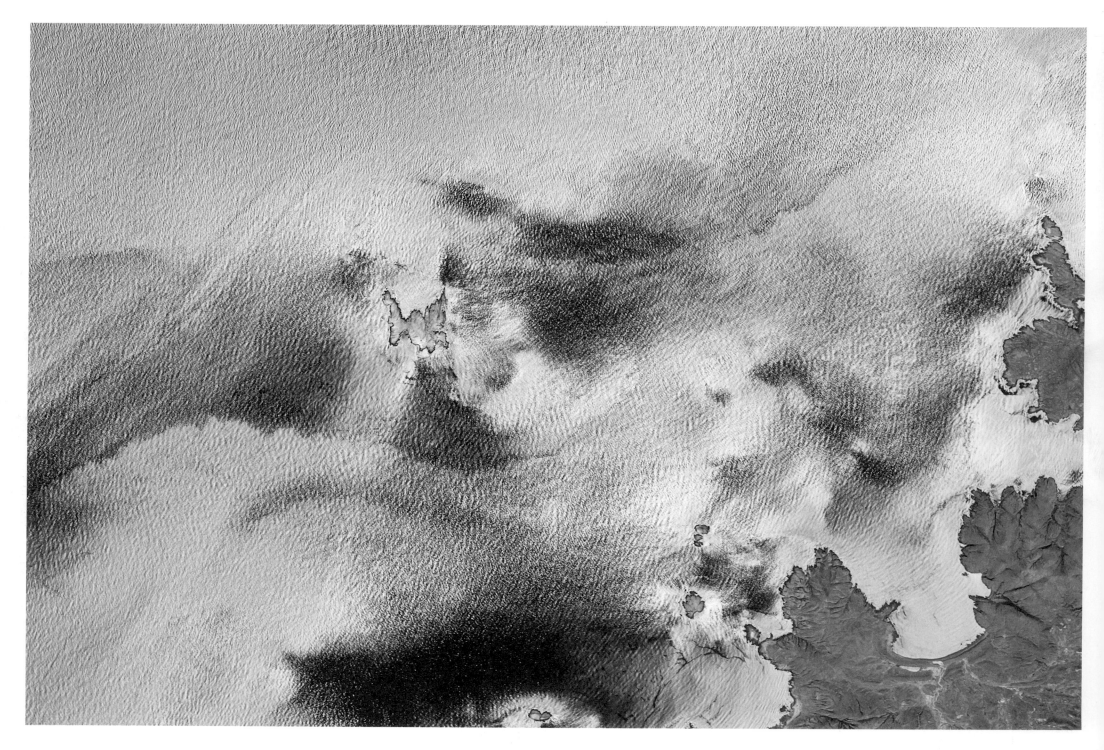

Chubut Province, Argentina, near the isolated tip of South America

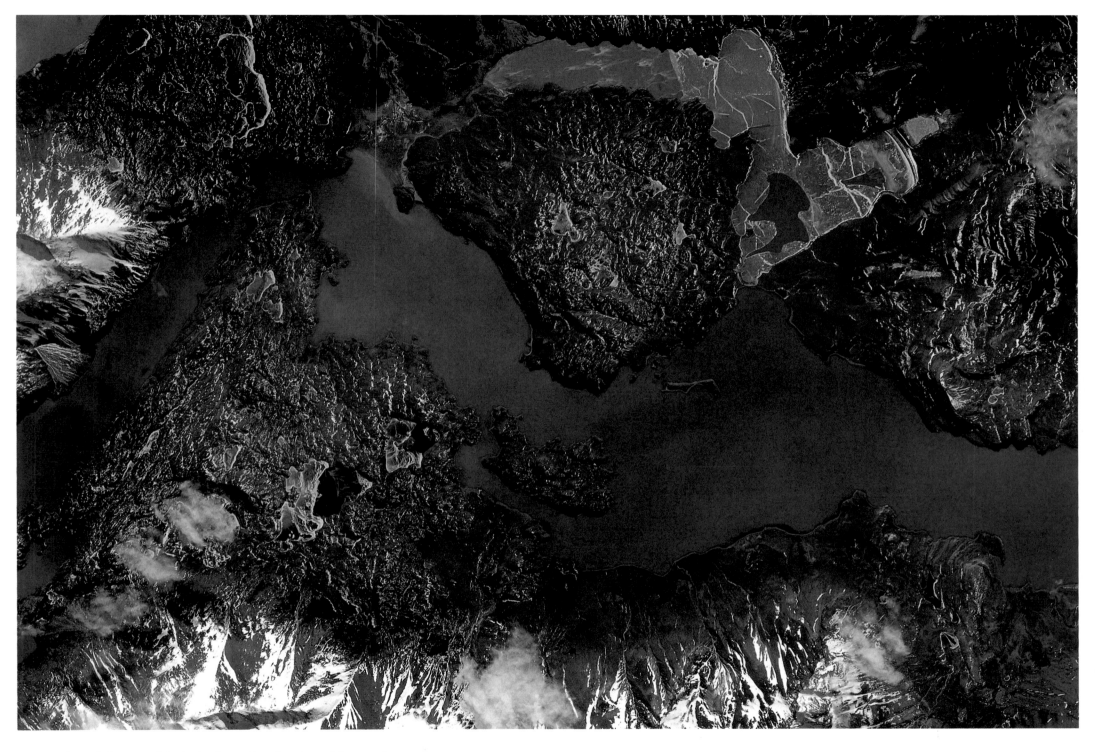

Lago Belgrano, a lake in the Santa Cruz Province of Patagonia

Desert dunes near Ouargla, Algeria,
almost double helix–like

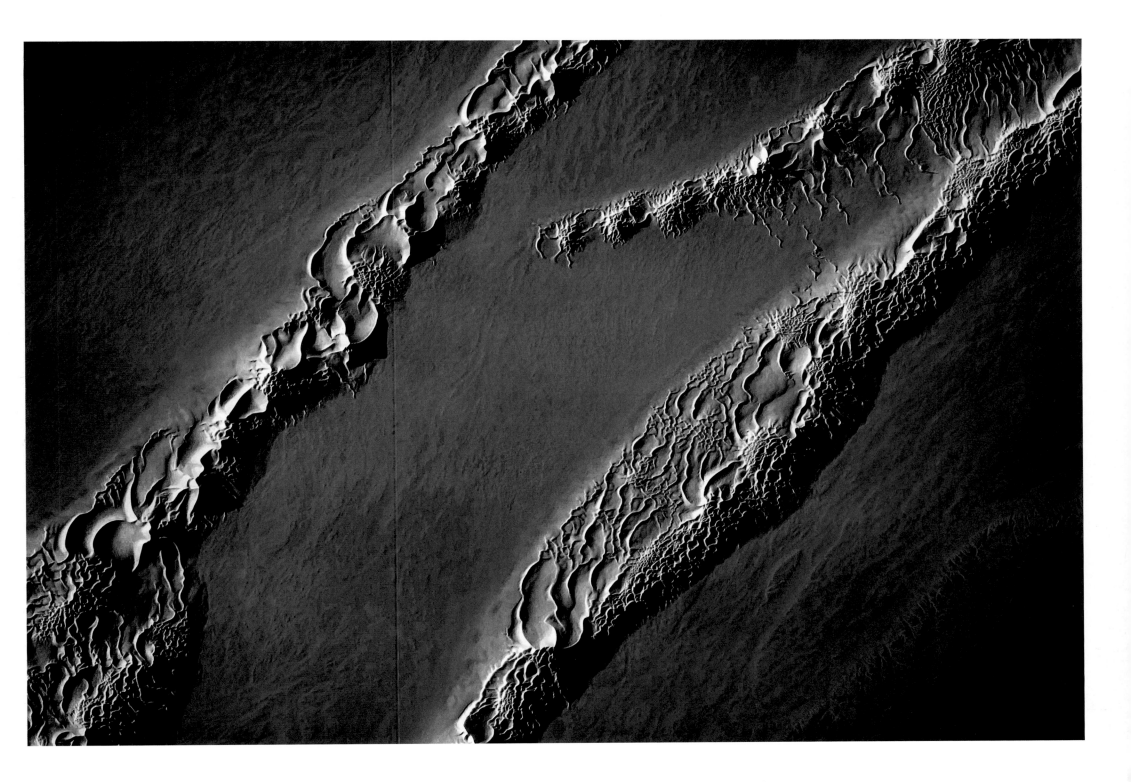

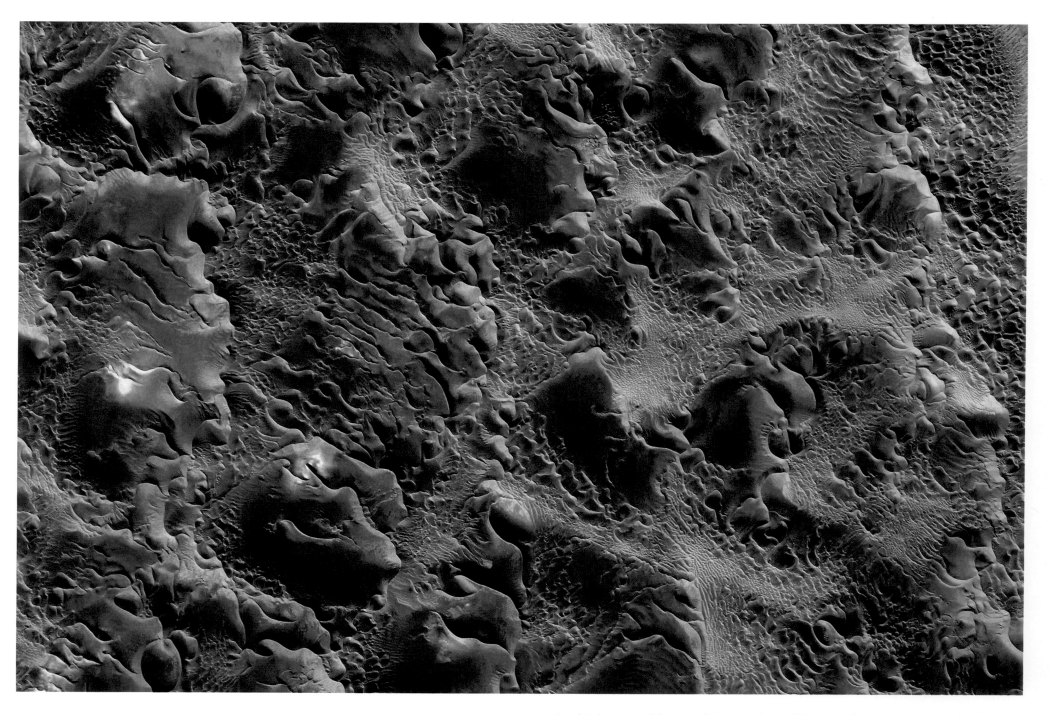

Earth's deserts yield some of the most beautiful images from space. Here is the Sahara, near Illizi, Algeria.

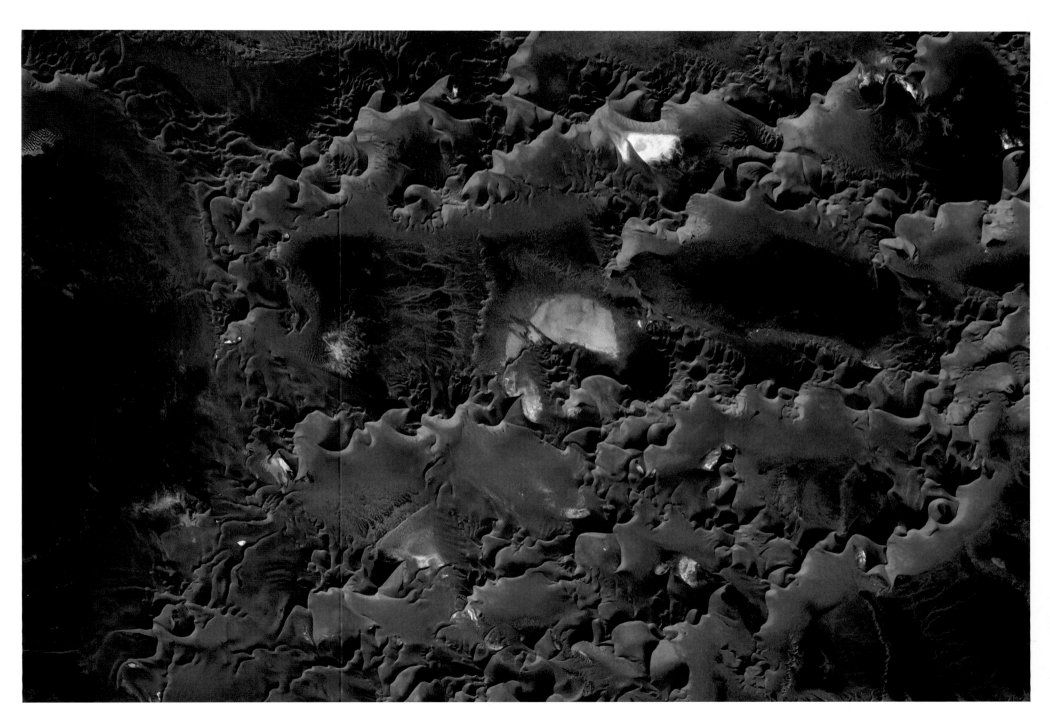

The Sahara, near In Amguel, Algeria. I always find it interesting how some of the most
uninhabitable areas on Earth, like the deserts, are the most beautiful of those seen from space.

The sky is always clear over Reggane, Algeria, an isolated but beautiful slice of Earth.

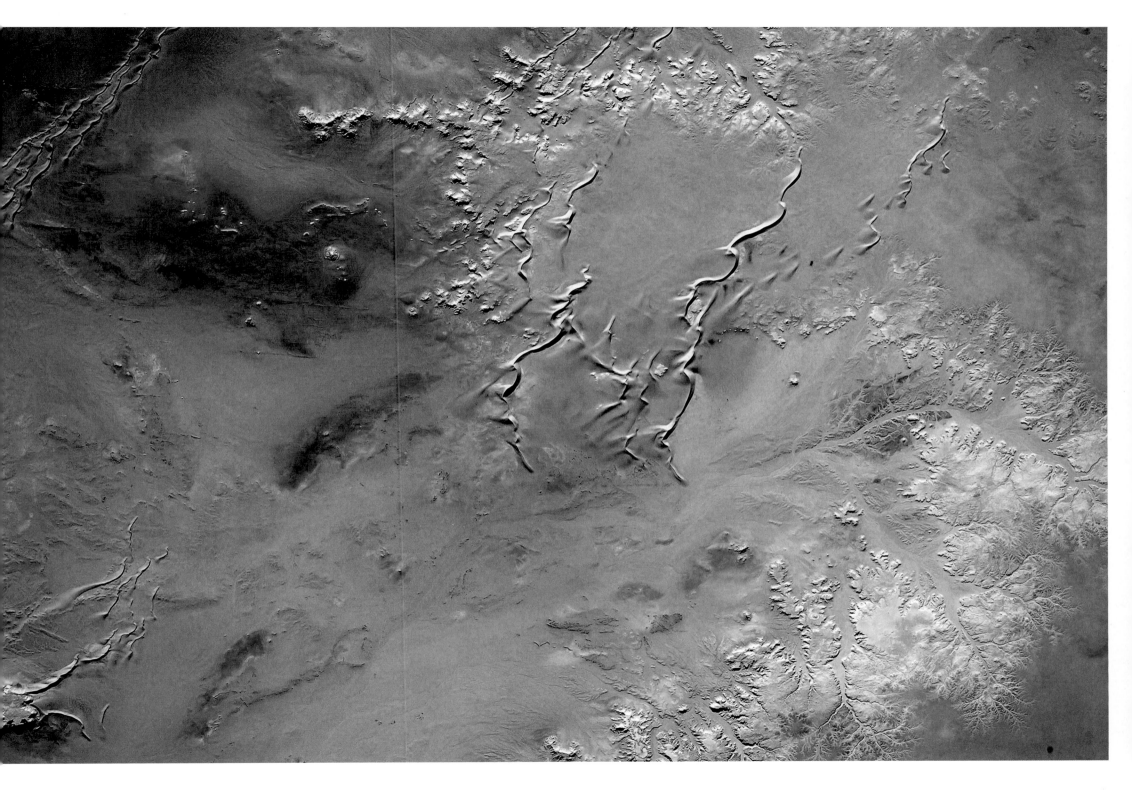

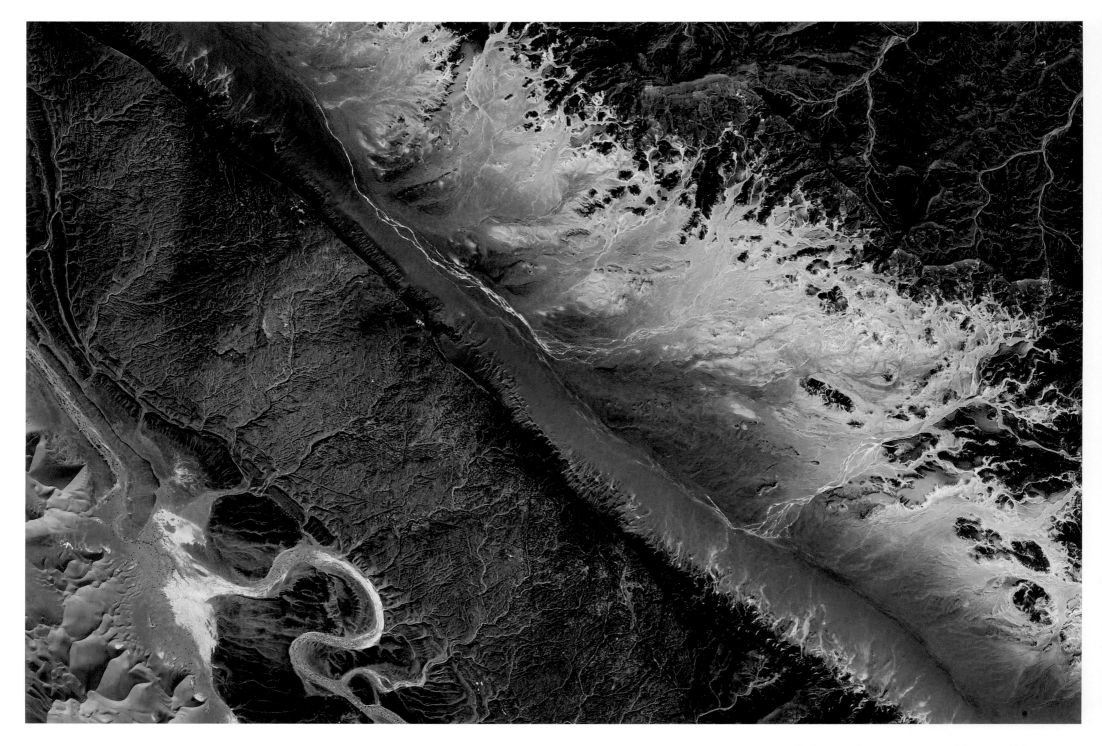

In Amguel, Algeria, where mountain and desert collide

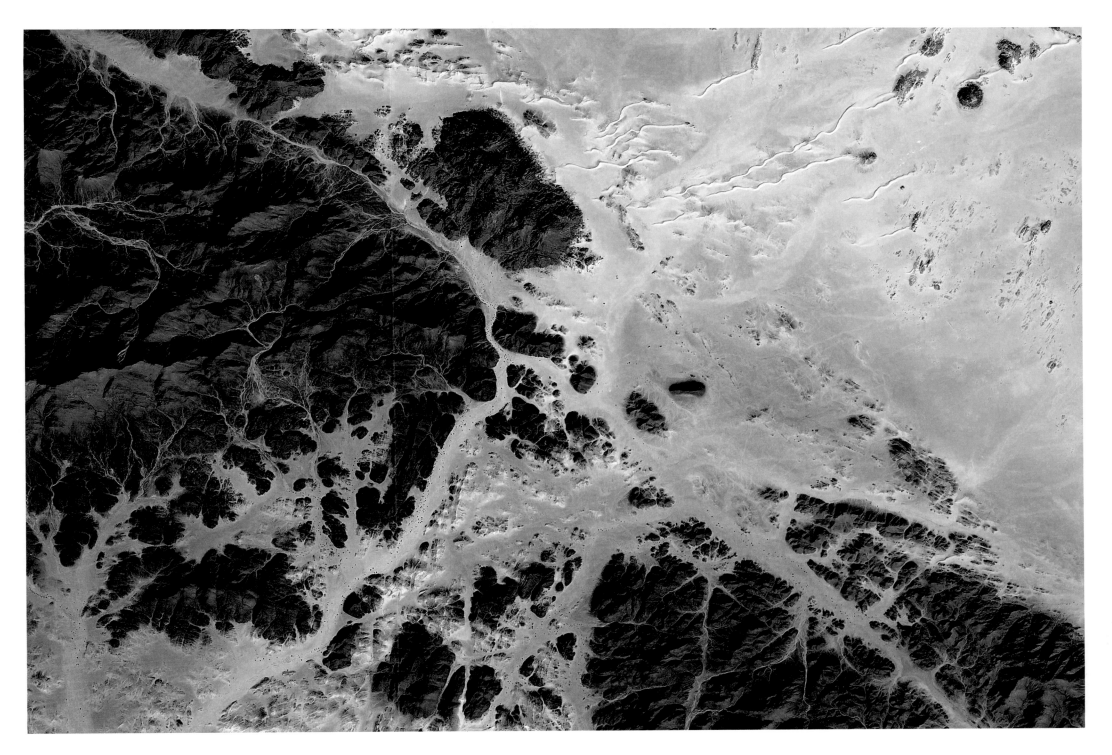

The Sahara, near Tamanrasset, Algeria

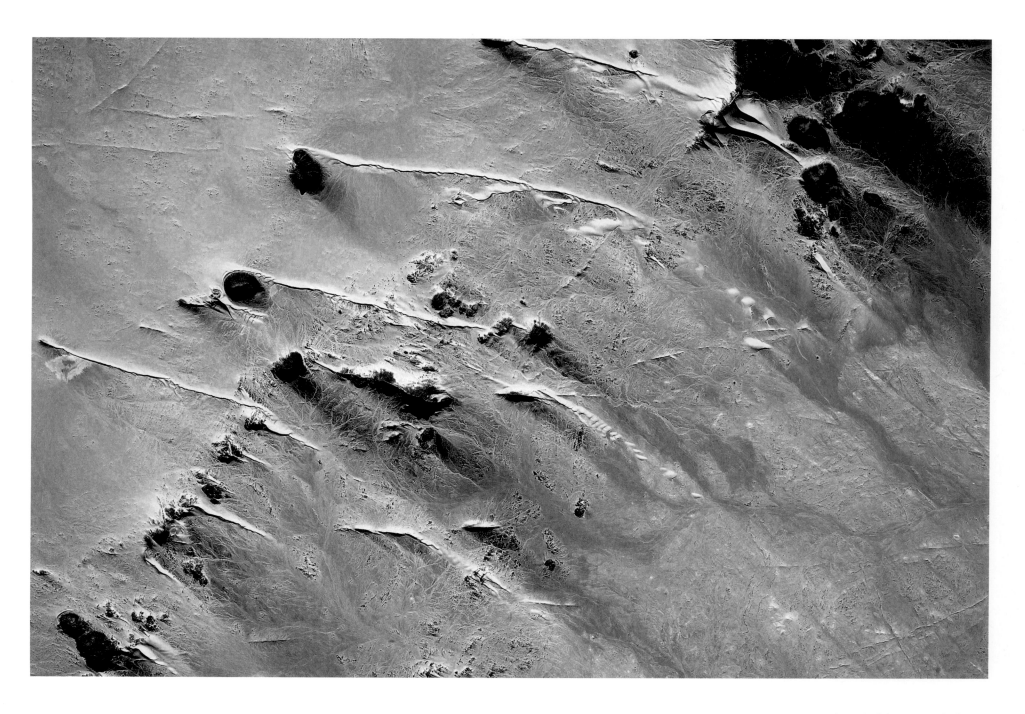

I never grew bored of the views of Africa.
Here, In Guezzam, Algeria.

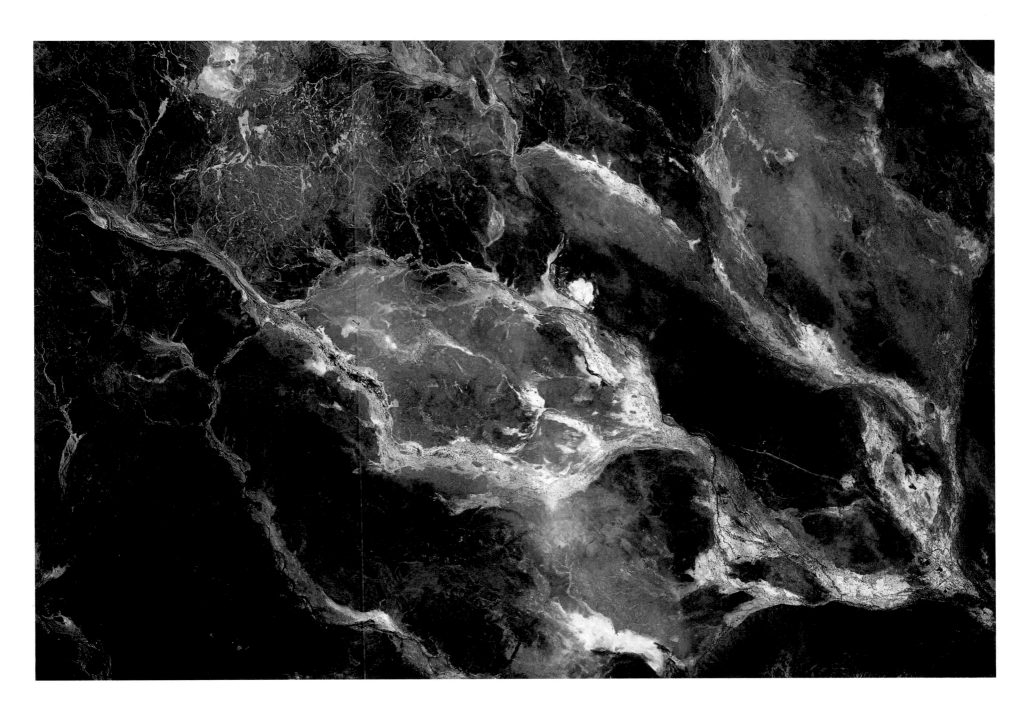

When I enhanced the colors of this image, the shade of purple over the Sahara in
Agharous, Niger, surprised me.

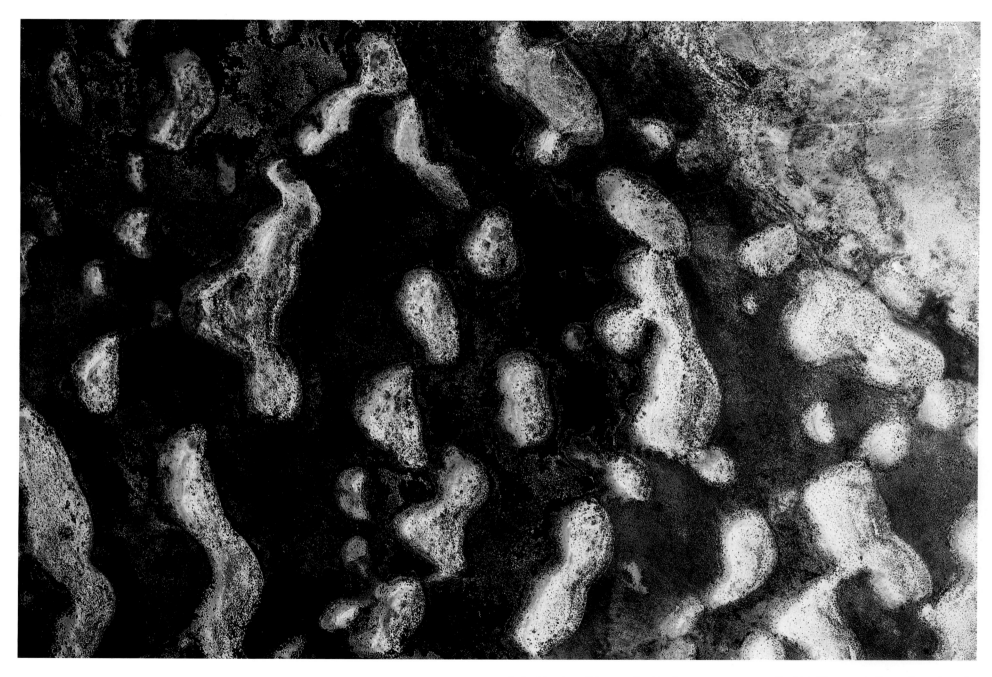

Lake Chad, well known for its disappearance over the last fifty years, sits on the edge of the Sahara Desert in Niger and provides water to its four surrounding countries—Chad, Cameroon, Niger, and Nigeria.

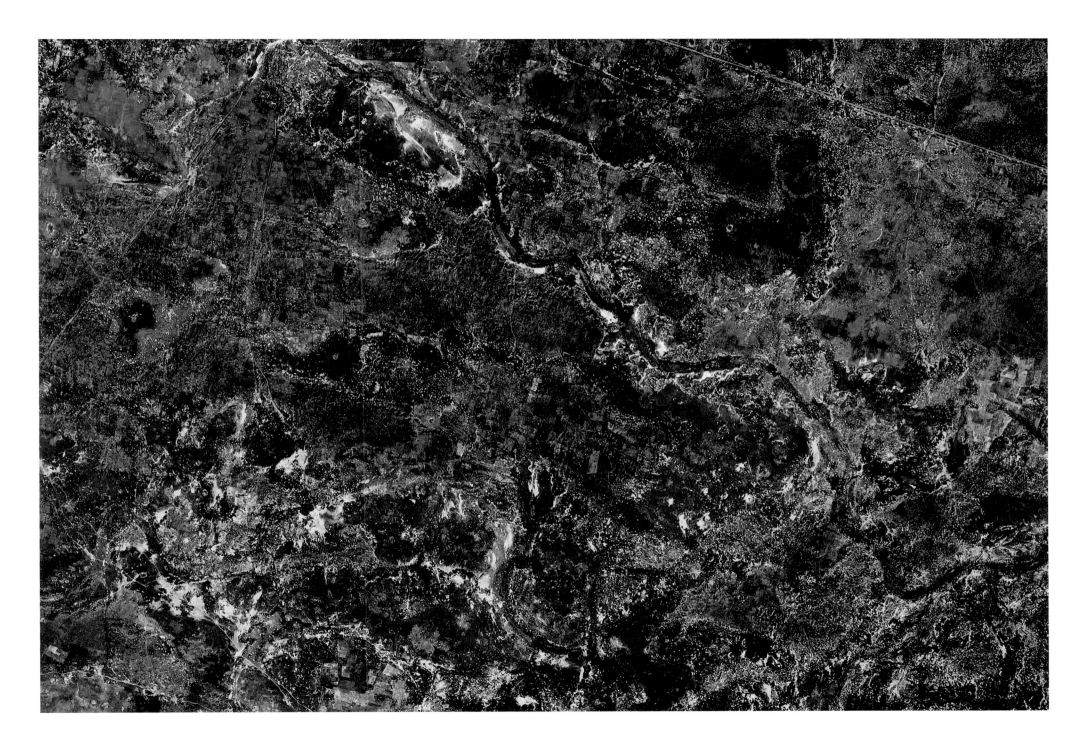

Borno, Nigeria

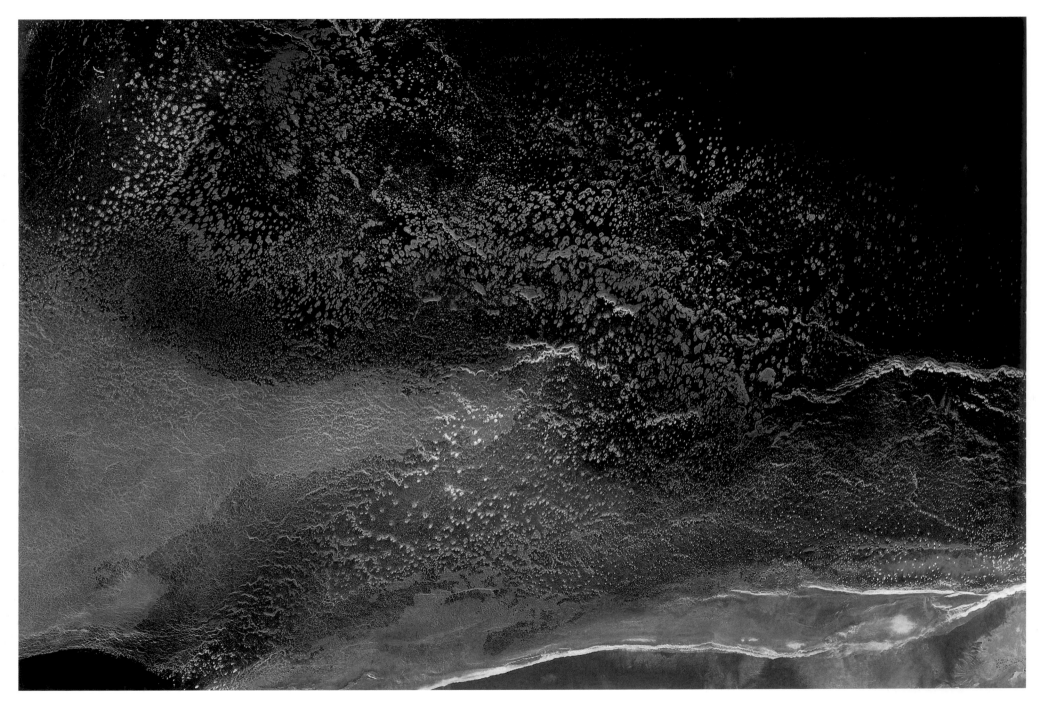

Mineral-rich Lake Natron in Tanzania is striking from space as its high-alkaline content produces the red waters below.

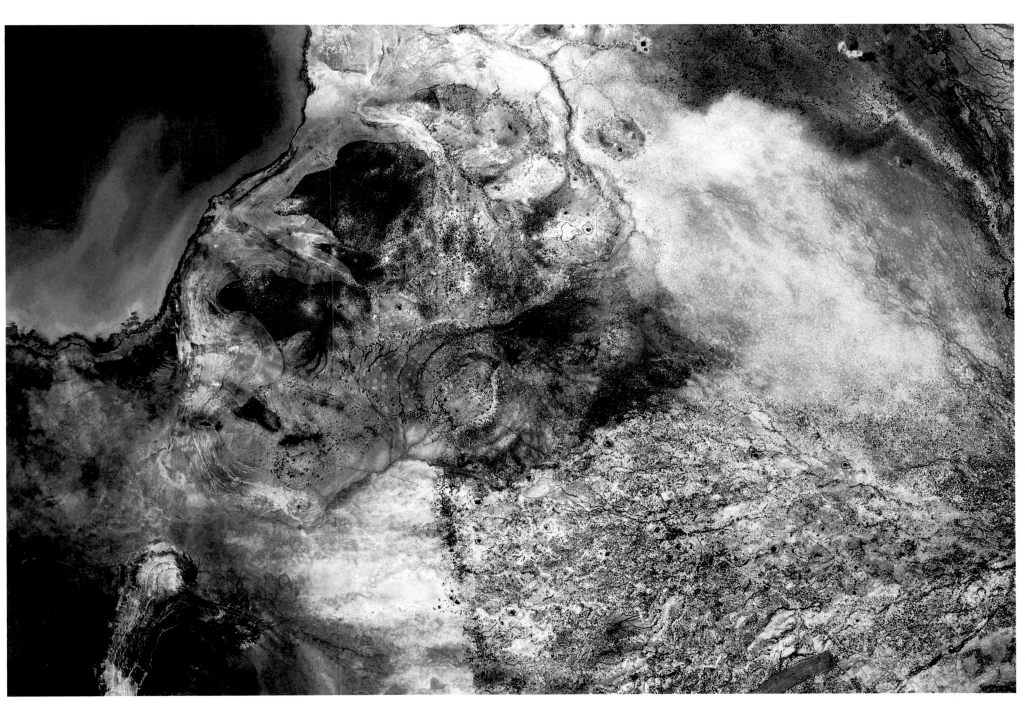

Patches of emerald, amber, and purplish blue woven over Mtera Reservoir in Tanzania,
a colorful carpet

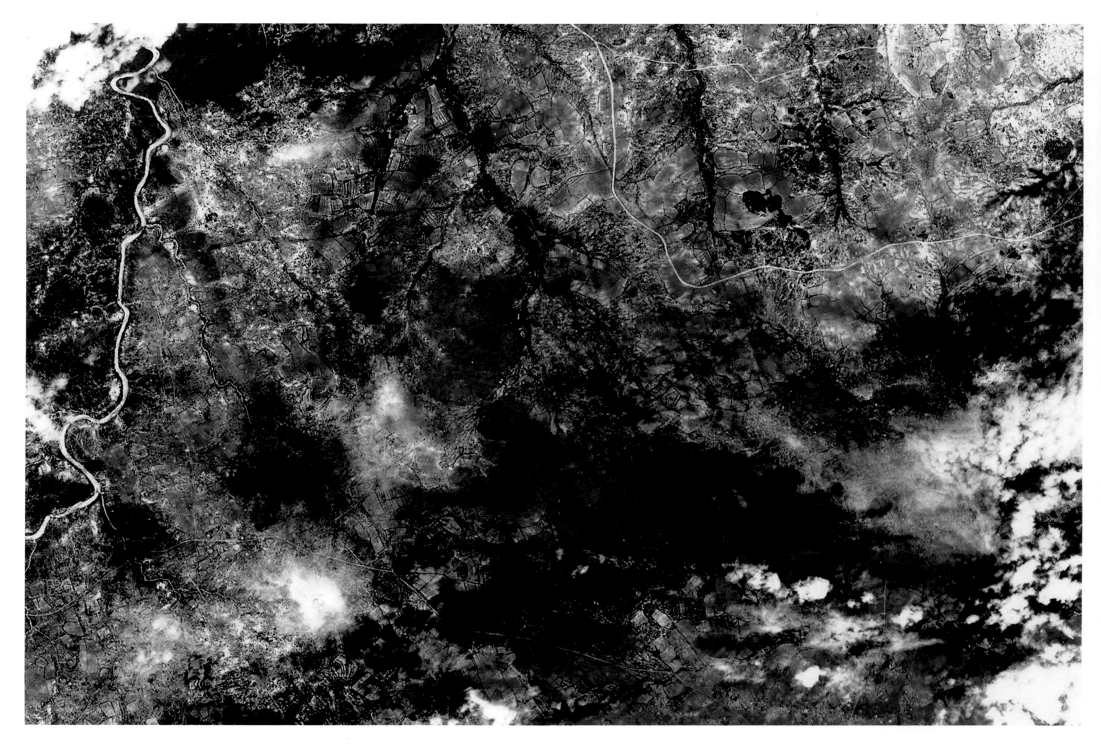

The Shashani River in Zimbabwe

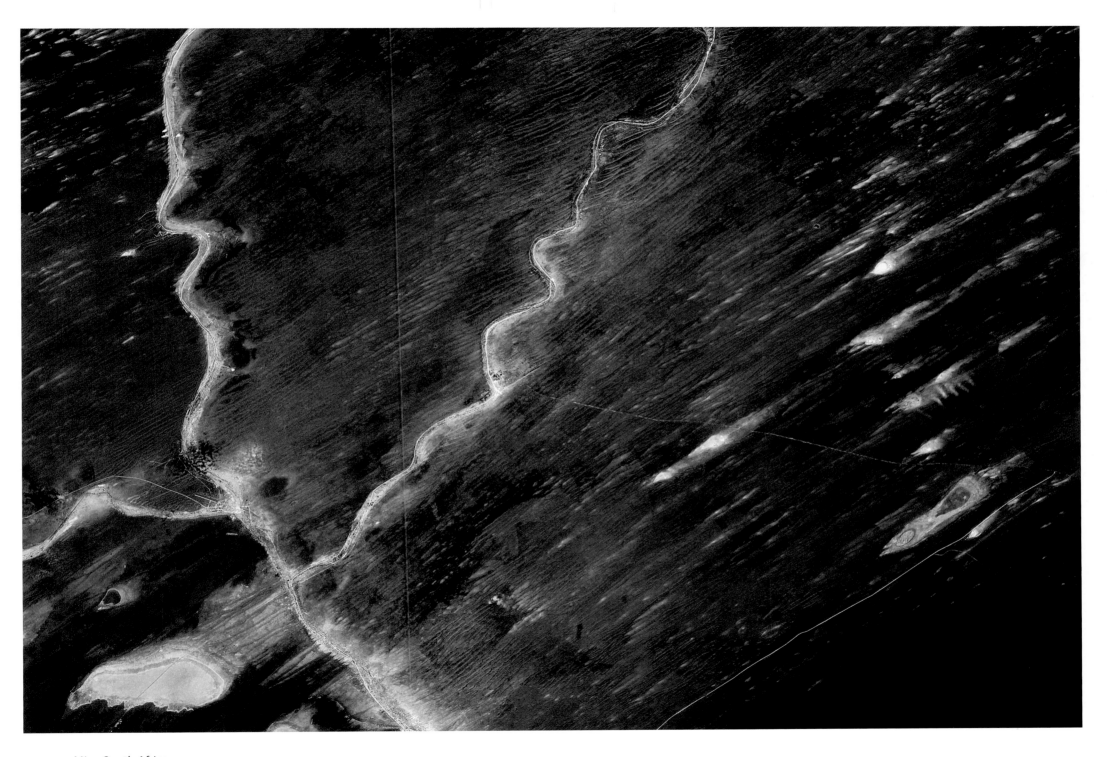

Mier, South Africa

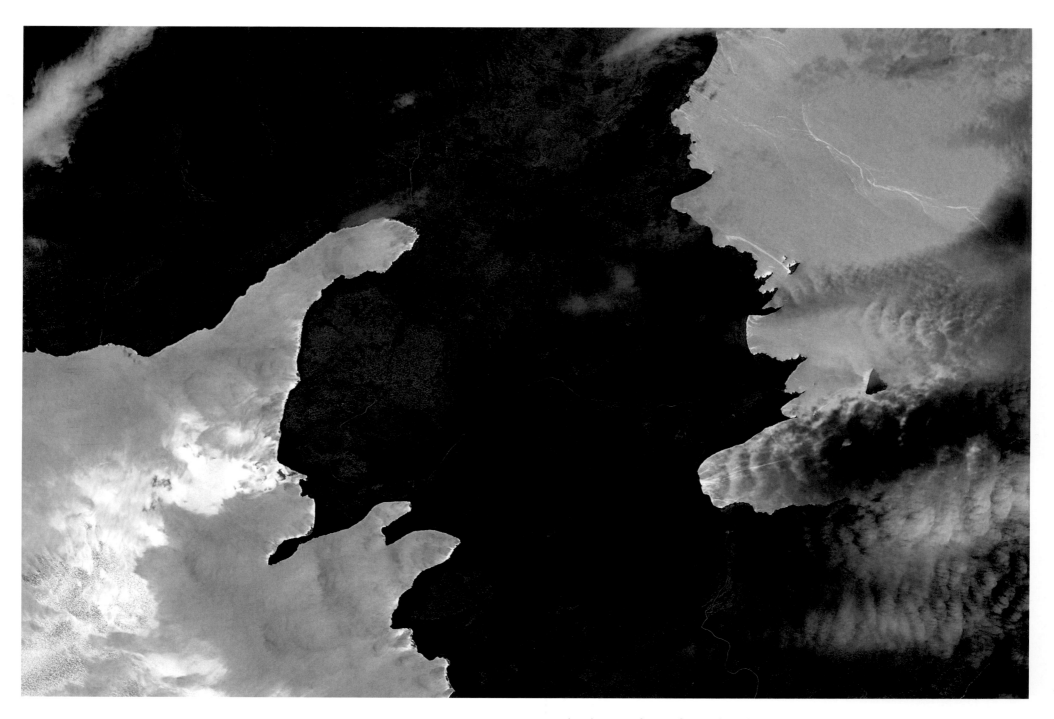

The element of water from Lakes Abaya and Chamo adds interesting contrast over Ethiopia.

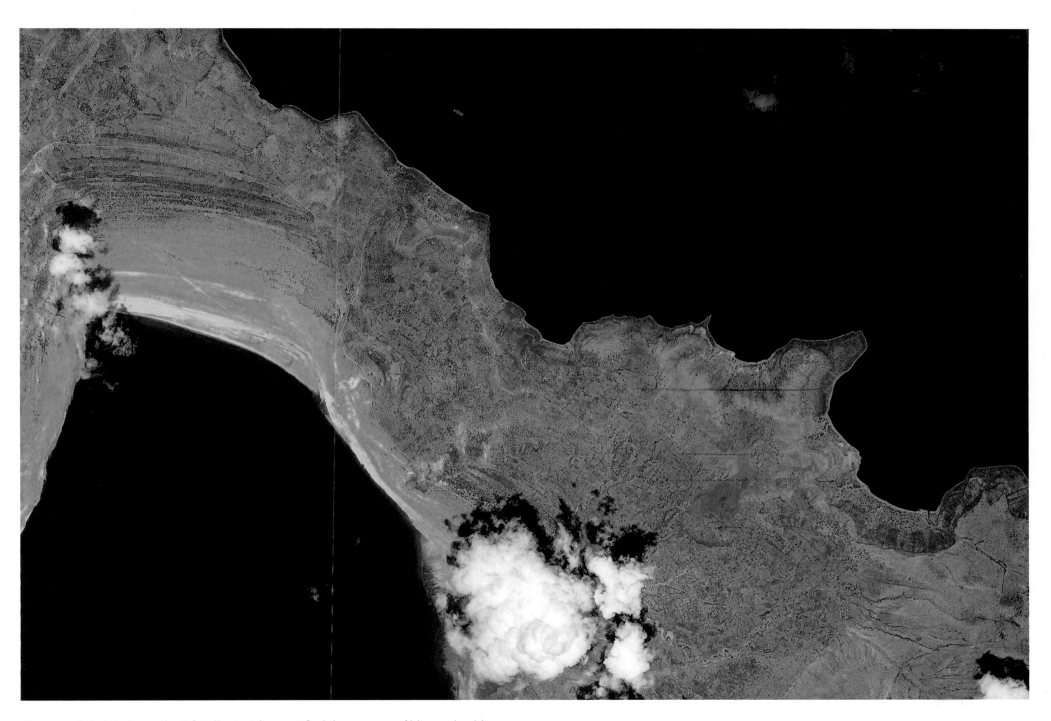

Abijata and Shala Lakes in the Rift Valley in Ethiopia. I find the contrast of blue and gold stunning, almost regal.

The Blue Nile River in Kamashi, Ethiopia. It was an amazing privilege to see so many destinations I would never have visited in person.

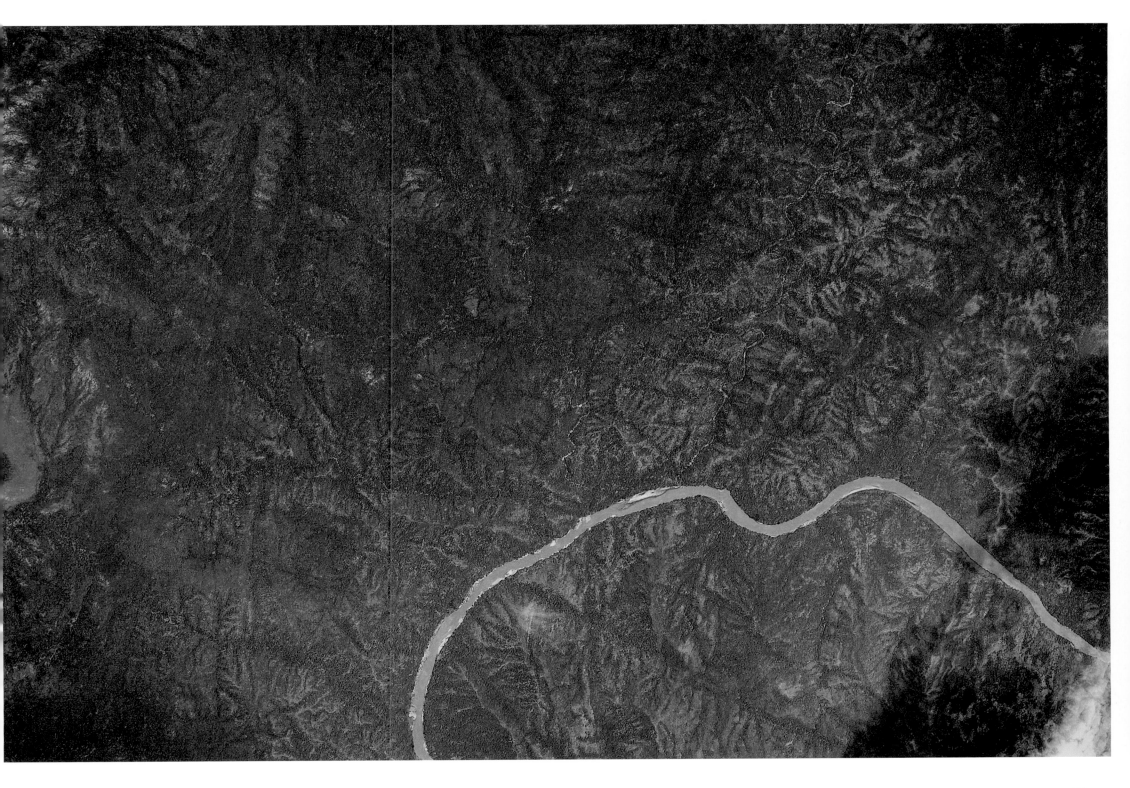

The sun's reflection appears to spill liquid metal onto the Gash-Barka region of desert in Eritrea.

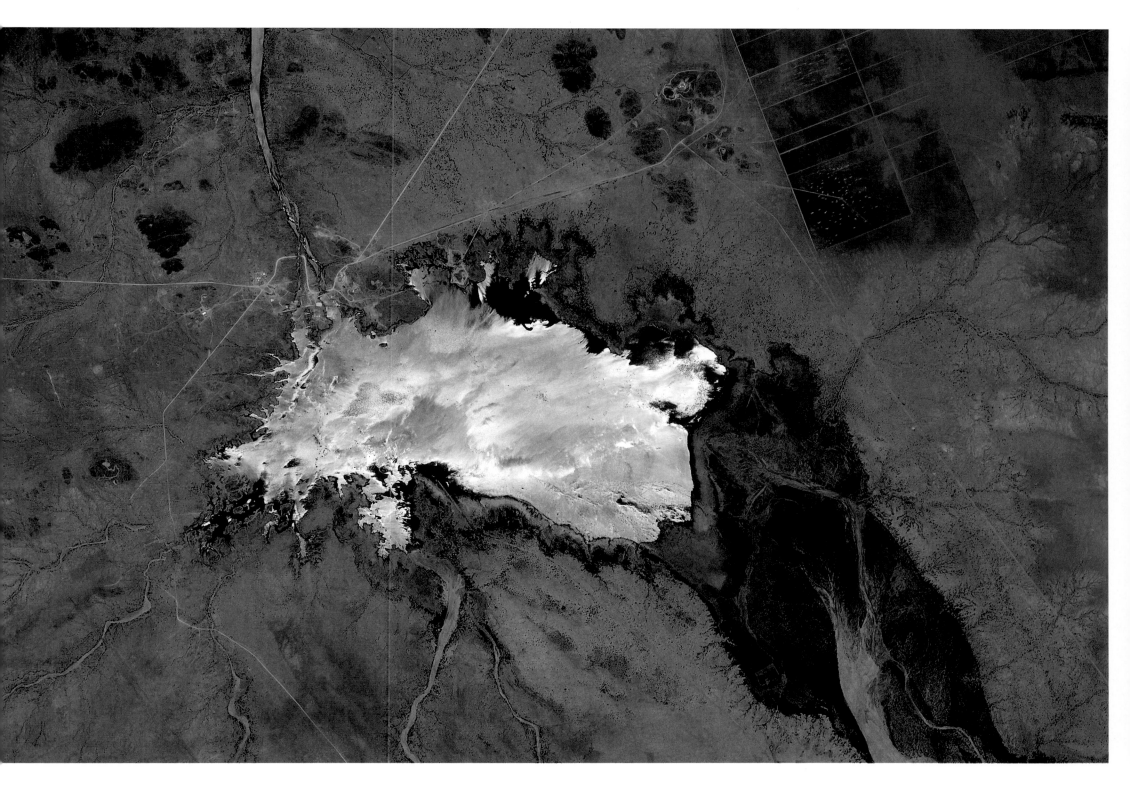

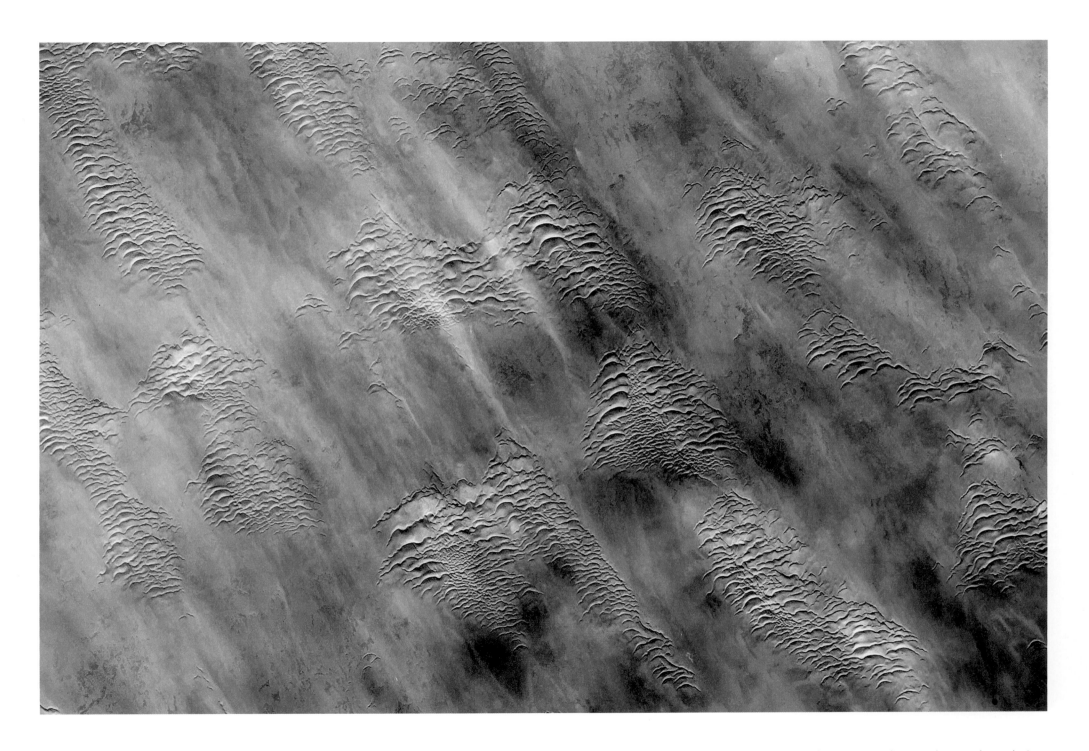

The desert sands of Al Matammah, Sudan. What can I say about such natural wonder?

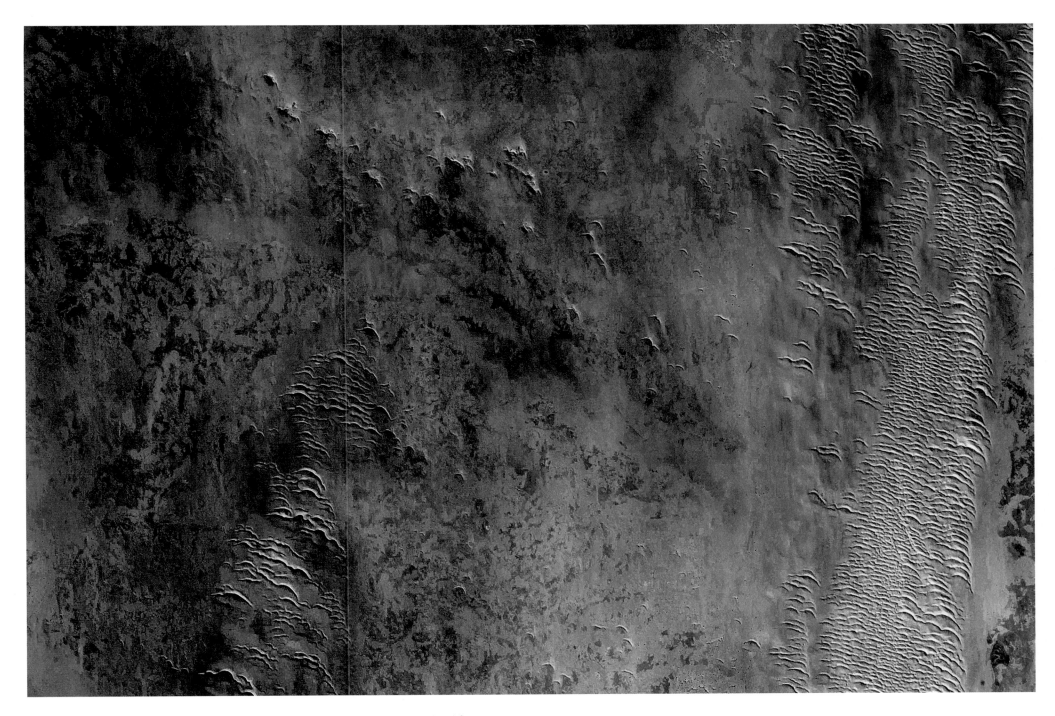

This photo near the Al Matammah region of Sudan says a lot about what makes life difficult there.

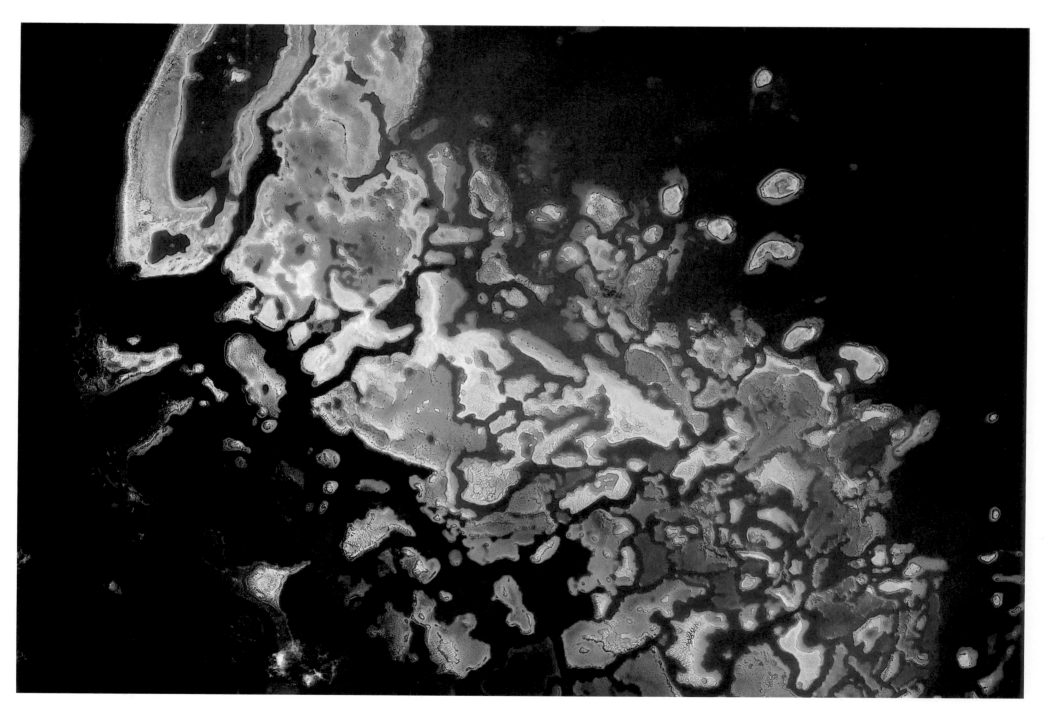

Saqir Islands and the blues of the Red Sea. The Red Sea is one of the saltiest bodies of water in the world due to very little rainfall and no major source of freshwater.

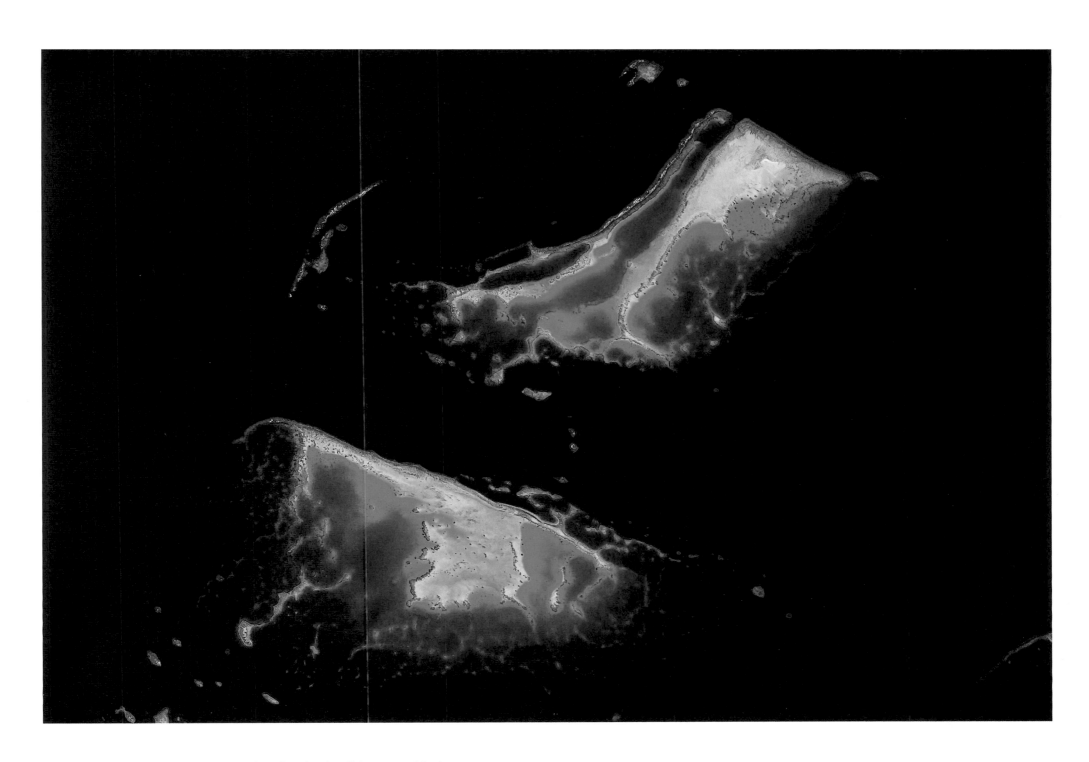

A splash of blue in the Red Sea surrounding the islands off the coast of Sudan

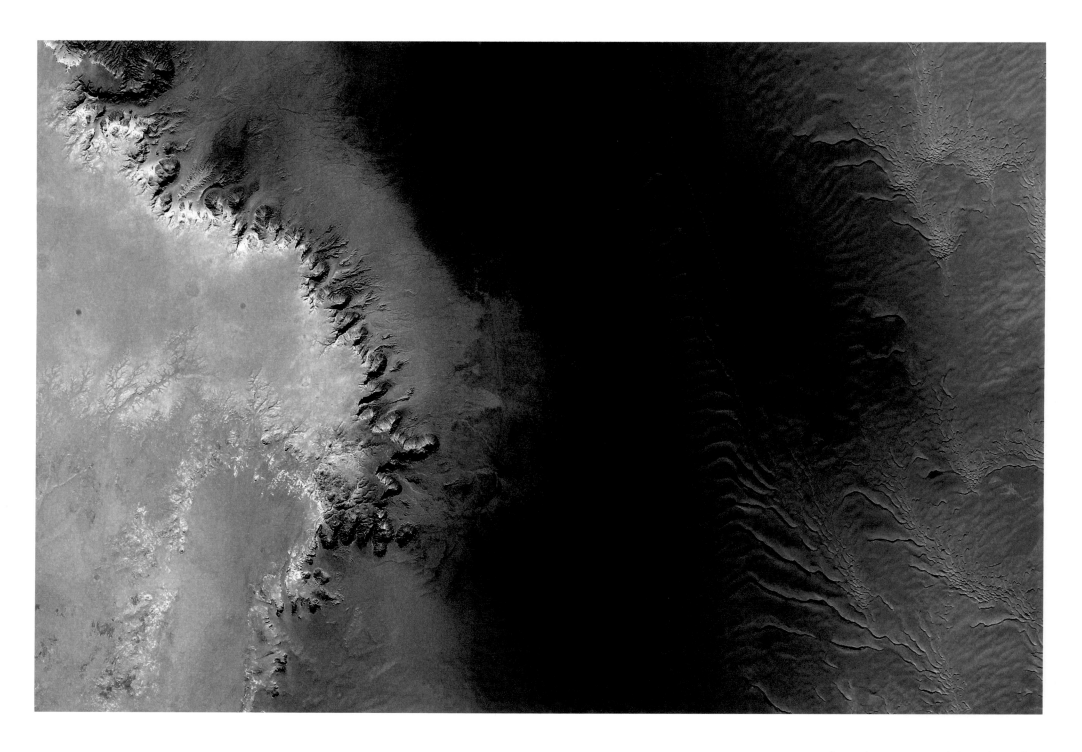

Colors in harmony over Idehan Ubari, Libya

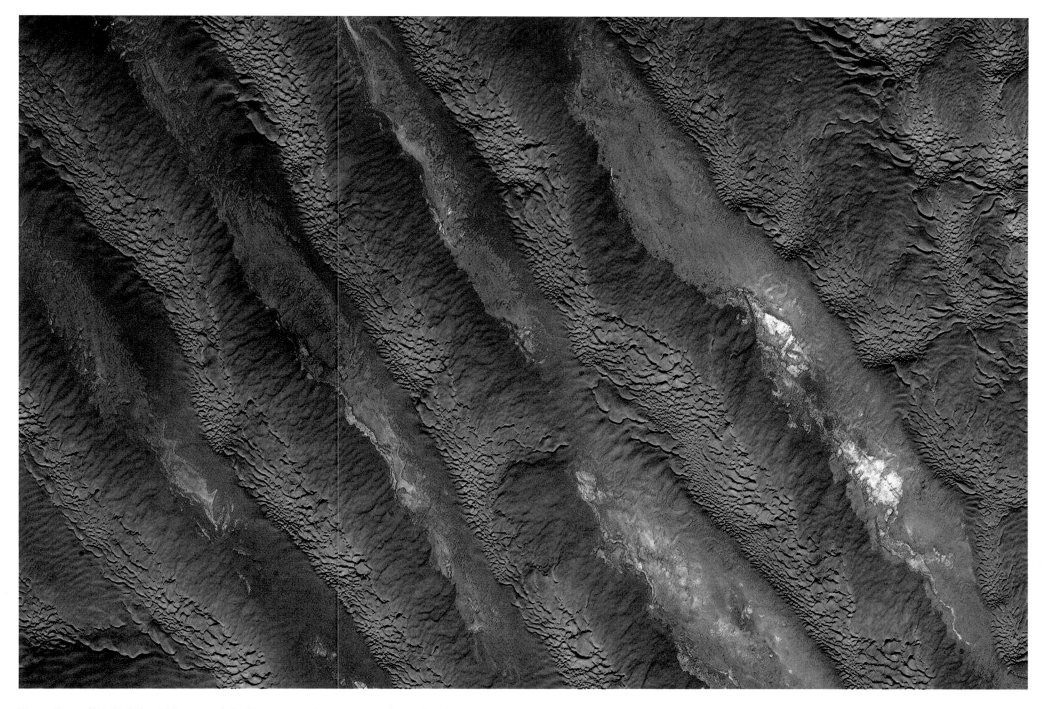

The valleys of Wadi al Shati, Libya, are full of iron ore and manganese that color the earth in a beautiful burnt orange shade reminiscent of fall.

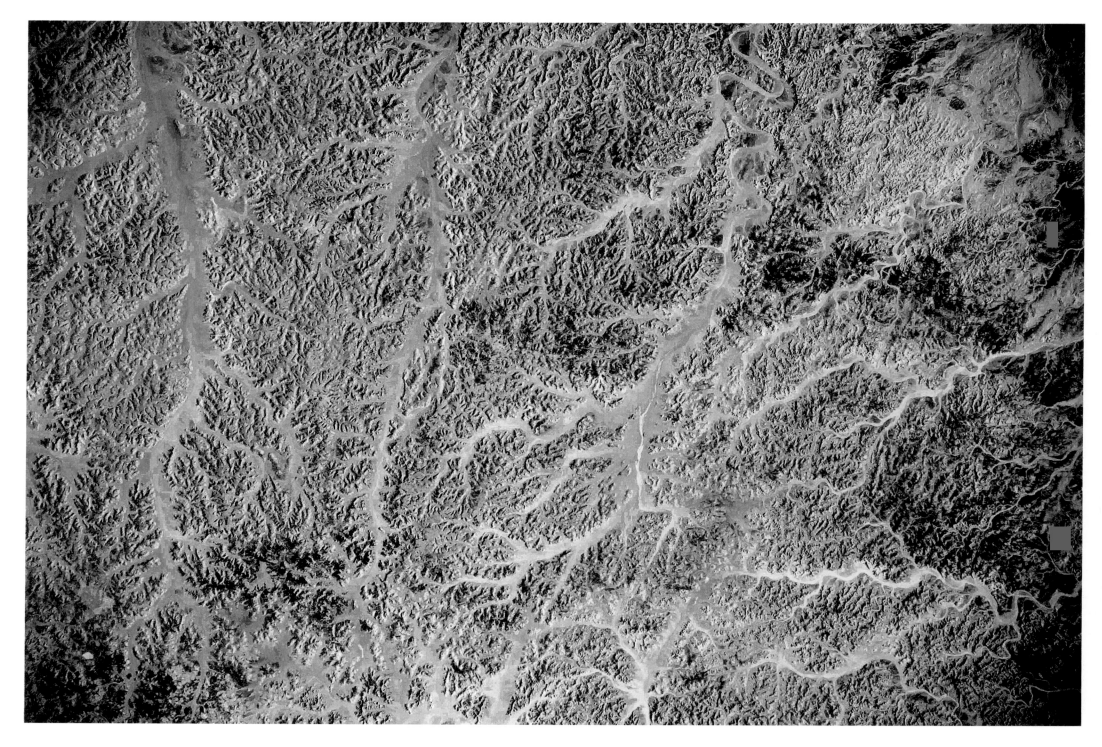

Some locales in Africa appear rigorously veiny from space: Waddan, Libya.

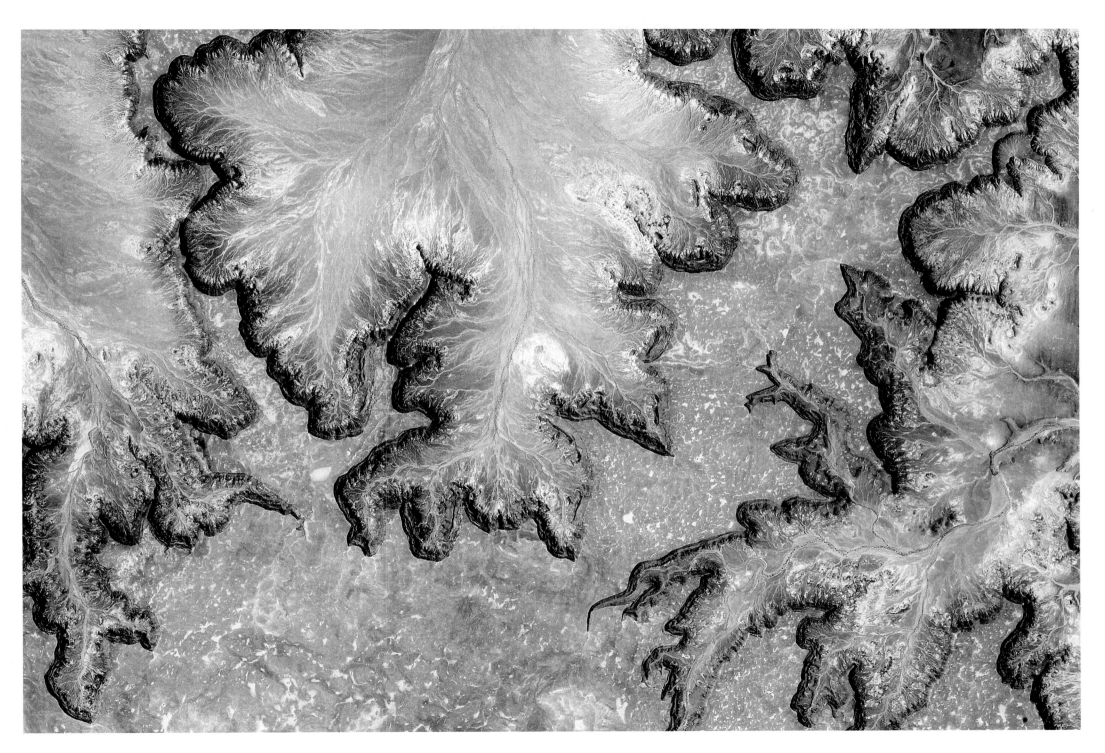

Great leaf impressions across the Greatest Desert of Sahara near Dirj and Nalut, Libya

Some of the most striking views of Earth are found over Africa in Qesm Al Wahat Ad Dakhlah, Egypt.

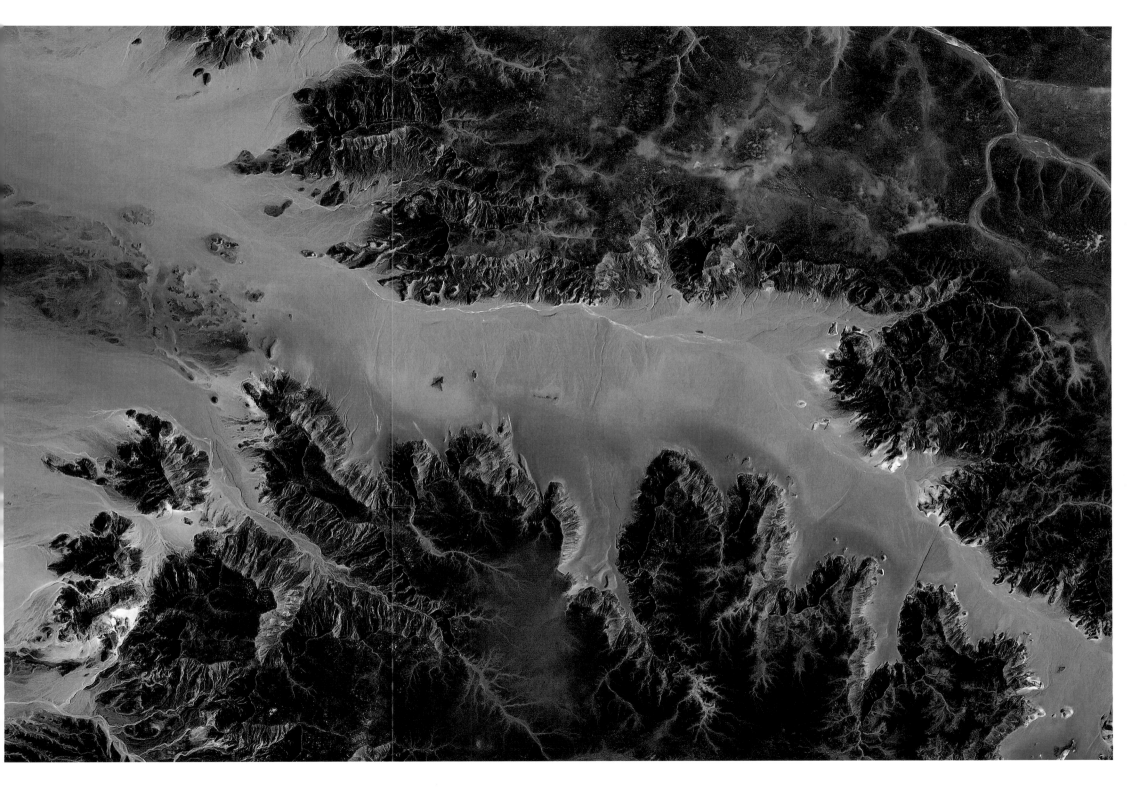

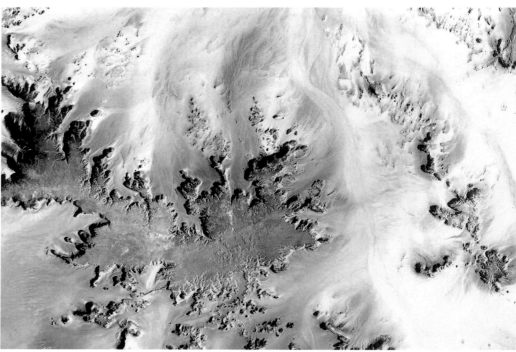

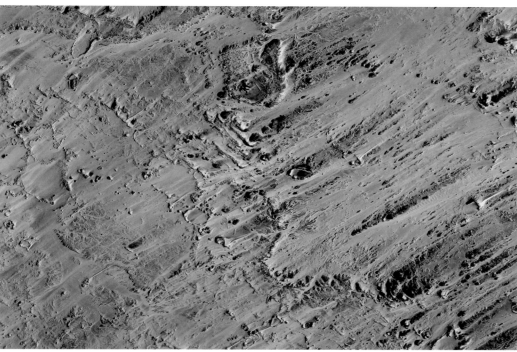

As I reached the end of my yearlong mission, I reflected on how I'd miss the views of the desert sands like these of Qesm Al Wahat Ad Dakhlah, Egypt. However, after 340 days in space, I knew I would soon appreciate sandy beaches up close.

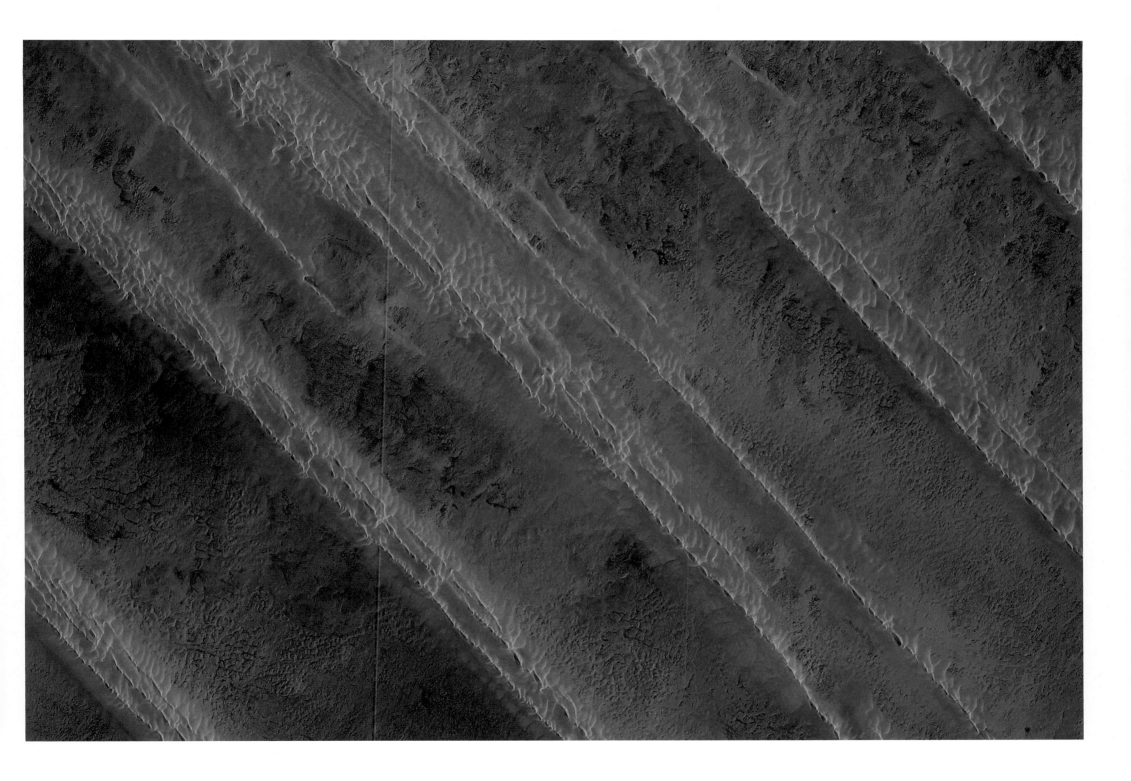

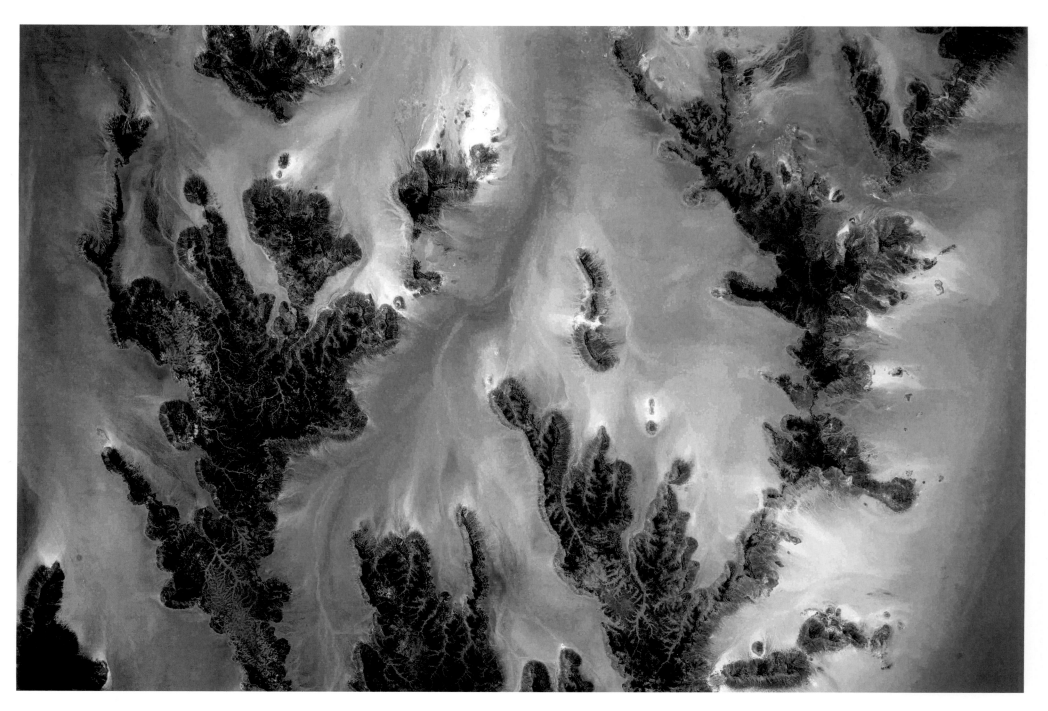

Gilf Kebir Plateau in southwest Egypt, also known as the Great Barrier, appears fiery from space.

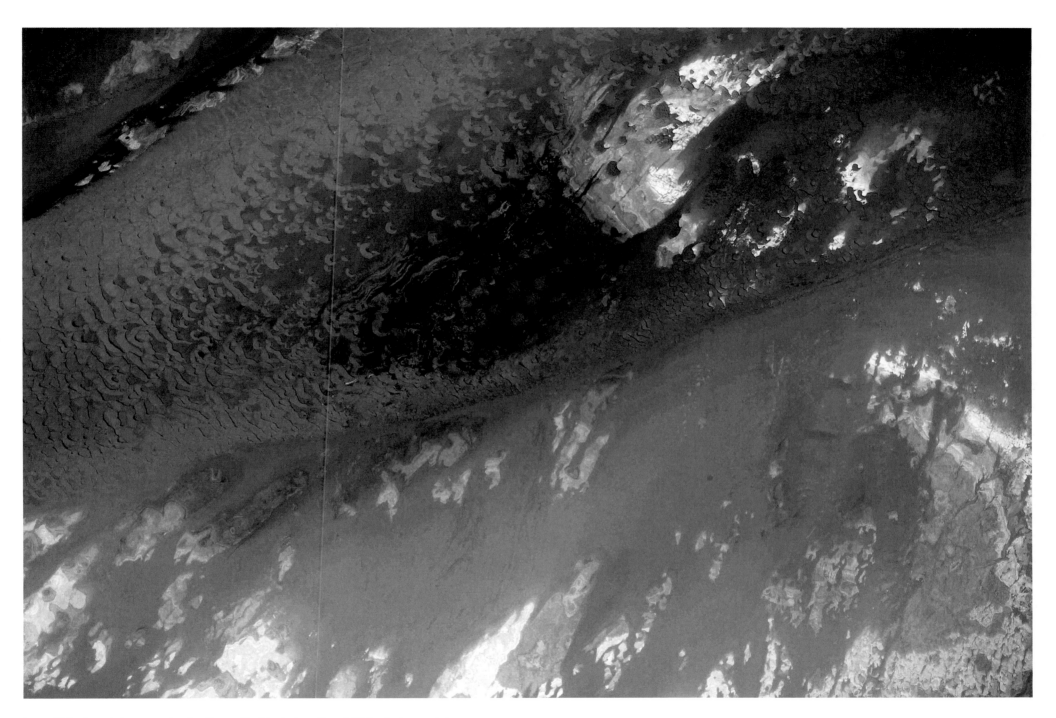

Incredible desert dunes and red soil near Toshka Lakes, Egypt. This photograph has lingered in my mind and whetted my appetite to visit this area in person one day.

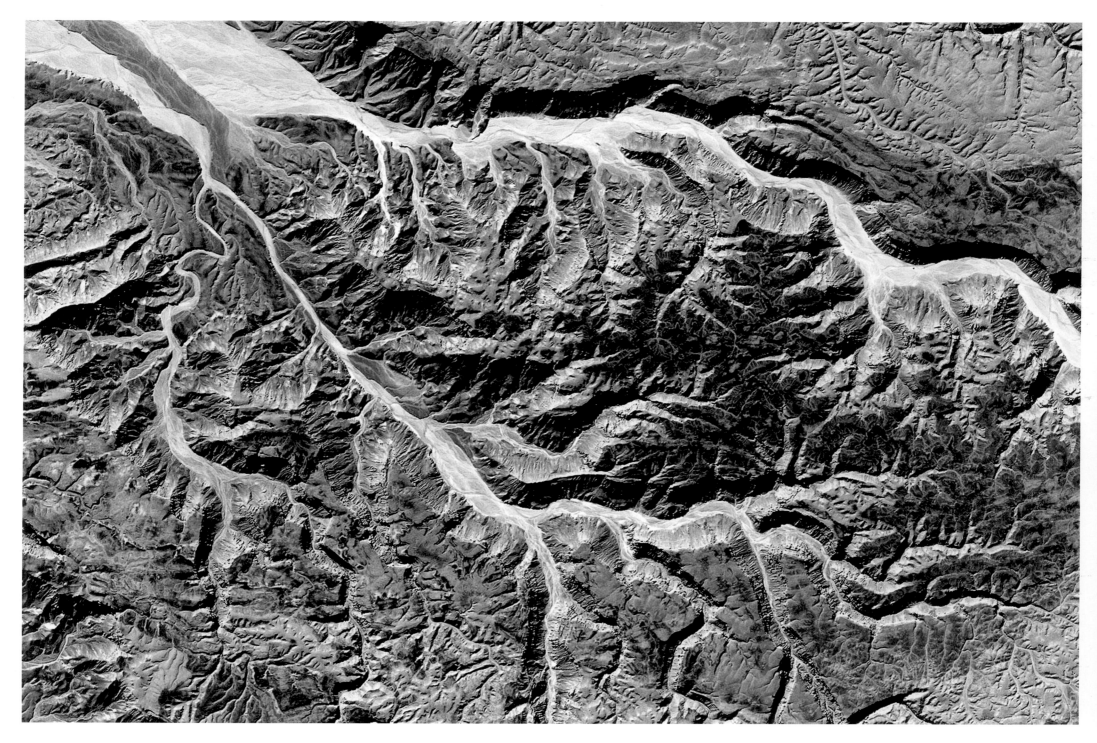

The Earth looked alive over Nagaa Ash Fawiyyah, Egypt.

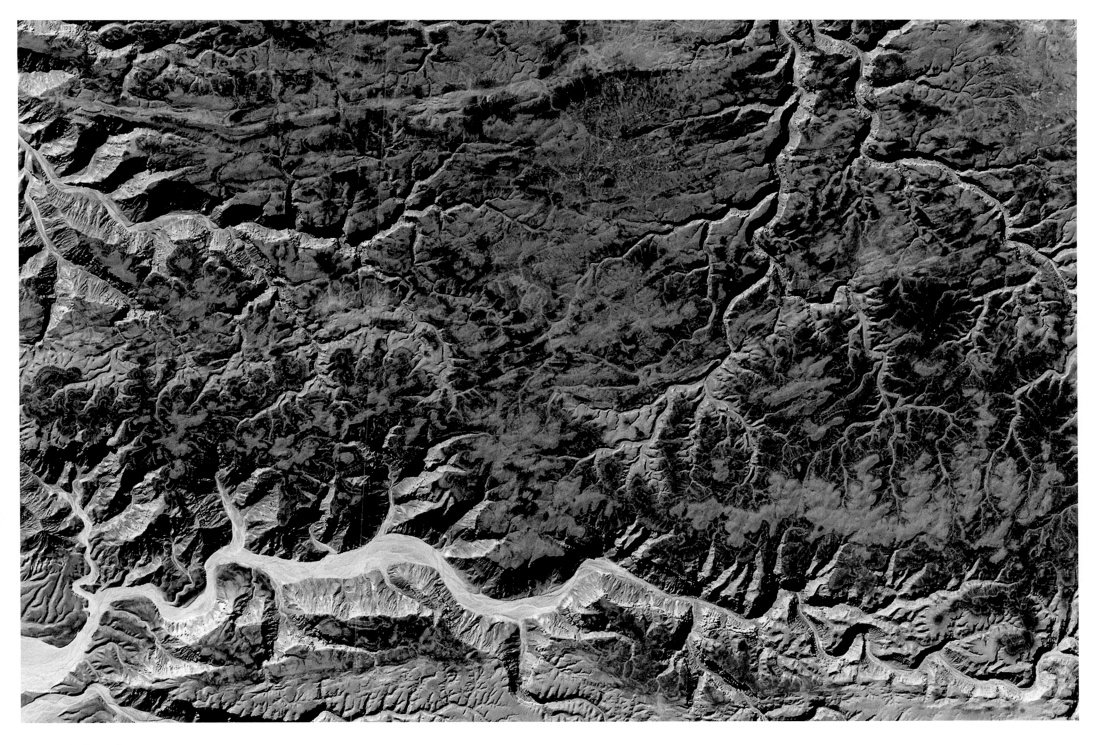

In Qena, Egypt

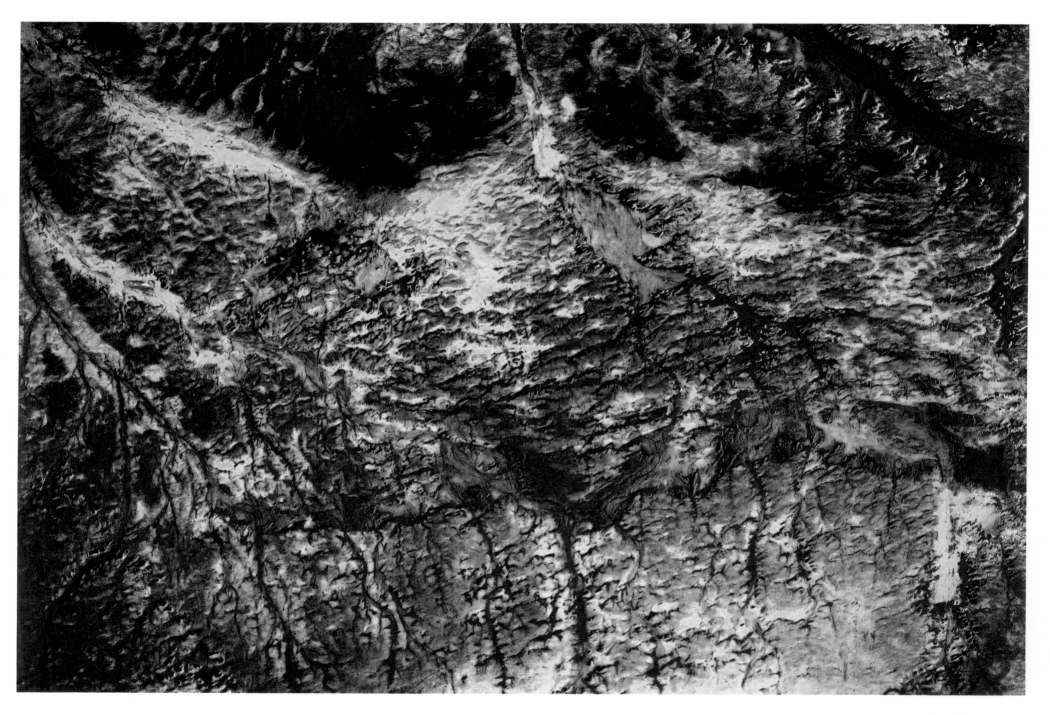

Fiery veins crossing in Al Farafra–Al Wahat,
New Valley, Egypt

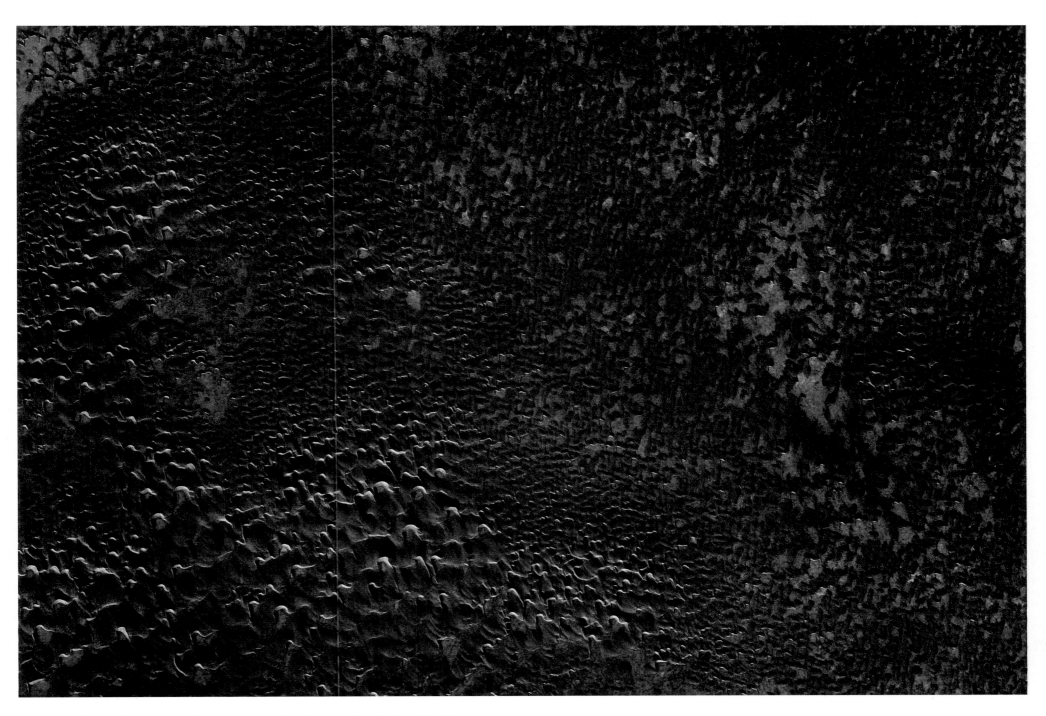

In 520 cumulative days in space, I had never seen the dunes in Riyadh, Saudi Arabia, quite like this.

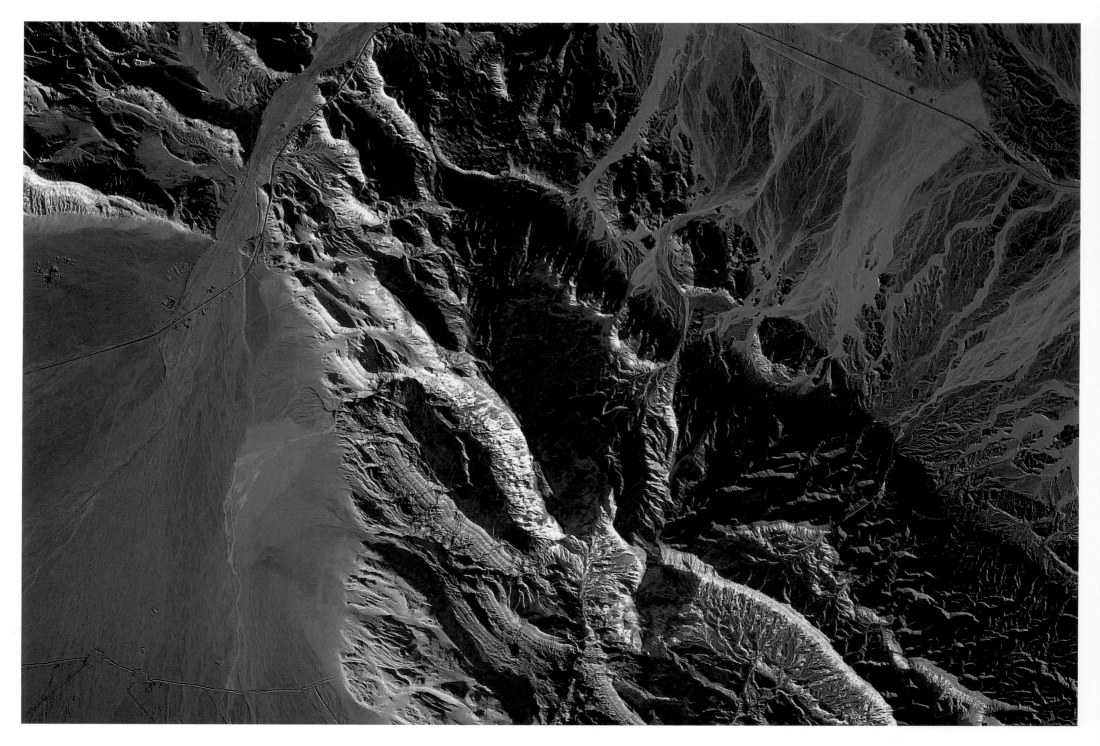

"Sophisticated art" are the words that came to mind as I gazed at Qesm at Tour, South Sinai.

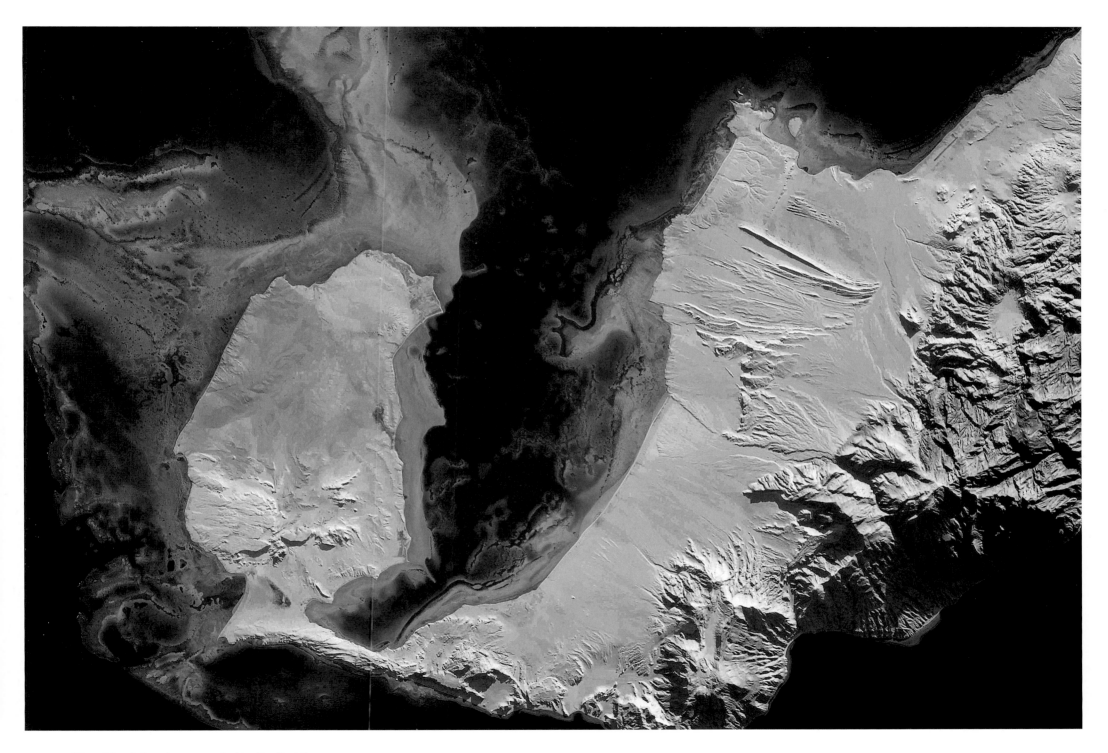

Tiran Island, Egypt, surrounded by the Red Sea

The lighting seemed exquisite as we
passed over the United Arab Emirates.

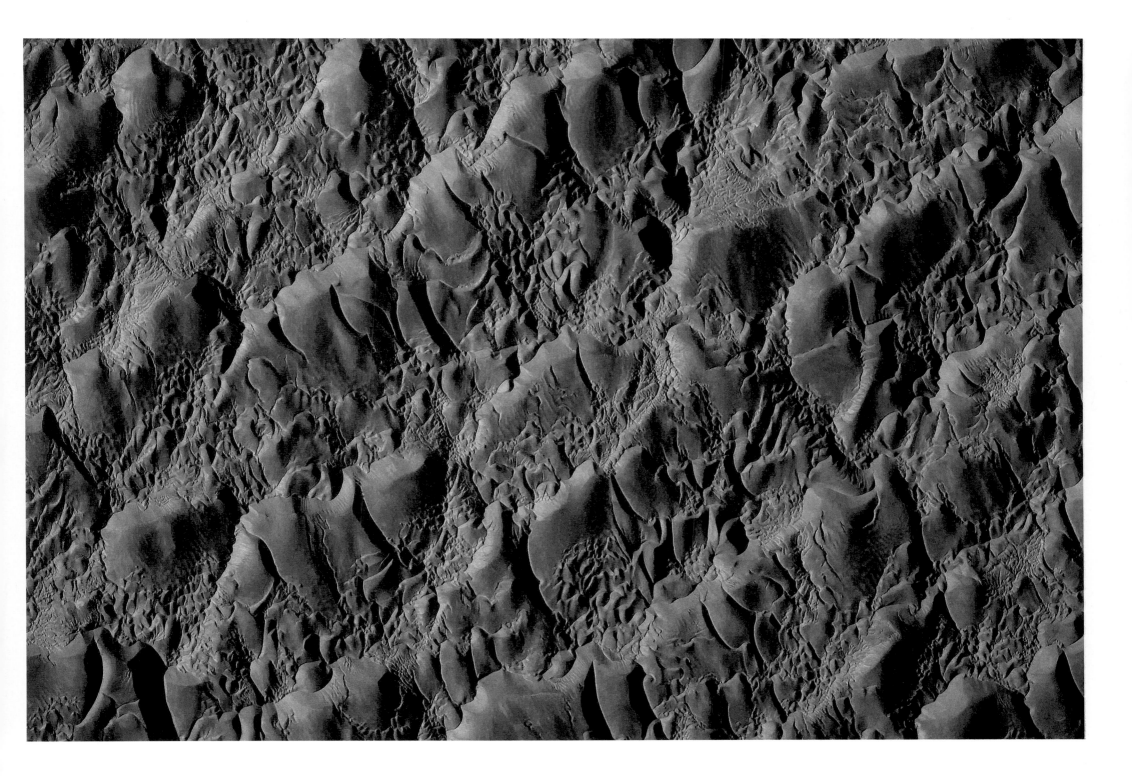

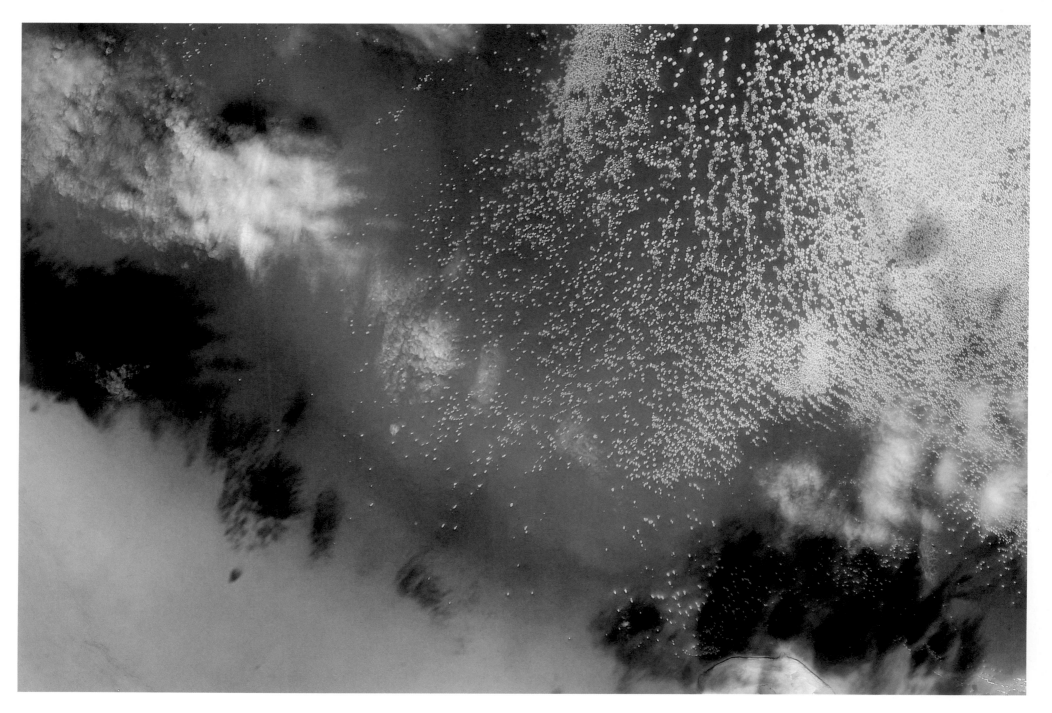

The swirling patterns and varied colors of a tie-dye as we flew over Lake Urmia in Southwest Asia

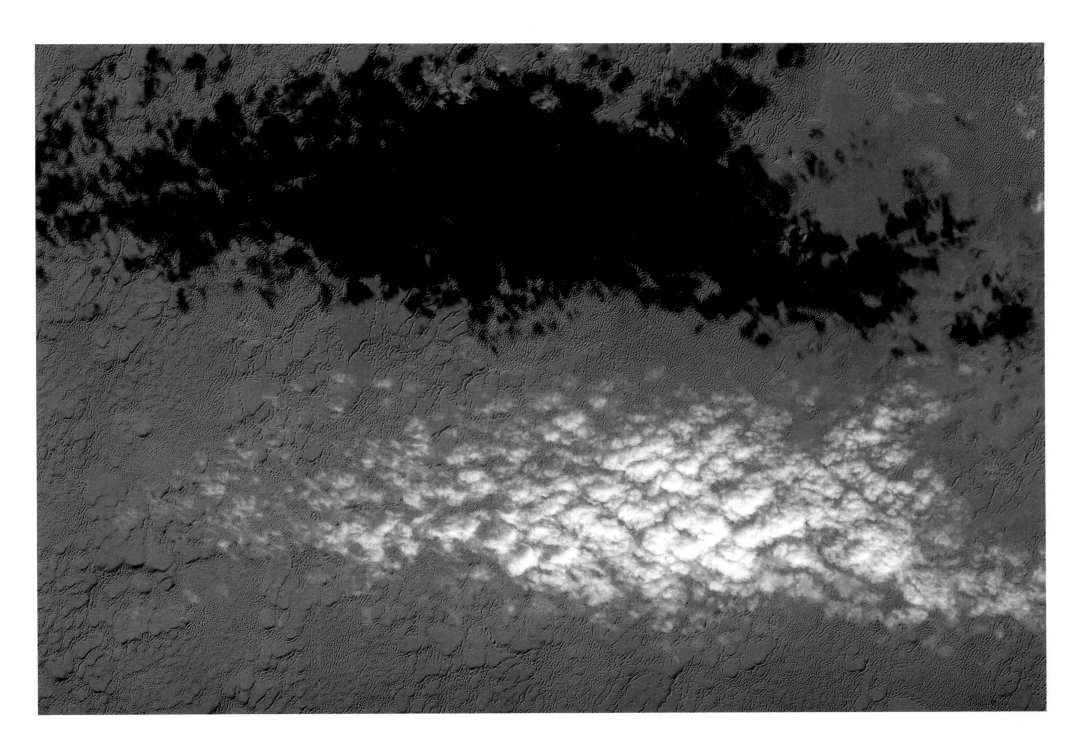

Shadows on a desert floor over central Saudi Arabia—stunning, I felt.

Unexpected color over the desert of
Al Jadidah, Yemen

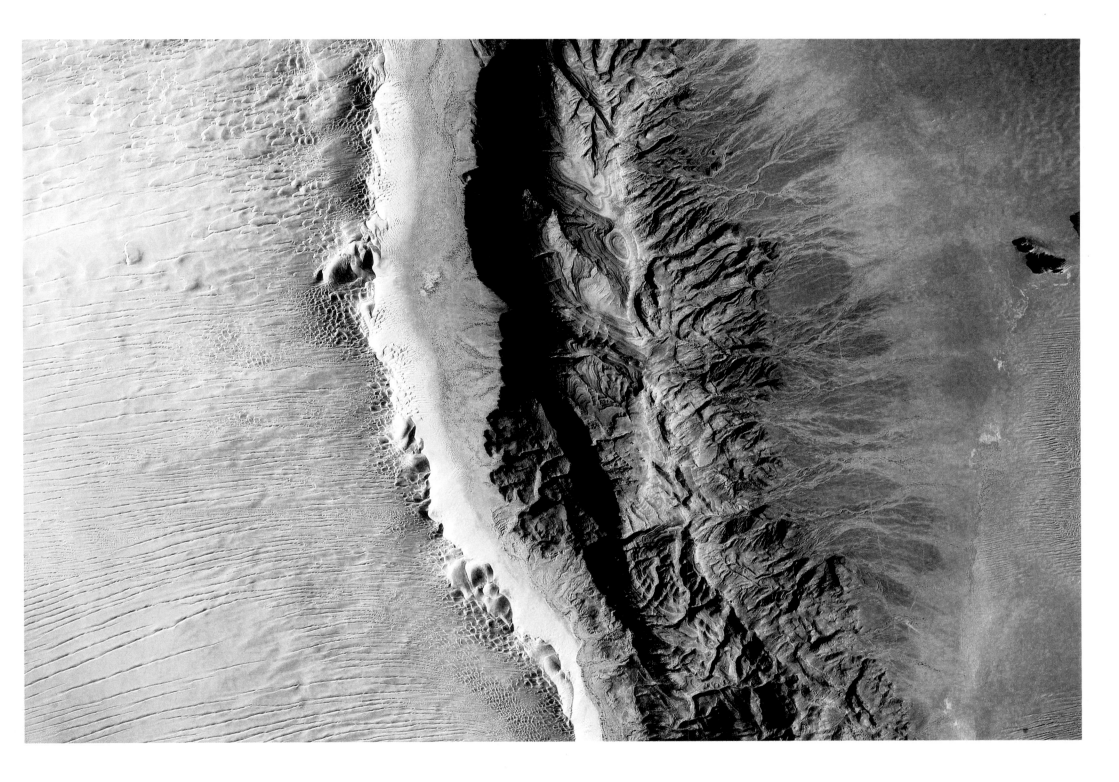

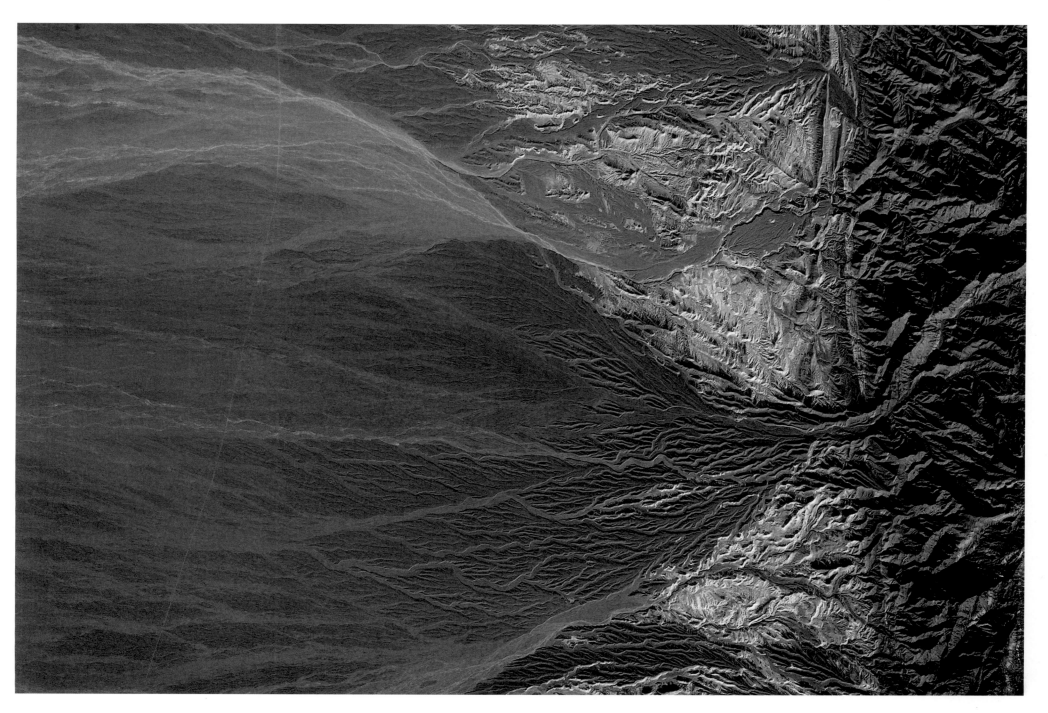

The story of water unfolds over the alluvial fans in Kavir National Park, Iran.
This is evidence of a river that once ran through it.

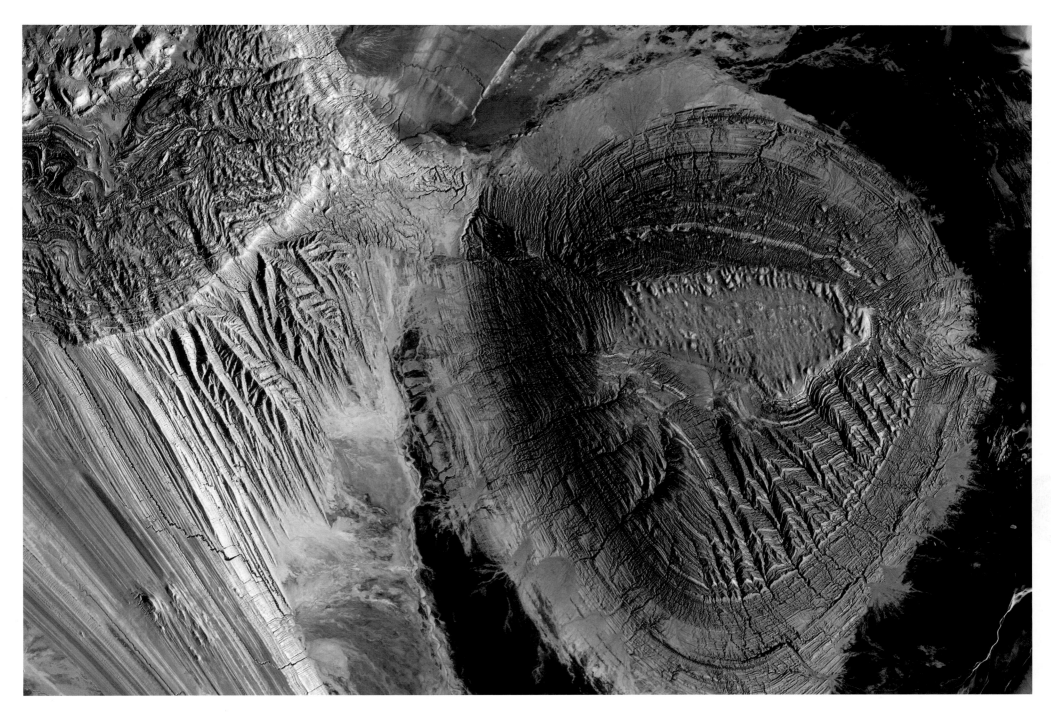

The Maranjab Desert of the Middle East over Semnan, Iran. I'd never seen anything like this in my life.

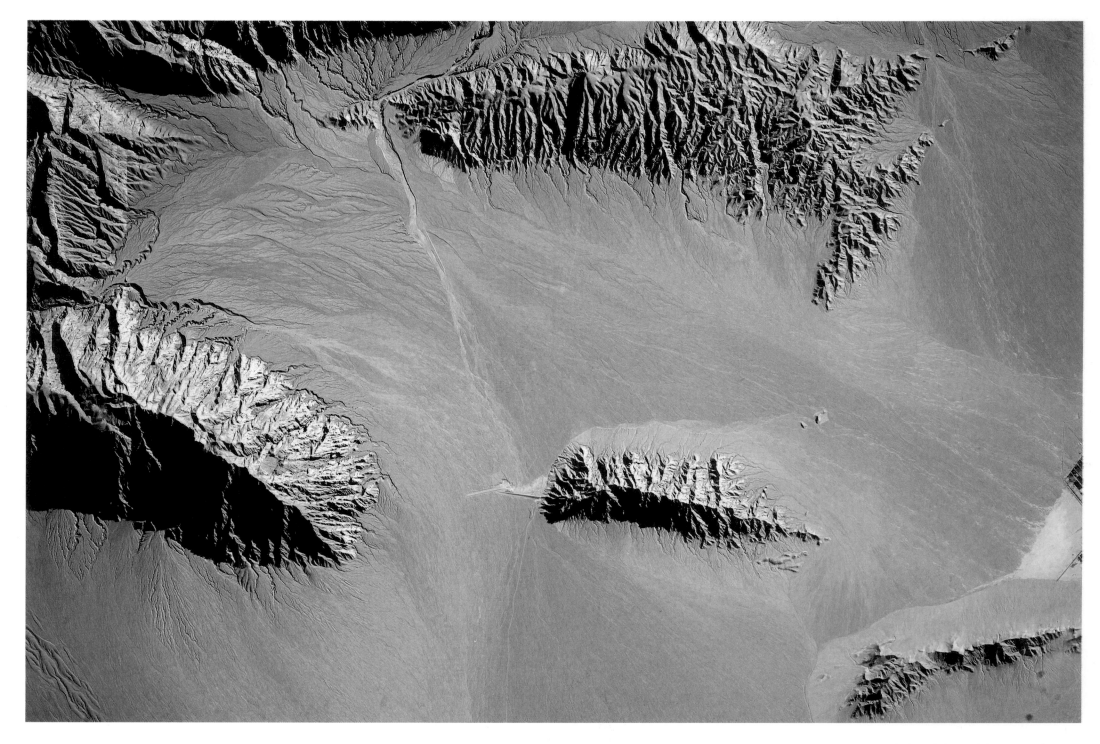

Near Chah Malek, in Isfahan, Iran

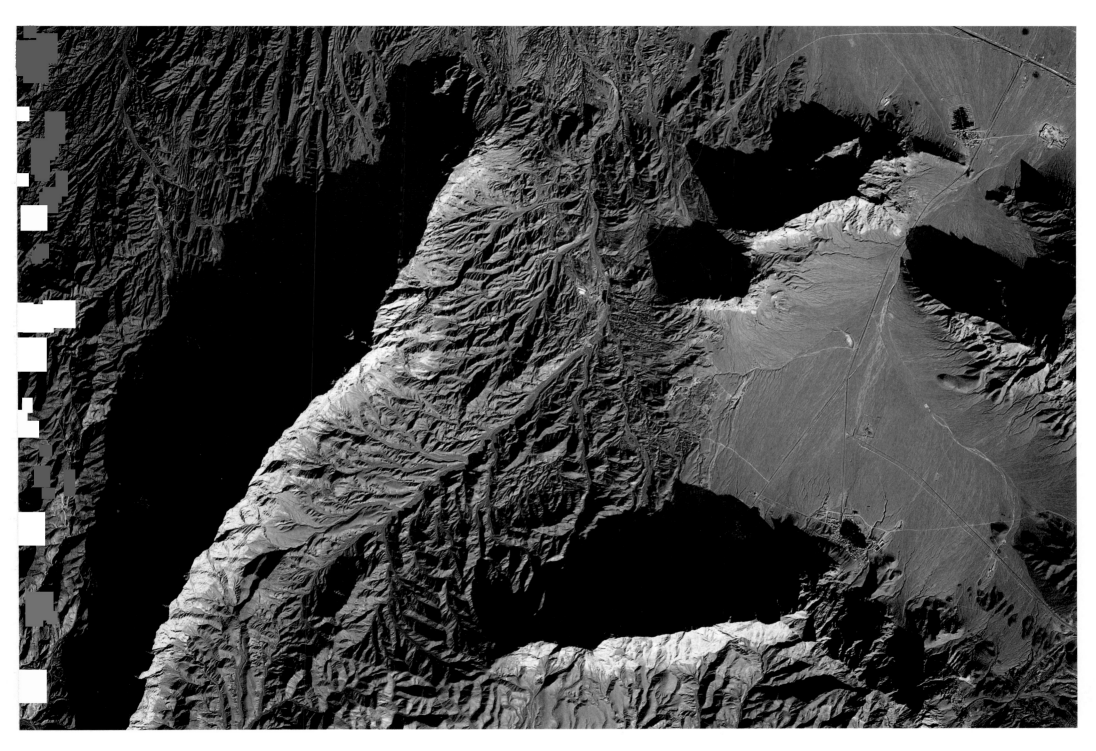

Near an old and crumbling mud-brick town, Kharanaq, Iran

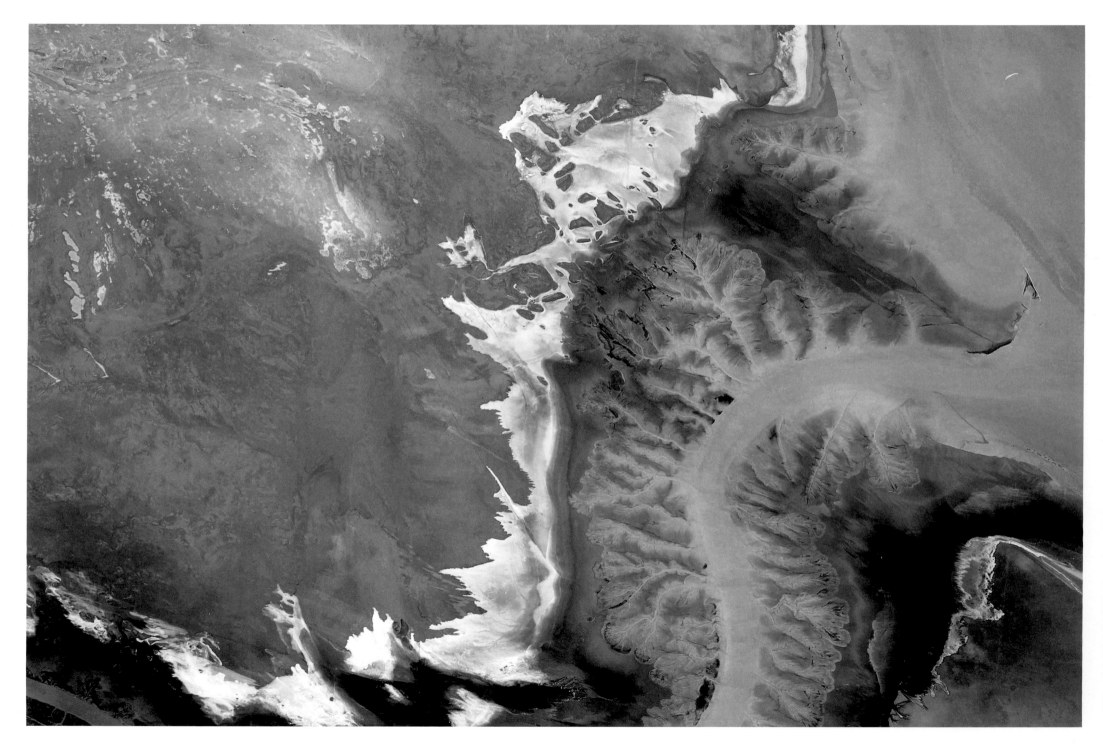

Earth tones. The Arzhan Lake in Iran is an important sanctuary for birds.

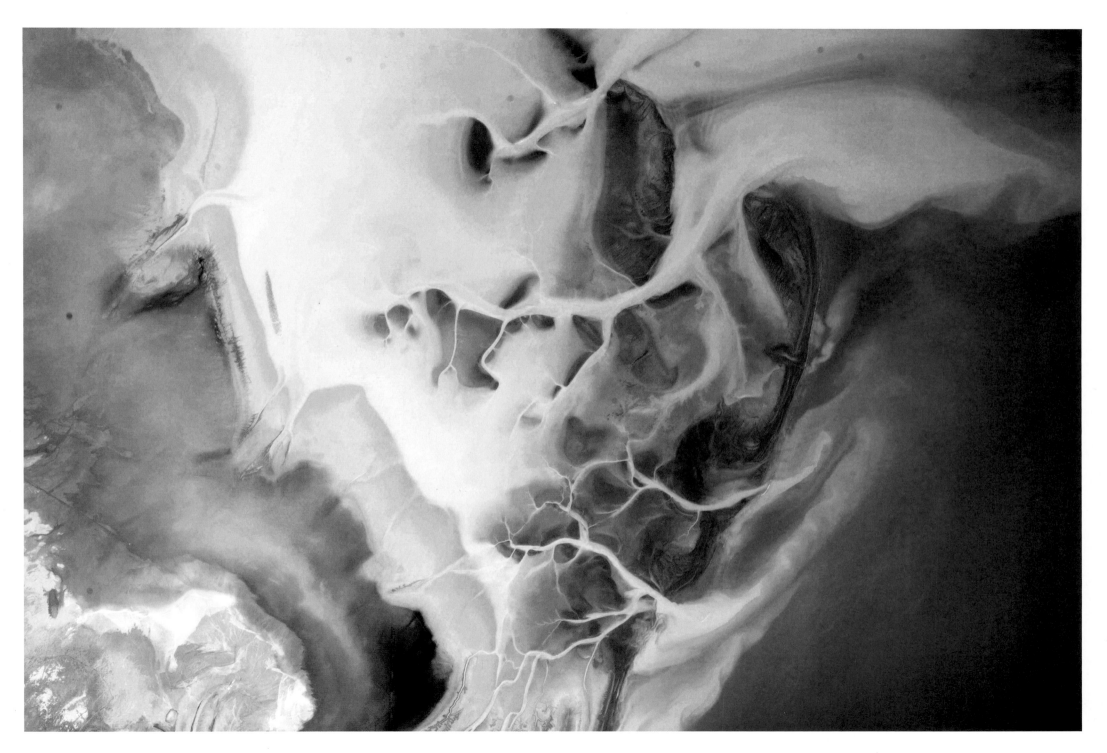

A dried salt bed in Bakhtegan Lake, Iran

Akbarabad, near Hormak, Iran, appears opalescent from the space station.

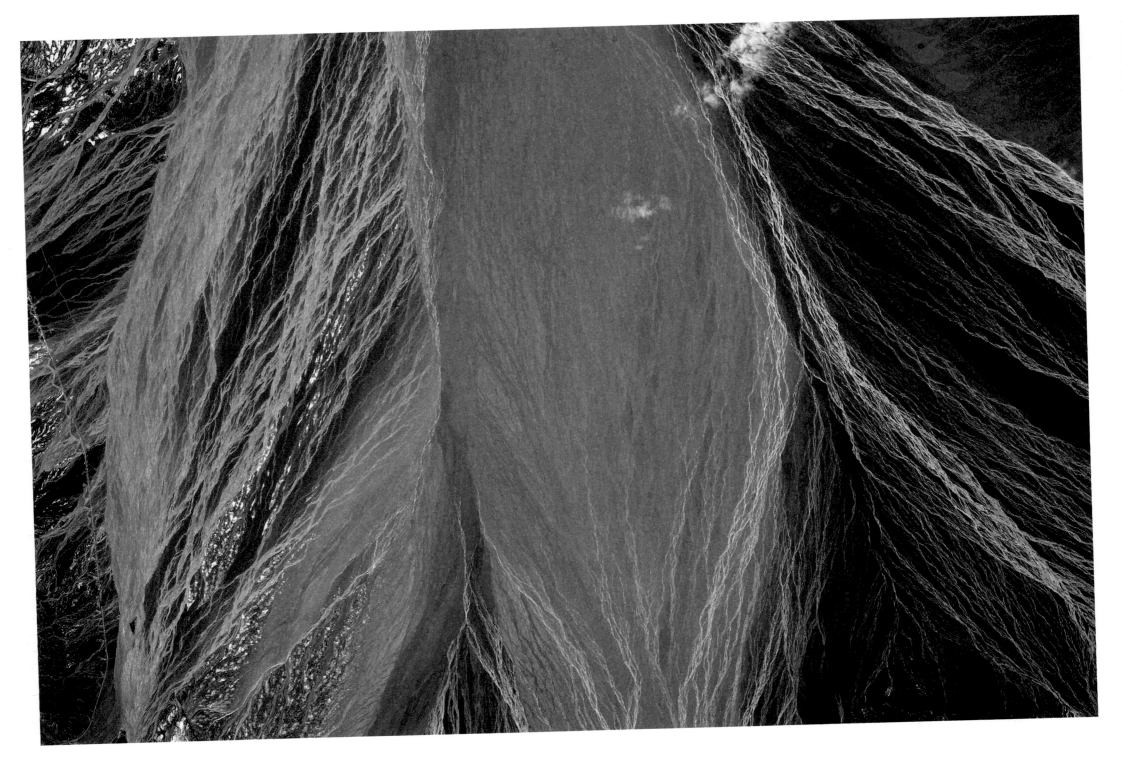

What looks like an epic surf wave over the South Aral Sea, an endorheic lake between Kazakhstan and Uzbekistan, starkly camouflages this lake's reputation as one of the planet's worst environmental disasters. Its shrinking waters destroyed a once vital fishing industry, leading to unemployment and economic hardship. In 2014, NASA satellite images revealed the lake, once among the four largest in the world, was completely dried up. I shot this photo one year after efforts to restore the lake began, a testament to how humans can affect progress.

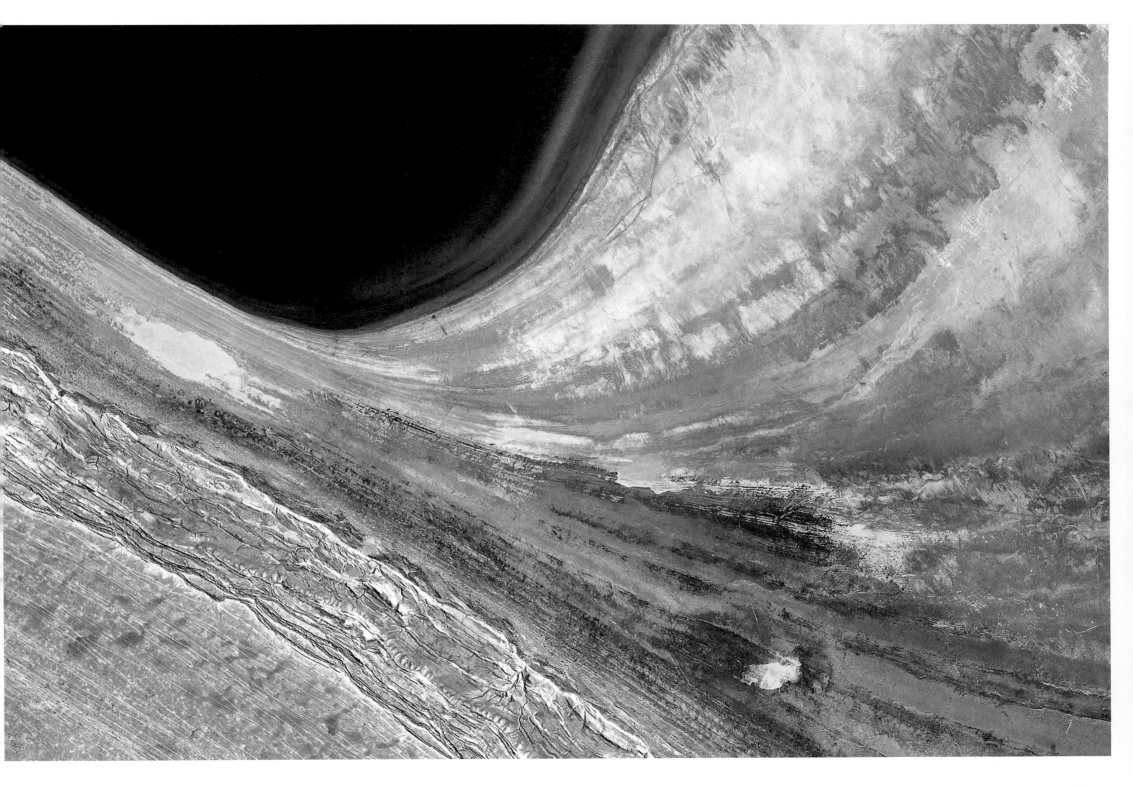

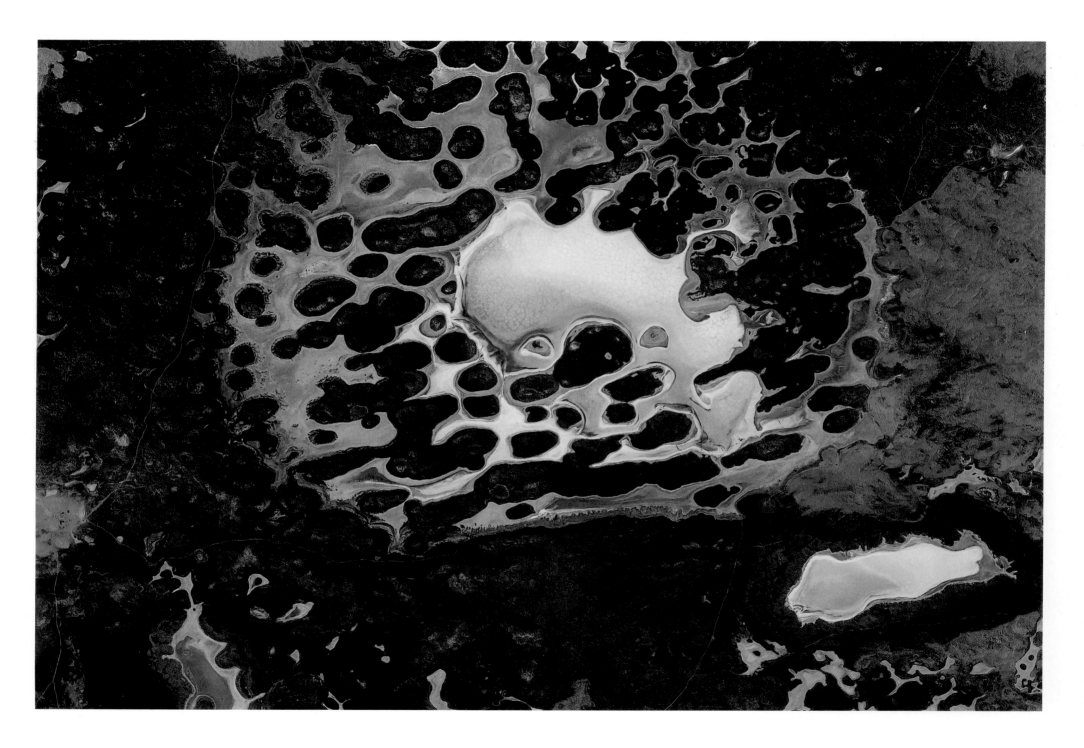

Over western Kazakhstan—otherworldly

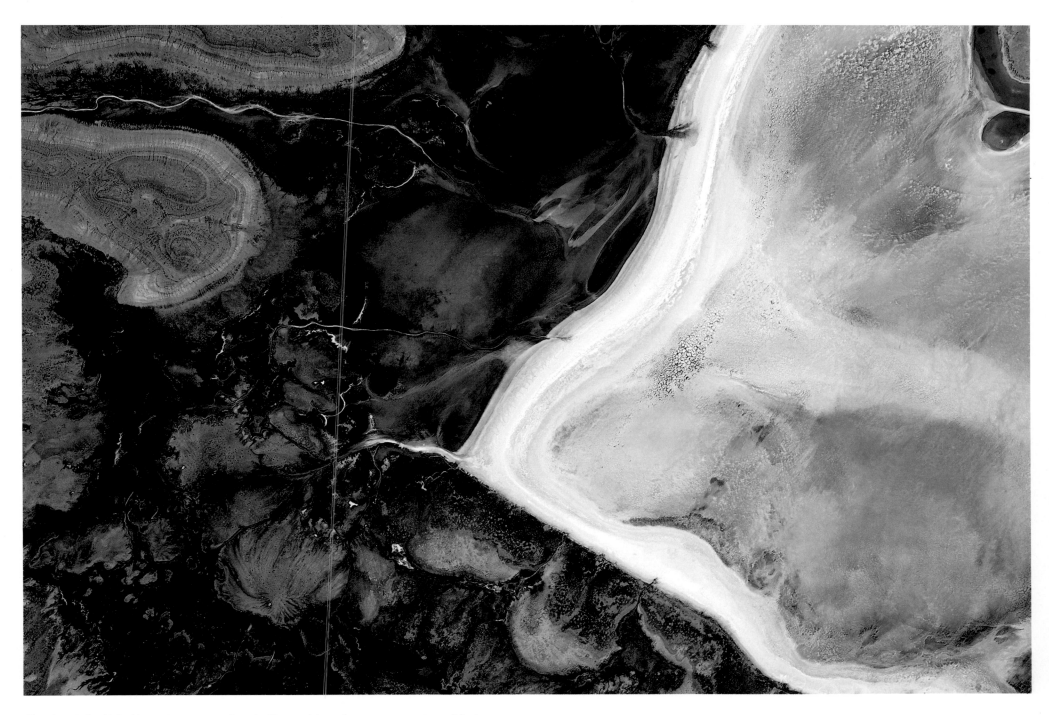

Chimboy Lake, Uzbekistan. It appears ghostly, like a white salt pan, contrasting with the surrounding land.

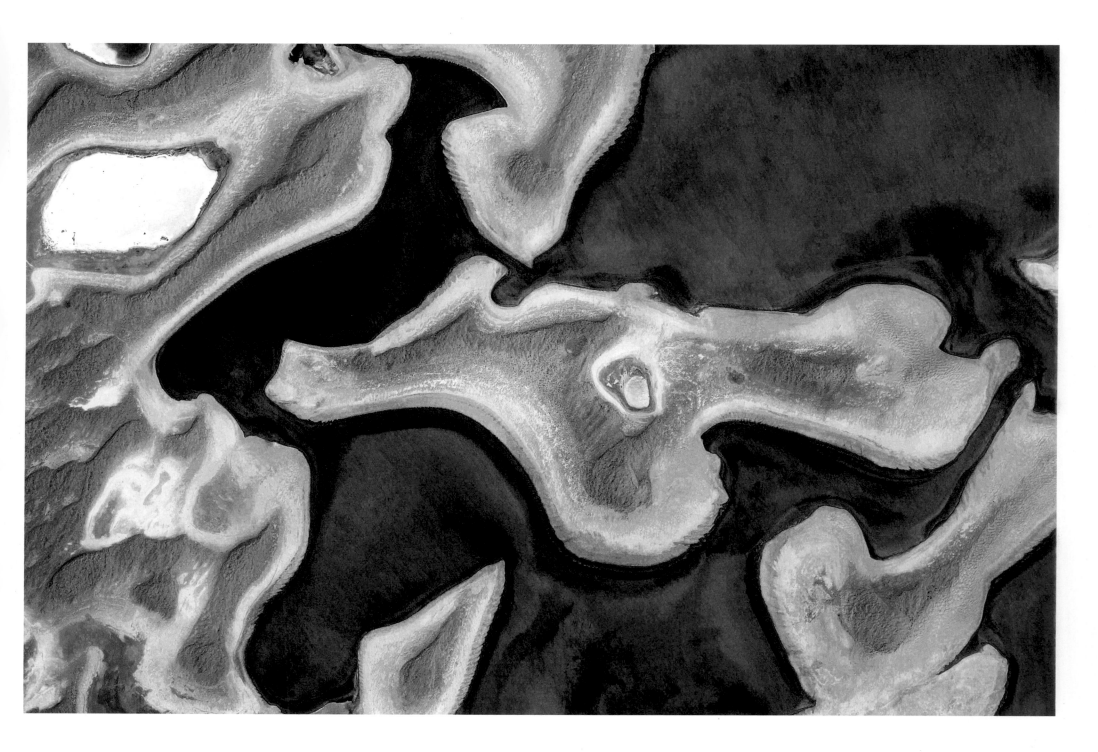

Abstract art in the real world. Over the Caspian Sea in Turkmenistan

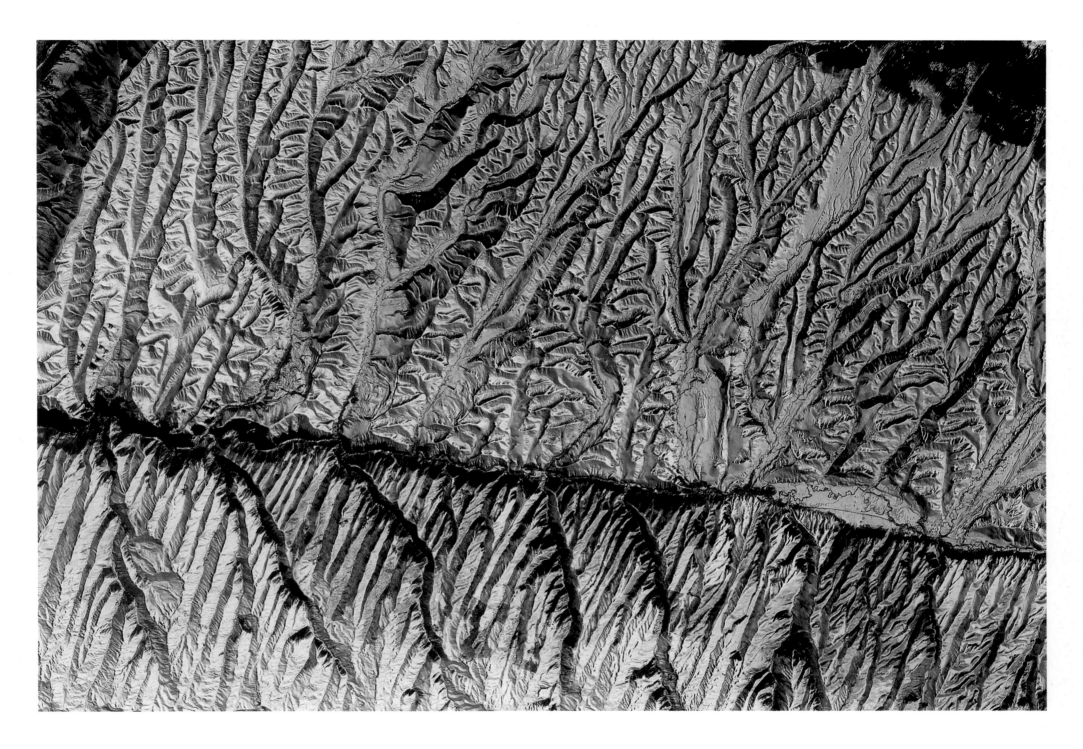

An arctic chill down the spine of Qiaxi, China

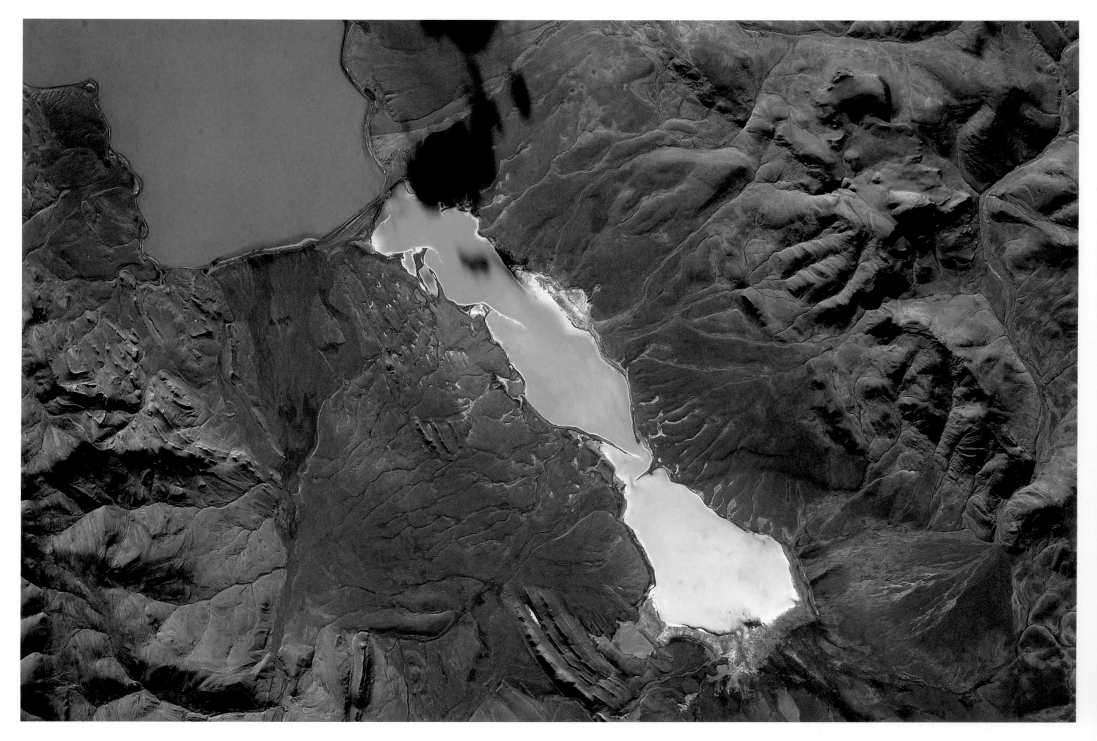

A lake near Nagpur, Tibet

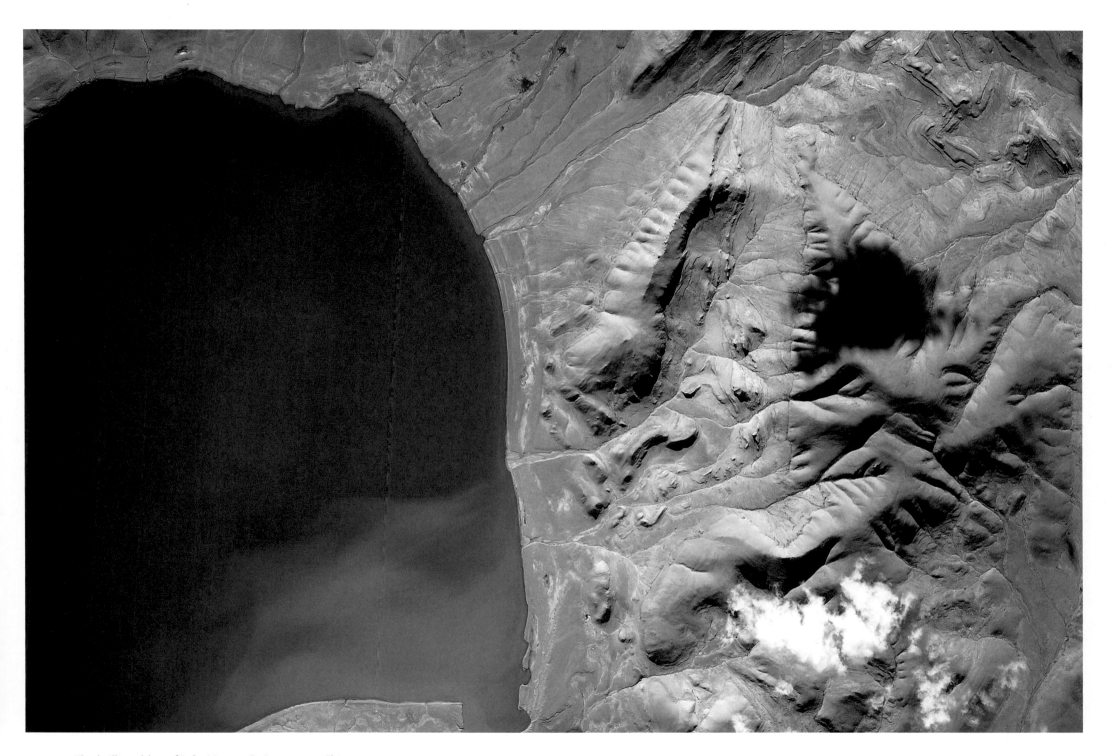

The brilliant blue of Lake Linggo Co in western China

A view of Bhomoraguri village in Assam, India, known for a nearby wildlife sanctuary that is home to wild animals such as the one-horned rhino, elephant, leopard, barking deer, tiger, and a variety of waterbirds

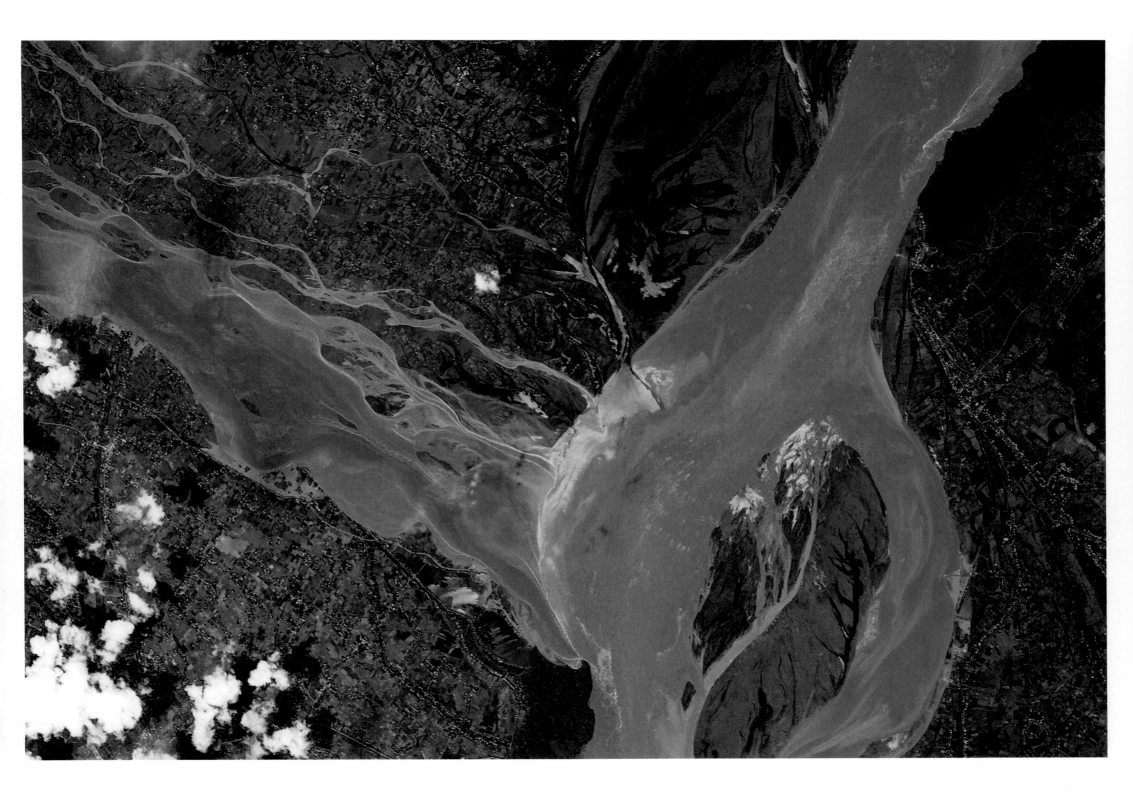

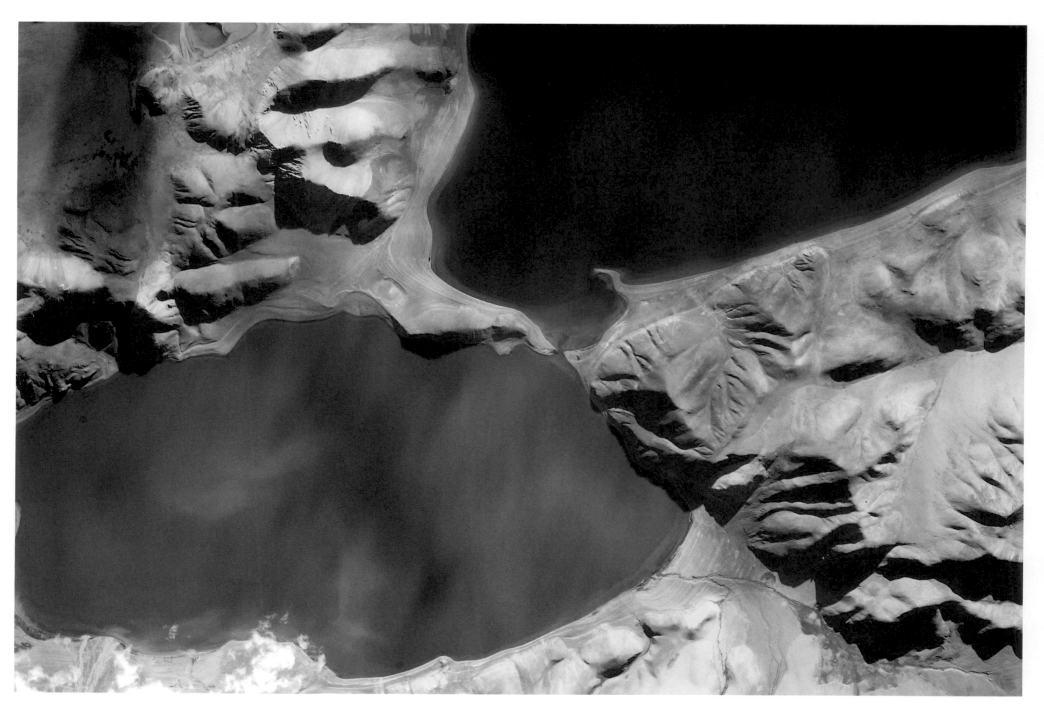

This scene over Bingni, Tibet, China, makes me think of the *Creation of Adam*, the Michelangelo fresco on the ceiling of the Sistine Chapel in Rome.

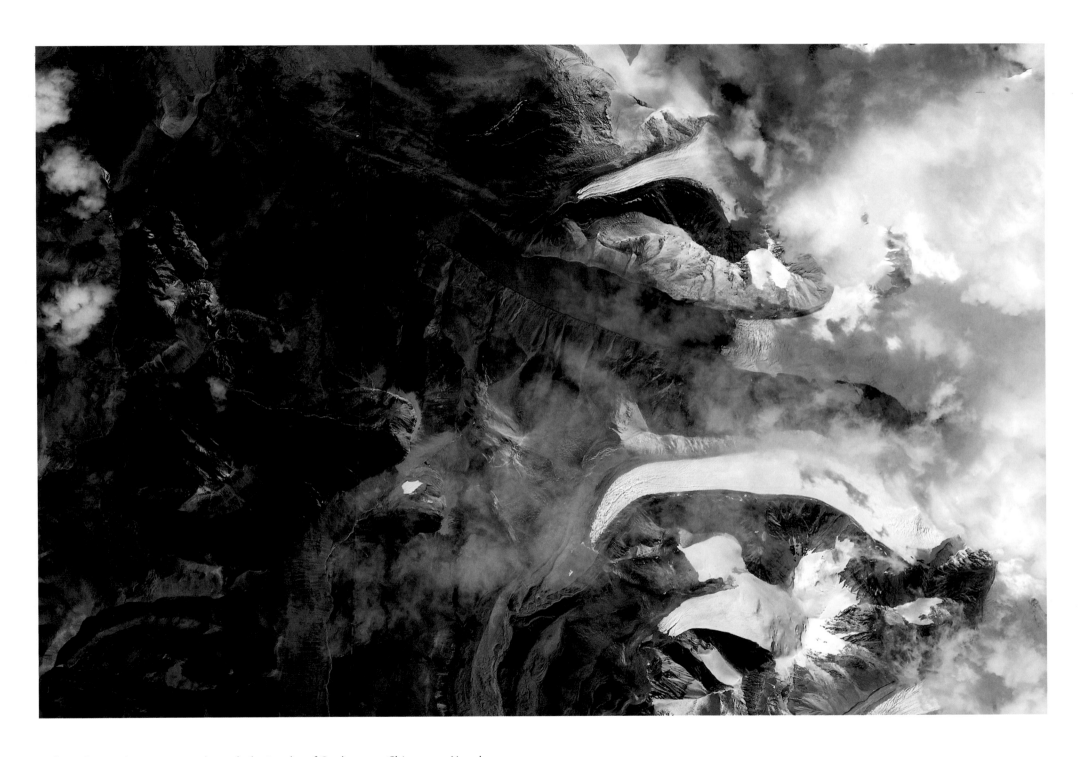

A slice of turquoise water cuts through the tundra of Cuolangma, China, near Nepal.

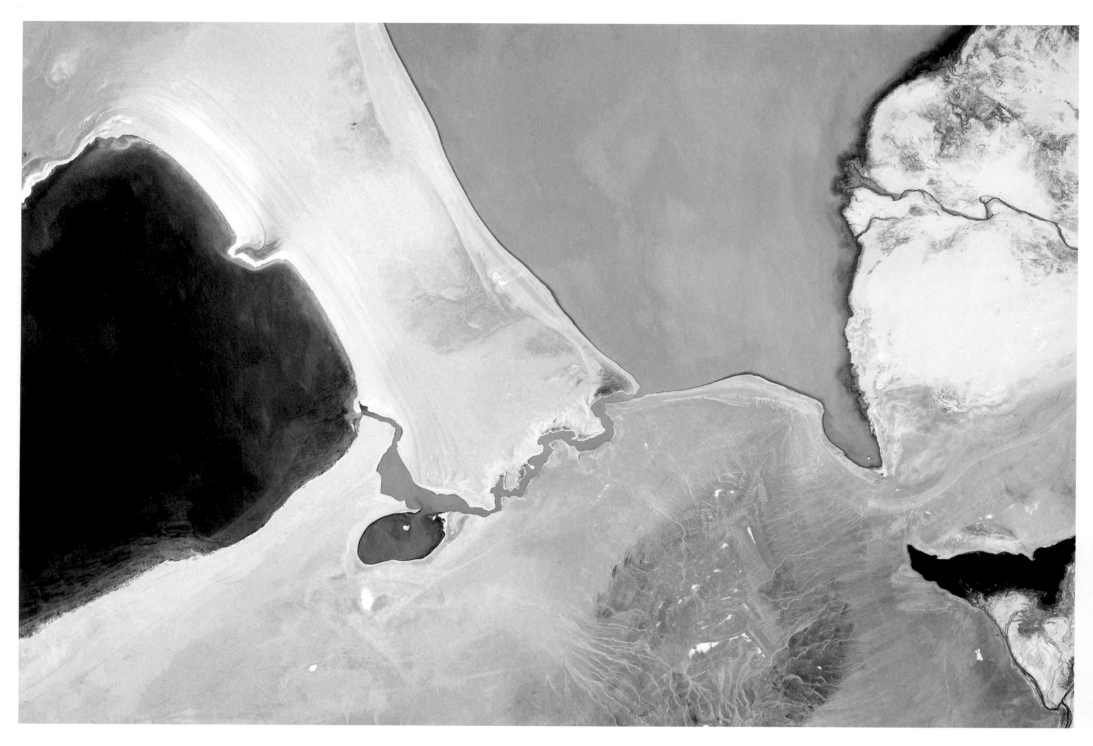

The painted world of the rift lakes of Mongolia

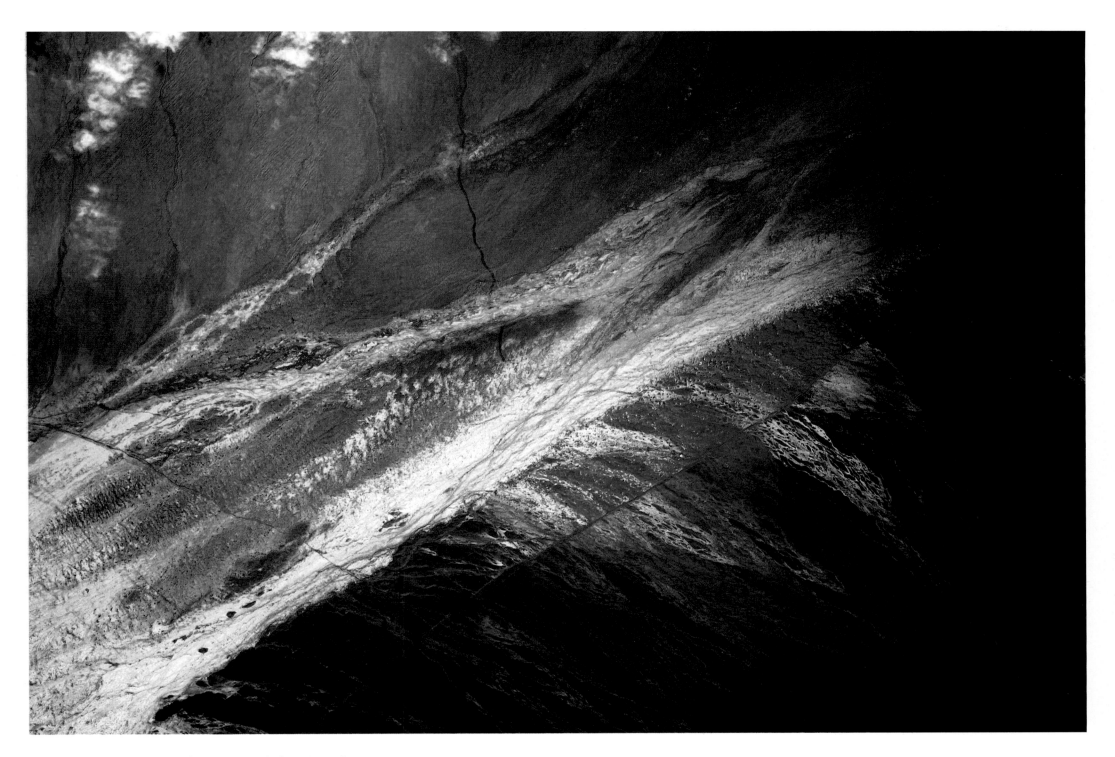

Vibrant textured strokes over Yesunbulag, Mongolia

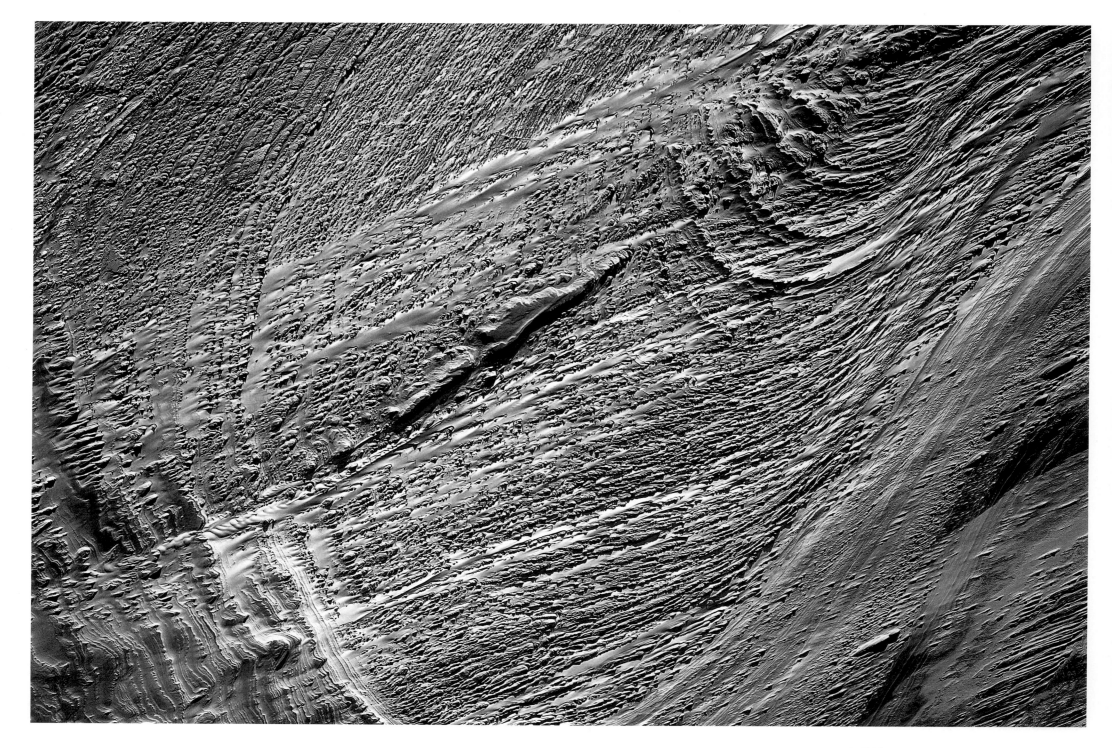

A seashell-like image over Qinghai, China

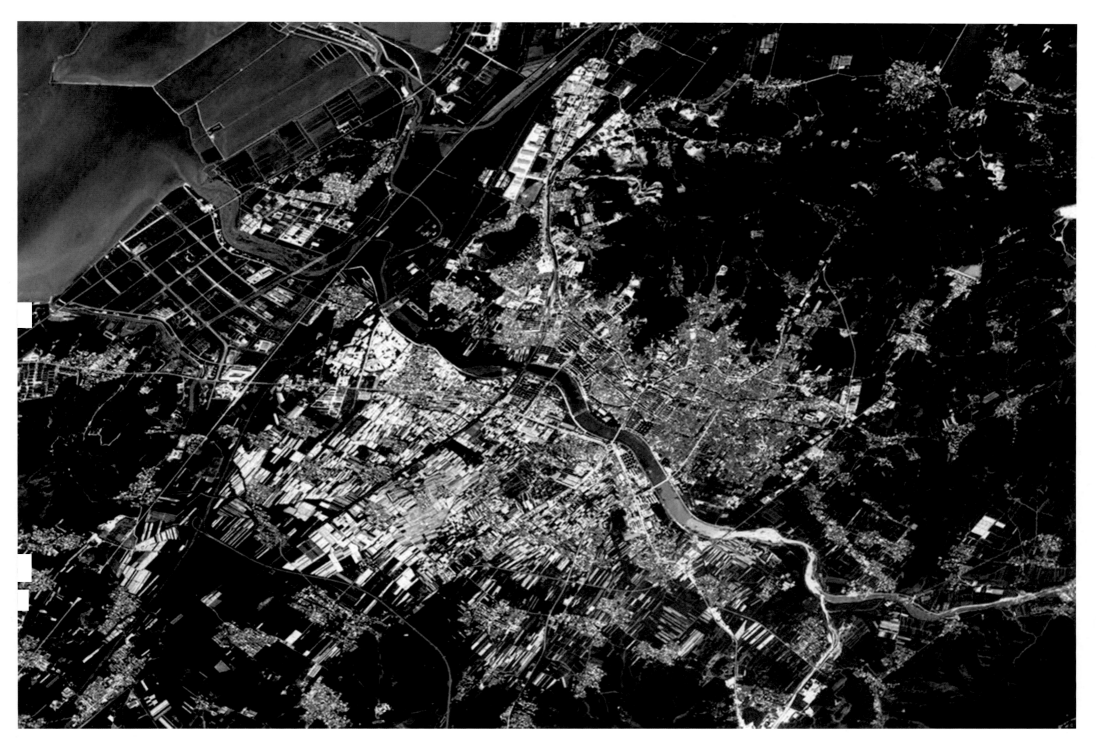

The Daqing River in China

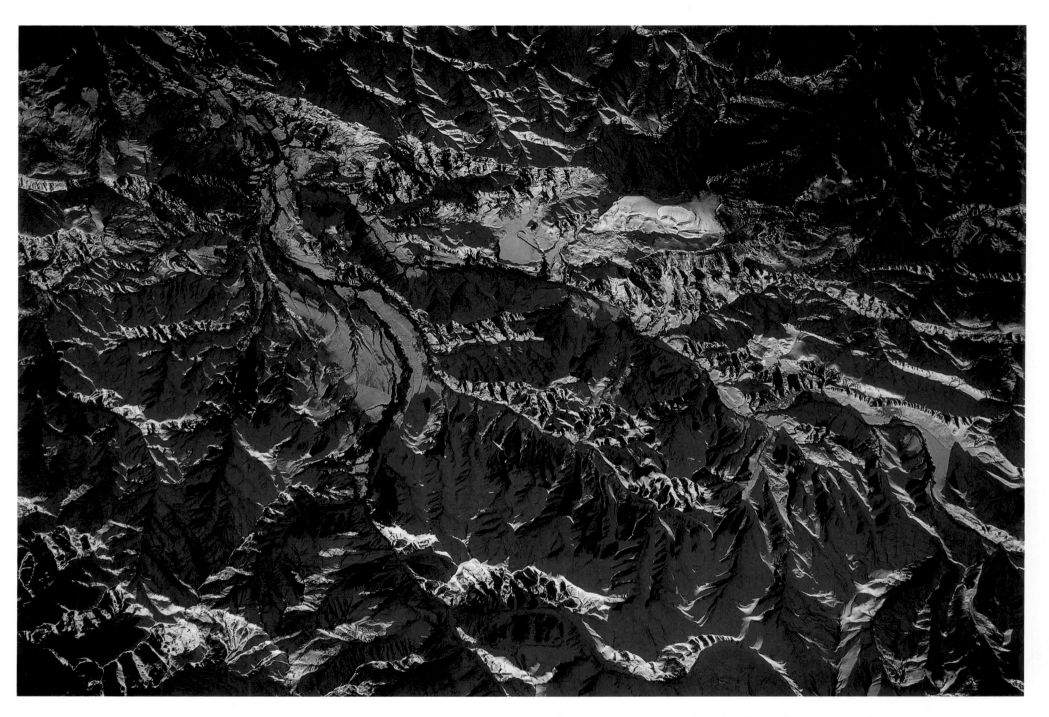

Coming upon mountain views like these of the Caucasus of Dagestan always gave me an almost palpable sense of the rock and grit below.

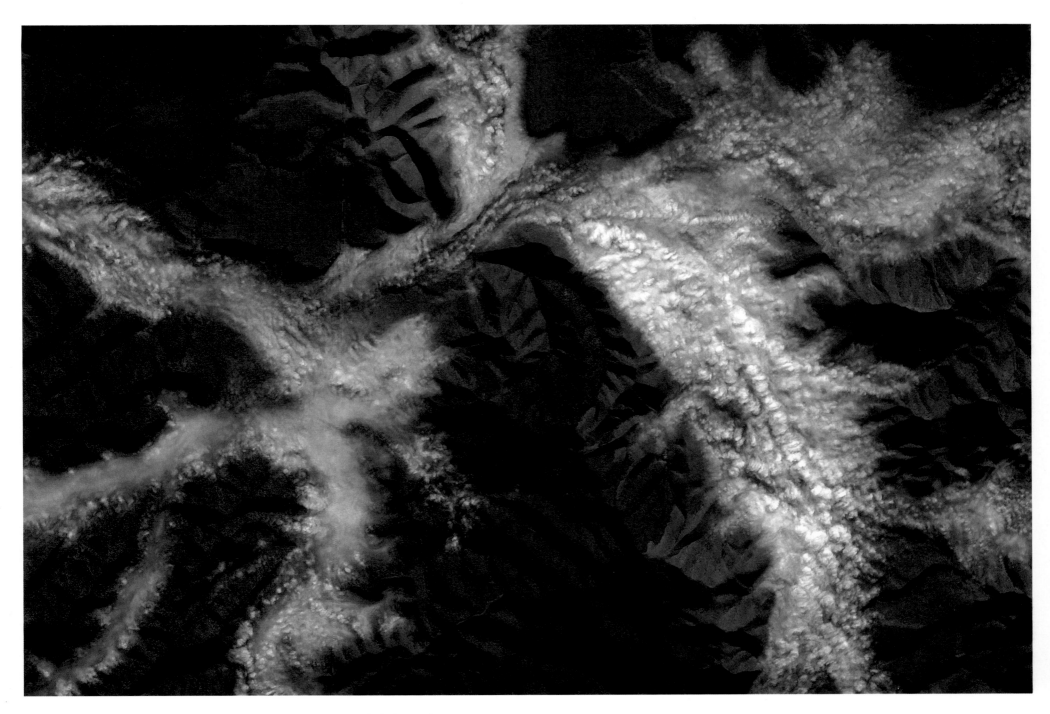

In this moody image, clouds drift above an emerald valley east of Khabarovsk, Russia.
My cousin Jamie Kelly lived there with her Russian husband.

Little Sandy Desert, Western Australia

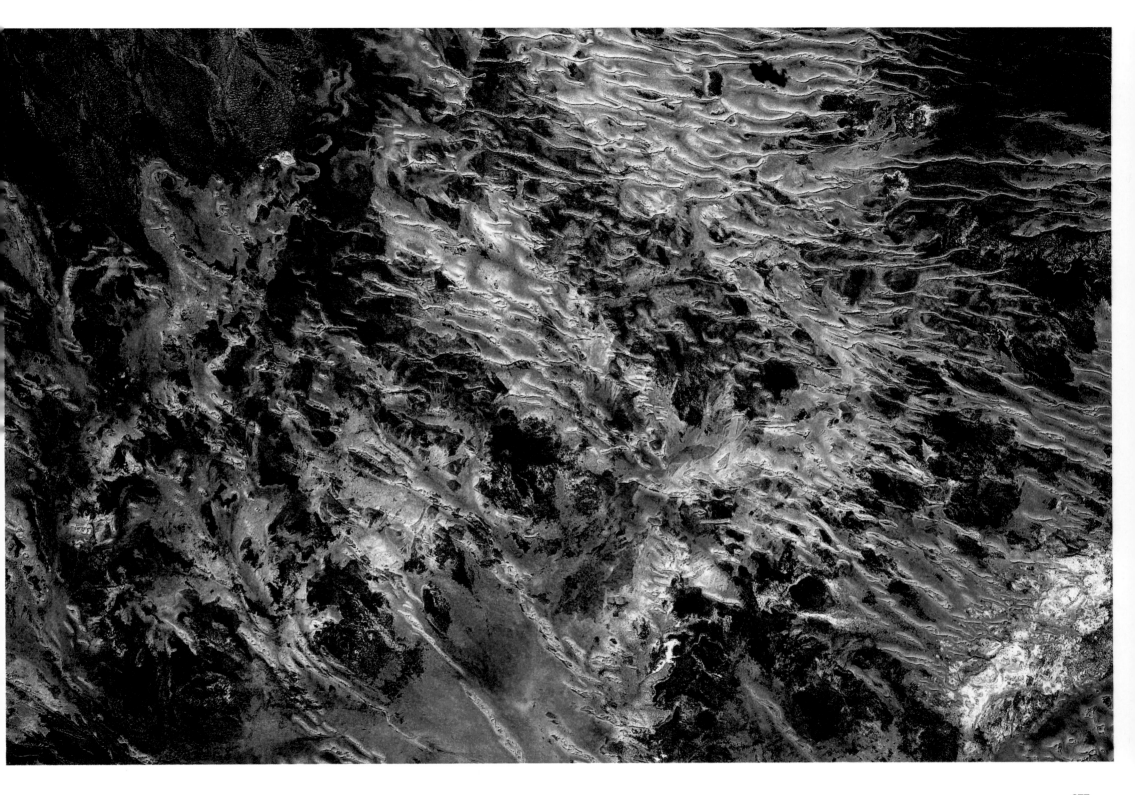

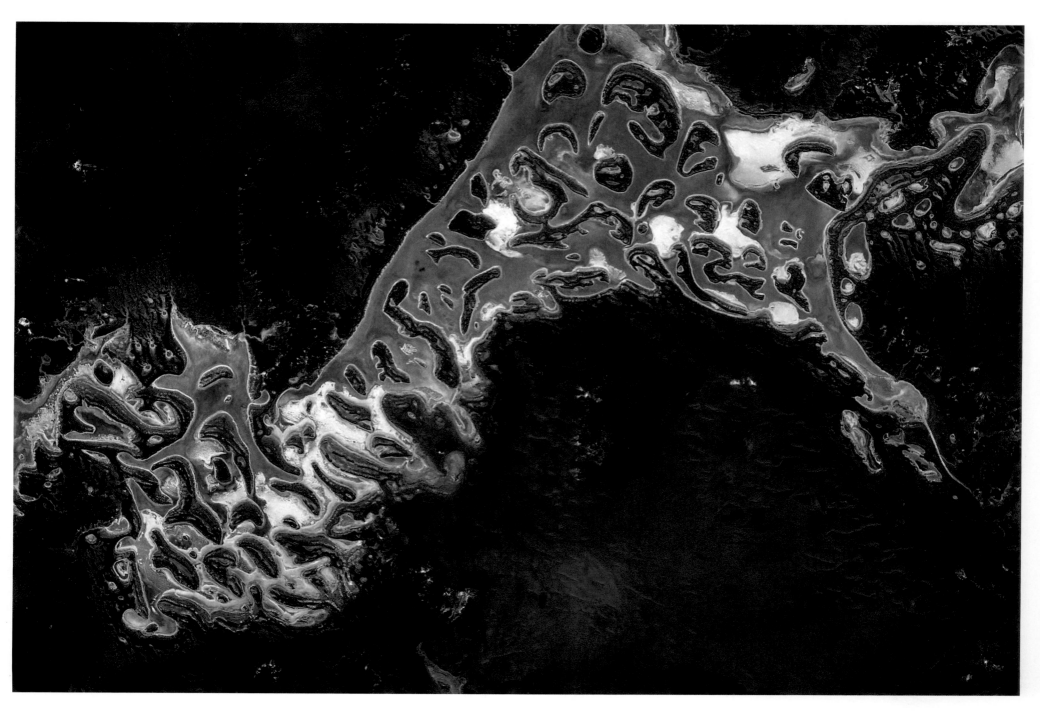

Peculiar and fascinating Lake Wells, Western Australia. I couldn't resist the red, white, and blue.

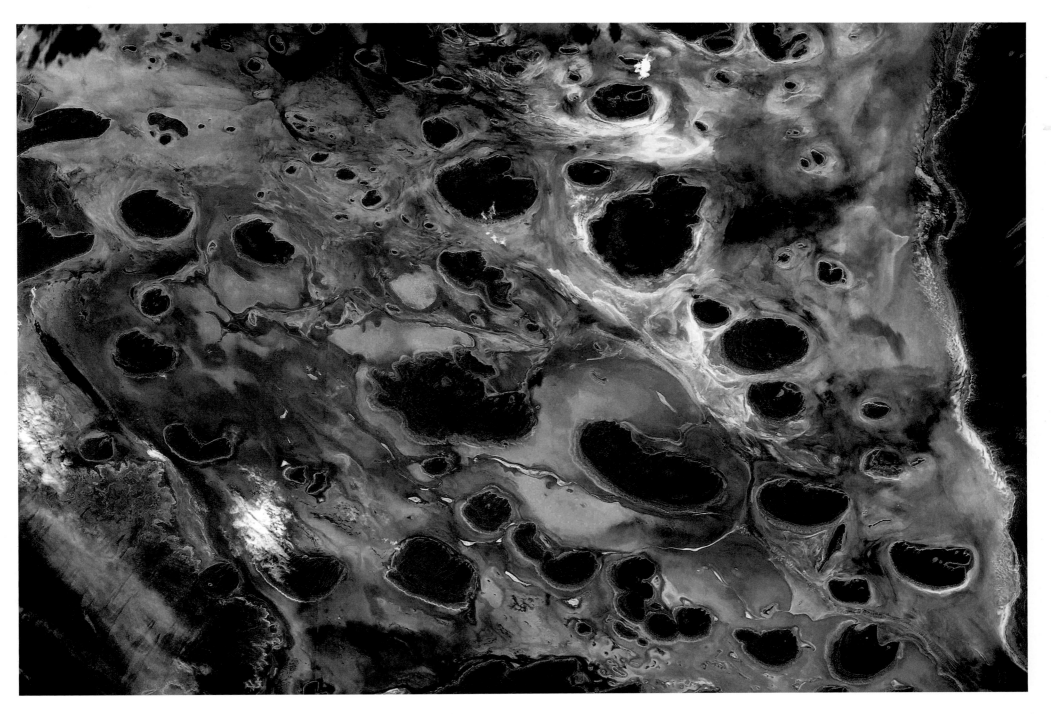

Lake Mackay stretches across the border between Western Australia and the Northern Territory. I couldn't ignore this striking microbial pattern.

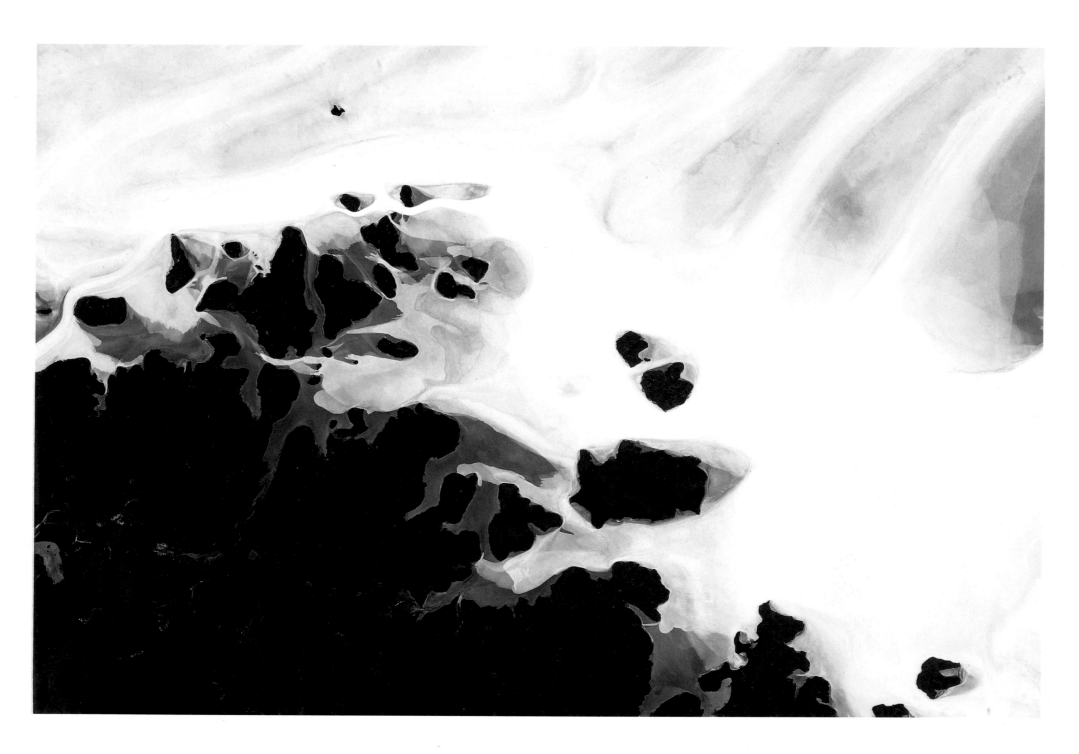

Lake Gairdner, a closed drainage basin with no outflow to any other body of water in South Australia

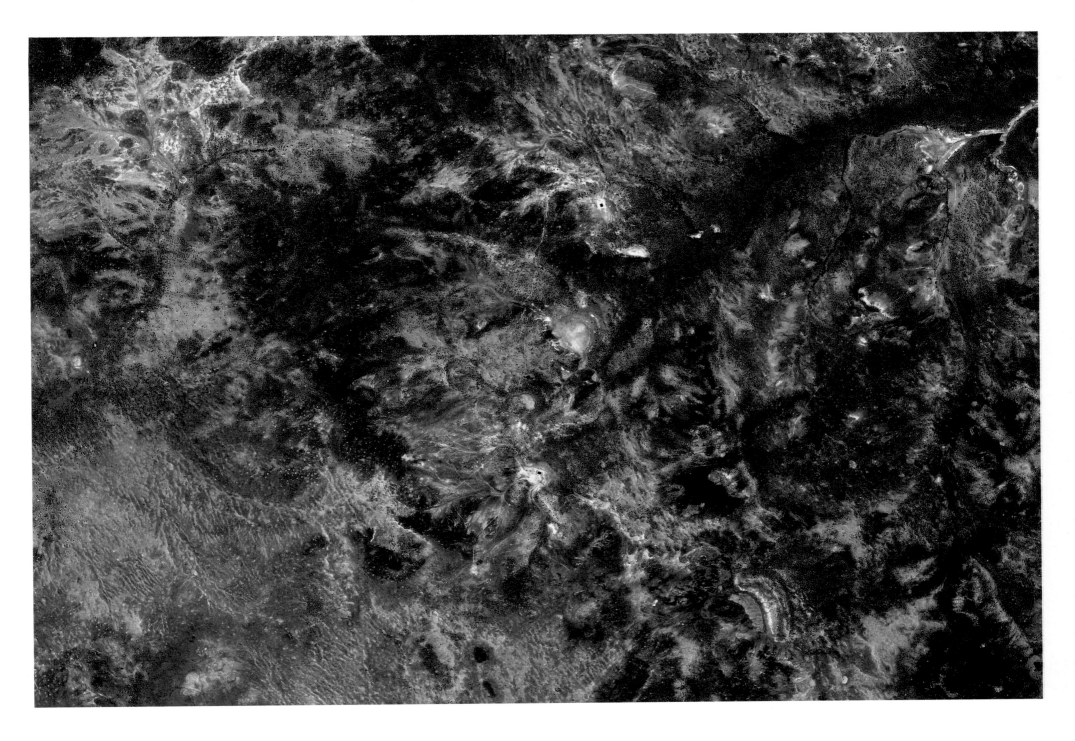

This image of Lake Gairdner, South Australia, feels ethereal to me.

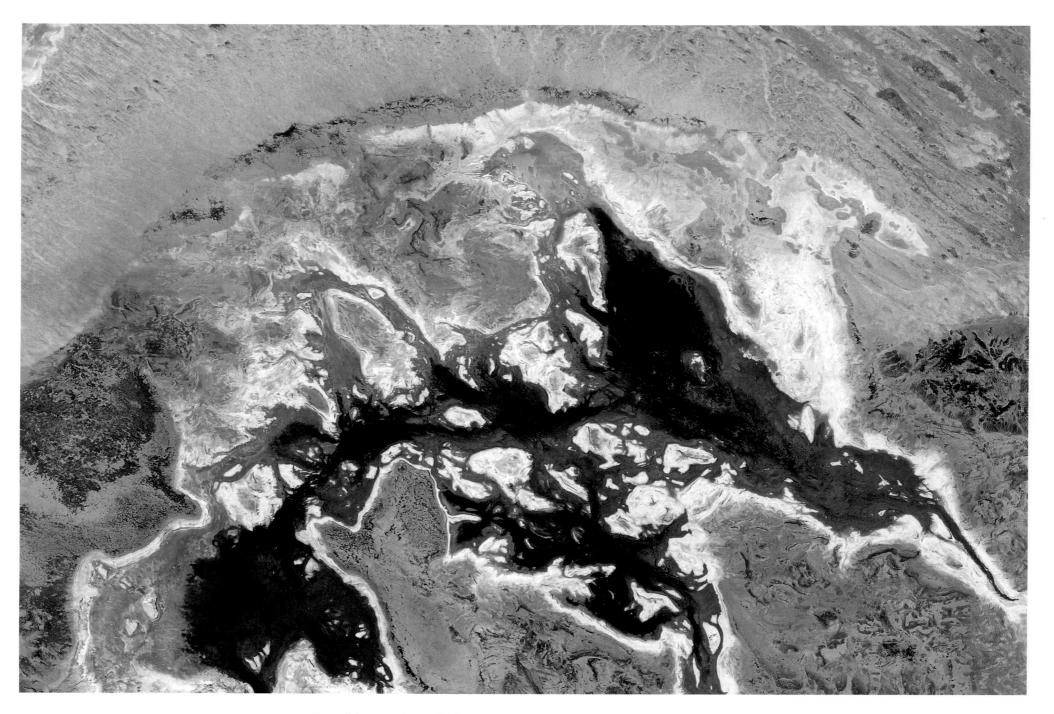

Two of the most beautiful features of Earth, water and desert. The permanent freshwater lake of Lake Gregory in Western Australia, situated between the Great Sandy Desert and the Tanami Desert, left a permanent impression on me.

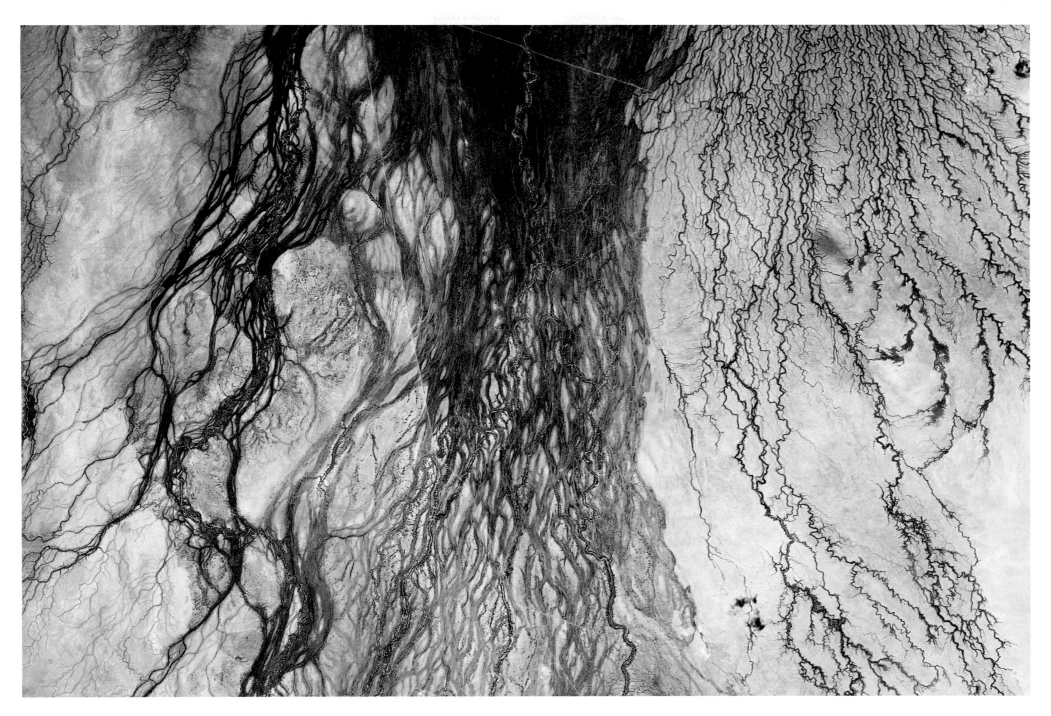

Over the Diamantina River, South Australia. There is no main body of water but rather a
series of wide, relatively shallow channels.

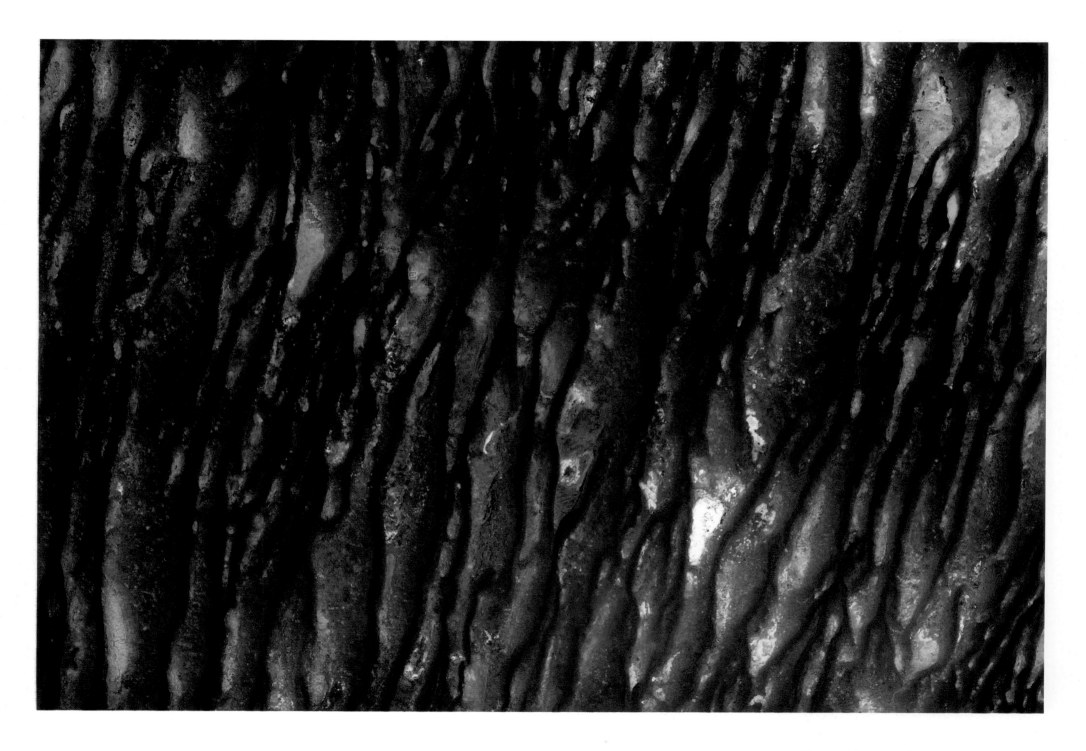

The sand dunes of Moomba in South Australia

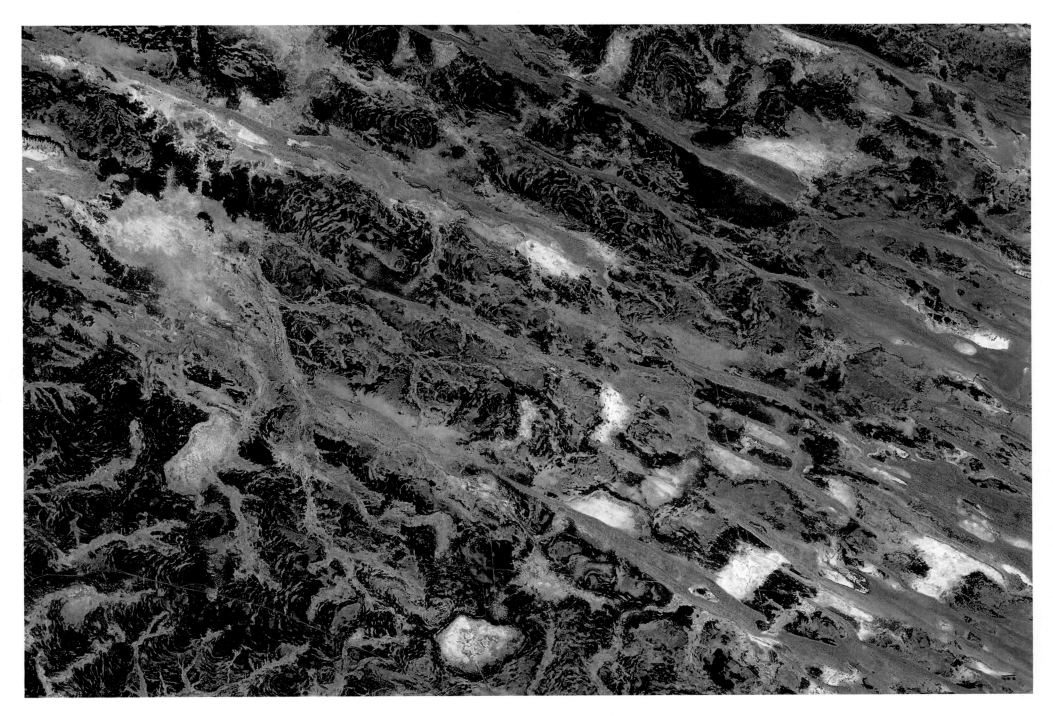

The notable outback route Birdsville Track runs between Birdsville in southwestern
Queensland and Maree, a small town in the northeastern part of South Australia.

A wonderful combination of colors near
Arrabury Airport, Queensland, Australia

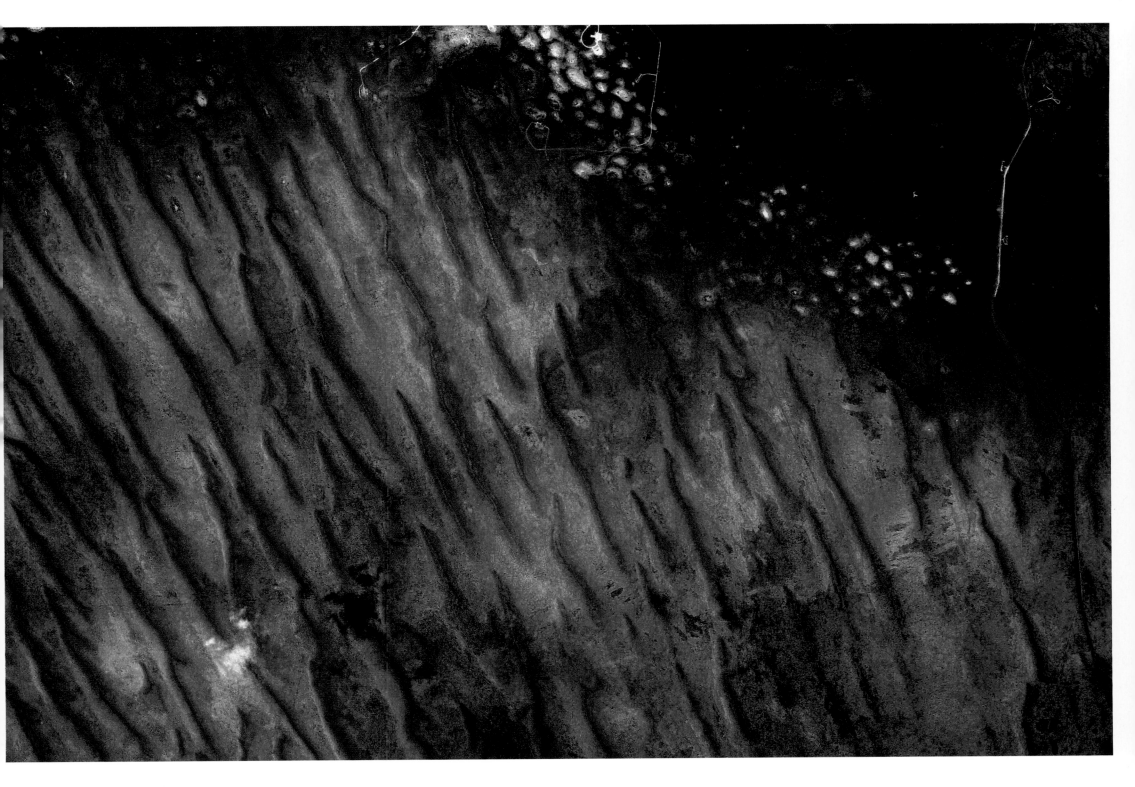

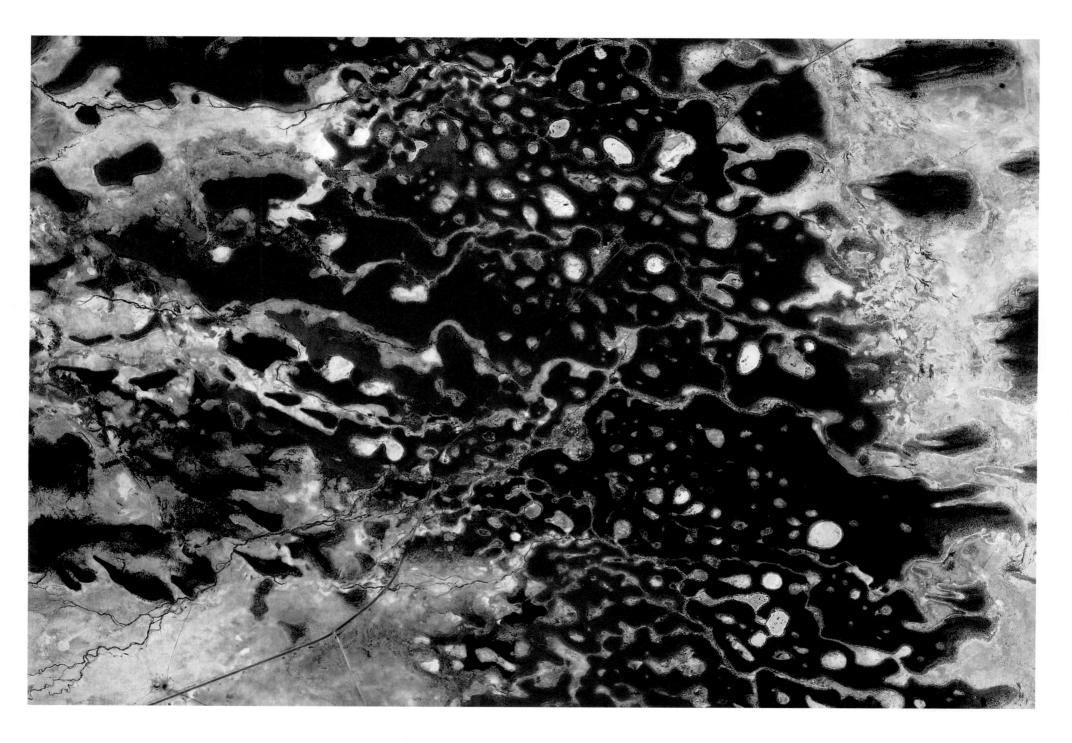

Iron and meteorite fragments near Carranya Station and Whitula Creek in Western Australia make for an edgy piece of artwork.

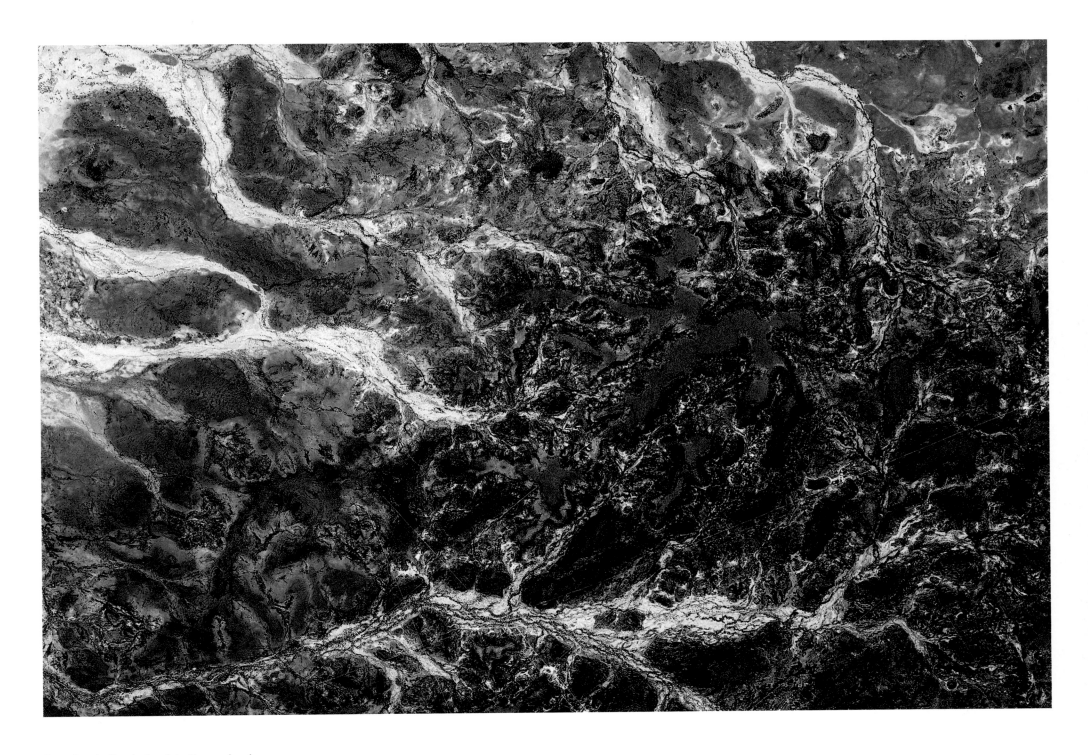

Over Sandy Creek, Jundah, Queensland

One of the many parks around Brisbane, Australia, known for their distinct range of flora and fauna

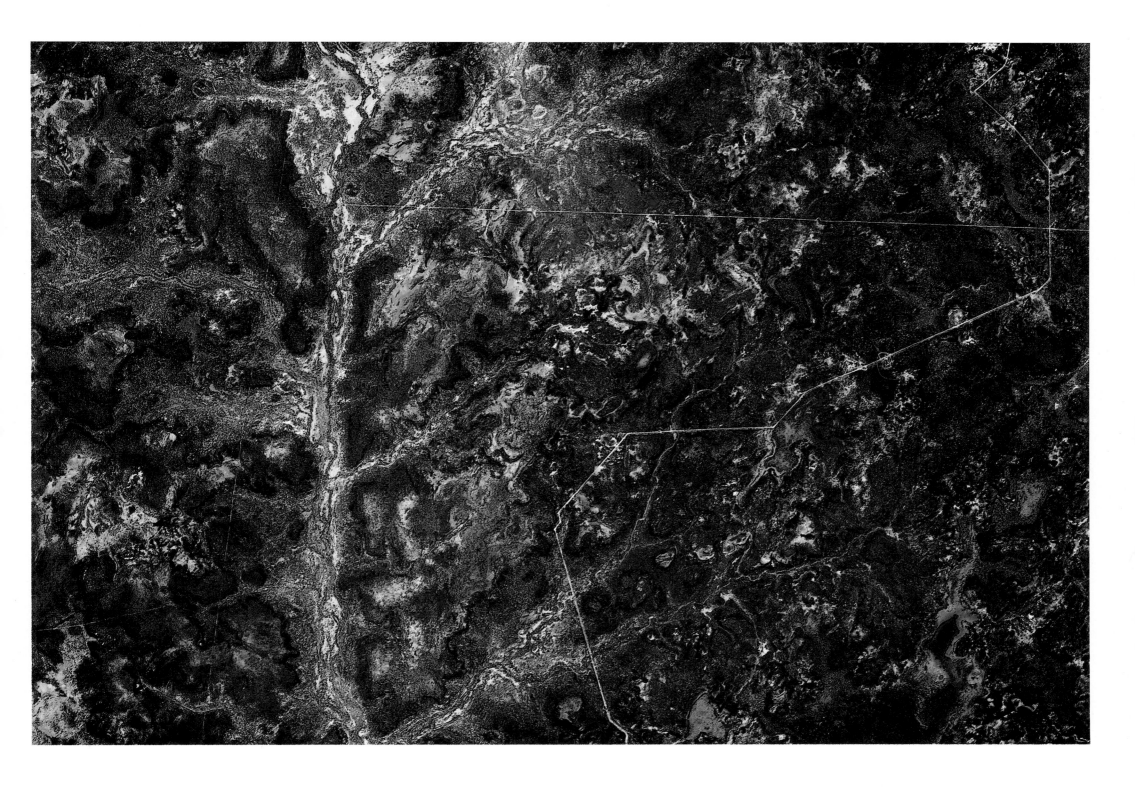

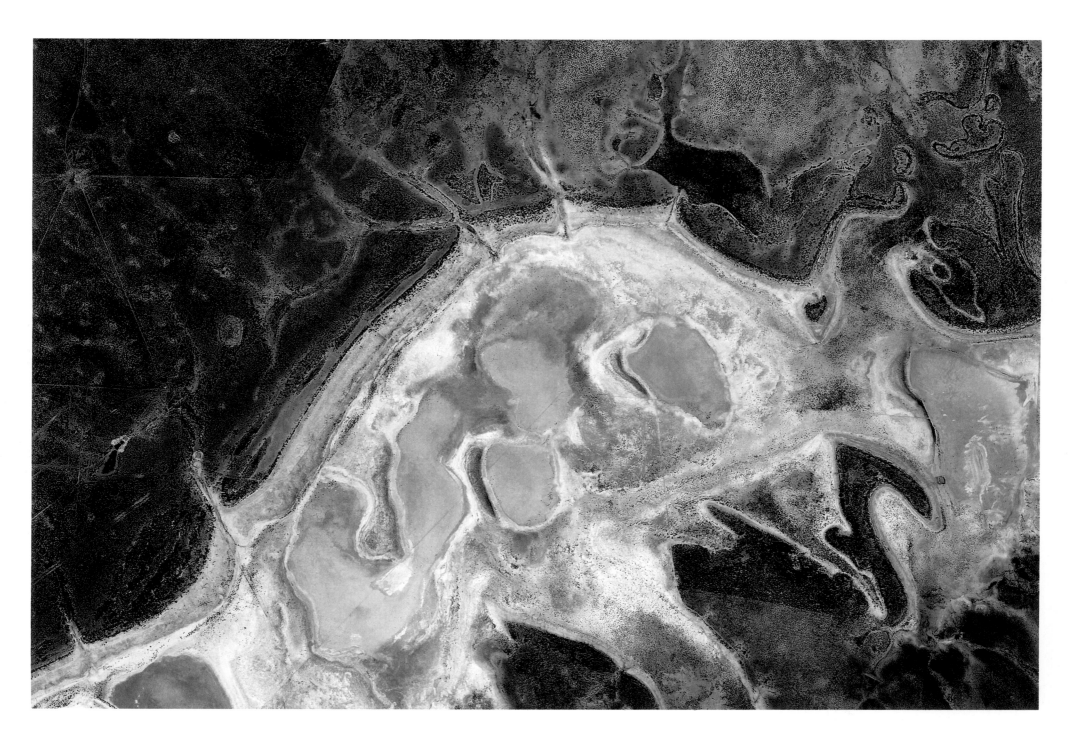

A palette of oil paint smudges seems to appear over the wetlands of Lake Galilee in Queensland.

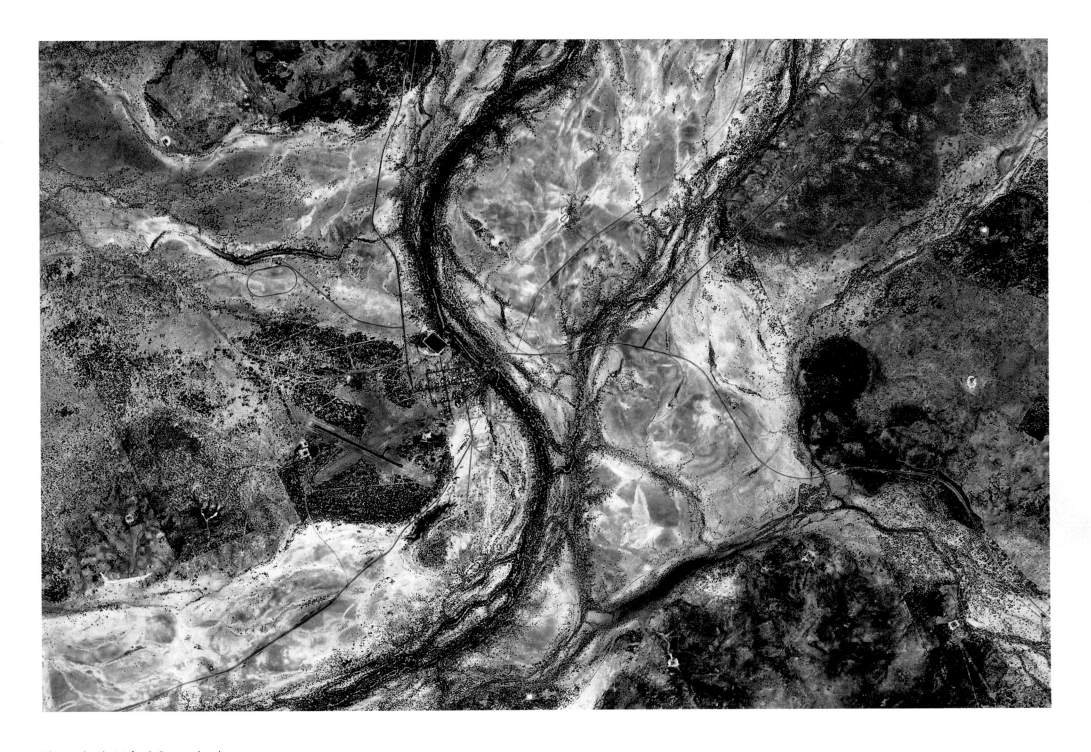

The outback, Isisford, Queensland

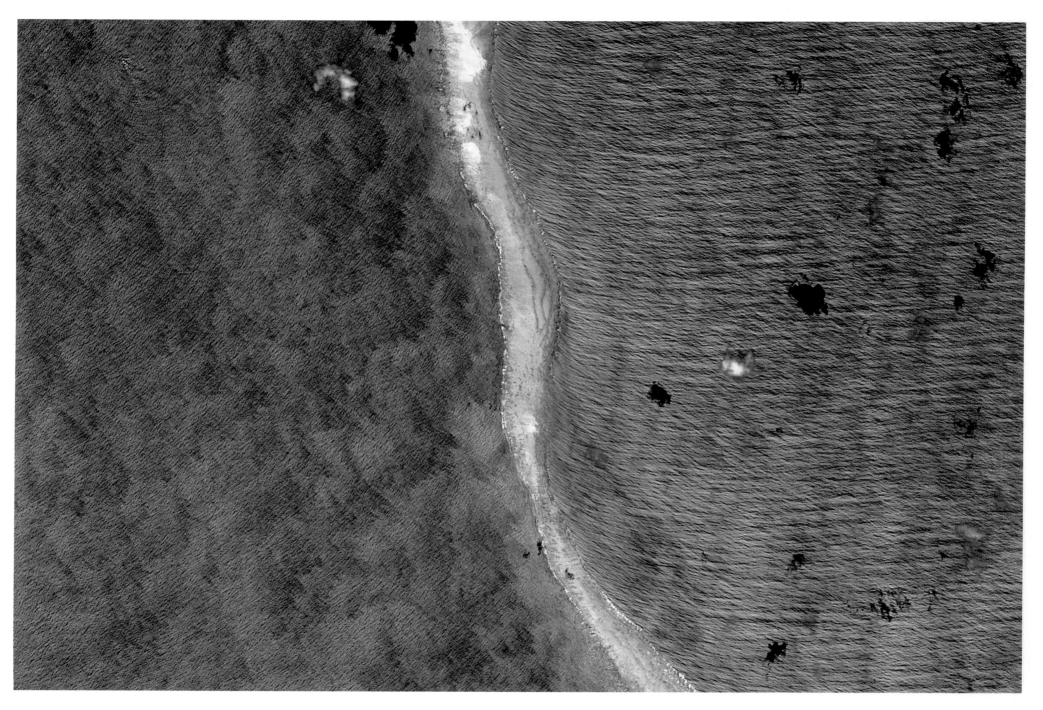

The brilliant coral sea off the northeast coast of Australia, featuring a wonder world of beautiful reefs and creatures below

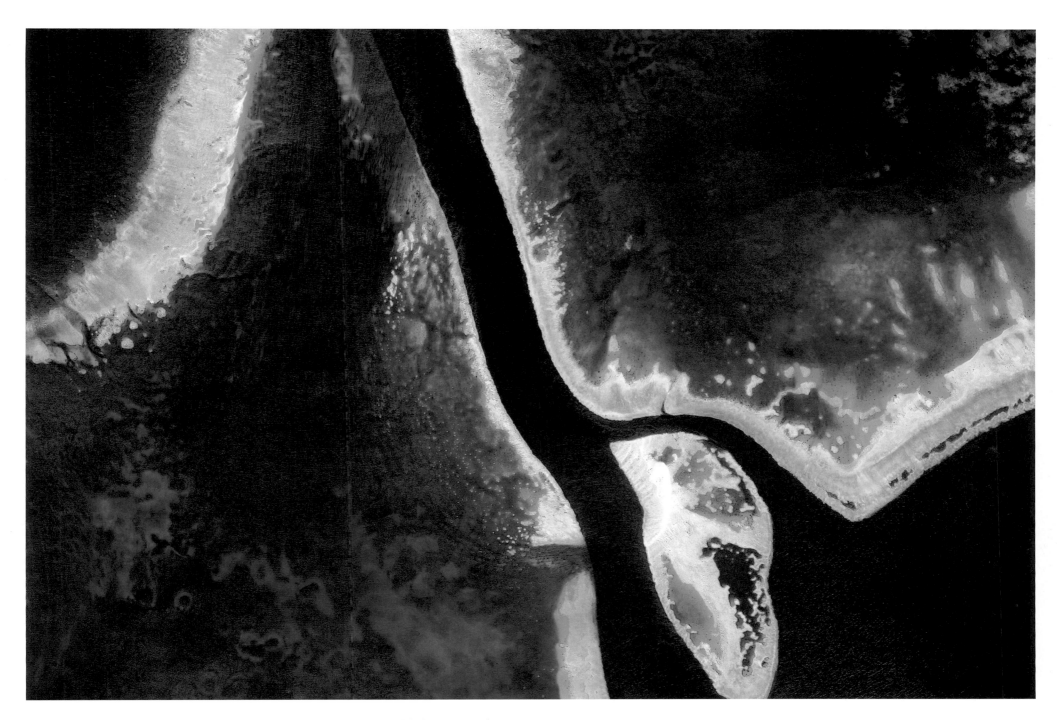

In Queensland, over the Gold Coast and the Great Barrier Reef, the world's biggest single
structure made by living organisms beneath brilliant blue waters

ACKNOWLEDGMENTS

Thank you to my fiancée, Amiko Kauderer, and to Ana Guzman for their help in creating this book. Thanks also to Peter Andersen, whose care and skill in executing the design are deeply appreciated, and to Andy Hughes, for his tireless commitment to producing a beautiful book.

ILLUSTRATION CREDITS

A NOTE ABOUT THE AUTHOR

Scott Kelly is a former military fighter pilot and test pilot, an engineer, a retired NASA astronaut, and a retired U.S. Navy captain. A veteran of four spaceflights, Kelly commanded the International Space Station (ISS) on three expeditions and was a member of the yearlong mission to the ISS. During the Year in Space mission, he set records for the total accumulated number of days spent in space and for the single longest space mission by an American astronaut. He lives in Houston, Texas.